QUANG TCHEW-FU

Ville CANTON

Fauxbourg

Faubourg
Ville
des Tartares
I des Chinois

Tallo-Pai

Forts

Forts

Linam

Tour Tacou

Corps de garde

Tour de Twancou

Corps de garde

Corps de garde

Houchon

Tour du Lion

I. Loucan

Channel

I Passam ou I des Serpents

Tongroanhien

I. du Tigre

Isle des Tigres

I. de Foun

Lanterion Porteresse

I. douce

Channel

Smn-gan-hien

Hang-chan-hien

Channel

Barre

CARTE
DE L'ENTRÉE DE LA
RIVIERE DE CANTON
dans la Chine.

Echelle de Quatre Lieues Communes.
1 2 3 4 L.

ISLE DE MACAO

I des Prêtres

Macao blanche

I. Lintin

Latitude
22. Deg. 25. min.

Longitude III.ᵉ Deg.
10. min. à l'Est de Paris.

Aes Neuf Isles

Macao

Heaven is High, the Emperor Far Away

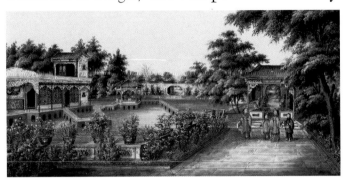

Heaven is High, the Emperor Far Away

Merchants and Mandarins in Old Canton

Valery M. Garrett

OXFORD

UNIVERSITY PRESS

OXFORD

UNIVERSITY PRESS

Oxford University Press is a department of the University of Oxford.
It furthers the University's objective of excellence in research, scholarship,
and education by publishing worldwide in

Oxford New York

Auckland Bangkok Buenos Aires Cape Town Chennai
Dar es Salaam Delhi Hong Kong Istanbul Karachi Kolkata
Kuala Lumpur Madrid Melbourne Mexico City Mumbai Nairobi
São Paulo Shanghai Singapore Taipei Tokyo Toronto

and an associated company in Berlin

Oxford is a registered trade mark of Oxford University Press

Published in the United States
by Oxford University Press Inc., New York

© Oxford University Press 2002

First published in 2002
This impression (lowest digit)
1 3 5 7 9 10 8 6 4 2

British Library Cataloguing in Publication Data
available

Library of Congress Cataloging-in-Publication-Data
available

ISBN 0-19-592744-3

Printed in Hong Kong
Published by Oxford University Press (China) Ltd
18th Floor, Warwick House East, Taikoo Place, 979 King's Road, Quarry Bay
Hong Kong

Contents

Acknowledgements vii

Introduction ix

A Note on Pinyin Spelling xiv

PART ONE: POWER AND GLORY

1 Palaces and Pagodas: The City of Rams 3

2 Within the City Walls: The Tartar Quarter 13

3 Scholars and Mandarins: The Chinese City 21

4 The Rich and the Wretched: The New City and the Suburbs 37

5 Executions and Flower Boats: By the Banks of the Pearl River 49

6 Spiritual Blessings: Faith, Prayer, and Piety 59

PART TWO: EAST MEETS WEST

7 Fankwaes and Celestials: The Thirteen Factories 73

8 China Trade: A Willow-Pattern Wonderland 85

9 Disobedience and Destruction: The China Wars 97

10 Across the River: Honam and Fati 111

11 A European Refuge: The Island of Shamien 125

PART THREE: GOD AND MAMMON

12 Made in China: Shopping in the Suburbs 141

13 Spreading the Word: Christianity Comes to China 149

14 Revolution and Change: The Twentieth Century 165

Addendum 181

Table of Chinese Dynasties and Periods 183

English/Pinyin and Cantonese/Pinyin Glossary 184

Sources for Illustrations 187

Selected Bibliography 191

Index 201

Acknowledgements

Friends, family, and colleagues have helped in many ways with the preparation of this book. From the very beginning, Dr James Hayes, from his base in Australia, has been a constant source of strength and good sense, making numerous insightful and helpful suggestions. His support has been invaluable. Here in Hong Kong, Dr Patrick Hase kindly read the manuscript and made useful comments, while Reverend Carl Smith, with his encyclopaedic mind and superb card index system, made the search for obscure facts much easier than it would otherwise have been. Richard, my husband, niece Katy Powell in Portugal, and good friend Vivienne Taylor in Singapore also read parts of the manuscript and made constructive remarks.

Caroline Davidson in London generously gave many hours of her time and helped greatly in shaping the book. Margaret Moore in New Zealand was helpful in loaning notes made by her mother, Jean Moore, and her grandparents, Reverend George and Mrs Margaret McNeur. Library staff, in particular Lorraine Lok at the University of Hong Kong and Ivy Kan at Lingnan University, followed up on many queries. Others who helped in many ways include S. J. Chan, David Hodson, May Holdsworth, John MacKenzie, Catherine Maudsley, Professor Puay Peng Ho, all in Hong Kong, William Shang in Tokyo, Peter Tang and Paul Van Dyke in Macau.

I am grateful, as well, to Patrick Connor in London, and Anne Selby and Jonathan Wattis in Hong Kong, for their help with identification of many illustrations. Thanks also to Dennis Crow, Cecily Godfrey, Robert Nield, and particularly Charles Slater. My stalwart editors at Oxford University Press, Anastasia Edwards and Peter Siegenthaler, always had faith in the book and gave me much good advice and support. Finally I must not forget Frank Davies, a colleague at Dodwell's in 1975, who first introduced me to Canton. My sincere thanks go to them all.

Valery Garrett
Hong Kong, 2002

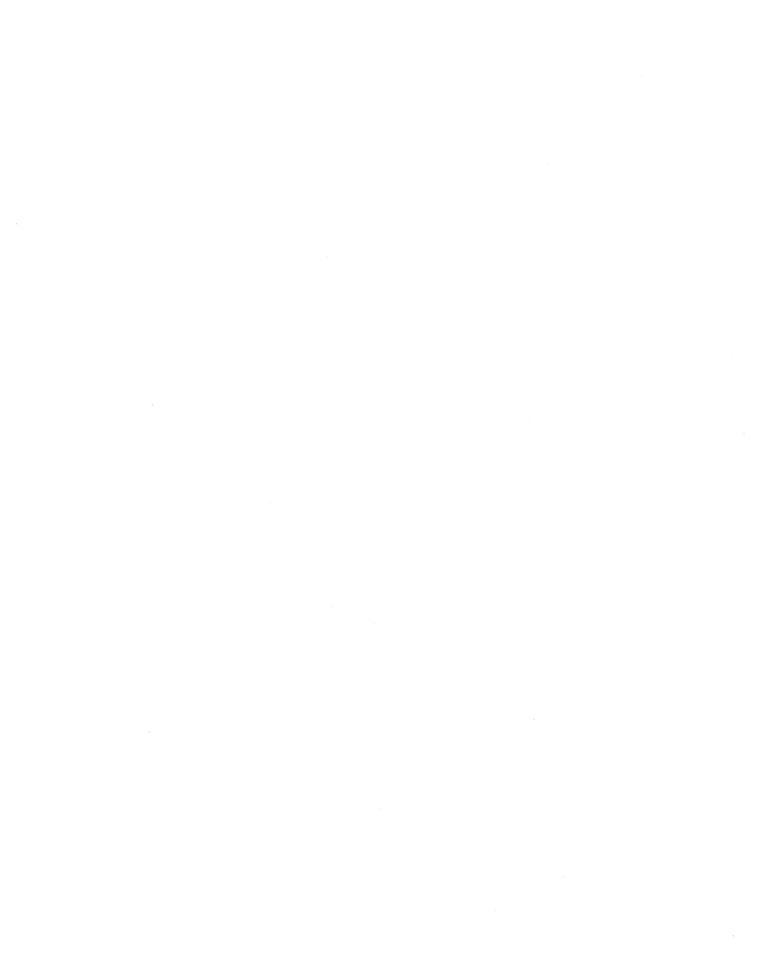

Introduction

Canton has always attracted opportunists. From the Arab traders in the Tang dynasty, to Western merchants in the sixteenth century, and the Hong Kong Chinese in recent times: all came to the city to make money. An international port of great renown for two thousand years, Canton became a mecca for adventurers. In the fourteenth century, with its population of almost 150,000 nearly equal to that of Beijing, it was made the capital of Guangdong province and an important centre of government. Powerful mandarins representing the Son of Heaven, the dragon emperor and omnipotent ruler of China, held court within the walled city. In 1759, during the Qing dynasty, when the Qianlong emperor confined trade with the West to Canton, the city grew increasingly prosperous, and by the early nineteenth century it had become the largest city in southern China, the second largest in the country after Beijing, and the nation's biggest port. Its population having grown to nearly a million people, it was one of the great commercial entrepôts of the world.

Like the merchants from the Middle East, the fankwaes, or 'foreign devils', from the West were tolerated but kept at arm's length, excluded from Canton's walled city, living and trading from factories down by the Pearl River. Ships brought cargoes of opium, the only import the Chinese desired in any quantity, in exchange for tea, porcelain, and silk. When those ships left the Chinese coast, what corners in their holds were left unfilled were crammed with curios carved in ivory, sandalwood, and mother-of-pearl. These exports fuelled the West's craving for chinoiserie, from figurines, fans, and embroidered silk shawls, through to porcelain tea cups and the tea that went in them. Brighton's Royal Pavilion, completed in 1787 for the Prince of Wales, was a magnificent monument to Oriental style. Country landowners with more modest means had special rooms devoted to all things Chinese. Chinoiserie style still charms us today, and the gardens of Canton are reproduced on 'willow-pattern' chinaware in every High Street.

Even as trade declined in the late nineteenth century, Canton continued to draw travellers eager for a glimpse of this fabled city. Their diaries and letters extolled its charms and curiosities and helped to form the West's perception of China. Yet all too often, to the present-day tourist it is a place

to avoid, just another modern city where joint ventures are formed, deals are struck, and traffic is often at a standstill.

Millions of viewers around the world watched the hand-over ceremonies when the British colony of Hong Kong, just 150 kilometres from Canton, reverted back to Chinese sovereignty in 1997, followed two years later by its neighbour, Portuguese-governed Macau. But how many realized that these two tiny territories, together little more than 1,000 square kilometres, owed their place on the world's stage to their links with Canton? When it became the only port in China open to the West, the foreigners in Canton were required to leave when the summer trading season ended, and so they sailed down the Pearl River to Macau. Until trade-winds brought ships to China's shore once more, the merchants spent the intervening months with their families in pastel-coloured mansions overlooking the Praya Grande, making Macau a tiny corner of Europe in Asia. The arrangement came to an end in 1839 when, drained both physically and financially, the Chinese authorities banned the import of opium and held up the chief exports, tea and silk. British troops attacked Canton, the defeated Chinese ceded the island of Hong Kong to Britain, replacing Macau's strategic role, and Hong Kong's future was set.

Canton's unique role as a window on China meant many who came here felt compelled record it. Early reports came from the Portuguese, the first Europeans to reach Canton in 1517. More explorers followed, like purser and diarist Peter Mundy, who arrived in 1637 on board the first English ship to attempt to trade with China. Soon after, the first embassy of the Dutch East India Company arrived, accompanied by Jan Nieuhof, the mission's official chronicler and draughtsman. Nieuhof's book, published in 1669, included drawings which showed the earliest views of Canton, and China, brought to the West. More than a century later, Lord Macartney led an embassy from the British monarch, George III, to the Qianlong emperor seeking to open more ports for trade. Their journey, including stop-overs in Canton and Macau, was carefully documented in diaries and drawings. Accounts of these abortive missions, however, were based on relatively brief observations of the country.

From the 1830s on, a rush of writing from traders and Protestant missionaries, now settled in Canton, gave valuable accounts of daily life, their first-person records most often published in periodicals of the time. The first general book on China written in English was by John Francis Davis, chief superintendent of British trade and a resident in Canton for over twenty years. Davis understood Chinese, and his work, *The Chinese: A General Description of China and Its Inhabitants*, published in 1836, opened up the wonderful world of China to the West. Personal accounts written at this time by Americans Oswald Tiffany and William Hunter, among others, added colour to the drier litany of facts. In the middle of the nineteenth century, a flood of outpourings came from soldiers fighting in the two China wars,

and then from consular officials stationed in the city, although inevitably there was much repetition and borrowing from earlier works. Accounts like *Walks in the City of Canton* by Reverend John Gray and *The Canton Directory* by Dr John Glasgow Kerr, are full of careful detail and lead the reader on tours of the city. Both men were long-time residents, spoke Chinese, and were well-versed in local customs.

Visual images of Canton's earlier days are plentiful. Scenes in and around Canton and views of the factories were painted by Chinese artists and Westerners alike. Later, acclaimed photographers like Scotsman John Thomson, who visited between 1868 and 1870, and Chinese Afong Lai left permanent records of everyday life which enchant and enlighten today.

Following the take-over by the Communists in 1949, China was once more closed to the West for the next thirty years. In the southern city of Canton, however, business continued. Accredited buyers were invited to attend the Chinese Export Commodities Fair, revived in 1957 and held each spring and autumn. My company in Hong Kong, Dodwell's, had traded with China for over a century, so having seized an opportunity to take part, I prepared to raise the bamboo curtain one October morning in 1975. The Cultural Revolution was raging, fuelled by the Red Guards and driven by Chairman Mao Zedong and his wife, Jiang Qing. Throughout that period those who upset the state disappeared, foreigners as well as Chinese, and only eight years before my October visit, the British colony had almost fallen to the Communists. In the streets around Hong Kong's Hilton Hotel, thousands of sympathizers brandished Mao's 'little red book' and chanted slogans against Western imperialism.

In those days, no high-speed trains whisked travellers direct from Hong Kong to Canton. Carrying my suitcase, I walked through the covered wooden bridge over the Shenzhen River, the boundary between freedom and coercion, and entered China. My visa was carefully checked, and my wedding ring, watch, camera, and cash noted. Attendants on the train brought flasks of hot water for tea, and with 'The East is Red' resounding from loudspeakers in every carriage, we pulled out of the station. Outside, not a patch of earth lay fallow. Armies of workers, in blue or green cotton Mao suits, tilled the land so every square metre produced rice or vegetables. China's red flag fluttered aloft from small hovels and tractors, the scene a revolutionary peasant painting brought to life. Our hotel in Canton, the Dongfang (East wind), was opposite the trade fair buildings and, like those eighteenth-century merchants, we were kept apart from the rest of the city. The view from my window looked south to the Pearl River: only the Flowery Pagoda and the spires of the Roman Catholic cathedral, symbols of Eastern and Western beliefs, rose above jumbled rows of terracotta tiled roofs.

The official guide to the Canton trade fair announced[1]: 'The exhibition halls are devoted respectively to works by Marx, Engels, Lenin and Stalin,

and Chairman Mao...; the movement to learn from Taching [Daqing] in industry; and the movement to learn from Tachai [Dazhai] in agriculture,'[2] and went on to list exhaustively the products on offer, from tractors and textiles to ivory carvings.

Despite the lofty tone, my buying duties were light. After an early start, the business of ordering men's shirts for a British department store was over by lunch-time, and I was instructed to 'go to my room and rest.' But the city beckoned, and instead I ventured out to explore. A taxi, hired from the few waiting at the hotel gates, took me to the Pearl River, through quiet streets with an occasional truck and numerous bicycles, passing patient queues waiting for rations of rice and charcoal. Large propaganda posters at main intersections exhorted cherry-cheeked workers, with fists upheld, to love the motherland and work for the Great Proletarian Cultural Revolution.

Leaving the taxi at the Bund I crossed to the Nanfang department store, the once-famous Sun Company which, in the 1920s, dispatched the latest fashions to young Hong Kong women desperate for a little glamour in the staid British colony. A curious crowd, clad in the universal uniform of baggy blue-cotton jacket and trousers, shuffled up the stone stairs behind me, stopping, in the dim light, to peer alongside into dusty display counters containing a few enamel bowls, thermos flasks, and screwdrivers all careful-ly arranged. Another afternoon I visited Shamien, the foreign concession from the 1860s to the 1940s, from which Chinese were excluded (except, of course, for the servants). The only way onto the island was by a narrow stone bridge, so I left the taxi and walked across. Majestic mansions, once home to wealthy merchants, stood in banyan tree-lined avenues. No curious onlookers followed me this time; the peaceful island was deserted except for guards outside the colonial residences, now occupied by consulates from the eastern bloc.

Evenings were spent with other delegates at famous eating places in the old Arab quarter, or at a restaurant in what had been a nineteenth-century mandarin's garden, whose willow trees and zig-zag bridges had once inspired those designs on dinner plates. We were driven through empty streets lit only by the dull light of the taxi's headlamps, our young guide intoning mechanically a 'brief introduction' to our destination: 'Before Liberation, this restaurant was very poor and served few people each day. Since Liberation and under Chairman Mao's guidance, "Let a hundred flowers blossom, and a hundred schools of thought contend; make the past serve the present and foreign things serve China," the restaurant now serves thousands every week.'

The Cultural Revolution ended with Mao's death in 1976. As the coun-try gradually opened up to the West, businessmen were welcomed and tourists tolerated. Canton was convenient for short visits, providing many with their first, and only, look at China. But with the implementation of

pinyin, a system of romanized spelling for transliterating Chinese, Canton became Guangzhou.[3] Seen as a commercial centre, Guangzhou was unable to compete with the romance of Beijing's forbidden splendour or Shanghai's decadent charm.

Irritated by present-day rejection of Canton and intrigued by the infectious enthusiasm of those earlier travellers, I wanted to delve behind the dull exterior to discover its colourful past. I sifted through a vast amount of material: reading tales by travellers, traders, and missionaries, and poring over out-of-date street maps to identify old districts and landmarks, great and small. I took only what I needed to tell my tale; readers keen to know more may refer to the Bibliography. My aim was to show how the city developed geographically as well as historically, so with maps and guidebooks in hand, I retraced routes suggested for nineteenth-century visitors. I followed the city as it grew from its early beginnings, over two thousand years ago, to the walled southern metropolis of the Qing dynasty, governed by powerful mandarins. I went into the suburbs, once home on the western side to rich Chinese merchants, and on the east to the outcasts of society. I crossed the Pearl River, where hundreds of thousands had spent their whole lives afloat, to Honam and Fati, with their centuries-old temples and fragrant flower gardens, and came back to the foreign settlement on Shamien. And I found that streets laid down over five hundred years ago still follow the same routes, that flyovers trace the walls of the old city, and a modern subway system runs under the ancient thoroughfare, the Street of Benevolence and Love. Instead of discovering that all had been swept away, I found there was much that had survived.

But modernization is gaining ground. The thrill of finding the old city temple, still with its green tiled roof, was tempered by the sight of plate-glass doors at the entrance, etched with a dancing couple. It was to become, for a brief time fortunately, a disco and karaoke bar, perhaps a fitting setting for what had once been called the Temple of Horrors. Although many temples and pagodas survive in their original role, offices now rise where Art Deco apartments once stood and fairy lights trail over faded yellow mansions on Shamien. A visit to Canton is like an audience with a grand old lady who has had too many face-lifts. But what a story she has to tell.

ENDNOTES

[1] Published by the *Ta Kung Pao* newspaper, Hong Kong, October 1975.

[2] These were the two models for the Chinese economy at this time, Daqing for industry and Dazhai for agriculture. Unfortunately the production figures were wildly distorted and gave a false picture, to the detriment of the rest of the country.

[3] Literally 'broad department'. Early foreign visitors and map-makers had wrongly taken the Chinese name for the province of Guangdong (Canton) and given it to the city.

A NOTE ON PINYIN SPELLING

Outsiders have called the city Canton for most of its history, and so that name, rather than the correct one, Guangzhou, is used here. Pinyin romanization was instituted by the Chinese government in the 1950s, as it is considered to be closer to the true sound of Mandarin Chinese, the official language throughout the country. However, it is difficult to avoid using a combination of the local language, Cantonese, and Pinyin in the text. Since many of the place names and proper names referred to are more familiar in their earlier nomenclature, these have been retained and the Pinyin name given in the Glossary. Suitability to place and historical context has been the guiding rule.

Power and Glory

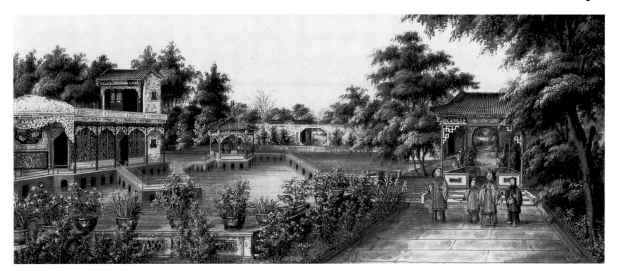

1

Palaces and Pagodas:
The City of Rams

One fine autumn day in Canton in 1983, a group of labourers were steadily digging on the site of an old restaurant in preparation for building the new China Hotel. Suddenly, a spade struck a wooden shaft, sunk deep into the ground. They had discovered the entrance to the 2,000-year-old tomb of Zhao Mei, the second king of the Nan Yue Kingdom. The wooden shaft went down 20 metres below the surface, to where the tomb had been hidden to prevent looting of the fabulous funerary goods inside. Like others from that period, the tomb was built in the shape of a cross, covering an area of a hundred square metres. Red-striped sandstone blocks formed the walls, and twenty-four huge stone slabs covered the roof, the largest weighing nearly four tonnes. These slabs of sandstone had been laboriously quarried from an ancient stone mine at Lotus Mountain, 40 kilometres from Canton.

When the burial chamber was opened (Fig. 1.1), the body of the king, Zhao Mei, was found, dressed in a suit made of more than 2,000 small plaques of jade fastened together with silk ribbons and thread. Jade was often used in funeral attire, as it was believed to prevent the body from decaying. Fifteen sacrificial victims, including four concubines, several servants, and guardians, together with some sheep and cows, had been buried alive with the king, as the tomb was to provide a dwelling for the soul in the afterlife. More than a thousand artefacts, including gold seals, jade ornaments,

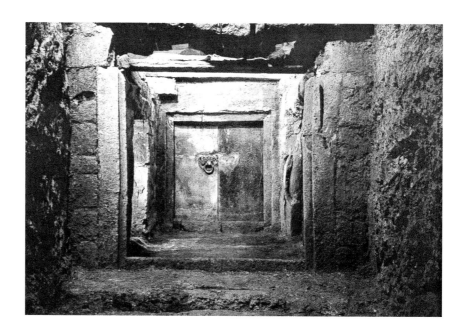

FIG. 1.1 Sandstone slabs guard the entrance to the tomb of Zhao Mei, second king of the Nan Yue Kingdom.

pottery and bronze vessels, and iron swords, were found on and around the bodies during the excavation. All these artefacts, including the king's burial suit, have been placed on display in an imposing red sandstone museum built over the Nanyuewang tomb on the main street of Jiefang North Road.

According to Chinese legend, there had been a settlement on that site almost a thousand years before the reign of Zhao Mei (r.137–122BC), at the beginning of the Western Zhou dynasty. This would make Canton one of the oldest cities in China, with a continuous burgeoning history exceeding many others, including Xi'an and Beijing. In 887BC, so the legends state, five *genii*, or spirits, came to the city, riding through the air on rams and landing in the midst of the court of the Zhou king, Xianwang, the local ruler of the Yue people. The Five Genii symbolized the five blessings: longevity, riches, health, love of virtue, and a natural death. Each ram was a different colour: black, white, red, green, and yellow, and held a stalk of grain in its mouth, emblems of plenty, bestowing future prosperity on the Yue people. The celestial beings then disappeared, the rams turned to stone, and since that time Canton has been known as Yangcheng, or 'City of Rams'. A 10 metre tall statue of the five rams now stands in Yuexiu Park, a symbol of the city (**Plate 1**).

Evidence of Canton's great antiquity continues to come to light. In 1995 sandstone slabs inscribed with the characters 'Pan Yu' were discovered on the walls of a pond in part of the site of the palace and garden of the Nan Yue kings, excavated when the new underground Metro system was built beneath the Street of Benevolence and Love. Pan Yu had been Canton's original name, taken from the two nearby hills, Pan and Yu. The palace and

garden are thought to have stretched for over 500 metres from east to west, and to have covered a total area of 150,000 square metres. Part of the site, roughly at its centre, opened in 2000 as a covered museum, reached from Zhongshan 4 Road, at the top of Wende Road and close to one of the new Metro stations.

Several layers of antiquity have been unearthed in the excavation. At the lowest level, in the Nan Yue king's garden, evidence was found of pavilions, crescent-shaped pools, lotus ponds, artificial brooks, and ponds with ramps for tortoises to climb up to ground level. Flagstones were laid for emperors and courtiers to walk around the garden and over what is now the earliest known surviving stone bridge in China. Old bricks from this period were used to build ducts and walls in the following Western Han period. There is later evidence of sewers and wells from the succeeding Jin, Tang, and Song dynasties, plus the foundations of a large building, thought to be the Southern Song Yushan College. Parts of a large house of the Ming dynasty, a mere five hundred years old, are artefacts of the most recent period revealed.

In the Qin dynasty, over two thousand years ago, the emperor Qin Shihuangdi sent ships to Pan Yu, and an important sea route was opened from this southern port, keeping the wharves busy along the wide Pearl River. Excavations in the palace garden of the Nan Yue king revealed the remains of a carpentry workshop in one of the Qin shipyards, with a large quantity of wood chips, fragments, and charcoal still visible. Other workshops produced exquisite ornaments from jade, lacquer, and glass, while salt production, brick and tile manufacture, and pottery-making were all carried out on a large scale.

In 214BC the Qin emperor's troops conquered Lingnan, literally 'south of the five ridges'. The area of Lingnan included the southern region of China and part of Vietnam, where important land and maritime trading routes had been established. Qin Shihuangdi sent in General Zhao Tuo to be governor of the newly conquered Lingnan, and when the Qin dynasty fell in 206, the new Han emperor Gaozu appointed the general to be prince of a region covering the territory of Lingnan and called Nan Yue. Three years later, General Zhao Tuo established the independent kingdom of Nan Yue, with its capital at Pan Yu, appointing himself emperor in 180BC and announcing that Nan Yue had equal status with the Han kingdom.

Despite promising to be subordinate to the Han regime, Zhao Tuo continued to rule as emperor for sixty-seven years. Elaborate precautions were taken at his funeral procession to confuse potential grave robbers, with four funeral hearses going in four different directions. His tomb has never been found, unlike that of his grandson, Zhao Mei, who then succeeded to the throne. Three more kings ruled until 112BC, when Han troops were sent to suppress Nan Yue. The reigning King Zhao Jiande and his prime minister were executed and the Nan Yue kingdom merged into the Han empire.[1]

In the years that followed, northern China was wracked by wars and many people migrated south to Canton, attracted by its stability, advanced technology, and culture, as well as by the prosperity brought by trade. Being the southernmost port in the Chinese empire, Canton was the first stop for foreign ships, and the eastern starting point for the maritime silk route, which led from the South China Sea, across the Indian Ocean, through the Arabian Sea to the Middle East. Buddhism arrived in southern China by this route, and one of the oldest Buddhist temples in China is in Canton. In the sixth century, from the Sui dynasty onward, Canton became the cultural and economic centre of the Lingnan region and an important centre of commerce for the whole of China.

Protecting Canton and the suburbs from marauders from the north was a low ridge of hills, about 8 kilometres back from the Pearl River and called the Baiyun, or White Cloud, Mountains, now the name and place of Canton's international airport. Like most cities, towns, and villages across China, Canton had walls to keep out invaders, with entry restricted to a few gates which were closed at nightfall. Inside the bamboo stockade surrounding the city was a 'crowded mass of thatch-roofed wooden houses, which were repeatedly swept by disastrous fires, until, in [AD]806, an intelligent governor ordered the people to make themselves roofs of tile.'[2] Outside was untamed tropical vegetation, where leopards and tigers roamed and human marauders threatened.

During the Tang dynasty thousands of Arab traders from the Middle East and Africa travelled along the silk routes to Canton, which they called Khanfu (Kwong-fu). They dealt in spices, agate, amber, ivory, and rhinoceros horn, their cargoes off-loaded in return for silk, ceramics, and precious stones. Imports of sandalwood, patchouli, frankincense, and myrrh, and exports of camphor, citronella, and musk produced by the Chinese, made Canton one of the great incense bazaars of the world. A market was officially opened in AD750, with an officer appointed to receive imperial duties. Between 763 and 778 more than 4,000 foreign ships arrived at the port.

The Arab traders played a major role in the development of Canton, although they were never fully integrated with the Chinese. The merchants lived in a community called the *fanfang* (foreign quarters), a residential suburb by the river outside the walls of the Tang city. 'Here, ...foreigners of every complexion, and Chinese of every province, summoned by the noon drum, thronged the great market, plotted in the warehouses, and haggled in the shops, and each day were dispersed by the sunset drum to return to their respective quarters or, on some occasions, to chaffer loudly in their outlandish accents in the night markets.'[3]

A minaret was built in about AD850 close to the northern bank of the river. About 50 metres tall, its smoothly tapering, circular walls gained it the name Kwang Tap, the Smooth Pagoda. Re-built in 1468 and returbished

many times since, two spiral staircases inside lead to the top, where the muezzin formerly gave the call to prayer. It was also known as the Tower of Light, for a beacon at its top was a navigation mark for incoming ships, while a golden cockerel served as a weathervane. Over the centuries the wide river has silted up and the minaret now stands well inland in the leafy street of Guangta Road.

After mooring their ships, Arab merchants made straight for the mosque next to the minaret to give thanks for a safe journey. Abu Wangus, an Islamic missionary from Medina who was said to be an uncle of the Prophet Muhammad, founded the Wai Shing Chi mosque, 'In Memory of the Saint', in AD626. The oldest mosque in China, and one of the oldest in the world, it was the religious and cultural centre for the Arab merchants in the neighbourhood. It burned down in 1343, was rebuilt seven years later, and has been remodelled many times since. Decorated with inscriptions in Arabic from the Koran, it housed a school for teaching boys to read the holy work. During the Kangxi emperor's reign (1662–1722), the gate tower leading to the mosque was rebuilt on the early foundations, retaining the Tang style (Fig. 1.2).

FIG. 1.2 The first mosque to be built in China, shown here with the Smooth Pagoda in the centre background.

Today the Huaisheng Mosque is decorated in both Chinese and Muslim styles. The names of prophets appear in Arabic in yellow paint on pillars painted green, the sacred colour of the Islamic faith, giving the appearance of Chinese characters when seen from a distance. The large shady garden is surrounded by walls with stone tablets inset naming donors to the mosque.

Three gate houses lead to the main temple, with its green tiled roof and red columns. Here visitors from Malaysia, Pakistan, and the Arab countries, Uygur traders from Xinjiang and northern China, as well as the local Muslims, descendants of the early traders, converge on the mosque, and every Friday well over a thousand kneel in prayer.

The Arabs who settled in Canton intermarried with the local Chinese women, and today many have family names of Sha or Ma, reflecting their Arabic origins. The *fanfang* is now bounded by two major roads, Zhongshan 6 Road and, near the West Gate, Renmin Middle Road. The Five Rams Muslim restaurant, now called Hui Min Fan Dian, stands on the corner, a popular eating place in 1975 for Mongolian hot-pot, though much smaller today. Several streets in the *fanfang* still bear names describing their original purpose, such as Tianshuixiang (Sweet Water Lane), running south from Guanta Road, and Manaoxiang (Agate Lane), which runs north from Guanta Road to Zhongshan 6 Road.

Abu Wangus died in Canton in AD629 and a tomb was built to the north of the Tang town to honour his memory (**Plate 2**). Still greatly revered, the burial ground and adjoining mosque are visited frequently by local Muslims. Reached off Jiefang North Road, north of the Canton trade fair buildings, an old stone archway leads to the compound, down a path of granite slabs under several stone arches. On either side of the path, trees shade the burial ground, with tombs carved with Arabic and Chinese inscriptions. Some head-stones were toppled during the Cultural Revolution, but many have been re-erected in neat rows and the inscriptions picked out in red paint. Half-way along the path are steps leading to a walled enclosure, with the tombs of imams and that of Abu Wangus inside. The tombs and the gravestones are set among clumps of thick bamboo, alive with birdsong and butterflies, the hum of the city barely discernible in this large and peaceful garden.

Jews, Armenians, and Persians joined the Arabs in the *fanfang*, and overseas trade expanded. By 758 the Arabs had become so numerous in Canton that 'they were able, for some reason which has not come down to us, to sack and burn the city and make off to sea with their loot.'[4] More unrest followed when rebellions against the Tang emperor Xizong swept through the country. In 879, the year following Xizong's death, the city was again besieged and a near-contemporary account by an Arab, Abu Zayd, writing in about 916, tells how Canton was laid waste by the Chinese rebel leader Huang Ch'ao: 'With the taking of the city, its inhabitants were put to the sword. Persons who have knowledge of the facts report that they [i.e. the rebels] slew 120,000 Mohammedans, Jews, Christians, and Mazdeans who were established in the town and did business there, besides numberless Chinese.'[5] This widespread massacre, out of a population of 200,000, together with the destruction of the mulberry trees which fed the silkworms, producers of the main export, brought the city to its knees. During the Song

dynasty, foreign merchants settled in other ports, such as Fuzhou and Quangzhou in the south-eastern province of Fujian, and these became important centres for the Arab and Persian trading communities.

Although trade from Canton would never again reach the heights attained in the Tang dynasty, by the end of the tenth century commerce had revived sufficiently for it to be made a government monopoly. The imperial storehouses were packed with the treasures of the southern seas, and Chinese people were encouraged to buy imported medicines, rhinoceros horn, ivory, coral, amber, pearls, and tortoiseshell. However, the heavy outflow of Chinese gold, silver, and copper cash in exchange for these goods caused the government concern. An edict was issued forbidding officials from engaging in foreign trade through agents, which lessened the government's profits. This had little effect and some foreign and Chinese merchants became very rich, as the city grew tenfold thanks to the wealth brought by trade.

In 1067, during the reign of the fifth emperor of the Northern Song dynasty, a brick wall[6] was erected around the city as a defence against persistent attacks from the Cochin Chinese, from what is now southern Vietnam. The town was divided into three districts: western, central, and eastern, each walled off from the other (Fig. 1.3). Around the perimeter were fifteen outer gates, and two inner gates connected the three cities. A road ran right across the centre from west to east through the two inner gates. In 1369, a year after the Ming dynasty was estab-

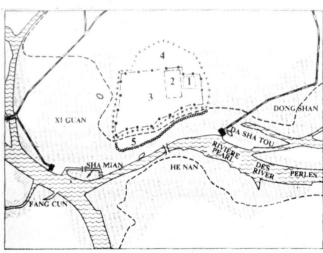

FIG. 1.3 A map of Canton showing its historical development: 1, Qin city; 2, City in the Sui and Tang dynasties; 3, Song city; 4, first Ming city; and 5, second Ming city.

lished, Canton became a seat of government for Guangdong province, and twelve years later the three cities were combined into one. Administrative offices were contained in the centre city, while the two other sections became flourishing commercial districts.

The city's shape was flat on three sides but on the northern edge the city walls were extended as far as Yu Hill. Here, where the danger of an attack from the north was greatest, the walls were their most substantial, rising nearly 300 metres above sea level. At the highest point of the wall was a prominent watchtower, 'Sea-calming' Tower (Zhenhai Lou), built in 1380 by General Zhu Liangzu after his army defeated the Mongols, rulers of China during the Yuan dynasty (Fig. 1.4). The building, also called the Five-Storey Pagoda, is now Canton's main museum of history. It is possible to stroll along a section of the old wall running around Zhenhai Lou, in what is now Yuexiu Park. In 1564 a wall was extended southwards, on land formed from silted-up

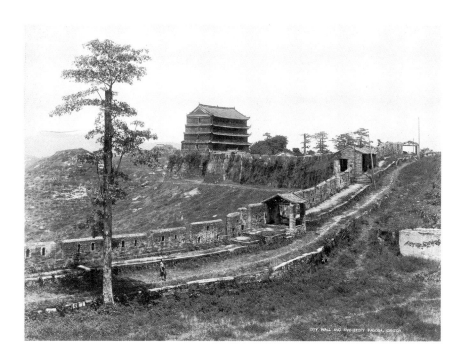

FIG. 1.4 A section of the city wall in the north, with the Five Storey Pagoda in the centre background; late nineteenth century.

riverbed, to protect the undefended area between the city and the river. The main city became known as the Old City and the southern part, the New City.

Trade with the outside world had been confined to Canton and Quangzhou during the twelfth century, but in a determined bid to stop emigration and the outflow of silver, foreign trade was completely forbidden by the Xuande emperor in 1431. Chinese ships were prevented from sailing abroad and any Chinese attempting to leave the country faced the death penalty. Those who did go were not allowed to return and Chinese living overseas were banned from trading with China. Memorials were sent to the Jiajing emperor in 1530 by the merchants of Canton to persuade him to reopen the city to foreign traders. This only resulted in trade being restored from the tribute-bearing Siamese and from overseas Chinese, but still with a ban on Europeans and Japanese. Smuggling and pirate ships had proliferated once the ban was imposed and illicit trade grew, especially between China and Japan.

In the sixteenth century, during the great age of exploration by seaboard European nations, the Portuguese came to dominate trade in Asia. First appearing at Canton in 1517, they were not allowed to settle, but in return for help in quelling pirates, they took the opportunity in 1557 to establish a base at Macau, the peninsula at the mouth of the Pearl River. Twice-yearly fairs began in 1578 in Canton, where foreign trade could be regulated by the authorities. At the summer trade fair the Portuguese, acting as go-betweens, brought in pepper, nutmeg, and cinnamon from the Spice Islands

of Indonesia, fine cottons from India, jewellery and daggers from the Middle East, and mirrors and clocks from Europe. At the winter fair Portuguese ships returned from their base in Nagasaki, on the southern tip of Japan, with Japanese silver. They off-loaded it in Canton and sailed for Malacca on the west coast of Malaysia carrying cargoes of Chinese silks, pearls, musk, rhubarb, ginger, and porcelain. Like the merchants who followed, their length of stay was strictly limited, needing to sign in and out at the gates of the city and spending their nights on board ship.[7]

In the years following the Portuguese arrival, more foreigners sailed for Canton in search of trade, with the Japanese arriving in 1575, the Dutch in 1601, and the English in 1637. It was the presence of the latter which would have the greatest effect on trade in Canton when, in 1684, they established the China connection of the English East India Company. Although other nations followed, to settle in factories by the banks of the Pearl River where they would trade tea, porcelain, and silk in return for silver and later opium, the English were the masters of foreign trade for the next 150 years.

Invasion was a constant fear during the Ming era, as China was threatened by the semi-nomadic Tartars from the northern region now called Manchuria. In 1626 their leader, Abahai, formally took the name Manchu for the collective tribes and attracted Chinese border troops into their army. The Manchu army entered Beijing on 1 June 1644, with the young emperor Shunzhi taking up residence in the Forbidden City. The Manchu conquerors, numbering only 2 per cent of a total population of almost 150 million, named their new empire Qing, meaning 'pure', and would rule China for the next 267 years.

The southern provinces took longer than the north to bring under control, as the population strongly resisted the invasion. Guangdong province was under siege for nine months, but Canton finally fell on 24 November 1650. 'The whole Tartar army being got into the city, the place was soon turned to a map of misery, for every one began to tear, break, carry away whatsoever he could lay hands on. The cry of women, children, and aged people, was so great, that it exceeded all noise of such loud distractions; so that from 26th November, until the 15th of December, there was heard no other cry in the streets but, strike, kill, and destroy the rebellious barbarians; all place full of woful [sic] lamentations, of murder, and rapine.'[8] When it ended almost 100,000 Cantonese had been slain.

ENDNOTES

[1] Pan Yu became the capital of Jiaozhou prefecture in AD210. Then, in 226, Sun Quan, emperor of the Eastern Wu state of the Three Kingdoms divided Jiaozhou into two parts, and the northern section became Canton, with that name being taken then. By this time the culture of the Yue was almost wholly integrated with

the Han. In the early years of the Republic, the Pan Yu magistracy moved from Canton and it is now an independent town.

[2] Edward H. Schafer, *The Golden Peaches of Samarkand*, Berkeley: University of California Press, 1963, p. 15.

[3] Schafer, 1963, p. 15.

[4] *Chau Ju-kua: His work on the Chinese and Arab trade in the twelfth and thirteenth centuries, entitled Chu-fandi*, translated from the Chinese by F. Hirth & W. W. Rockhill, St. Petersburg: Imperial Academy of Sciences, 1911, p. 15.

[5] L. Carrington Goodrich, *A Short History of the Chinese People*, New York: Harper & Row, 1959, pp. 125–6. Mazdeans were the Parsees.

[6] During excavations in 1972, many bricks from the wall, dating from the Southern Song dynasty, were unearthed and are now in the Guangzhou museum.

[7] E. C. Bowra, *A History of the Kwang-tung Province of the Chinese Empire*, Hong Kong: De Souza & Co, 1872, p. 100.

[8] Bowra, 1872, p. 93.

2

Within the City Walls:
The Tartar Quarter

The long battle for Canton was finally over, and worth all the misery and destruction for the Manchu army, for they knew they had gained a significant prize. In 1650 Canton was the third largest city in China, after Beijing and Hangzhou, and the centre of power for the country's southern region. Wealth from commerce grew as increasing numbers of foreign merchants arrived, all eager to trade with the Cantonese.

The city the Manchus entered was encompassed by a high wall about 10 kilometres long, which circled both the Old and New cities. The Old City was bisected by two long broad avenues paved with granite flags. The first avenue connected the two main city gates, the West Gate and the East Gate, and was called Yan Oi, the Street of Benevolence and Love. The second ran due south from the Great North Gate to the Gate of Virtue, itself named Sze Pai Lau from its four (*sze*) massive ornamental stone arches (*pai lau*) erected in honour of certain of the city's most distinguished citizens (Fig. 2.1). Although the four arches were removed in 1947, these two streets are still the main thoroughfares of the city, renamed Zhongshan Road (itself in turn divided into numbered sections) and Jiefang Road, respectively.

Large areas of the Old City had been laid waste after the capture of Canton by the Manchus. The land from the left of Sze Pai Lau to the western wall was then cleared and became the Tartar Quarter, where the Manchu troops lived separately from the local Chinese (Fig. 2.2). To the east of Sze

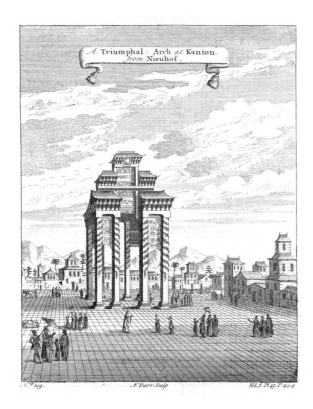

FIG. 2.1 A pai lau, or memorial arch; drawn by Jan Nieuhof, c.1655.

Pai Lau were the yamens of the civil government officials, who in the Qing dynasty were either Manchu or Chinese. A yamen (from *nga men* or 'official's gate') was a large walled enclosure with offices at the front and a series of halls at the back where the official lived with his extended family. The lower-class Chinese were moved south to the New City, as they had been ordered to in Beijing, since geomancy dictated that the north direction was superior to all others.

Battlements, and a broad pathway, lined the walls all the way round the Old City. The walls, built with coarse red sandstone blocks at the base and grey bricks above, rose to heights of 8 to 14 metres and were, in places, as much as 6 metres thick. Watchtowers were set at frequent intervals in the walls, built high above the roofs of the houses, and served as look-outs for fire as well as thieves. Two short walls in the south-east and the south-west corners of the city led out from the main wall and were designed to block passage from the walls and ditches around the city. Like veins of the city, these ditches or moats had been formed when building the ramparts

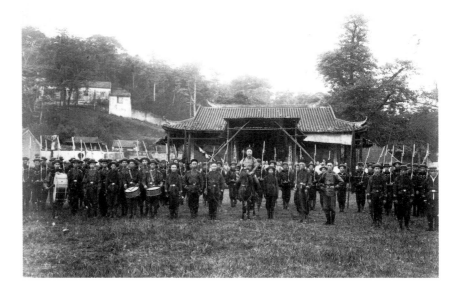

FIG. 2.2 The Manchu regiment on the parade ground in the north of the city; c.1880.

and were the main means of transportation of people and goods. Two of the largest ran along the length of the wall on the east and the west sides, with a third linking the two along the wall on the north side of the New City. The only way into the city was through heavily guarded gates set in the wall. At the time of the Manchus' arrival in the city, there were six gates around the walls (Fig. 2.3). Each had a sumptuous entryway with battlements above and a strong portcullis ready to be lowered when necessary.

By the mid-nineteenth century, the number of gates had increased to sixteen, along with a small gate in each of the two short walls in the southern corners. Around the Old City were the original four main gates. The principal one on the northern section was the Great North Gate, used by government officers and bearers of public dispatches when arriving overland from Beijing. The Little North Gate was used for bringing water and provisions and building materials into the city. The West Gate was very broad and high and led to the Western Suburbs. Directly opposite was the East Gate (Plate 3), the only gate in the Old City giving access to the Eastern Suburbs.

On the wall dividing the Old City from the New City were four inner gates. First, from the western end, was the Gate of Virtue, sometimes called the South Gate, followed by the Great South Gate, one of the principal gates of the city and the only one through which entry could still be made at night. The Gate of Literature was next, and then the Little South Gate, the last on the south side of the wall. A special feature of this entryway were shelves in the side walls on which all lost property, found in the city streets, was placed until claimed by its rightful owner. By the middle of the nineteenth century, however, falling standards meant the shelves were always empty.

There were eight gates around the New City: first, travelling from west to east, was the Great Peace Gate, the sole entrance into the New City from the Western Suburbs. Around the south-west corner, along the wall by the river, was the Bamboo Gate, followed by the Oil Gate, designed to allow heavy merchandise into the city. The Tranquil River Gate was next, then came the Gate of the Five Genii, which led to the temple dedicated to the five spirits. Further along was the Gate of Eternal Purity, a euphemism as the passage led to the execution ground. Next came the Gate of Eternal Joy, and lastly, the Little East Gate which led from the New City to the Eastern Suburbs, where institutions housed the elderly and infirm.

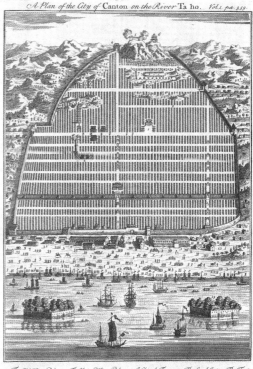

FIG. 2.3 A plan of the city of Canton, based on the original drawn by Jan Nieuhof; first published by John Ogilby in 1655.
Key: 1. The Old King's Palace [the Governor of Canton]; 2. The Young King's Palace [the Tartar General]; 3. A Chinese Tower; 4. The Land Gate; 5. The Fort; 6. The Banqueting House; 7. The Place of Exercise for the Tartars; 8. The Quarters for the Tartars; 9. The City Wall; 10. The Armoury; 11. The Vice Roy's Palace; 12. The Watergates; 13. Floating Castles [Folly Forts].

Throughout the day and night Manchu soldiers guarded the gates inside the wall and held the keys, while Chinese soldiers watched over the outside gates. At dusk the gates were closed and a paper with the chief captain's mark on it was glued to the door. A token from the same officer opened them at sunrise. No one was allowed to pass through during the hours of darkness, except on special occasions, although some, caught in or out of the city, managed to bribe the gate-keepers. The keys of all the gates were removed after they had been locked, with the exception of those for the Great South Gate, and left with the officer-in-charge, so that government messengers arriving with dispatches during the night could gain entry.

Successful military conquests had resulted in expansion of their territory, so the Manchus placed great emphasis on military training. In 1601 all Manchu troops were placed into battalions and an organization was established that was known as the Eight Banner system. This system served as a defence and a means of organizing taxes and land distribution for the whole Manchu population. Each battalion followed a banner of yellow, white, red, or blue, based on a mystical system in which yellow represented the centre, white the west, and red the south. North should have been black, but since this was seen as a bad omen, blue was substituted. East was green, and the native Chinese troops were ordered to adopt this as their standard. In 1615, when the army was reformed, four more banners were added, by trimming the first three with red and the red one with white. Tartar soldiers based in Canton were of the 'bordered white' banner, and wore white jackets bordered in red, with white leggings tucked into knee-high boots, and a black hat with two fox-tails attached behind.

Although it continued to be called the Eight Banner system, from the start of the Qing it actually comprised twenty-four banners or units, made up of eight banners of Manchu soldiers, plus eight of Mongolian Tartar soldiers, and eight of Chinese soldiers (Han Kun), direct descendants of those who helped in conquering China. Eight ranks of commissioned officers were stationed in Beijing; there were six ranks in the provinces, together with the lower-ranking non-commissioned officers and soldiers. More than half the bannermen remained in the capital, while about 4,000 men and their families were stationed in the garrisons in each of the major provincial cities, such as in Canton, to quell possible uprisings. The 'native' Chinese troops, known as the Green Standard Army (Lu Ying), acted as a local constabulary.

Together with the banner garrisons commanded by Manchu generals, these two armies were responsible for the internal security and external defence of the country. Compared with Western armies of the time, the soldiers were poorly equipped; in the words of one Western observer at the time: their armour and weapons, 'consisting of shields and helmets, bows and arrows, spears and javelins, short swords and matchlocks, seem ill fitted

either for defence or attack.'[1] This antiquated equipment would cause major problems for China from the middle of the nineteenth century onwards.

Since Canton was a major port, by the 1850s there were almost 5,000 bannermen, along with their families, stationed in the city. This group was made up of 91 officers of the six main ranks, and below them 4,265 soldiers, plus a marine division with nine officers from third to sixth rank, and 604 in the lower ranks.[2] Most bannermen in these important provincial centres kept their posts permanently from generation to generation, forming a kind of privileged hereditary caste. In the 1860s, the British vice-consul, William Mayers, noted: 'There are some three thousand Chinese troops in Canton, in addition to the Tartar garrison, of whom about 1500 belong to the division called the Kwang-hip, 500 are of the Viceroy's brigade, and 1000 of the Governor's brigade. The latter, denominated the Fu Piao, garrison the outer gates in the city-wall (all the inner gates being garrisoned by Tartars), together with some guard houses in different parts of the city, whilst the Kwang-hip troops [belonging to the Chinese General] are stationed as a military constabulary in the New City and the suburbs.'[3]

The area cleared for the Tartar Quarter, on the west side of Sze Pai Lau, was laid out with broad thoroughfares and the area appeared quiet and lifeless (Fig. 2.4). Like those in the northern homeland of the Manchus, the houses were built, not with clay bricks like Chinese homes, but of adobe, mud mixed with a little lime and water rammed solid, which was not long-lasting and frequently needed rebuilding. The dwellings were white-washed and had a wide black border around the doorway, with a red circular spot representing the sun for the lower ranks. Representations of animals were painted on the walls of the homes of the higher officials, differing animals denoting different ranks.

The Tartar General, the commander-in-chief, was head of the banner garrison, and his yamen was located in the Tartar Quarter at the western end of the Street of Benevolence and Love. Built on the site of the palace of the Nan Yue king, the yamen was constructed originally at the end of the seventeenth century as a residence for the son-in-law of the Kangxi emperor in his

FIG. 2.4 A street in the Tartar Quarter showing whitewashed houses painted with the sun disk; in the background is the Flowery Pagoda; photograph by Felice Beato, April 1860. Collection of Jane and Michael G. Wilson, Courtesy of Santa Barbara Museum of Art.

role as pacifier of the province. The two-storey building was among the largest and most imposing buildings in China and one of the biggest official residences in Canton (Figs. 2.5 and 2.6). In the late 1860s part of the yamen was walled-off and formed the residence of the British consul, while the remainder was occupied by the Tartar General Jui-Lin. Mayers describes, on a visit to the Consul, how two marble lions guarded the grand entrance to the yamen, with 'two lofty flag staffs and two small pavilions whence the official band discourses sweet (Chinese) music on occasion. The gateway is approached by a fine flight of granite steps, and consists of the usual three enormous double gates which indicate rank and importance. …[l]ooking through the open gateway… a glimpse may be obtained of a wide, granite paved quadrangle, terminating with another flight of steps. These lead to… the offices and tribunal of the Tartar commander. The large quadrangle in front is bordered right and left by buildings occupied as clerks' offices, whilst on either side of the central range stretch minor courtyards, with numerous buildings attached. …[T]he entire depth of the yamen is 300 yards by a breadth of one hundred'.[4]

Life was not easy for the Manchus. They lived amid a semi-hostile population, far from the capital and their homeland in the north, speaking only their Manchu dialect and the court language of Mandarin, and not the local Cantonese. There was little contact between Manchu and Chinese women, and their appearance was very different from the diminutive Cantonese. Known for their penchant for wearing three earrings in each pierced ear, they did not adopt the Chinese custom of binding the feet, but instead wore elevated shoes with a high concave heel in the centre of the instep. As one writer observed: 'The Manchus are… a taller… race than the Chinese, and the artificial increase to the height afforded by these shoes gives them at times almost startling proportions.'[5] Their exaggerated winged head-dresses and long embroidered gowns, which fell straight from shoulder to ankle, only served to emphasize this towering height.

Manchu rule was not accepted easily by the Cantonese. Even the Tartar General, the highest military officer and a member of the Manchu race, although nominally superior to the highest Chinese official, was often merely indulged and ignored. The troops were never paid in full, and the Tartar Quarter was an area of much misery and actual starvation. Yet despite their poverty they would not lower themselves to copy the industrious Chinese and take to other occupations. Mayers found 'the semi-Tartars, or Han Kun, are better off than their Manchu comrades, as the comparative slackness of discipline under which they are kept permits their engaging in sundry avocations, such as those of [sedan] chair-carrying, vegetable-hawking, etc. by which they eke out their scanty pay.'[6]

Gradually the power of the Tartars declined, and by the latter half of the nineteenth century the descendants of the bannermen, too proud to work or

FIG. 2.5 A reception room in the grounds of the Tartar General's yamen, surrounded by banyan trees; photograph by William Floyd, c.1870.

FIG. 2.6 Manchu bannermen of the Bordered White Banner, who formed the guard of the British Consul Sir D. B. Robertson, in the grounds of Tartar General's yamen (at that time the Consul's home). The Flowery Pagoda is seen in the background; photograph by John Thomson, c.1873.

stoop to trade, had become so impoverished that they sold off their land and homes to the Chinese. At the same time, in a glorious volte face, many Manchus in Canton changed their names to appear Chinese and to hide their shame. After the overthrow of the Qing dynasty in the early twentieth century they moved to an area near the Pearl River, east of Beijing Road. Now a road filled with crumbling apartment blocks and street-side barbers, the only reminder of the Manchus' presence in Canton is the name: Baqi Yi Ma Road (Eight-banner Two Horse Road). Their glory had turned to dust.

ENDNOTES

[1] Anders Ljungstedt, *An Historical Sketch of the Portuguese Settlements in China; and of the Roman Catholic Church and Mission in China & Description of the City of Canton*, Boston: James Munroe & Co, 1836, reprint, Viking Hong Kong Publications, 1992, p. 199.

[2] Thomas Wade, The Army of the Chinese Empire, Canton, *The Chinese Repository*, 1851, Vol. 20, reprint, Tokyo: Maruzen Co, Ltd, p. 319.

[3] Wm. Fred. Mayers, N. B. Dennys, & Chas. King, *The Treaty Ports of China and Japan*, London: Trubner and Co, and Hong Kong: A. Shortrede & Co, 1867, pp. 142–3.

[4] Mayers et al., 1867, pp. 154–5.

[5] Alexander Hosie, *Manchuria, Its People, Resources and Recent History*, London: Methuen & Co, 1904, p. 157.

[6] Mayers et al., 1867, pp. 142–3.

3

Scholars and Mandarins:
The Chinese City

T he real seat of power in Canton lay on the east side of Sze Pai Lau in the Old City, where the centre of administration had always been based. Here, and in the New City, were the yamens of the civil officials, known to the West as mandarins,[1] appointed by the Emperor to govern Canton and Guangdong province. There were two groups of mandarins, each with nine ranks, the civil ones being in charge of day-to-day administration, and the military officials responsible for maintaining internal stability and external defence. This system of government had been set in place in the Ming dynasty, and the Manchus continued to follow the practice.

Both Manchu and Chinese men were eligible to become mandarins as long as they could pass a series of qualifying examinations, based on literary ability, which had been in use in one form or other since the Tang dynasty. In theory, the poorest man could become a distinguished official, providing he had both the time and the talent to pass these arduous examinations, and they were the surest way to advancement both socially and materially until their abolition in 1905. The examinations were open to all men, with the exception of the boat people, labourers, executioners and torturers, actors and musicians, the so-called mean people, in other words, those considered to be in disreputable professions.

In Canton, as in the rest of China, boys would begin by studying the thirteenth-century primer, the 'Three Character Classic', committing to memory

scores of passages, each of which was composed of three characters. The next day the boy would repeat the previous day's lessons, word for word, to the teacher: this was known as 'backing the book'. When he was proficient he moved on to the Chinese classics. In learning by rote, the boys acquired a large vocabulary, and gradually absorbed moral concepts which at first they could not hope to understand. It was not considered necessary to educate daughters: their role was simply to marry and produce sons, and to help out in the home. Girls were not given any formal education as such, but some, the daughters of officials and sisters of graduates, managed to acquire a little learning. Apparently, 'in 1403, educated young ladies were in request at court for the service of the Inner Household and keeping the accounts of the Imperial ladies.... [G]irls who could read and write [were required]. Search and examinations were instituted, and in Canton one such lettered beauty was chosen. Her name was Wang, and she lived in Nan-hai.'[2]

The examination for the first degree, taken at about 18 years of age by those who had studied thoroughly, was held in the prefectural city: Canton was both a prefectural city and a provincial capital. The Literary Chancellor officiated, and the examination was held at his yamen in the centre of the city below the Street of Benevolence and Love, bordered by what is now Jiaoyu Road and Huifu East Road. Wrote Dr Kerr in the 1880s in *The Canton Guide*: 'On each side of the [Literary Chancellor's] court yard are three long ranges of stone tables.... There are 232 permanent tables (each one 33 feet long), which accommodate 3,168 writers. Additional temporary tables are provided when needed. From the 1e [premier] districts of Kwong-chau-fu [Canton], about 25,000 under-graduates, who have passed numerous preliminary examinations, are required to compete here for the Siu-tsai [*xiucai*, budding talent] degree. ...About 500 are passed each year, and their names are posted on the front wall.'[3] A pass on this examination has been compared by some to today's Bachelor of Arts degree.

There were several public colleges around Canton, founded by the government for graduates of the first degree. These offered very welcome financial assistance and tuition to enable the graduates to compete successfully in the next examinations. Academies like these also fostered culture in Canton, despite its having a reputation by some for being merely a place for trade, and there were many poets, scholars, and artists in the city. Zhong Qichun, a *jinshi* ('finished scholar', that is, one who had passed the highest-level examination) of the Southern Song dynasty, had established the Yuyan Academy in the north-eastern suburbs in 1205. Another *jinshi*, Ruan Yuan, originally from Jiangsu province and Viceroy of Guangdong and Guangxi from 1817 to 1826, founded the Sea of Learning Hall. In 1824 the academy moved from temporary premises to its own buildings on Yu Hill near the Five-Storey Pagoda, offering four courses: in the study of history, the Confucian classics, literature, and philosophy. Viceroy Zhang

Zhidong, Governor-General of Guangdong and Guangxi from 1884 to 1889, founded the Kwong Nga Academy of Learning in 1888. This academy was originally located outside the city walls to the north-west of the Five-Storey Pagoda. In the early twentieth century it became the Guangya Middle School for Boys, and in more recent times it was renamed the Number One Provincial School.

Examinations for the second degree, equivalent to a Master of Arts, were held every third year in Canton and other provincial capitals during the eighth moon of the lunar calendar, usually in September, the time of the mildest weather. Men, young and old, travelled from all parts of Guangdong province to take part. There had been an examination hall in Canton since the Song dynasty, and in 1242 one was built just outside the city. During the Qing dynasty it moved to its final position within the walls in the south-east corner of the Old City (Fig. 3.1), bordered by what is now Wenming Road and Yuexiu Middle Road and on the site of the present Guangdong Provincial Museum. Scotsman John Thomson, who recorded his impressions in both words and photographs in the 1870s, recalled that it 'cover[ed] an area of 1300 feet by 583 feet, hedged round by a high wall pierced by gateways on the east and west, and by a main entrance. The space is divided into two; one section contains rows of cells for candidates, and the other, apartments for superintending officers. Entering the great gateway…, one is admitted to the central avenue, a sort of paved boulevard, flanked on each side by rows of cells, each row by a colossal character taken from "The Thousand Character Classic". On the east are seventy-five rows made up of 4767 cells;

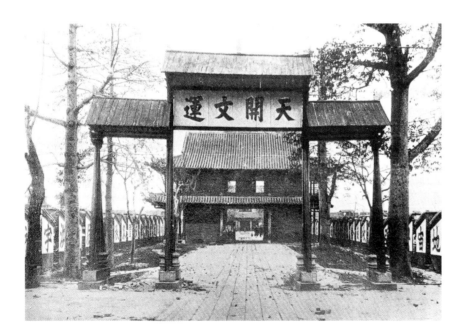

FIG. 3.1 Rows of cells in the Canton examination hall on each side of a gateway whose characters read: 'The opening heavens circulate literature'. The end of each row is marked by a character from *The Thousand Character Classic*; photograph by John Thomson, *c*.1873.

on the west eighty-six rows numbering 3886 cells [Fig. 3.2]. Each row carries a sloping roof facing south, and six feet above ground at its lowest part. A narrow passage divides the rows and admits access. Each cell has an area of six feet by three feet, and the walls are grooved to carry planks which serve as tables and seats during the day and unyielding beds at night. While the students are at work doors are fixed at the ends of the rows, and each candidate is isolated absolutely as if in prison. They are, indeed, officially sealed into their cells, the seal only broken when the task is completed.'[4]

An official cook was attached to each row of cells. During their stay each candidate was provided with a quantity of boiled pork, ham, salt fish, moon cakes (for the examination was held at the time of the Moon Festival), rice,

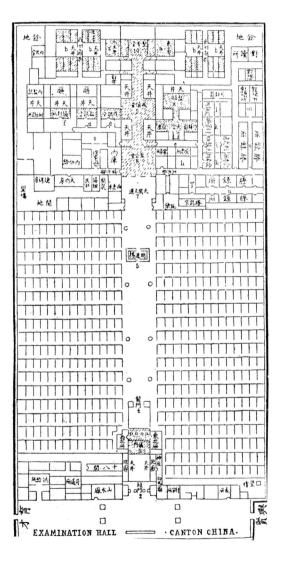

FIG. 3.2 Native woodblock print showing a section of the cells in the examination hall; from *The Canton Guide*, 1889. 'Key: 1. Outer entrance; 2. Principal entrance; 3. Gate of Equity; 4. Dragon Gate, which leads into the Great Avenue; 5. Watch Tower, the God of Literature in the second story; 7. Inscription over the avenue, 'The opening heavens circulate literature'; 8. Hall of Perfect Rectitude, where essays are handed in; 9. Hall of Restraint, where the title pages of the essays are sealed up; 10. Hall of Auspicious Stars, where essays are examined; a. Private rooms of Chief and Second Imperial Commissioners; b. Private rooms of ten Assistant Examiners; c, x. Private rooms of the Governor, who is the chief civil officer; m. Rooms where copies of essays are read and compared; n. Room where essays are copied in red ink.'

EXAMINATION HALL ⟺ ·CANTON CHINA.

preserved eggs, pickled vegetables, and congee water made from boiled rice. All this was given courtesy of the Emperor, although the quality left much to be desired after the local officers had taken their cumshaw. The sometimes-stifling heat could cause death from fatigue and exposure; when this happened the body would be passed over the wall and left there for family or friends to remove.

A very small percentage of those taking part achieved success: strict quotas were imposed nation-wide, based in general on the size of the province, so some men spent their whole life in unsuccessful attempts to pass. Sometimes father, son, and grandson would all enter for the same examination. Many who failed returned home to become schoolmasters, while those who did obtain their degree were known as *juren*, 'promoted men', and could then take part in a further examination held in Beijing the following March. A man who graduated from this final metropolitan examination would become a *jinshi*, the equivalent of attaining a Doctor of Philosophy degree. Those with plenty of money and little ability, however, purchased degrees and official honours, while others obtained them through patronage and nepotism.

Towards the end of the Qing dynasty obtaining a degree without sitting for the examinations became a much more accepted practice. Since the Cantonese are inveterate gamblers, it was perhaps inevitable that sweepstakes, which depended on drawing the names of successful candidates, appealed to poor villagers or aspirants. 'It was often as lucrative to draw a successful number or name in the lottery as to take the degree. The profits to the owners of the lottery were so enormous that they were able to pay £160,000 to the Viceroy at Canton as hush money.'[5] In his defense, the Viceroy announced that this new source of revenue was earmarked to complete a scheme for improved river defences, but in 1875 he and all other high officials in Canton were punished by being down-graded by the central authorities in Beijing.

The route to becoming a military mandarin meant taking examinations which were, naturally, based upon physical feats and required less literary ability. Because of this, a military degree was never held in high esteem by the intellectual élite. The first-degree examination for the military aspirants also tested their ability in archery, both standing and on horseback, and in swordplay (Plate 4). This emphasis on the use of bows and arrows continued throughout the nineteenth century, even as other nations of the world had progressed to using modern firearms. The military examinations for the second degree took place every three years at a parade ground outside the city walls of Canton, on the east side where the Chinese troops held their annual review. Again quotas were applied: for Guangdong province in the mid-nineteenth century the numbers allowed were 1,166 for the *wuxiucai*, graduates of the first degree, and 44 for the *wujuren*, graduates of the second

degree.[6] The *wujuren* would then go to Beijing to take the examinations for the third degree. Success there meant immediate employment for the *wujinshi* in the army or navy anywhere in China.

The fabulous beasts painted on the exterior walls of the Manchu military officials' homes in the Tartar Quarter appeared again on insignia badges worn by the military mandarins. The different animals, including the mythical *qilin*, symbol of great wisdom, the tiger, and the bear, denoted the nine ranks. The ranks of the civil officials were distinguished by nine different birds, such as the crane, peacock, and silver pheasant.[7] The plain dark surcoat with the badges of rank, placed on chest and back, was worn by both groups of mandarins over a full-length robe of deep blue silk, the dynastic colour, richly embroidered with gold dragons and auspicious symbols. A jewelled finial on top of the hat was a further indicator of rank.

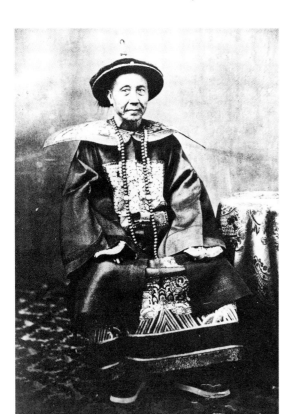

Each civil mandarin was attached to a particular section of the administration, but throughout his career he could be transferred from one post to another with little regard for his previous experience. The 'Law of Avoidance' ensured a mandarin would be posted a long distance away from his home, so as not to succumb to family or friendly persuasion or corruption. This applied especially to senior officials, and many viceroys and governors of Canton came from the central and northern provinces of China.

The most senior dignitary in the provinces was a civil official, the Viceroy or Governor-General, who ruled over one, two, or even three provinces depending on their size, and who was directly responsible to the court in Beijing. A viceroy had governed the 'Two Guangs', Guangdong and its neighbour Guangxi,[8] from his residence at Wuzhou, on the banks of the West River at the border of the two provinces, since 1469. The Viceroy (**Fig. 3.3**) held the first civil rank and was appointed for a period of three years, but office-holders sometimes served a longer term. His was one of the most important positions in the land, as he was in direct communication with the Emperor. Twice a month he would receive petitions from the common people, who could appeal against convictions or miscarriages of justice. Outside his yamen was a gong called the 'Cymbal of the Oppressed', which could be sounded by a victim of wrong-doing. Unfortunately, anyone sounding it was liable to be given a few swift strokes of the cane by the yamen's clerks, and the custom eventually fell into disuse.

In the Qing dynasty the Viceroy continued to govern the two neighbouring provinces of Guangdong and Guangxi. His official seat had been transferred in the Ming dynasty from Wuzhou to Zhaoqing on the north bank of the West River, 111 kilometres up-river from Canton, but when necessary he stayed in his Canton yamen in the New City near the Oil Gate (Fig. 3.4). In 1664 the Viceroy was ordered to make his headquarters Canton, instead of Zhaoqing, and Canton became the vice-regal city. James Dyer Ball, born in Canton in 1847 of a missionary doctor of the same name, wrote: 'A Viceroy in the provinces gets as his yearly official salary about £100, and allowances amounting to £900 or £1,200 more; but he has to defray out of these sums all his *yamen* expenses, including stationery, etc., salaries, and food to his secretaries, writers, and ADC [aide-de-camp], his body-guards and general retinue, to entertain his innumerable guests, and send his annual tributes to the various high officials in the capital, to say nothing of supporting his high station and his numerous family.... [T]o meet his expenditure he would require no less than £10,000 or £15,000 per annum.... From these high magnates downwards, the Chinese officials are underpaid in the same proportion, until we get to the lowest grade, the petty mandarin, whose official pay is scarcely better than that of a well-paid Hongkong coolie, and the soldiers and sailors who receive four to ten shillings a month, subject oftentimes to various unjust deductions and squeezes by their superiors'.[9]

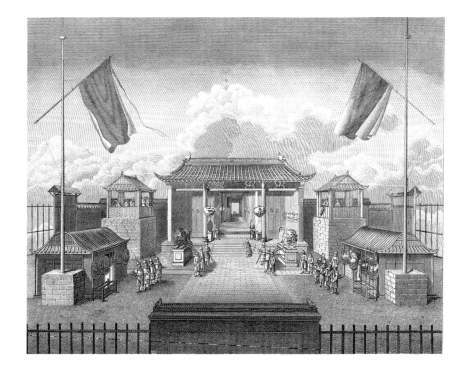

FIG. 3.4 A Viceroy's yamen with guards on duty outside; c.1810.

The New City, and not the Old City, was the site of the yamen of another powerful mandarin. There, on the eastern side (Plate 5), below the South Gate and to the east of the Five Genii Gate, was the Customs House, where the Hoi-Kwan, Imperial Commissioner of the Guangdong Customs, regulated all foreign commerce. He was known to the foreign traders as the Hoppo, formed by the corruption of his title in Cantonese, *hoi-pu*. The Hoppo, a third-rank mandarin usually a distant member of the Manchu imperial household, and his assistants, who were always Manchus, received only nominal salaries and their chief emolument was derived from fees, exactions, and percentages on imperial duties. This gave the Hoppo ample opportunity to amass a large fortune during his temporary stay in the city. A post as Hoppo in Canton became one of the most highly prized positions in the Chinese empire.

Other government officials lived in yamens on the east side of Sze Pai Lau in the Old City (Fig 3.5). The Governor's yamen was in the middle of the Street of Benevolence and Love, in what had been originally a palace built during the reign of the first Qing emperor for one of the Tartar Generals sent to pacify the Chinese. The Governor was second-in-command to the Viceroy, a second-rank mandarin, and considered a colleague rather than a subordinate.

FIG. 3.5 Map of Canton showing the locations of the yamens; drawn by Rev. Daniel Vrooman, c.1860.

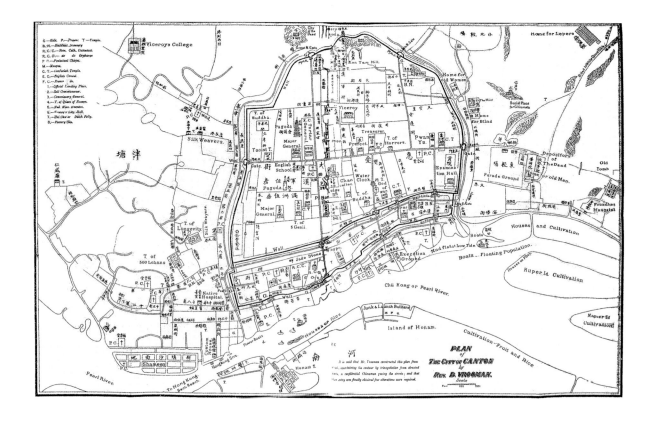

He was in charge of civil and military affairs in the province of Guang-dong and his term of office was also usually for three years. While the Tartar General and the Hoppo were always Manchus, and the Viceroy could be either Manchu or Chinese, the Governor was usually Chinese. The yamens of the Tartar General and the Governor were at opposite sides of Sze Pai Lau in the Old City, while those of the Viceroy and Hoppo were at opposite ends of the New City. The four gates linking the New City with the Old City were locked at night and these officials were thus separated to prevent them from hatching plots or becoming over-friendly. Each worked independently but needed to gain approval from another before taking action. In this way checks and balances were used against each of these high-ranking officials.

Like the Governor, the Treasurer was another second-rank mandarin, who was head of the civil service in each province. He controlled the provincial exchequer and sent revenues to Beijing. His yamen, at the eastern end of the Street of Benevolence and Love, was one of the most spacious official residences in Canton and, located in the original part of the city, had been a seat of government since the Sui dynasty (Fig. 3.6). This large low building held the city's store of silver bullion and copper cash, and it had a separate store-house as well for safe storage of costly mandarins' robes, lined with sable and other rare furs, when they were not required.

From the Treasurer's yamen, a third broad and handsome thoroughfare led down to the Great South Gate. This boulevard, called Sheung Mun Tai, took its name from the double gateway placed in a section of the wall dating from the Tang dynasty. Now named Beijing Road, it was a popular street where many large book-stores attracted the literati. It was best known, however, for the building over the double gateway, erected in the Ming dynasty, which held a clepsydra, a water clock, a common device for telling time that was also found in other major cities in China.

First cast by a Canton craftsman, Xian Yunxing, in 1316 (Fig. 3.7), and replacing one originally made in the Tang dynasty, the mechanism fascinated many Westerners. One American visitor, Edward Morse, took careful note and wrote: the 'water clock consisted of four deep copper vessels arranged

FIG. 3.6 The entrance to the Treasurer's yamen; photograph by Felice Beato, c.1860. Collection of Jane and Michael G. Wilson, Courtesy of Santa Barbara Museum of Art.

FIG. 3.7 Clepsydra, or water clock, in Sheung Mun Tai; photograph from the late nineteenth century.

on the steps one above the other. A flight of short steps was at the side of this contrivance to enable the attendant to fill the upper bucket with water, and this has to be done twice in twenty four hours. The water slowly drips through a faucet in the upper bucket to the next in turn, and so on down to the lowest one. In this is a float, to which is attached an upright strip of wood having painted upon it the characters for one, two, three, and so on. This strip passes through a bail which spans the bucket, and as the float rises the numbers pass in succession through the bail, and thus the hours of the day are rudely indicated. The keeper has a set of large boards upon which numbers are painted in black, and as each hour is indicated by the float the keeper hangs out a board with the corresponding number, and this may be seen only by those who are in a line with it down a wide avenue. Here the number remains in sight till the next hour is indicated by the float; in the mean time, unless one has closely followed up these sign-boards, there is no way of determining whether the time is one minute past nine, for example, or one minute to ten. To know the time within one hour seems to be quite enough."[10]

The next most powerful official was the Provincial Judge, a third-rank mandarin who had the highest judicial authority in the province, in real terms above that of the Viceroy. He was the judge of offences committed by officials, and the connecting link in judicial cases referred to Beijing. His yamen was near that of the Literary Chancellor in the middle of the city, now bordered by Guangzhou Qiyi Road and Huifu East Road to the south. Below the Provincial Judge's yamen, near the Gate of Virtue, was the office of the Salt Commissioner, a third-rank civil mandarin in control of the salt gabelle. The salt trade was an important government monopoly and the taxes from it were a major part of the imperial revenue. Salt was brought along the rivers from the coast in long convoys of boats tied together, the salt covered with large woven-reed mats to protect it from moisture. Once in the city, it was stored in guarded warehouses and sold for up to fifteen times the price of rice.

Another essential post was held by the Grain Commissioner, a fourth-rank civil mandarin in control of all the public granaries in the province, whose yamen was just south of that of the Governor. There were fourteen granaries in and around the city of Canton, which had to be kept full of rice for the people to have access to in times of scarcity. Rice was brought by boat from the island of Hainan off the coast of southern Guangdong, as the province could not grow enough for the needs of all of its population.

Next in the government hierarchy was the Prefect, a fourth-rank mandarin who controlled a *fu* or prefecture. Since Canton was the chief prefectural city, his department included fourteen districts or counties, each administered by a magistrate and an assistant magistrate. These mandarins had many duties and were, at the same time, judge, tax collector, and director of police and sheriff of the district (**Fig. 3.8**). The Prefect's yamen was to the right of that of the Governor, also on the Street of Benevolence and Love. Further along to the east of the same street was the yamen of a fifth-rank mandarin, the magistrate in charge of the Pan-yu district, whose title recalled the name of the city in Han times. The area under his control covered the eastern half of the city, including the area lying down-river to Whampoa (Huangpu), where foreign ships lay at anchor waiting to load up and sail away. His colleague, the Nam-hoi (Nan-hai) magistrate, was in charge of the western half of the city and the district lying up-river; his yamen was in the lower centre of the Old City bordered by Sze Pai Lau Street. The factories where the foreigners lived when trading with the Chinese came under his jurisdiction.

FIG. 3.8 A page showing the *Titles, Rank, and Legal Income of the Mandarins*; taken from Meadows's *Desultory Notes*, 1847.

Official Title in Chinese		Official Title in English	Title used in direct Address. In Chinese (used after the surname or alone.)	(Equivalent) in English.	Class	Button	Salary (varying with the Rank)	Anti-extortion (allowance varying with each Post.)
							£	£
總 督 tsung tu	or 制 臺 chi tai	Governor General	大 人 ta jen	Your Excellency	1	Plain & Red.	60	8333
巡 撫 hsün fu	or 撫 臺 fu tai	Governor	ditto	ditto	2	Flowered & Red.	50	4333
布政司 pu ching si	or 藩 臺 fan tai	Superintendent of Finances	ditto	ditto	2	ditto	ditto	2666
按察司 ancha si	or 臬 臺 niĕ tai	Provincial Judge	ditto	ditto	3	Transparent Blue	43	2000
鹽運司 yĕn yün si	or 運 臺 yun tai	Collector of the Salt-Gabel	ditto	ditto	3	ditto	ditto	1666
糧儲道 leang chu tau	or 糧 道 leang tau	Grain Collector	ditto	ditto	4	Opaque Blue	35	1266
守巡道 shou hsun tau	or 道 臺 tau tai	Intendant of Circuit	ditto	ditto	4	ditto	ditto	1000 †
知 府 chi fu		Prefect of Department	大老爺 ta lau ye	Your Honor	4	ditto	ditto	652
直隸知州 chi li chi chou		Prefect of Inferior Department	ditto	ditto	5	Uncolored Glass	26	383
直隸同知 chi li tüng chi		Independent Sub-Prefect	ditto	ditto	5	ditto	ditto	300
同 知 tüng chi		Sub-Prefect	ditto	ditto	5	ditto	ditto	225
通 判 t'üng p'an		Deputy Sub-Prefect	ditto	ditto	6	White	20	176
知 州 chi chou		District Magistrate	ditto	ditto	5	Uncolored Glass	26	262
知 縣 chi hsien		ditto	太 爺 t'ai ye	Your Worship	7	Plain Gilt	15	262
縣 丞 hsien ching	or 左 堂 tso tang	Assistant District Magistrate	ditto	ditto	8	Gilt with Flowers in relief	13	All these, from the District Magis- trate downwards gets about £22, with the exception of the Treasurer
主 簿 chu pu		Township Magistrate	ditto	ditto	9	Gilt with engraved Flowers	11	
巡 檢 hsün chien		ditto	ditto	ditto	9	ditto	ditto	
吏 目 li mu		Inspector of Police	ditto	ditto	9	ditto	ditto	
典 史 tien shi		ditto	ditto	ditto	unclassed	ditto	ditto	
河泊所 ghò pô so		Inspector of River Police	ditto	ditto	unclassed	ditto	ditto	

The two magistrates held court in the afternoons (Fig. 3.9). Wrote the U.S. Consul-General from Hong Kong, Rounsevelle Wildman, after a visit to Canton in 1900: the yamen 'is a low, one-storied building with grotesquely carved gates under a red-tiled roof that is surmounted with porcelain dragons.... [T]he magistrate's room would probably seat two hundred people if chairs were provided; but there are only three of these articles in the room, and they stand behind a common kitchen table covered with turkey-red calico, a yard of which had also been thrown over each of the chairs. The place is about as cheerful as a stable, and a trifle cleaner than a hen-coop. On the walls hang an array of whips, bamboo rods, iron instruments of all sorts, chains, and the cangue.... To right and left, facing the table, passages lead off to the cells where the witnesses and the prisoners are awaiting trial, all huddled together in their filth.'[11]

FIG. 3.9 A Chinese court of justice; c.1890s.

Next to each magistrate's yamen was a prison. Prisons in China were places of detention where, often, it was widely believed, an innocent man was held, manacled and half-naked, and while awaiting trial tortured for whatever meagre property he had, until he was glad to confess to a crime he had not committed. In the street outside, prisoners were chained to stones and iron rods. To one side of the entrance was a room for those prisoners wearing the cangue, a heavy wooden collar large enough to prevent him from lying down or raising his hands to his face to eat. On each side of the cangue were pasted notices informing passers-by of the man's crime, usually theft.

All the mandarins, even the lower-ranking magistrates of the sixth to the ninth rank, were held in great esteem, and were among the elite of the country. As a measure of this high regard, when an official appeared in his sedan chair in the street all passers-by must stop and look away, and other sedan chairs were set down. Anyone who did not comply could be beaten unmercifully. Cannons were fired when the official left his yamen, when he entered the yamen of another, and again when the procession returned home. Men bearing gongs and flags ran in front, while others carried boards denoting the mandarin's rank. Some attendants held a large official fan and a large umbrella of state. Two men carried a trunk with changes of clothing if the magistrate was travelling around his circuit. Several men brandished whips, and it was their business to clear the way, to call out when passing the yamens of other officials, and when turning corners. Others received petitions while soldiers following the sedan carried swords, spears, flags, hammers, and iron chains (Fig. 3.10).

All civil and military mandarins were required to perform state worship and various rites of filial piety at a temple dedicated to the Emperor, its name, the Palace of Ten Thousand Ages, a wish that his life may be long. The temple, founded in 1714, was situated in the New City, reached through the Gate of Literature, and comprised a series of halls, one behind the other, built of wood painted red and decorated with dragons, with a roof covered in imperial yellow tiles, the colour reserved for the Emperor

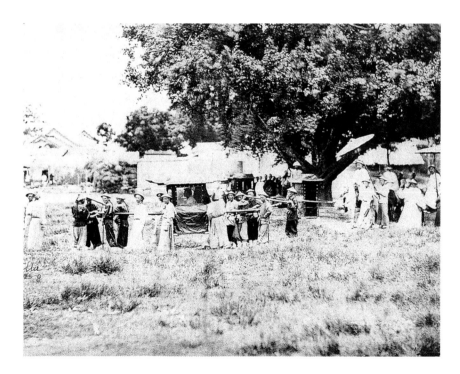

FIG. 3.10 Viceroy Liu Ch'ang-yu being carried in his sedan chair; 1862.

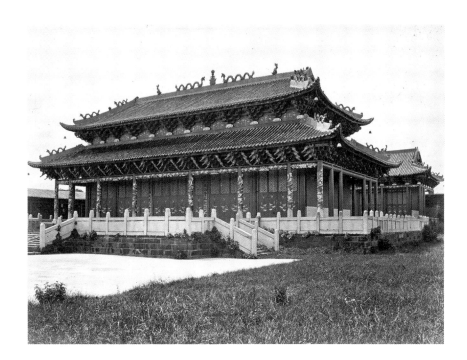

FIG. 3.11 The Emperor's temple with its glazed yellow tiled roof and decorated columns; *c.*1870.

(Fig. 3.11). On ritual occasions, such as those held for three days before and three days after his birthday, at Lunar New Year, and on the occasion of the Emperor's marriage, the gates of the city were open all night, so that the mandarins could assemble in order of rank. The lowest would send a message to the next in the hierarchy announcing he had started his journey. This way the lower orders would arrive first, ready to greet the next level. The ceremony took place, like other temple ceremonies, in the early hours of the morning, when it was believed the spirits were likely to be present in the tablets and thus more able to hear the petitions. Thousands of attendants congregated in the courtyard outside the temple, under the flickering lights of huge torches set on each side of the great doorway.

Inside the hall scores of mandarins, all in the splendid attire of dark blue silk court robes emblazoned with fierce gold dragons, collected to pay homage to the Emperor. Civil mandarins took the Chinese place of honour on the left, while the military mandarins were on the right. No seats were allowed in the sacred halls, so everyone carried a cushion on which to kneel. A wooden tablet, representing the Emperor, was placed on an elaborate throne, copied from the one in the Forbidden City and reached by nine steps. At a given signal the mandarins knelt down and, facing the tablet, performed the ceremony of the kowtow, the Chinese custom of kneeling three times, each time knocking the head on the ground three times. Thus did the Emperor, far away in the Forbidden City, receive homage from his distant subjects.

ENDNOTES

[1] The name came from the Portuguese *mandar*, meaning to command, the Portuguese being the first foreigners to encounter these officials in Macau.

[2] E. C. Bowra, *A History of the Kwang-tung Province of the Chinese Empire*, Hong Kong: De Souza & Co, 1872, p. 72. Nan-hai was a district in the city.

[3] Dr J. G. Kerr, *The Canton Guide*, 4th edition, Hong Kong: Kelly & Walsh, Ltd, and Canton: A. S. Watson & Co, Ltd, 1889, pp. 25–6. Kerr's guide was reprinted and revised several times, often with different titles.

[4] John Thomson, *Through China with a Camera*, London & New York: Harper & Bros., 1899, p. 4.

[5] Prince Albert Victor and Prince George of Wales, *The Cruise of Her Majesty's Ship 'Bacchante', 1879–1882*, London: Macmillan & Co., 1886, Vol. II, 'The East', p. 233.

[6] Thomas Wade, The Army of the Chinese Empire, Canton, *The Chinese Repository*, 1851, Vol. 20, reprint, Tokyo: Maruzen Co, Ltd, p. 391.

[7] See Valery M. Garrett, *Mandarin Squares: Mandarins and their Insignia*, Oxford University Press, Hong Kong, 1990.

[8] Guangdong, literally, 'broad eastern', and Guangxi, 'broad western'.

[9] J. Dyer Ball, *Things Chinese*, Hong Kong: Oxford University Press, 1982, reprint of 5th edition, Shanghai: Kelly & Walsh, 1925, pp. 277–8.

[10] Edward Morse, *Glimpses of China and Chinese Homes*, Boston: Little, Brown, 1902, pp. 168–170.

[11] Rounsevelle Wildman, *China's Open Door: A Sketch of Chinese Life and History*, Boston: Lothrop Publishing Co, 1900, pp. 262–3.

4

The Rich and the Wretched:
The New City and the Suburbs

For much of the Qing era, the majority of Canton's population lived in the New City, where lower-class Chinese were moved when the Manchus took power, and in the suburbs outside the walls. Outside the city centre social disparity was at its greatest for, on one side in the Western Suburbs, wealthy merchants lived in palatial splendour with gardens so magnificent that their images are still reproduced on dinner services and other decorative porcelain today, while to the east, hundreds existed in squalor more suited to beasts.

The New City was a labyrinth of crooked lanes, paved with granite slabs worn smooth over the centuries by the bare feet of countless coolies. Although most lanes were less than 3 metres wide, many had highly auspicious names, like the Street of Everlasting Love, Heavenly Peace Street, and the Street of One Thousand Grandsons. Screens of straw matting were hung at roof level across the main thoroughfares to shield the sun's strong rays (Fig. 4.1), but during the frequent heavy summer storms, rain poured through in torrents. Open drains were soon flooded, and pedestrians waded knee-deep through the muddy effluent; streets became canals as the Pearl River overflowed its banks, and boat girls in their sampans made a profitable business.

Mandarins and wealthy merchants did not walk: they travelled aloft in sedan chairs, some streets just wide enough for two chairs to pass. In others,

FIG. 4.1 A typical street, this one is Physic Street in the Western Suburbs, showing the matting strung across at roof level to shield passers-by from the strong sunlight; photograph by John Thomson, *c.*1873.

the alleyways were too narrow, so that in one the chairs all went in one direction, while in a parallel one they went the opposite way. Noted an American, William M. Wood, on a visit in the middle of the nineteenth century: 'The crowd passes in single file in opposite currents, and the foot passenger hears ever behind him loud roaring cries from coolies bearing sedan chairs, or heavy burdens depending from poles, supported at either end upon a man's shoulders. The street is not wide enough to permit these chairs and loads to pass without the foot passengers giving way, and as the coolies so laden proceed at a very rapid walk — almost a dog trot — unless their cry is heeded, and way made for them, the force of the burden will clear its own way.'[1]

Fifty years later little had changed, as fellow American Edward Morse discovered: 'The crowded thoroughfares are still more congested by the various artisans carrying on their occupations in the middle of the streets, …the hammering, planing, ricepounding, the loud din of the coppersmith, the musical clink of the blacksmith's hammer, the multitudinous variety of weird street-cries, with the occasional rattling outburst of fire-crackers, all made up a perfect pandemonium. The three senses of sight, hearing, and smell were incessantly assailed by interesting, ear-splitting, and disgusting impacts.'[2]

Shops opened onto the street, their frontage seldom more than 5 metres wide, although they reached far back into the gloom (Fig. 4.2). The narrowness of the streets meant purchases could be made directly between sedan chair and shop, without the chair's occupant having to alight. Tall narrow signboards were suspended on each side of the shop doorways to proclaim their wares. Painted black, blue, red, or green, with the Chinese characters picked out in gold or vermilion, they were jolts of colour against the blue-grey bricks and granite blocks of the buildings themselves. As many customers were illiterate, some shops would hang out a large pasteboard model of their principal goods: 'a satin skull-cap or a conical straw hat denote a hatter, a shoe for a shoemaker, a fan or an umbrella for the seller of these; a huge pair of spectacles or a great gilded dragon each convey their invitation to all comers. Some streets are all given over to the workers in one trade —

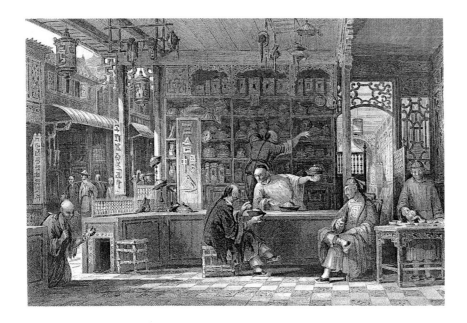

FIG. 4.2 Two men discuss the purchase of a winter hat with the owner of the shop, while an assistant pours tea and, at the entrance, a beggar asks for alms; drawn by Thomas Allom, c.1841.

they are all ivory-carvers, or coffin-makers, or purveyors of strange offerings for the dead or for the gods.'⁵ At night the shops were closed with wooden shutters and the counter by the doorway became a bed for the watchman. The owner made his way home, through streets dimly lit with oil lamps and scented by the curling smoke from incense sticks, to more spacious quarters in a quieter part of the city.

Most buildings in Canton were crowded together to shut out the strong sunlight and lower the temperature, which could rise to over 35 degrees centigrade in the summer. The common people lived in one- or two-storey houses built of clay bricks with terracotta-tiled roofs and small windows covered with rice paper or translucent capiz shells. No windows opened onto the streets, which were faced with blank walls and the occasional doorway. Heavy gates at the main street intersections were shut at nightfall, making each district, or ward, separate from the next, and confining outbreaks of violence to one area.

There were few tall buildings except for the pawnbrokers' warehouses, common throughout China, which were usually built of granite, up to five storeys high, with rows of narrow windows each with a vertical iron bar (Fig. 4.3). Around the interior walls of these warehouses were wooden shelves filled with camphor-wood chests and leather trunks containing the pawned goods. The shops were well-patronized, as it was the custom to pawn the previous season's clothing for safe-keeping, especially fur-lined and silk embroidered robes. Each object was labelled with the customer's name, due date, and value of the item. Furniture was stored on the ground floor,

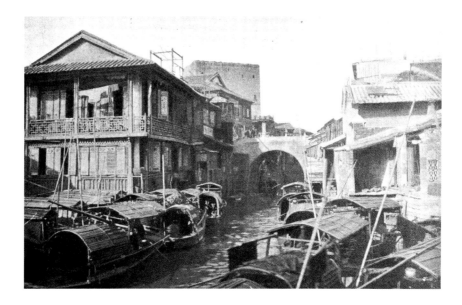

FIG. 4.3 An inner city canal crammed with sampans: in the centre background can be seen a pawn warehouse with its tiny windows; *c.*1890.

clothing and other lightweight articles were on the next, while the most valuable items of bullion and jewellery were on the top floor. A unique feature for deterring thieves were the boulders kept on the roof and ready to be dropped on the heads of unsuspecting villains.

The Chinese consider the west to be a more favourable direction than the east, and the suburbs in this part of Canton were the most salubrious. In that district were some of the largest temples, finest streets, and best country residences built for wealthy Cantonese. Several of the hong merchants lived here, the twelve or so men who formed the Co-hong, an organization established to control foreign trade, and who were the go-betweens for the foreigners wishing to do business in Canton in the eighteenth and nineteenth centuries. No Western trader could buy his prized tea and silk without a Chinese intermediary, and many hong merchants grew exceedingly wealthy on the proceeds from foreign trade. Several of the progeny of hong merchant P'an Chen-ch'eng (1714–88), better known as Punqua, at times chief of the Co-hong, were famous for their wealth and official ranks, which they could well afford to purchase, by-passing the arduous examinations.

The home of a descendant of Punqua, the mandarin P'an Shih-ch'eng, was renowned for its ornate architecture and collection of rare books, paintings, and calligraphy. He became a mandarin by having the *juren* degree conferred upon him in 1832 by the Daoguang emperor for his generous contribution to relief funds for famine victims in Hebei (then called Chihli) province. P'an's villa was situated a little way up the Pearl River from the main part of the city, off a small tributary. But it was his celebrated garden, Lai Heung Yuen (Fig. 4.4), that drew countless visitors in the mid-nineteenth century.

Gardens were very important to the Chinese literati: they were seen as a retreat, a refuge from the affairs of government, and a place in which to revive the spirits. After disembarking at a summer-house, visitors to Lai Heung Yuen crossed over small 'willow-pattern' bridges that intersected over lakes filled with a carpet of lotus flowers. Reverand George Smith of the Church Missionary Society found, on his visit in the 1840s, that 'gold and silver pheasants, mandarin ducks, storks, peacocks, some deer, and other animals of rarity or beauty, were placed in cages along raised walks, which led around and across the lakes. Beautiful trees, shrubs, and parterres of flowers, added their portion of variety and interest; while, again, lofty platforms, surmounting the roofs of the numerous summer-houses, afforded a prospect into the neighbouring localities.'[4]

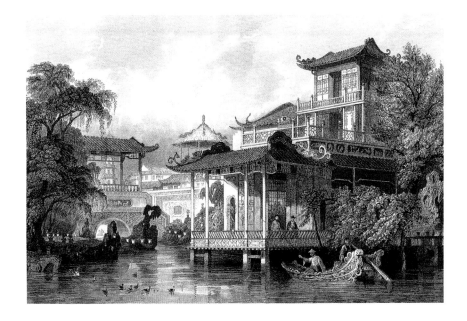

FIG. 4.4 House and garden of mandarin P'an Shih-ch'eng; drawn by William Alexander, c.1792, copied by Thomas Allom.

For ten years, beginning in 1848, P'an Shih-ch'eng was Salt Commissioner for Guangdong province. Forced by the government to pay a fixed sum for the monopoly of the salt trade, however, P'an went bankrupt and his garden was raffled in a public lottery. The garden was looted by French troops in the Second China War of 1856–60 and by the following decade it had fallen into ruin. It opened as Liwanhu Park in 1958 and is especially popular today with elderly men who bring their caged birds to hang from the trees while they chat to each other. The Panxi restaurant, in one corner of the park, dates from the nineteenth century and is a popular rendezvous spot, with regular performances of Beijing opera and classical music. The exotic animals and birds in cages near the restaurant are, sadly, now destined only for the cooking pot.

Along the main streets of the Western Suburbs, the homes of the wealthy were concealed from onlookers by walls 4 metres high. Inside the south-facing main gate of each compound was a screen wall of granite about half a metre thick and as high and as wide as the buildings inside; its purpose was to block evil spirits, thought only to travel in straight lines, from entering the compound. Visitors entered through the main gateway into an open courtyard paved with granite slabs. In colonnades on either side were large red boards with gold calligraphy listing the titles of both the living and dead members of the family. Green glazed flower-pots holding flowering shrubs, such as peonies and azaleas, surrounded the courtyard, and lotus flowers grew in small ponds. As well as being decorative and fragrant, all the plants cultivated were symbols of good fortune and longevity.

Upon arrival, a servant would escort the visitor to a reception hall, where the host and other male members of the family waited to greet him. Many Chinese mansions had several halls and courtyards, the main rooms ornamented with wood-carvings and hung with scroll paintings and calligraphy: '[I]n the houses of the wealthy there is no little elegance. The stiff-backed chairs and tables are of carved ebony or inlaid with mother-of-pearl or marble. The divan is supplied with mats and cushions on which the guests may recline and smoke their opium, while they may sip their tea and take their refreshments from choice China on the little marble-topped teatrays or tables arranged around the room' (Fig. 4.5).[5]

Behind the halls were the domestic apartments, a school-room, and a garden, where the women and the younger members of the family were

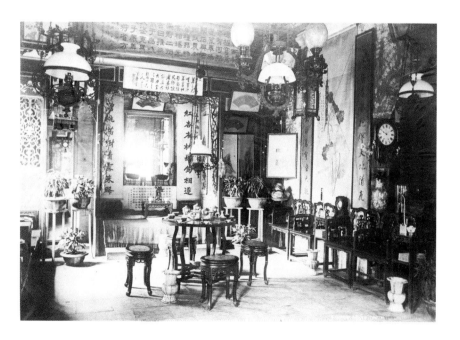

FIG. 4.5 A room in a Chinese home where visitors were entertained; c.1900.

cloistered, spending their time gossiping, playing cards, and embroidering. Chinese custom decreed that on marriage, the bride should live with her husband's family, and these extended families meant three or more generations lived under one roof, not always harmoniously (Fig. 4.6). Often a man would take concubines, especially if his principal wife had been unable to provide him with sons. P'an Shih-ch'eng, owner of the famous garden, thought nothing of having twelve concubines in addition to his principal wife.

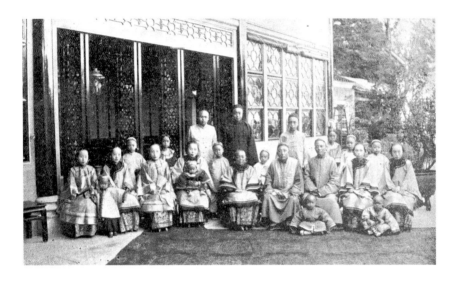

FIG. 4.6 A Chinese family of three generations; c.1890.

Terraces at roof level on some of the houses enabled their occupants to walk in the evening and enjoy the views (Plate 6). Women did not venture far, for walking was difficult and painful on their tiny bound feet. For almost a thousand years Chinese women, from a very young age, had followed the custom of binding their feet to make them small, for they were considered unmarriageable with natural feet. The tiny shoes were the last items of clothing to be removed in the privacy of the bedchamber, the smell of the deadened flesh fuelling erotic associations. The swaying gait induced by the cramped feet also titillated men's desire, as well as restricting women's movements.

If they wished to go out, women from wealthy families would be carried in sedan chairs, peeping out through the window blinds, or carried, crab-like, on the back of their servant. Those from the Hakka ethnic group, and the very poor, did not follow the fashion, nor did the wives and daughters of the Manchu rulers, who tried unsuccessfully to ban the fashion upon taking power. It was not until the early twentieth century that the custom finally died out. Growing emancipation for women, a ban by the government of the new republic, together with pressure from foreign missionaries and anti-footbinding societies, all contributed to its demise.

Beyond the Western Suburbs, and to the north of the city, was flat open countryside with scattered small villages. Farmers, wearing wide-brimmed hats of woven bamboo to shield them from sun and rain, tended their paddy fields, growing two or even three crops of rice a year. Lychee, pomegranate, and persimmon trees grew all around. Here, too, were groves of mulberry bushes raised to feed silkworms and so supporting a significant local silk-weaving industry. A few kilometres beyond the walls of the city was the low range of hills visible from the river, the Baiyun Mountains **(Plate 7)**, where two hill forts protected the city from intruders from overland.

Near the northern section of the wall was the City of the Dead, a repository for the coffins of those from other parts of China who had died in Canton and were waiting for a propitious date to be transported back to their native provinces. 'The city is laid out like a miniature city of the living, in streets of small houses built of stone', wrote Constance Gordon Cumming in 1888 **(Fig. 4.7)**.[6] Relatives would pay an entrance fee followed by a monthly rent to ensure that the dead were well cared for. The coffins were 'surrounded by cardboard models of all manner of comforts, including life-sized servants, fans, pipes, umbrellas, and in many cases a light is kept ever burning above the altar.' Paper offerings of sedan chairs and servants were also burnt so that the spirits of the ancestors could enjoy their benefits in the next world.

In the northern corner of the Eastern Suburbs was a military camp and a parade ground where the Tartars held their annual review. Another parade

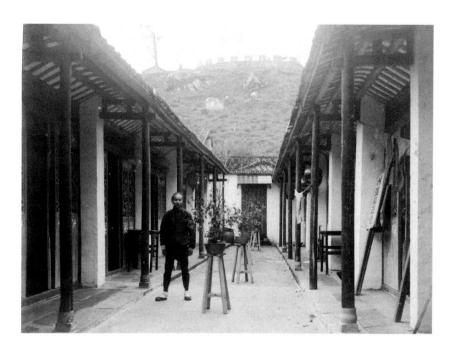

FIG. 4.7 An attendant in the City of the Dead; 1906.

ground was south of the East Gate, where the Chinese troops were reviewed and the military examinations held. It was there that the three high officials, the Prefect and the Nan-hai and Pan-yu magistrates, performed the annual ceremony to initiate the agricultural year, as part of Canton's role as a prefectural city. During the ceremony, held on the first day of spring, the Prefect, representing the Emperor as father of the people, ceremonially ploughed a few furrows of land in front of a shrine set up for the god of spring, as a wish for a good harvest (Plate 8).

A modern mint was established a short distance to the north of the East Gate in May 1889 by Viceroy Zhang Zhidong, who hailed originally from Hebei province. Zhang was a brilliant scholar, official, and reformer who, the previous year, had founded the Kwong Nga Academy of Learning. The machinery for the mint came from Birmingham, England, but the buildings were in the Chinese style and occupied about 6 hectares surrounded by a wall. Water was pumped from a canal into an elevated reservoir which supplied the works. At the time it was said to be the largest mint in the world, and the first modern mint in China, with eighty-six machines for stamping copper cash, turning out two million coins a day.

Metallic coins had first been introduced in the Chinese empire by the Qin emperor, Qin Shihuangdi, during the third century BC. During the Qing dynasty, silver ingots, known to the Western traders as 'sycee',[7] were used for major transactions, their value based on their weight in taels.[8] For smaller amounts, copper alloy cash was used, the coins having a square hole in the centre and carried by the merchants' attendants on strings around their necks. Silver coins, such as Spanish and Mexican dollars, were introduced in Canton and other treaty ports on the China coast in the middle of the nineteenth century. The reliable purity of these foreign dollars put China's currency at a disadvantage and eventually led to the Chinese government's own production of silver currency.

Closer to the East Gate was the old tomb of the Tartar General, Pang Chi Fu, who helped in the capture of the city in 1650. A large marble slab was inscribed in his memory, while the approach to the tomb was lined with statues carved in stone of pairs of animals, such as rams, horses, and camels, together with warriors and civil officers, similar to those lining the 'spirit way' leading to the Ming emperors' tombs near Beijing. The eastern direction was considered unpropitious, and so the road from the North-East Gate led to a cemetery where the dead were laid to rest and the outcasts of society lived. Charitable institutions, maintained by the Chinese government, had been in existence in Canton since the thirteenth century. Homes for the unwanted were founded in the seventeenth century and were supported by imperial patronage from taxes imposed on foreign ships bringing rice to Canton.

The Foundling Asylum, or government orphanage, established in 1698 and enlarged in 1732, was situated half a mile from the Little East Gate

(Fig. 4.8). In the latter years of Qing rule, every day between six and ten abandoned infants, usually girls, were brought in to the asylum, for, by tradition, Chinese parents wanted sons in preference to daughters. Even more girls were left in the Year of the Tiger, for it was thought that girls born under that sign would grow up to be fierce women and therefore unwanted wives. In poor families boys were needed to help in the fields or when fishing, while for others, success by their offspring in the imperial civil service examinations brought wealth and distinction to the clan. Moreover, sons were needed to ensure the continuation of the clan, as well as to perform the necessary ritual ceremonies of ancestor worship. In the grounds of the Foundling Asylum, about 150 wet-nurses each took care of between three and five babies in her own small cottage. The majority of these children died, but those girls who survived were usually adopted by families to work later as domestic servants or by wealthy merchants to become their future concubines, or else were destined for the brothels. Even today, despite efforts through education, most parents in China prefer sons, and many daughters are aborted, killed, or neglected, threatening to create a nation of spoilt 'little emperors'.

FIG. 4.8 The entrance to the government orphanage; 1917.

Closer to the wall in the north-east section of the suburb was the Home for Aged Females, where up to 500 destitute widows spent the remainder of their days. Each old lady had her own small cottage, and those with reasonable health and eyesight spent their time on needlework, shoemaking, and similar tasks. The old men were more fortunate. The largest and best

preserved institution for the elderly was the Home for Aged Men, located near the parade ground by the East Gate, where rows of cottages housed up to 1,000 inmates. Although the salt trade was a government monopoly, and no one could deal in salt without a licence from the Salt Commissioner, the government allowed a limited number of old men to trade and thus undersell the government monopoly, to provide an income for them and their families.

The Home for Lepers was placed well away from the city, to the far north-east. It, too, was supported by the annual taxes from the rice ships, but it received just one-eighth of the sum given to the Foundling Asylum. There were several hundred rooms built on two sides of the main street, many of which were occupied by the families and descendants of lepers who were free of the disease. Leprosy had still not been eradicated by the 1930s, when a modern hospital was built. The blind were another neglected group. Contained within a large enclosure, close to the East Gate, were rows of single-storey rooms, about 500 in all, each housing four blind, maimed, and diseased beggars. During the day, they walked the streets of the city, strung together in a chain with a hand on the shoulder of the one in front, begging for alms. This was the least well-cared for of all the homes, as the authorities argued that, as the inmates couldn't see the squalor, they weren't affected by it.

Wrote Dr John Kerr, champion of the underdog in Canton in the late nineteenth century: 'In place of the well-furnished and neatly-kept rooms in Asylums at home, we find here the hovels filled with ricketty [sic] stools and tables, bedding, broken earthen vessels, furnaces for cooking, and rubbish, the accumulation of months or years. The kindness and attentive care shown to the inmates of the one, with the desire to make them comfortable, to give them something of the feeling of home and to soothe the declining years of life, find no counterpart in the management of the other, but the chief aim of all concerned is to divert to their own use as much as possible of the charitable fund and, not satisfied with this, even levy a tax on those who receive it!'[9] Still, away in the Western Suburbs, those with wealth and comfort, for the most part, ignored the misery and suffering on the other side of the city.

ENDNOTES

[1] William M. Wood, *Fankwei, or The San Jacinto in the Seas of India, China, and Japan*, New York: Harper Bros., 1859, p. 279.

[2] Edward Morse, *Glimpses of China and Chinese Homes*, Boston: Little, Brown, 1902, pp. 118–19.

[3] Constance Gordon Cumming, *Wandering in China*, London: Wm. Blackwood & Sons, 1888, p. 37.

4 Rev. George Smith, *A Narrative of an Exploratory Visit to Each of the Consular Cities of China, and to the Islands of Hong Kong and Chusan, on Behalf of the Church Missionary Society, in the Years 1844, 1845, 1846*, London: Seeley, Burnside & Seeley, 1847, reprint, Taipei: Ch'eng Wen Publishing Co, 1972, pp. 118–19. Birds and animals had symbolic meanings and implied the raised status of the officials.

5 Rev. R. H. Graves, *Forty Years in China, or China in Transition*, Baltimore: R. H. Woodward, 1895, reprint, Wilmington, Del.: Scholarly Resources Inc., 1972, p. 28.

6 Cumming, 1888, pp. 91–2.

7 So called because the surface of the silver looked like fine silk, *xi si*.

8 One tael was equal to approximately 37.31 grams, or 1.3 ounces.

9 J. G. Kerr, 'The Native Benevolent Institutions of Canton', *The China Review* 2 (1873): 94.

5

Executions and Flower Boats:
By the Banks of the Pearl River

Migrants from other provinces of China were long attracted by the opportunities for work and prospects of wealth in Canton, just as they are today, and with natural population growth, by the early years of the nineteenth century the city had spread well beyond its walls. Between the southern wall of the New City and the banks of the Pearl River, a strip of land had formed from silted-up riverbed to become the Southern Suburbs. There, and along the banks of the inner canals that ran by the city walls, lived the city's poorest people, in mud hovels or in shanties on stilts put together from driftwood and old matting. Families of ten or more lived in utter squalor, while pigs, dogs, and chickens roamed freely through the filthy streets until destined for the cooking pot.

At the eastern end of the Southern Suburbs was the execution ground, a famous sightseeing attraction for the locals as well as for foreign visitors, many of whom wrote lengthy accounts of it in the nineteenth century. It was a short lane running from north to south, narrowing at the southern end (Fig. 5.1). On the eastern side was a high brick wall forming the back of some warehouses; to the west was a row of workshops where crude, unglazed pottery was made. Normally the lane was used for drying the pottery in the sun, but it was cleared out when an execution was scheduled. Ten to twenty criminals were executed at one time, averaging three hundred per annum, with many more in some years. Those who were sentenced to death were

FIG. 5.1 The potters yard where executions took place; c.1890.

informed of their fate only a short time before execution. To dull their senses, they were given a meal of fatty pork and a quantity of wine, then tied up and carried away in wicker baskets from the Governor's yamen to the execution ground.

Watched by a group of mandarins and a crowd of several hundred people, including many children, the criminals were arranged in rows. A strip of paper, inscribed with the offender's name, crime, and penalty, was fastened to the back of the neck with a stick. The event became a must-see on every visitor's itinerary, and William Mayers gave an eloquent description in the 1860s: 'An assistant runs rapidly along the line bringing each neck into the most effective position, and snatching away the ticket with which each man is marked. In less than a minute from the time when the procession first appeared on the scene the order to proceed with the execution is given from the magistrate's bench... and the dull, crashing blows of the headsman's sword are heard falling along the line.... In as many seconds as there are criminals to despatch, the inanimate bodies and gaping heads of the guilty wretches are bathed in pools of gore. Another quarter of an hour suffices to remove the bodies in rough coffins to the criminal burying ground outside the East Gate, the heads usually carried off in cages to be suspended at various localities where the crime for which each suffered was committed, and the potters are again at work before the ground has lost its purple stain.'[1]

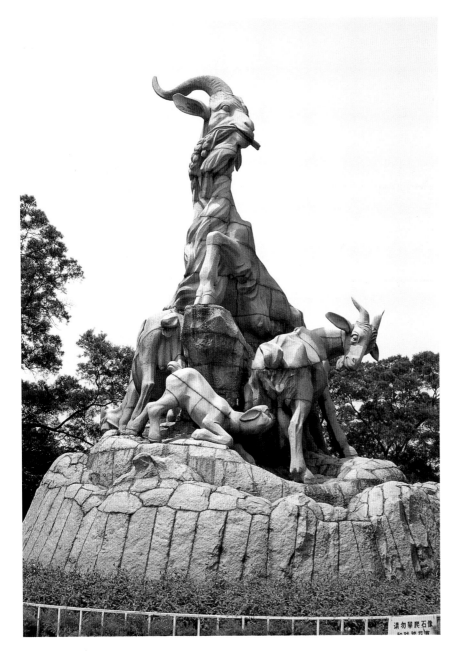

PLATE 1 The statue of the Five Rams in Yuexiu Park.

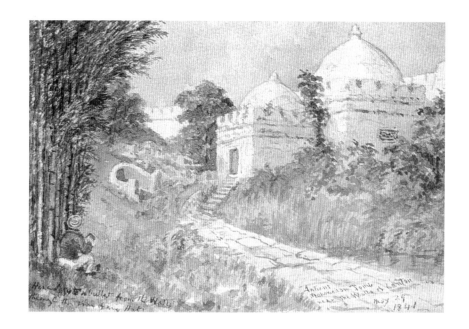

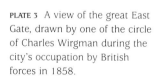

PLATE 2 Qingzhen Xianxian Gumu, the tomb of Abu Wangus, is a squat structure with a half-domed roof built in the seventh century in the Arabian style. This sketch of the tomb was made by Dr Edward Cree, RN Surgeon, on 29 September 1841; he is shown sketching in the foreground.

PLATE 3 A view of the great East Gate, drawn by one of the circle of Charles Wirgman during the city's occupation by British forces in 1858.

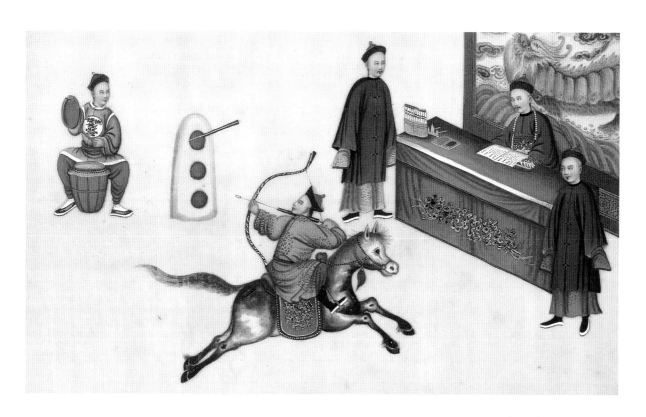

PLATE 4 The archery assessment
in the military examination;
painted on pith paper in Canton,
*c.*1850.

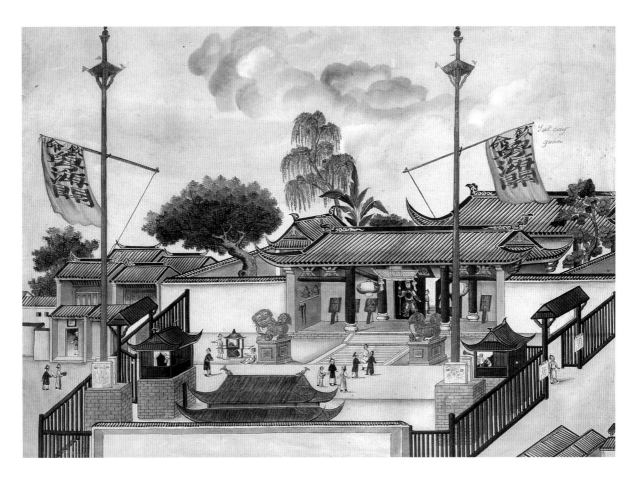

PLATE 5 The Chinese Customs House and Hoppo's head-quarters; body colour on paper, *c.*1850.

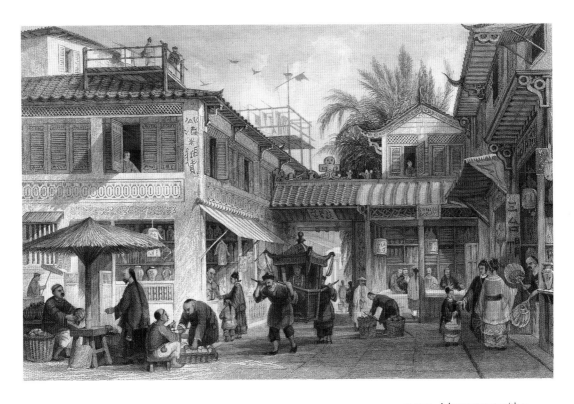

PLATE 6 A busy street with a large residence (on the left), on whose roof is a terrace for taking the air; *c.*1860.

PLATE 7 The Northern Suburbs and a temple in the Baiyun (White Cloud) Mountains; *c.*1858.

PLATE 8 A view of Canton from
the Eastern Suburbs; 1857.

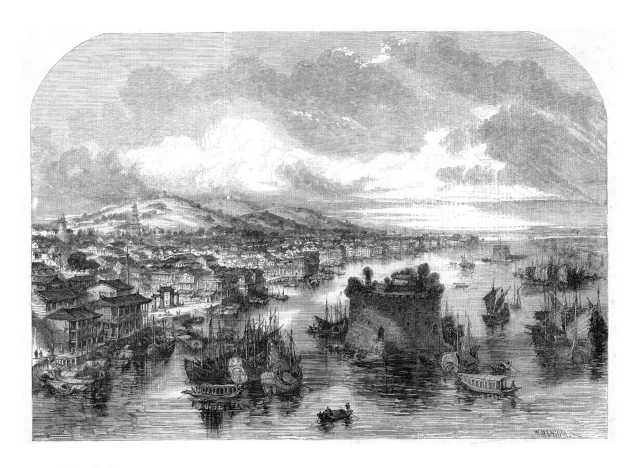

PLATE 9 A view, looking east, of the Pearl River with the Southern Suburbs and river forts; 1856.

PLATE 10 A duck boat anchored near Canton; painted by Thomas Daniell, 1785.

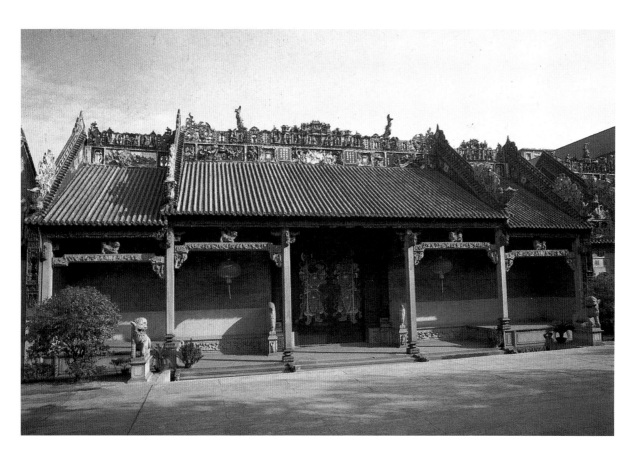

PLATE 11 The main entrance of
the Chan family temple in the
Western Suburbs; 1990s.

In front of the execution ground by the Pearl River was the jetty where the mandarins arrived on assuming office, or departed when their tour of duty was over. There were always large numbers of officials in the city waiting for appointments in the provinces, or at the end of their term of office waiting for an auspicious day to travel back home. Some would stay in rest-houses, others at guildhalls built as an early form of hotel accommodation for people from a particular district. These guildhalls were erected by subscription from the people themselves and had meeting halls and show-rooms, provided restaurants and theatrical entertainment, and were both chamber of commerce and gentleman's club. Signboards hung in the halls, proclaiming such practical homilies as 'A smiling salesman enhances his wares' or 'When there's a fire, a distant lake is not as good as a near bucketful'. The guildhalls would come to play an important role in China's civic development in the early twentieth century, by providing forums for political debate.

At the west end of the banks of the river was the guildhall for people from the Swatow region in eastern Guangdong province. Guildhalls were some of most beautiful buildings in the city, filled with intricately carved wooden panels, all lacquered and gilded, and the Swatow hall was no exception. Each guild had its own patron deity whose birthday was celebrated with due ceremony. Tin Hau, Queen of Heaven and the Goddess of the Sea, was the patron deity in this hall, for Swatow was by the coast. In the first court-yard of the guildhall stone pillars, encircled with dragons, supported a canopy at the entrance of the shrine of Tin Hau. The altar of the goddess, her image, and all the fixtures were elaborate and very richly carved. There were two more shrines in the upper hall, one to the god of literature, Man Cheung, and the other to Pak Tai, the Daoist god of the north. Fronting onto the river, on the east side of the large court, was an ancestral hall where the tablets of deceased members of the Swatow guild were placed.

The Pearl River ran like a main artery along the banks of the Southern Suburbs, bringing the lifeblood of the city (**Plate 9**). When Arab traders had first stepped ashore during the Tang dynasty, the river was very wide, its banks close to the Smooth Pagoda. Over the centuries it silted up and by the nineteenth century had narrowed to about 400 metres between the Southern Suburbs and the island of Honam opposite them. West of the walled city, facing the inner passage to Macau, were several forts on a sand-bank called Shamien.

Two small fortified islands guarded the main river approaches. One, to the west of the city walls, was called Hai Chu (Pearl Island), where the fort was manned by forty soldiers with twenty-six cannons. When the fort was destroyed during the Second China War, a little temple was built, dedicated to Li Maoying, a distinguished Song-dynasty official, and surrounded by a group of magnificent banyan trees. Foreigners had called the island the

Dutch Folly Fort (**Fig.** 5.2), from the time when a group of Dutchmen, intent on supplanting the Portuguese hold on trade, arrived in Canton in 1601. Chinese officials gave them their own island where they could build a warehouse, but once there, they attempted to bring cannon ashore, concealed in water tubs, to fortify the island. Their scheme was discovered when the tubs broke up, at which point the Chinese boycotted them, withholding food and water, until they left. Hai Chu was eventually reclaimed in 1931, becoming part of the mainland.

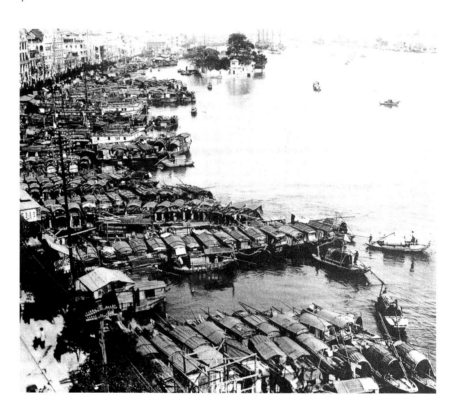

FIG. 5.2 Rows of junks and sampans near the Dutch Folly Fort at Hai Chu; early twentieth century.

The other island, to the east of the city, was known to foreigners as the French Folly Fort, although it is not clear why it had the name. Here was the Tong Pau Fort, guarded by thirty soldiers and twenty cannons. A French artist, Auguste Borget, who painted it in about 1839, described it as being 'oval and embattled with some buildings, and a square tower in the middle.' It was destroyed in April 1847 during a retaliatory offensive by the British forces, and not long after the island itself was incorporated into the mainland.

The Pearl River was home to almost a tenth of the total population of Canton. Wrote a visitor in the early eighteenth century: 'The River is crowded on both sides with a prodigious number of Barks in several Rows, which contain an infinite Quantity of People, and make a kind of floating City.

These Barks lying close together form Streets; each bark contains a whole Family, and like Houses is divided into different Apartments; the common People who inhabit them, go out betimes in the Morning, either to fish, or work at the Rice, which yields two Crops every Year. At the End of each Street there is a Barrier, which is shut every Evening soon after the Gates of the City; so that every Body is obliged to be at home by the time it grows dark. This Regulation prevents many Disorders in China, where the greatest Cities are as quiet in the Night-time as if they consisted of but single Families.'[2]

Swedish trader Anders Ljungstedt was resident in Canton in the early nineteenth century and noted: 'A very large majority of these [river boats] are tan-kea (egg-house) boats, these are generally not more than twelve or fifteen feet long, about six broad, and so low that a person can scarcely stand up in them: their covering, which is made of bamboo, is very light and can easily be adjusted to the state of the weather. Whole families live in these boats, and in coops lashed on the outside of them, they often rear large broods of ducks and chickens, designed to supply the markets' (**Plate 10**).[3] Six-week-old ducks were bought from hatching houses across the river, in the village of Fati, where large numbers were hatched out by artificial heat. Special duck boats, with a mat-roof converting the hull into a dwelling space, were fitted with wide trays projecting from each side. These moored in a little bay near another fort, called Bird Cage Fort, in the inner passage to Macau by Honam, where the birds were lodged and fattened until they were ready for the table.

The Tanka fisherfolk were sea gypsies who were born, married, and died afloat, seldom setting foot on land. Always despised by land people, since the fourteenth century they had been forbidden to marry land-dwellers, to take the civil service examinations, or to live ashore unless they could afford to purchase property.[4] Only after the Qing dynasty fell did they receive full civic rights. The men spent their days loading and unloading vessels and worked on shore, while the women rowed the sampans,[5] transferring folk from ship to shore. The women would be dressed in blue cotton jacket and black trousers, their sleek black hair, fastened into a bun, ornamented with bright hairpins, red wool, or artificial jade. As the women worked, bare feet manoeuvring the small boat, they often carried one infant on their back while, at the same time, nursing another. Each young child had a large gourd strapped to its back with the number and position of the sampan to which it belonged carved in Chinese characters on it. If the child fell overboard it could then be returned to the correct boat, so great was the confusion of crafts.

The river was the main means of transportation. It was invariably 'crowded with heavy trading junks, towering in unwieldy masses from the water, with swift glancing sampans conveying passengers or paddled about with vegetables, fruit, or bean-curd, the favourite food of the lower classes,

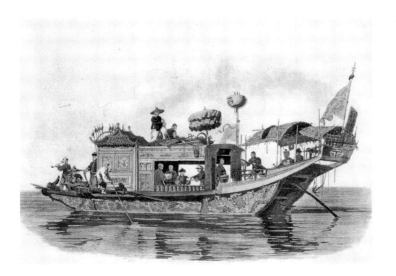

FIG. 5.3 A mandarin's boat with the official's flag and umbrella raised; drawn by William Alexander, *c.*1792.

for sale, whilst at the various landing-places [were] seen squadrons of mandarin boats [Fig. 5.3], gay with flags of every hue, and discharging quantities of powder in perpetual salutes.'[6]

'Trading junks from the North, Fukien [Fujian], or Singapore, lie in tiers in the lower part of the river, whilst higher up are anchored the large but swift sailing passage junks plying to Hong Kong and Macao, with their vast butterfly-wing sails and gaudy flags.... Ranged along the shore opposite Dutch Folly will be seen long, heavy boats, with sides of moveable boards arched over with mat roofs, which are employed for voyages into the interior by officials or merchants. Above these lie the vast house-like pleasure or "flower boats" [Fig. 5.4], the fronts of which are elaborately carved and often profusely gilded, whilst during the summer they are seen decked with garlands of flowers. These boats are hired for pleasure parties and banquets by wealthy Chinese, whose gaily lighted feasts, enjoyed in the society of damsels highly rouged and gaudily attired, with the unmelodious accompaniment of high falsetto wind instruments and the maddening din of tom-toms and gongs, are of nightly occurrence during the warm season.'[7]

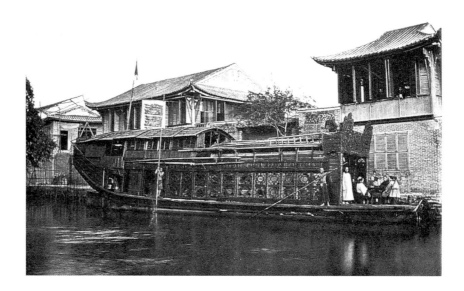

FIG. 5.4 A flower boat anchored in a creek on the Pearl River; *c.*1880s.

The flower boats, much frequented by prostitutes, were better known to the Chinese as 'houses of the four pleasures'.[8] Dr Yvan, in company with the French ambassador and an interpreter, was entertained in one in the 1850s by the mandarin P'an Shih-ch'eng. He describes how the boats were of two or three storeys with, usually, a 'basement divided into a multitude of small apartments, decorated with rather free pictures after the Chinese fashion, and each containing perhaps a table, a few chairs, and sometimes a bed. The upper storey serves as a cloak-room for the visitors of both sexes, and a store for the various articles consumed' (Fig. 5.5).[9] On the roof was a terrace set with tables and chairs, while others had a large public room as well. The boats were moored close enough together to form regular streets, and in front of each was a gravel path. They were frequented by the gilded youth of Canton who came in the evening to dine, gamble, smoke opium, and flirt with the singing girls (Fig. 5.6). Wealthy merchants and mandarins would hire a flower boat to take them and their party up or down river for an evening's entertainment. Two of P'an Shih-ch'eng's twelve concubines were young girls he had bought from a flower boat.[10]

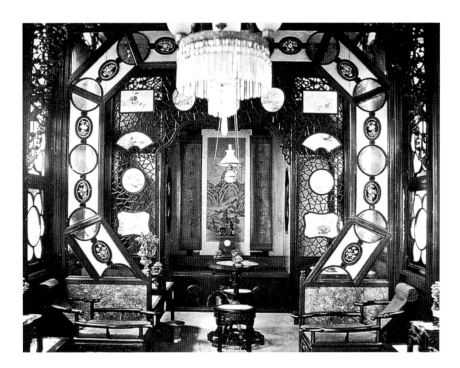

FIG. 5.5 The interior of a flower boat; *c*.1880s.

Also anchored near the Shamien forts were the 'Red Boats' of the Cantonese opera troupes, which visited the villages and hamlets on the waterways of the Pearl River delta. These boats were not painted red, but they had many flags and red decorations, and because red had been the

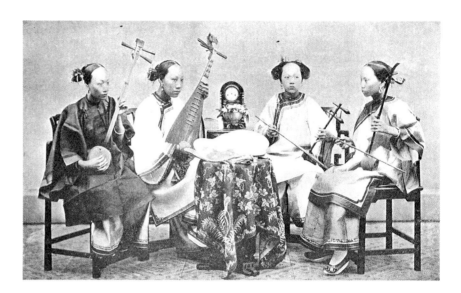

dynastic colour of the Ming and was considered to be an auspicious colour, it has been suggested that even the use of the word 'red' was lucky.[11] This form of provincial opera dated back to the reign of the Jiajing emperor in the Ming dynasty, gaining popularity during the late Qing, and reaching a peak in the early years of the twentieth century.

The opera troupe always travelled in pairs of boats, one named Heaven, the other Earth. The boats were self-sufficient communities with troupe members living year-round in the cramped cabins. A troupe comprised sixty-two actors, twelve musicians, and a doctor whose skills in massage and bone setting were necessary given the acrobatic feats attempted by the performers. There were cooks, laundrymen, and barbers and, together with the boatmen, a total of over 130 men on the two boats. Strict rules, superstition, and taboos governed the behaviour and performance of the troupe. Rehearsals were held on board, and a wooden stump, simulating an opponent, was placed in the middle of the boat so members could practice martial arts, an essential part of the opera performance. Each boat carried sixteen costume trunks containing glittering sequinned costumes of the styles worn in the Ming dynasty. Actors and musicians were considered to have very lowly status in China, and, like the Tanka, were forbidden from taking the imperial examinations. Yet they played the part of emperors and generals, ministers and mandarins, using correct gestures known to an audience both educated and illiterate, having special knowledge of the very culture from which they were excluded.

But all movement on the water came to a halt every year on the fifth day of the fifth lunar month, usually in June, when teams in dragon boats raced each other along the Pearl River (**Fig.** 5.7). A Chinese legend states that the origins of the festival date back to the third century BC, when a minister

and poet, Wat Yuen, tried to give wise counsel to his king. When his advice was rejected and he was dismissed, in despair he threw himself into the river. The people of his district in Hunan province rowed out in search of him, throwing rice into the water so the fish would spare his body, at the same time making a great commotion to keep the fish away. In nineteenth-century Canton, on the day of the festival, which is still a popular celebration in Chinese communities around the world, long narrow boats with the head and tail of a dragon raced against each other, propelled by up to a hundred men paddling in rhythm while a drummer beat time loudly. Thousands of excited spectators lined the river banks cheering on their favourites, waving flags and setting off millions of fire crackers, as the steady boom of the drums and the sound of gongs filled the air, a heavenly feast of noise and discord.

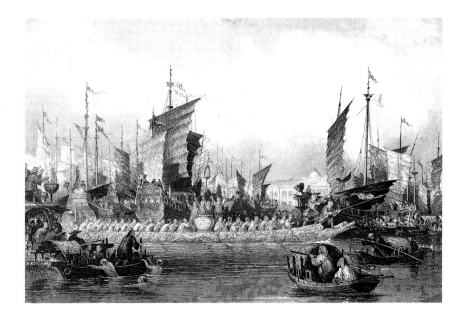

FIG. 5.7 Dragon boat races, with the Western factories in the background; drawn by Thomas Allom, c.1840.

ENDNOTES

1 Wm. Fred. Mayers, Dennys, N. B., & King, C., *The Treaty Ports of China and Japan: A Complete Guide to the Open Ports of those Countries, together with Peking, Yedo, Hongkong and Macao*, London: Trubner and Co, and Hong Kong: A. Shortrede & Co, 1867, pp. 175–6.

2 Jean-Baptiste Du Halde, *The Description of the Empire of China*, London: T. Gardner, 1738–41, Vol. 1, p. 115. Father Du Halde never actually visited China, but his book, which was the first to consolidate reports of China for the West, was based on Jesuit accounts from the early eighteenth century.

3 Anders Ljungstedt, *An Historical Sketch of the Portuguese Settlements in China; and of the Roman Catholic Church and Mission in China & Description of the City of Canton*, Boston: James Munroe and Co, 1836, reprint, Viking Hong Kong Publications, 1992, p. 229.

[4] However, some Tanka men managed to acquire learning and subsequently status: E. C. Bowra, Commissioner of Customs at Canton, reports meeting several high-ranking Tanka officials, one being the High Admiral of Guangdong province, Huang Ting-piao. E. C. Bowra, *A History of the Kwang-tung Province of the Chinese Empire*, Hong Kong: De Souza & Co, 1872, p. 54.

[5] Sampans were small boats constructed, literally, of three boards, *sam*, three, + *pan*, board.

[6] Mayers et al., 1867, p. 129.

[7] Mayers et al., 1867, pp. 144–5.

[8] Yvan, Dr Melchior, *Inside Canton*, London: Henry Vizetelly, 1858, p. 142.

[9] Yvan, 1858, pp. 142–3.

[10] Yvan, 1858, p. 178.

[11] Barbara Ward, 'The Red Boats of the Canton Delta', Proceedings of the International Conference on Sinology, Taipei, *Academica Sinica* 6 (1981): 249. This traditional entertainment ended with the Japanese war and the last pair of Red Boats were seen at Macau in 1951.

6

Spiritual Blessings:
Faith, Prayer, and Piety

Although the mandarins were responsible for the people's welfare, it was to the numerous deities that the Chinese looked for their equally important spiritual well-being. Temples, or joss-houses,[1] were abundant throughout Canton, each dedicated to a particular god, who was expected to bestow blessings and favours on the people. An account published in 1840 revealed as many as 124 temples, in both the city and its suburbs, devoted to the main beliefs of Daoism and Buddhism.[2] Such was the perceived power of the idols that almost every lane and alleyway had an altar dedicated to the earth god, each shop had its kitchen god, and there were thousands of small neighbourhood shrines as well. Just as worshippers do today, the idols were given daily offerings of wine, pieces of pork, poultry, and oranges, and sticks of incense, called joss-sticks, were burned. In return, the gods were asked for certain favours.

Mothers, especially, prayed to Man Cheung, the Daoist god of literature, for their sons to do well in examinations. An important request like this was written and placed in a red packet tied to a large spiral coil of saffron-yellow incense hung up like a cone inside the temple. As the incense burned and wisps of smoke rose up into the darkened rafters of the temple roof, the wish was carried to the gods, who, it was hoped, would then give a favourable response.

On several occasions throughout the year, especially on their birthday, the gods would be honoured with sumptuous festivities. As a foreign visitor

noted in the 1830s: '[P]rocessions are fitted out at the different temples; and the images are borne in state, through all the principal streets of the city, attended by bands of musicians; by priests; lads on horseback; lasses riding in open sedans; old men and boys bearing lanterns, incense-pots, flags and other insignia; ...the different streets and trades, have their religious festivals, which they celebrate with illuminations, bonfires, songs and theatrical exhibitions. A great deal of extravagance is displayed on these occasions — each street and company striving to excel all their neighbors.'[5]

To those brought up believing in one faith or deity, Chinese religion can be complex and confusing. Daoism is among the oldest Chinese religions and began as a philosophy sometime around the fifth century BC. The Daoists seek to achieve harmony with the Dao, or 'Way', and strive for patience, simplicity, and contentment. Buddhism was founded in the sixth century BC in India and later spread to China and other parts of Asia along the trade routes known collectively as the Silk Road, arriving in Canton in the third century AD. Most Chinese people acquired some measure of Buddhist faith, but at the same time they believed in Daoism, animism, and other religious elements. In fact, many devotees prayed to every deity, despite his or her 'denomination', because each one granted a different favour. The more deities worshipped, the more favours granted.

Unique to Canton was the Temple of the Five Genii (Ng Sing Kwun) (Fig. 6.1), dedicated to the group of supernatural visitors whose legendary

FIG. 6.1 The entrance to the Temple of the Five Genii, with its ornamental gateway; photograph by Felice Beato, 1860. Collection of Jane and Michael G. Wilson, Courtesy of Santa Barbara Museum of Art.

appearance, riding through the air on rams, gave it the name 'City of Rams'. The temple was built in 1374, situated north of, and running parallel to, the wall dividing the Old and New cities, on what is now Huifu West Road. The temple was well kept, being supported by donations from Tartar military officials. In the nineteenth century, a flight of steps led up to the temple, at the top of which was an ornamental gateway built in 1842 from funds contributed by Keying, the Imperial Commissioner for Foreign Affairs. In the first pavilion of the temple was the chief idol, Shang-ti, Supreme God of War, of the Daoist pantheon. On the right side were three halls containing the five idols: 'the spirits of the five principal planets, Mercury, Venus, Mars, Jupiter and Saturn, the patrons of water, metal, fire, wood and earth, who rule respectively over the year and its four seasons, and influence respectively the five parts of man, the kidneys, lungs, heart, liver and stomach, and are the sources of the five tastes, salt, pungent, bitter, sour and sweet.'[4] The spirits were truly omnipotent!

The temple was destroyed in a fire in 1864 but later restored, and it can be visited today, reached up an alleyway off Huifu West Road. The gateway is altered but a pair of stone *qilin* and two scholar stones stand at the foot of the steps as reminders of an earlier time. The idols are gone, and it is no longer used as a temple; instead, the main hall is an exhibition gallery and contains a statue of the Five Celestial Beings riding on the five rams. In the garden around the temple are pairs of stone animals and a Song-dynasty stele. Behind is the bell-tower, whose bell would play an important part during the Second China War. To the rear of the bell tower was a shrine of the Five Genii, in front of which were five blocks of granite roughly shaped like rams' heads.

Since so much of Canton's wealth and prosperity came from the sea, a Daoist deity very important to Canton's people has been Tin Hau, the patron saint of all who travel or work on the sea and a popular goddess today in the coastal provinces of Fujian and Guangdong. As well as the shrine to Tin Hau in the Swatow guildhall, there was a temple dedicated to her near the Viceroy's yamen in the New City. Those, like the Hoppo, whose livelihood depended on the sea, worshipped at this temple on the first and fifteenth days of each month as well as on the goddess's birthday, on the twenty-third day of the third moon (falling in either April or May); this is still a special day for worship.

Tin Hau is said to be a fisherman's daughter who lived in Fujian in the tenth century; when she was born a red light appeared over the house. One night she dreamed her father and two brothers were on two fishing junks in the middle of a storm. She began pulling on ropes to bring them to shore but at that moment her mother shook her awake, and she dropped one set of ropes. Her brothers returned home and said a beautiful girl saved them, but their father was lost. She died, unmarried, at 28, but many have reported

seeing a red light in times of danger at sea, when they have then been saved from certain death.

Every walled city in China had a temple for worshipping the City God, the Daoist deity Shing Wong (Ch'eng-huang, *ch'eng* being a wall, and *huang*, the ditch around it whose earth is used to form the wall), guardian deity of walled cities. Earth gods are subordinates of the City God, and their function is to oversee and protect all the people who live within their territory. Gods with a large population to protect are superior to those watching over just a few dwellings, thus the City God was the most senior. Newly appointed officials arriving in Canton always made a point of presenting offerings to the Shing Wong.

The city temple for the Pan-yu district was in the Chinese section of the Old City, situated just past the middle of the Street of Benevolence and Love, today a little way back from the main road where Zhongshan 5 Road becomes Zhongshan 4 Road. The temple was a busy, noisy place with many worshippers paying their devotions and consulting the gods. In the square in front were fortune tellers, peddlers, gamblers, and quack doctors, with even greater crowds at Lunar New Year. 'This seems to be the favourite resort of the dentists also,' wrote Francis and Harriet Clark in 1895, 'for I saw several of their ilk with long strings of extracted molars and grinders at least thirty feet in length, which looked like ghastly necklaces' (Fig. 6.2).[5]

FIG. 6.2 Street-side dentists at work; *c.*1900.

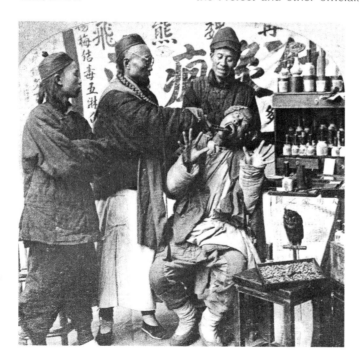

Several times a year state worship was performed at the city temple by the Prefect and other officials; these rituals involved burning incense and offering grain, wine, and meat, with music and much kow-towing. It was also known to the foreigners as the Temple of Horrors, the name derived from the recesses at the sides of the main court containing representations of the Buddhist hells, which served as a warning to those who misbehaved. Each of the ten punishments was graphically portrayed with life-size figures; one showed a victim being sawn in half between two boards, another having his head crushed in a stone mill.

By the 1930s the tableaux had been destroyed and the hall used as an exhibition hall for locally made products, but still with fortune tellers in abundance. Two upper floors were formed by this time in this lofty building, with the large floor area divided into many rooms. The temple building, with towering timber pillars and a steep green-

tiled roof, survives to this day. For a short time in the 1990s the temple was turned into a karaoke bar, but now it is under the protection of the city's Conservation and Antiquities Bureau.

The temple of Kwan Ti, patron deity of the military and god of martial arts, and the temple of the Daoist god of literature, Man Cheung, built in 1685, were also situated in the Old City on what is now Wenming Road (Fig. 6.3). Civil and military mandarins performed state worship at the temples on festival days in spring and autumn, Lunar New Year's Day, and on the gods' birthdays, for Kwan Ti, the thirteenth day of the fifth month, and for Man Cheung, the third day of the second month. Kwan Ti was also the patron deity of the Qing imperial house, and the Emperor's personal divinity. Popular idols still, Man Cheung is usually depicted holding a brush and a *ruyi* or sceptre, a symbol for 'may all your wishes come true'. Kwan Ti has a red face and holds a sword; he is responsible for the upkeep of honesty and fidelity; as such he is worshipped in police stations and offices of the other disciplinary services in Hong Kong today.

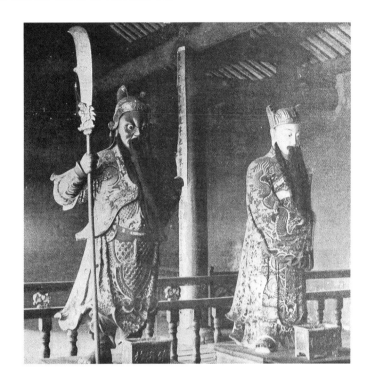

FIG. 6.3 Carved and painted wooden images of the gods of literature and martial arts; *c.*1900.

Out in the Western Suburbs was the temple dedicated to the Daoist god of the north, Pak Tai. He was regarded as the most beneficent of the deities and anyone about to embark on trade sought his blessing. Masters and servants ratified their engagements there, and affirmed oaths and obligations. Such was the authority of the deity that if a man were accused of theft and declared his innocence in front of the idol, the accuser would often acquit him. This was a wealthy neighbourhood, and, wrote Dr Kerr in his Canton guide, 'immense crowds attend the celebration of the idol's birthday on the third [day] of the third month, on which occasion a large and imposing procession parades the principal streets of this part of the City. The large open square in front of the temple is a favorite place for theatrical performances, and on these occasions is filled to its utmost capacity. In the temple is a pool in which several large turtles are kept.'[6] Turtles, and tortoises, were ancient Chinese symbols of the north and symbolized longevity and steadfastness.

Many Chinese gods cannot be classified as purely Daoist, Buddhist, or otherwise. The very popular Kwun Yam, Goddess of Mercy, is found in both Buddhist and Daoist temples. Kwun Yam was, according to the Chinese

version of her life, an Indian Buddhist nun who attained enlightenment and became a Bodhisattva, a saint who declined Nirvana and remained in contact with the world in order to save others. Through compassion and self-sacrifice, she gives hope of enlightenment to ordinary people. A temple dedicated to Kwun Yam, founded in 1403, was in the north of the Old City just below the Five-Storey Pagoda. A large stone elephant stood in front of the temple, while in the chief pavilion was a gilded image of the goddess sitting on a lotus flower. The mandarins worshipped there on her birthday, the nineteenth day of the second moon, the day of her enlightenment, on the nineteenth of the sixth moon, and the day of her death, the nineteenth of the ninth moon. Nearby was the Daoist monastery, the Sam Yuen Kung, founded in the fourth century AD. Still used by worshippers and reached off Yingyuan Road, there is a separate shrine to Kwun Yam inside the temple on the left.

One of the oldest temples in China is the Kwong Hau Buddhist temple (Fig. 6.4), at the top of a street running north from the western end of the Street of Benevolence and Love. The site was originally the palace of King Zhao Jiande, whose recently excavated garden extends east along the main thoroughfare. It then became the home of Yu Fan, a Confucian scholar; on his death in AD233, his widow gave the land to some Buddhist priests. A monastery was founded in the year 397, during the Eastern Jin period, and became an important place for the exchange of religious and cultural teachings between China and India. From that period onward many monks came

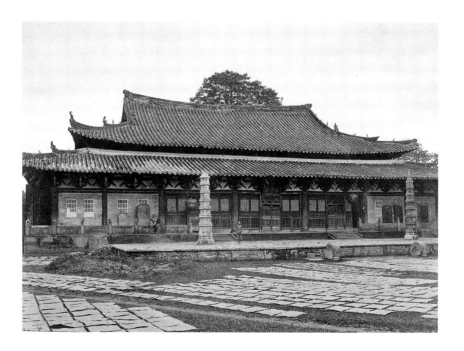

FIG. 6.4 The Kwong Hau Buddhist temple; c.1860.

to Canton to preach and translate sutras, including the monk Dharmayasa, who arrived from Kashmir and stayed at the temple. The literary civil service examinations were held here on ten occasions when the examination hall, at that time on Yu Hill near the Five-Storey Pagoda, was destroyed after the capture of Canton by the Manchus.

The site of the Kwong Hau Temple, which was in the north-west corner of the Tartar Quarter, made it the natural choice for the Tartar city temple, and for that of the Nan-hai district, in whose area it stood. It was one of the largest and richest temples in Canton, with about 200 inmates, and was the most imposing Buddhist temple in Guangdong province. The temple was repaired many times over the years: it was rebuilt in 1629 after a fire, then again in 1832, and is in constant use today. Guangxiao Road, running north from Zhongshan 6 Road, is a quiet street leading to the temple. It is lined with shops selling incense sticks and paper offerings, while vendors sitting by the entrance offer for sale lotus buds, symbols of good overcoming evil.

On the platform in front of the temple is a pair of small granite pagodas. Inside the temple three colossal gilded effigies of the Buddha, each some 6 metres tall, are placed in a richly decorated hall. In the grounds to the left of the temple is the well once used by monks for cleansing their alms bowls, and an ancient bodhi tree, the sacred and holy fig tree of India. Nearby is an iron stupa carved with sutra texts. Cast in 967 and originally the largest and oldest iron pagoda in China, now only its lowest three layers remain. There is also an altar to Lu Wai Lung (AD637–713), the Sixth Patriarch, who came from Xinxing county in Guangdong province. He became a novice here in 676 and inaugurated the Southern Sect of Zen (Ch'an) Buddhism. The seven-storey, red-brick octagonal Yi Fa pagoda dates back to that date, built by monks to commemorate the occasion.

Nearby, also in the north-west corner of the Old City, was the Buddhist Luk Yung Temple (Temple of the Six Banyans), established in AD537, according to Chinese legend, by a Chinese monk, Tang Yu. The temple burned down and was rebuilt in 989, during the Northern Song period, and has been repaired many times since. The name of the temple relates to a visit in about 1100 by the celebrated scholar-official, poet, and calligrapher Su Dongpo, who was moved to record the presence of six banyan trees in the courtyard. The two large Chinese characters, *liu rong*, meaning 'six banyans', are reproduced on a stone tablet near the entrance to the temple, reached off Liurong Road. Su Dongpo is also remembered for his wise advice that bamboo aqueducts be laid to bring drinking water from a spring in the Baiyun Mountains into the city to replace the brackish well-water then being consumed. The spring water was still being brought in from the hills in the nineteenth century, by this time in buckets by coolies, to be used for tea by wealthy Chinese and foreigners. Even today, the spring provides the most sought-after drinking water supply, with people queuing to bring buckets back to the city.

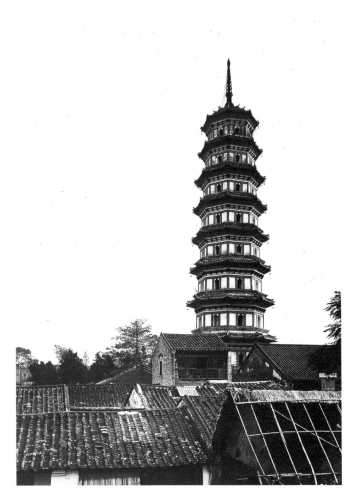

The Liurong Temple was desecrated in the Cultural Revolution and the statues destroyed, but these were replaced by fibreglass ones when the temple reopened in 1988. It is now the centre of the Canton Buddhist Association, with fourteen monks in residence. In the three halls of the temple, as viewed from left to right, are a tall brass statue of Kwun Yam, three brass images weighing 5 tonnes each of Amitabha, Sakyamuni, and Maitreya (Buddha in his different forms), and a copper statue of the Sakyamuni Buddha presented by Thai Buddhists. There is also a bronze statue of the Sixth Patriarch cast in the Northern Song period. In the grounds adjoining the temple, the octagonal Fa Tap (Fig. 6.5), literally, 'Flowery Pagoda', so-called for its highly ornamented appearance in contrast with Kwang Tap, the Smooth Pagoda, was a landmark in the city. It was visible for many miles around — and from the window at the Dongfang Hotel in 1975 — until hidden in more recent days by high-rise office blocks. Viewed from the Pearl River, in years past Canton was said to look like a huge junk: the two pagodas, Flowery and Smooth, resembling the masts, and the Five-Storey Pagoda, the sails.

The Flowery Pagoda is 58 metres high, its nine exterior storeys each representing a Buddhist heaven. The seventeen interior stories can be ascended by steps. At the top of the building is a bronze column, added in 1358, on which are more than one thousand small Buddhas carved in relief. Pagodas always had an odd number of storeys, whether three, five, seven, or more. The word *pagoda* itself comes from the Portuguese pronunciation of the Indian word *dagoba*, meaning 'a holy building', used to refer to structures that were built to contain the bones of buddhas.[7] In more recent times, they have had no direct religious significance, but in China they were thought to have good geomantic influence, or *feng shui*, over the surrounding countryside, resulting in fertile fields and abundant rivers. The proximity of a pagoda was felt to ensure good fortune, especially for those men taking part in the literary examinations.

The Wah Lam Temple, also known as the Temple of the Five Hundred Genii (Fig. 6.6), in the Western Suburbs, was originally situated near a tributary

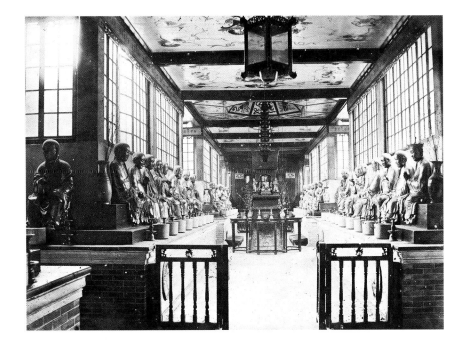

FIG. 6.6 The Temple of the Five Hundred Genii; *c.*1890.

of the river and is now reached up a narrow alleyway off busy Xiajiu Road. The temple was first established by the Indian monk Bodhidharma, who arrived in Canton by sea in AD520 and founded the Ch'an school of Buddhism. This sect's teachings later became the mainstream Buddhist faith in southern China. The spot where he landed is marked by a stone memorial tablet bearing the characters *xilai chudi*, meaning 'the first touching of land on journeying from the west'. The tablet has stood at the junction of Shangjiu Road and Yuqi Street for fifteen centuries, although it is easy to overlook.

Over the centuries, the Temple of the Five Hundred Genii, known for the large number of idols arrayed inside it, was one of the wealthiest in Canton, and much money was spent by the rich on its most important ceremonies. Its Chinese name, Wah Lam, means Flowery Forest, as the grounds were planted with flowering trees, and it was by this name that the foreigners knew it. This was one of the few places Westerners ventured while their movements were restricted, because of its location outside the city walls. Nevertheless, Sir John Bowring, later Governor of Hong Kong, was pelted with stones when he paid a visit in the early 1850s.

In the first pavilion were the statues of three Buddhas; in the second, a seven-storey marble pagoda presented to the temple by the Qianlong emperor. Behind the pagoda, on the north side of a quadrangle, was the Hall of the Five Hundred Genii, the disciples of Buddha. The hall was arranged in aisles, on each side of which were rows of richly gilded images, each about 1 metre

FIG. 6.7 Abbott at the Temple of Five Hundred Genii; photograph by John Thomson, 1873.

high, sitting on elevated platforms and representing the worthies of the Buddhist faith. One effigy had Western features, and was said variously to be that of Marco Polo or a devout Portuguese seaman. Reverend John Gray, however, a long-time resident of Canton with extensive knowledge of local matters, believed it was 'a native of one of the northern provinces of India',[8] whose long and virtuous life gained him a place in the temple. At the north end of the middle aisle was an image of the Qianlong emperor. To the west of the pavilions was a dining room and guest room, and on both sides were rooms for more than sixty priests (**Fig. 6.7**). The temple was vandalized by the Red Guards during the Cultural Revolution but restored and reopened in 1988, and it is well patronized today.

Ancestor worship is for many Chinese an important and deep-seated belief associated with Confucianism. The philosopher Confucius (551–479BC) developed a system of ethics and politics based on the Five Virtues: charity, justice, propriety, wisdom, and loyalty. His teachings greatly influenced the lives of the Chinese, fostering strong family ties, respect for the elderly, and reverence toward ancestors. Confucius is honoured as a wise teacher but not worshipped as a personal god. Temples built to Confucius are not places where people have gathered to worship, but rather public buildings designed for annual ceremonies, especially on the philosopher's birthday, the twenty-seventh day of the eighth lunar month.

There were three temples in Canton dedicated to the sage. The main one, the Temple of Confucius for the Canton department, the prefectural temple, adjoined the temple dedicated to Man Cheung in the Old City. On the spring and autumn remembrance days the Viceroy, Prefect, and other mandarins performed state worship of the tablets representing Confucius and his disciples. The Confucian temple of Nan-hai district (**Fig. 6.8**) was to the south-east of the Smooth Pagoda, close to the Nan-hai magistrate's yamen, off what is now Mishi Road. This maze of buildings was more a school than a temple, used for study and examinations. After passing through a large red triple gateway, a visitor encountered a quadrangle paved in granite that was divided by an avenue of banyan trees, at the head of which was a large plain temple containing an image of Confucius. Behind this, in a two-storey building, were rooms for students preparing for the entry-level district examinations. The other temple to Confucius, for the Pan-yu district, was built in 1370 and was situated next to the Pan-yu magistrate's yamen on the Street of Benevolence and Love. Much

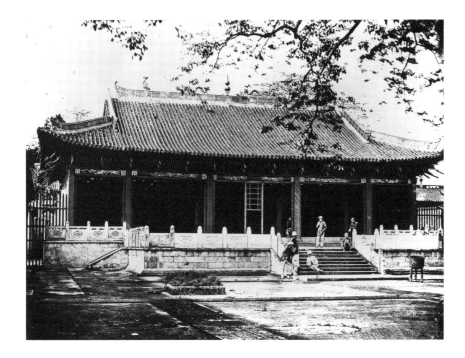

FIG. 6.8 The Confucian temple for the Nan-hai district; photograph by Felice Beato, 1860. Collection of Jane and Michael G. Wilson, Courtesy of Santa Barbara Museum of Art.

later, this site would play an important role in the founding of the Chinese Communist Party.

One of the most splendid buildings in the Western Suburbs was the Chan Family Temple (Plate 11). Situated directly in line with the West Gate, and approached today from Zhongshan 7 Road, this magnificent ancestral hall was built for all members of the Chan clan in the seventy-two counties of Guangdong province. Construction of the ancestral hall began in 1888 and was completed in six years at a cost of over 100,000 taels of silver. The main structure had a total floor area of 6,400 square metres, with the traditional layout of five halls wide and three halls deep. The wooden ancestral tablets of the élite and praiseworthy members of the clan were arranged in the halls. Worshipping the tablets is a way of continuing the relationship with one's ancestors, and of acknowledging the good fortune they have brought to the clan. In the Chinese belief system, on death, the soul divides itself between the ancestral tablet and the grave. As a result, worshipping at the grave or in the ancestral hall amounts to the same thing, and very often the latter is more convenient.

This beautiful building is a showplace today and receives many visitors. The halls are separated by elaborate screen walls of carved wood, interspersed by spacious courtyards. The front facade is enriched with a roof ridge of Shek Wan pottery showing an urban scene with figures in Ming dress, while pastoral scenes are depicted at the extreme left and right. The decoration on granite and wood throughout the building is of superb crafts-

FIG. 6.9 Children of the Chan clan standing by the entrance to their ancestral hall; c.1909.

manship, the themes covering Chinese classic tales, auspicious birds and animals, as well as mythological figures from folklore.

Like many ancestral halls of the period, it was also used as a place where boys from the Chan clan could study for the imperial examinations, hence its other name of Chan's Academy of Classical Learning. When the examinations were abolished in 1905, it became a school where both boys and girls in the clan could study (Fig. 6.9). In 1959 it became the folk crafts centre for Guangdong province, and in 1988 a cultural relic and historical monument protected by the state. Thus, in the end, the authority of latter-day mandarins and present-day bureaucrats has proved to be no match for the power of the spirits, whose temples survive for centuries as testament to the force of the eternal over the temporal.

ENDNOTES

1 Joss-house, from the Portuguese word *deos*, meaning 'god'.
2 Howard Malcom, *Travels in Hindustan and China*, Edinburgh: Chambers, 1840, p. 48.
3 Taken from 'A Description of the City of Canton', originally published in *The Chinese Repository*, 1834; Anders Ljungstedt, *An Historical Sketch of the Portuguese Settlements in China; and of the Roman Catholic Church and Mission in China & Description of the City of Canton*, Boston: James Munroe and Co, 1836, reprint, Viking Hong Kong Publications, 1992, p. 214.
4 Prince Albert Victor and Prince George of Wales, *The Cruise of Her Majesty's Ship 'Bacchante', 1879–1882*, London: Macmillan & Co., 1886, p. 225.
5 Rev. Francis E. Clark and Mrs. Harriet E. Clark, *Our Journey Around the World, an Illustrated Record of a Year's Travel*, Hartford, Conn.: A. D. Worthington, 1895, p. 174.
6 Dr J. G. Kerr, *The Canton Guide*, 4th edition, Hong Kong: Kelly & Walsh, Ltd, and Canton: A. S. Watson & Co, Ltd, 1889, p. 5.
7 It may also be a corruption of the common term used by Chinese, *po-ku-t'a*, meaning 'white bones tower'. William Geil, *Eighteen Capitals of China*, London: Constable, 1911, p. 97.
8 The Venerable John Henry Gray, *Walks in the City of Canton*, Hong Kong: De Souza & Co, 1875, pp. 207–8.

East Meets West

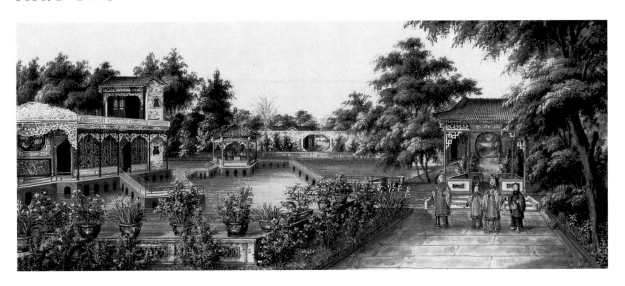

7
Fankwaes and Celestials:
The Thirteen Factories

Because of its huge size, immense population, and wealth of natural resources, China has long been viewed by outsiders as a valuable source of trade, with Canton the door through which great riches could be attained. The Arabs successfully established a base during the Tang dynasty, but by the Ming their business had declined, and for those that followed, gaining a foothold was not only more difficult but could also be dangerous. In 1517 the first Portuguese ship arrived at Canton, captained by Fernao Peres de Andrade. On board was Tomes Pires, chosen by the governor of Goa to be the first Portuguese ambassador to the Chinese emperor. The following year de Andrade's brother Simon arrived, but he clashed with the Chinese authorities who then blockaded his ship. The diplomatic mission ended in failure, with the two brothers escaping, but poor Pires was thrown into prison, where he died some years later.

The ban on overseas trade imposed by the Xuande emperor led to large-scale smuggling, and pirate ships proliferated, especially between China and Japan. In 1557, as a reward for suppressing the pirates, the Portuguese were granted an outpost in Macau at the mouth of the Pearl River. They were to govern the tiny territory for over four centuries, finally handing it back to China in 1999. Several other nations, envious of the Portuguese position, tried to follow suit. Their first rivals were the Dutch who, as previously noted, arrived in 1601 and attempted to fortify an island in the Pearl River before

being thrown out. The Chinese called the Dutch the 'red-haired barbarians' (*hung mo kwai*) and the name stuck to those who followed from other Protestant countries.

At the end of the sixteenth century, the English East India Company, known variously as the Company, the Honourable Company, or John Company, after the nickname for an Englishman, John Bull, had been granted a monopoly over trade with the East Indies by the British government. Eager to follow the success of the Portuguese, however, the Courteen Association, a rival concern supported by King Charles I, arrived at Taipa, off Macau, on 28 May 1637. The Courteen squadron of six ships was led by Captain John Weddell, with Peter Mundy on board as purser. After some delay Weddell sailed to the Bogue[1] forts at the mouth of the Pearl River. When his request for trade went unanswered, he raised anchor, and despite being fired on from the forts, he returned the attack and sailed on to Canton. Here he off-loaded his cargo of silver and took on sugar, ginger, silks, and chinaware. This time the hostile reception from the Chinese was blamed on the Portuguese, wishing to protect their monopoly: every nation at the time believed that by allowing others in to trade, their share would be that much smaller.

The Courteen Association was absorbed into the East India Company in 1649, and the Company finally established a base at Xiamen, on the coast of Fujian province, in 1676. The Kangxi emperor wanted trade with the West for the revenue it brought, so in 1685 he opened four ports, including Canton, to foreign trade and lifted the ban on Chinese vessels trading overseas.[2] The English East India Company then secured the right to a base in Canton, seen as more stable than Xiamen, and by 1715 they had established permanent headquarters on a strip of land by the river, outside the city walls. A select committee of 'supercargoes',[3] called *taipan* (headman) by the Chinese, controlled all the British trade. In time the ships of John Company would be considered the finest and largest of all the fleets: they had the greatest number of employees and were always given the first choice of the market for their goods. Until their monopoly was abolished in 1834, the English East India Company was the most powerful trading body in Canton.

Although the Company's monopoly excluded other British traders from dealing with China, they could not prevent the involvement of merchants from other European nations. These soon followed, bringing cargoes of silver, lead, glass, pistols, swords, woollen cloth, watches, and wines to Canton. The Dutch made another attempt to gain a foothold in China when an embassy was dispatched to Beijing in 1655, calling briefly at Canton with Jan Nieuhof, a draughtsman, on board. But the Dutch East India Company had established headquarters in Batavia in Java (now Jakarta, Indonesia) and their trade at Canton was slow until the nineteenth century. The French East India Company established a factory at Canton in 1728, but trade was always very light, and non-existent during the time of the French Revolution.

The Danes arrived in the early eighteenth century and were more active: between 1732 to 1744, thirty-two ships were dispatched.

The Swedish East India Company began to trade 'with lands east of the Cape of Good Hope' in 1731 and over the next seventy-five years sent one or two ships each year to Canton. In 1750, Per Osbeck, a chaplain on board the *Prince Charles* of the Swedish East India Company, reported seeing two Swedish, one Danish, two French, four Dutch, and nine English vessels alongside his ship anchored at Whampoa, the port for Canton. Osbeck's ship stayed just over four months, then in January 1751 sailed for Sweden carrying tea, a large quantity of silk, Nankin cotton, porcelain, and curios made of mother-of-pearl.

The Americans began trading at Canton in 1784, when the *Empress of China* sailed from New York with Samuel Shaw, who was later to serve as the first United States consul in Canton, as its senior supercargo. In the years that followed, American ships, such as the *Grand Turk* from Salem, near Boston, carried cargoes of cotton, quicksilver, lead, ginseng, silver, and sealskins, returning with tea, lacquerware, and porcelain. Furs, including the sea otter pelts used for the brim of a mandarin's winter hat, were obtained from the west coast of Canada and traded in Canton, first by the British, later by the Americans, of whom some, like John Jacob Astor, amassed great fortunes. By 1810, America had become the second most important trading nation in Canton after the British.

Remote in the Forbidden City, the Emperor avoided direct contact with the foreigners and relied on the mandarins to report on the state of business as it gradually developed in the four open ports. Messengers, riding relays of fast horses, took just a month to carry their missives from Canton to Beijing, more than 1,800 km away.[4] There the Emperor would consult with the Grand Council, then his orders would be returned to Canton. Everything depended on the accuracy, or otherwise, of the mandarins' reports, and misunderstandings were common.

In 1702 an 'emperor's merchant' was appointed to be the sole broker through whom foreigners must buy their teas and silks. Both foreigners and the other merchants at Canton objected to this monopoly, so two years later more merchants were included. In 1720, to regulate the prices of their goods, the Canton merchants formed a guild, or Co-hong, through which all foreign trade must be channelled. The role of the hong merchants was to maintain trade with the foreigners and to be intermediaries between them and the mandarins. This gap between mandarin and merchant was wide. Society in China had been divided into four distinct classes since the Qin dynasty. The most respected was the Scholar-Gentry Official: the mandarins who combined the political power of holding public office with, in many cases, the economic power of land ownership in his home district. Next was the Farmer: the peasantry who fed the rest of the population. Then came the Artisan:

skilled workers who did useful work. Last was the Merchant: wholesalers, shippers, and shopkeepers who merely traded goods supplied by others.

Despite much wrangling between the Hoppo and foreigners, and threats by the supercargoes to move their ships to Xiamen, trade continued at Canton, and by the middle of the eighteenth century the volume of overseas trade had doubled. But in 1754 the supercargoes, angered by what they felt were exorbitant demands, informed the Viceroy that they would cease trading at Canton. In December 1757 the foreign merchants were ordered to return to Canton from the other ports. Then on 7 November 1759 an imperial edict was issued by the Qianlong emperor restricting all foreign trade to Canton only, as far from the capital as possible.[5]

Demands by the East India Company for direct access to the Hoppo and a reduction of taxes were met with the formal chartering of the Co-hong by the Qianlong emperor. Five regulations were issued in January 1760 in a proclamation to control both traders and hong merchants. These regulations required that the traders must not spend the winter in the provincial capital (Canton), and during the trading season, they must reside in the hong merchants' factories and be under their control and supervision. The hong merchants must not accept loans from the foreign barbarians; moreover, foreigners were forbidden from hiring Chinese servants, and they could not hire Chinese to carry news to traders away from Canton. Finally, a bigger garrison was needed where the foreign ships anchored to prevent unfortunate incidents caused by men of a 'cruel and violent character'.[6]

In 1782, the Emperor gave licenses to twelve (later, thirteen) merchants, who continued to be known as the Co-hong, to control foreign trade. This official recognition allowed them to deal with foreigners on condition that they were responsible for the latter's good behaviour while on Chinese soil, and guaranteed their payment of customs and other dues. This 'Canton system' continued unchanged for the next sixty years.

During the late eighteenth and early nineteenth centuries, the heads of two wealthy merchant houses, Howqua and Punqua,[7] alternately took the post of chief of the Co-hong. Howqua was the name given by the foreign traders, in pidgin English, to the company established by Ng Kwok-ying in about 1777. His son, Ng Ping-chuen (1769–1843), called Howqua II, was the most famous merchant in Canton (Plate 12), with a fortune estimated in 1834 to be £4.5 million.[8] Over the years his generosity and friendship helped many overseas traders to prosper.

Punqua I (P'an Chen-ch'eng), one of the original founders of the Co-hong, was its chief from 1778 to his death in 1788. His son, Punqua II, inherited the firm and was succeeded by his nephew, Punqua III. One of the descendants of Punqua I was the salt commissioner P'an Shih-ch'eng, owner of the famous garden that became an inspiration for the willow pattern beloved of Western hostesses.

Since the hong merchants had not passed the imperial examinations and held no official position in the government, they were not entitled to wear a badge of rank and the corresponding hat button. Nevertheless, the wealth attained through their office enabled them to purchase this insignia and to be portrayed wearing official robes. Many wore military squares, being the easier of the two orders to obtain. Punqua III, for instance, wore the sixth-rank button (opaque white), while his colleague Chi-chin-qua wore a crystal (fifth-rank) button, and even owned a blue button of the fourth rank. He only wore this at home, however, 'lest the Mandarins in office should visit him on that account and make use of it as a pretence to squeeze presents from him, naturally supposing that a man could well afford them who had given ten thousand taels [of silver]... for such a distinction.'[9]

The anomalous situation of the merchants certainly left them vulnerable to extortion, and in general the position of hong merchant was a difficult one. Although they were entitled to certain privileges, such as being allowed to ride in a sedan chair with a limited number of bearers, not all the merchants were as successful as Howqua. They had to make compulsory contributions to the imperial court and, as Chi-chin-qua well knew, they were vulnerable to the extortions of the mandarins, who demanded presents at the Lunar New Year and on many other occasions. Some went bankrupt, as they were held personally responsible for debts and insolvencies of the traders, yet no hong merchant was allowed to retire and his sons were expected to succeed him on death.

The Co-hong merchants built thirteen two-storey factories, or hongs, with warehouse space on the ground floor and accommodation above. These factories were built on a portion of land about 200 metres outside the city walls to the south-west and so were not considered part of the city of Canton itself (Fig. 7.1). The site was bounded by the Pearl River to the south, a creek to the east and, about 340 metres away, a narrow street to the west. Within this area, thirteen sites were marked out, ranging from 15 to 45 metres wide (Fig. 7.2). By reclaiming land from the surrounding Chinese shops and dwellings, the area was eventually enlarged to a depth of 150 metres.

The East India Company's monopoly prevented other traders in Britain from trading in Canton, however British merchants based in India defied the regulations and were eventually allowed to trade under licence. These 'country traders' were allotted space on Company ships to import cotton, indigo, opium, spices, sandalwood, ebony, and ivory into China, and, once in Canton, leased factories from the hong merchants. Per Osbeck had reported seeing one 'country' ship as part of the flotilla of nine English ships in 1750. But their numbers grew when peace came to Britain at the end of the Napoleonic wars in 1815, and hundreds of young officers, the second sons who traditionally went into the army or navy, were made redundant. The rule of primogeniture in Britain meant a firstborn son inherited the right of

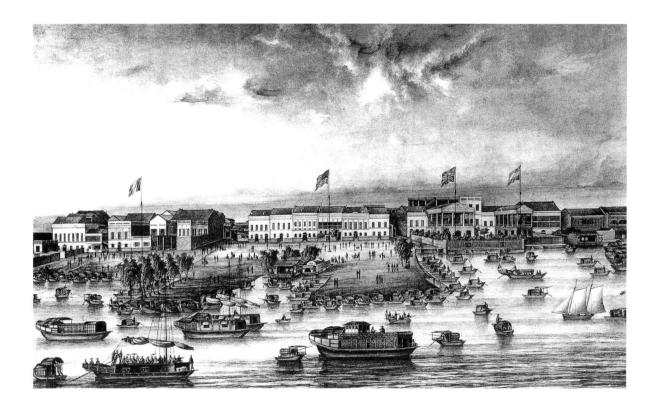

FIG. 7.1 A view of the factories, with the French, American, British, and Dutch flags flying; ink and sepia on paper, *c.*1830.

succession by which the whole estate passed to him. Many of the younger sons, at a loss for a means to make a living, grasped the chance to go to India and Canton to trade and try to make their fortune. With a blend of hard work and business acumen, many succeeded (Plate 13).

Dr William Jardine (1784–1843), a Scotsman and a surgeon's mate with the East India Company, turned to trade in 1817 and by 1824 had taken control of an ailing old firm, Charles Magniac & Company. Another Scotsman, James Matheson, arrived in Canton in 1820, aged 24, to form Matheson & Company. An urbane and go-ahead young man, Matheson founded the first English-language newspaper in China, *The Canton Register*, in 1827, and the following year joined forces with Jardine. They dropped the name Magniac and in 1832 founded Jardine, Matheson & Company, with their offices in a factory next to the creek. The firm was called *E-wo* in Chinese, meaning 'justice and peace', and still carries that name. Their company prospered: Jardine's is a major employer today in Hong Kong and in many other parts of the world.

When the East India Company's monopoly was revoked in 1834, Dr Jardine became the most powerful Westerner in Canton. In one season he had seventy-five ships to his consignment. Second only to Jardine's was another British firm, Dent & Company, founded by William Dent in the late

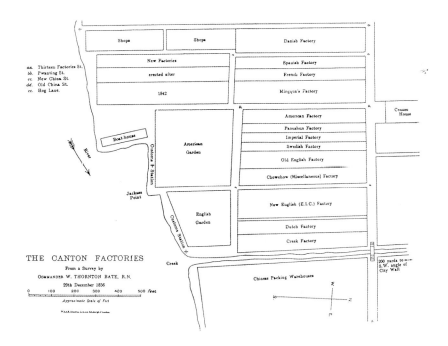

FIG. 7.2 A plan of the factory site, 1856; drawn by Commander W. Thornton Bate, R.N.

eighteenth century. By the 1820s, Dent & Company was run very successfully by William's three sons, John, Lancelot, and Wilkinson. However, strong competition from Jardine's, and commercial depression, caused it to fail in the 1860s.

Indians, Parsees, and Armenians were also active in Canton throughout the nineteenth century, at first under license from the East India Company. The Parsees, who practised the Zoroastrian faith, had been expelled by the Muslim Arabs from Persia and settled in Bombay beginning in the seventh century. They were natural traders, who established many successful business ventures in conjunction with the British merchants, most often dealing in raw cotton and opium from India. They began trading with China in the late eighteenth century, and there was a sizeable community resident in the factories. One, Sir Jamsetjee Jeejeeboy, had a highly profitable trading partnership with Jardine, Matheson & Company, and in 1842 became the first Indian to be knighted. Wrote Oswald Tiffany: '[T]he Parsees are the most remarkable of any of the races in Canton. ...They give feasts and drink wine, and cheer vociferously, and are a jolly set. Their dress is peculiar, in summer a white robe fitting closely to the back and arms, with wide pantaloons of the same, or of red or blue. In the cold season they have dark colored coats cut in the same fashion, and edged with red cord. Their hair is shaved in part, leaving it growing at the temples, and all wear the most enormous moustaches, which may often be seen as one walks behind them. ...Many of them speak English well, and all are very courteous in their manners.'[10]

Not all companies were successful, and many small firms were short-lived. The country traders envied the Americans, whose trade was free and open to all. Unhindered by a national monopoly, several American companies thrived, such as the one founded by Samuel Russell of Boston in 1819. Russell was joined by a partner, Philip Ammidon, in 1824 and their firm, trading in tea, silk, and opium, became known as Russell & Company. Young William Hunter arrived in Canton from America the following year, aged just thirteen, and was employed by Russell & Company from 1829, serving as a partner in the firm from 1837 to 1842. He had studied Chinese at the Anglo-Chinese College at Malacca and, on retiring from Russell's, wrote two entertaining books on life in Canton.

William Low was head of Russell's from 1829 until his death in 1834. Robert Bennett Forbes, also from Boston and captain of some of the most famous opium clippers, joined the company in 1839 and soon became its head. Another member of the family, Paul S. Forbes, was a partner from 1844 to 1873 and during the same period served as the United States consul at Canton. The country traders welcomed the opportunity to become a consul of another nation as a way to avoid the East India Company's jurisdiction. James Matheson, for instance, became Danish consul in 1821, whereby he acted for any Danish ships which came into port and in return could fly the Danish flag when he wished to disassociate himself from the Company in times of trouble. This arrangement between Denmark and Jardine, Matheson & Company lasted for more than sixty years.

The hong merchants leased the factories to the different nationalities, some properties being named after the foreign nations doing business in Canton, others after the hong merchants themselves. By the early nineteenth century, as they stood facing the river, from west to east, the Danish factory was first, separated by New China Street from a row of three factories. These were the Spanish factory, whose flag represented the Philippine Company of Manila,[11] the French factory, whose flag was removed in 1803, during the war with Britain, and not raised again until 1832, when it simply indicated the residence of the French consul, and Chungqua's factory, used by a hong merchant.

Then came grand Old China Street, being all of 4 metres wide, the same as the principal streets within the walled city, and lined, like New China Street, with rows of Chinese shops. This was followed by a group of six factories: the American, Paoushun (used by a hong merchant), Imperial (used by nations, such as Austria, not having a separate relationship with a hong), Swedish, Old English, and Chowchow, or Miscellaneous, used by different renters and called Fungtai by 1840. Next was Hog Lane, a narrow dirty alleyway, where livestock roamed freely, hence its name. On the other side was the New English factory built after the British negotiated a new lease in 1810, and whose area, covering about seven thousand square metres, made it the

largest of the group. Then came the Dutch factory, and finally the Creek factory, next to the creek, used by a hong merchant and where Jardine's had their offices and warehouse. A bridge over the creek led to the factories belonging to the hong merchants Howqua, Mowqua, Kinqua, and Samqua.

National flags were flown at the factories during the trading season, and the traders took up residence in the same factories each time. With the exception of the English and the Dutch, and later the Americans, the names of the factories did not necessarily correspond with the nationality of the renting occupants. For instance, of the forty-four American traders and missionaries in Canton in 1836, *The Canton Register* lists seventeen as staying in the Swedish or Imperial factories.[12]

The first factories were built with a ground floor of bricks and an upper floor entirely of wood, but gradually the foreign merchants had them rebuilt in brick and granite, with alterations and additions continuing over the years. Nearly all the factories were gutted in the great fire of 3 November 1822 when a conflagration, which started in a bakery behind the New English, Dutch, and Creek factories, spread. When the factories were rebuilt, a third storey was added to some. The ground floors had warehouses where chests of tea, delicate porcelain, and bales of coloured silks were stored. Here the weighing and packing was done, before the goods were loaded onto boats in front of the factories and taken down river to Whampoa. Wrote William Hunter, 'the lower floors were occupied by counting-rooms, godowns, and store-rooms, by the rooms of the Compradore, his assistants, servants and coolies, as well as by a massively built treasury of granite, with iron doors, an essential feature, there being no banks in existence. In front of each treasury was a well-paved open space, with a table for scales and weights, the indispensable adjuncts of all money transactions, as receipts and payments were made by weight only, except in some peculiar case.'[13] After the money was weighed, for it was never counted, shroffs[14] would assay the coins. To do this an operator felt every coin carefully, then, if in doubt, placed it on his long left thumb-nail, tossed it suddenly in the air, and listened keenly to the sound as it landed on this horny projection. If deemed to be genuine, he marked the coin with a puncheon which bore a Chinese character of the merchant who put it into his coffers. Some coins were stamped through so many times they resembled metallic lace.

Running behind the length of the factories, parallel to the river, was Thirteen Hong Street, which took its name from the number of factories. The name survives today as Shisanhang Road, lined each side with shops while bicycles weave through sauntering pedestrians. On the north side, at the top of Old China Street, stood Consoo House, whose name came from the foreign pronunciation of the Chinese *kung so*, or guild (**Plate 14**). This was the assembly hall of the guild of hong merchants, where the East India Company chiefs met deputies of the mandarins. Up to 1839 all public

business connected with foreign trade and government was transacted here; fifty years later it had become a police station.

Court trials also took place in Consoo House, including one involving Chinese pirates who attacked the crew of the French vessel *Navigatre* in 1827. Pirates were a constant threat to ships sailing in the Pearl River and South China seas. Bad weather had forced the crew of the *Navigatre* to take refuge near the coast of Vietnam. Given an inhospitable reception, they were ordered to sell their ship and cargo and travel on a Chinese junk bound for Macau. During the journey the crew of the Chinese junk formed a plan. On nearing their destination, they transferred the Chinese passengers to another junk while the foreigners were robbed and then murdered, except for just one sailor who escaped to tell the tale.

The trading season was determined by the onset of the regular monsoon winds, and generally lasted from May through to November, the ships departing as soon as the teas had been loaded. Catching the monsoon was important for getting a speedy sail back to the home port and beating the competition. Before 1745, all foreign traders, except the Portuguese at Macau, had to leave China at the end of each season, and return to their own countries. Subsequently, the Chinese officials relented and allowed the foreigners to join the Portuguese in Macau during the rest of the year. Wrote Dr Toogood Downing in 1838: '[E]dicts come down every year from the Imperial City, to order that all the Fan-quis shall leave Canton as soon as the season of business is over. However disinclined the merchants may be to quit the place, they are always obliged to comply; as the Hong merchants, those poor scape-goats for all the misdeeds of the foreigners, represent to them, "More better you go Macao," or else they will be punished for the offence of their obstinate customers.... The foreigners go down to Macao to enjoy there a gay and lively season, leaving the Chinese in the undisturbed possession of their town during the grand solemnity of the Feast of Lanterns.'[15]

Ships heading for Canton on the last leg of their long journey from the West left Macau and sailed past Lintin Island at the mouth of the Pearl River. Passing the Chinese forts at the Bogue, the ships wound their way past rice fields, banana plantations, bamboo thickets, and pagodas hidden in groves of banyan trees. Skirting between French Island on the left, where the French had a warehouse for storing ships' supplies and where the English, Swedes, French, and Dutch were buried, and with the Danish cemetery on Dane's Island to the right, they reached the island of Whampoa 20 kilometres downriver from Canton. By the middle of the nineteenth century, at the height of the season as many as a hundred ships would anchor here at one time (Plate 15).

Each ship was measured at Whampoa by the Hoppo's staff to determine its size and volume, so that port customs charges could be imposed

and cumshaw, or entry fees, could be paid. Wrote a member of the East India Company of a visit from the Hoppo: 'On August 1, [1747] the Captain, supercargoes, the Interpreter and Company's Agent, came again on board, to attend the Mandarine, who was appointed by the... Vice-Roy of the province to measure our ship. ...He brought a numerous retinue with him. There was a great deal of magnificence and grandeur in his *sampans* or boats, but no less in his person and habit. He was attended by several inferior Mandarines, and these last had each their Attendants. On his approaching our vessel, a band of musick played all the time.... The chief Mandarine [the Hoppo] was seated on a grand chair, which was brought on board, and placed on the quarter-deck for him, while the inferior Mandarines measured the ship, which took about an hour. At his departure there was a great deal of ceremony, in cringing, bowing and firing cannon' (Plate 16).[16]

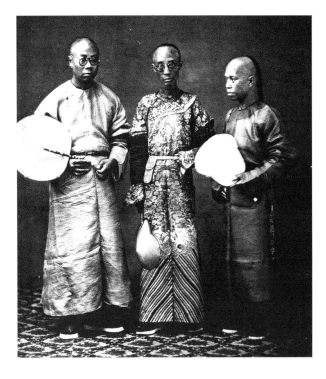

FIG. 7.3 A Chinese linguist wearing a dragon robe, flanked by his two secretaries; photograph by M. Miller, *c.*1861–4.

Linguists were hired to supervise the off-loading of cargo in Canton and the purchase of return cargo (Fig. 7.3). Being a government interpreter, the linguist would speak Mandarin to the Hoppo, Cantonese to the merchants, and Pidgin English to the foreigners. His duties were considerable, and included translating documents and transacting all affairs with the customs house. This was a very necessary appointment, as Westerners were forbidden to learn Chinese and most communicated in Pidgin, or 'business' English, a mixture of Chinese, English, and Portuguese. Bookshops near the factories sold a small pamphlet called *Devils' Talk*, written by a Chinese, which attempted to give the equivalent definitions to common words and phrases used by both parties. Thus, from a hong merchant to a trader: 'Just now hav settee counter, alla finishee; you go, you please' was understood to mean, 'Our accounts are now settled, you can leave when you like.'[17]

Compradores[18] were also hired at Whampoa to provide each ship with all the supplies it needed. These Chinese business agents were indispensable intermediaries between the foreign traders and Chinese officials, tradesmen, and artisans. Whampoa was an unhealthy, swampy place, so most traders stayed on board while the various transactions were taking place. When the cargo was finally unloaded and taken in small boats up to Canton, traders would follow in order to purchase the return cargo, while the crews were kept hard at work repairing the ship. Within three months the ship would be ready to set sail for its home port.

ENDNOTES

1 The name Bogue, given to an island shaped like a crouching tiger, was a corruption of the Portuguese *bocca tigris* or 'tiger gate'; in Chinese, *humen*.

2 Fu Lo-Shu, *A Documentary Chronicle of Sino-Western Relations (1644–1820)*, Tucson: University of Arizona Press, 1966, Vol. 1, p. 61, and Note 144, Vol. 2, p. 461.

3 From the Portuguese *sobrecarga*, meaning an officer in a merchant ship whose duty was to manage the cargo and supervise the commercial affairs of the ship. J. M. Braga, 'A Seller of "Sing-Songs"', *Journal of Oriental Studies* 6 (1961–4): 65.

4 In 1842 the official schedule for express delivery of mail allowed 32 days by horse from Canton to Beijing. M. Loewe, *Imperial China*, London: George Allen & Unwin, Ltd, p. 216.

5 Fu, 1966, Vol. 1, p. 222.

6 Fu, 1966, Vol. 1, pp. 224–6.

7 The hong merchants' names carried the suffix *qua*, a term of civility or respect, the word meaning to 'manage' or 'control'.

8 Braga, 1961–4, p. 105.

9 J. L. Cranmer-Byng, ed., *An Embassy to China: Being the Journal Kept by Lord Macartney During His Embassy to the Emperor Chien-lung, 1793–1794*, London: Longmans, 1962, p. 207.

10 Osmond Tiffany, Jr, *The Canton Chinese, or the American's Sojourn in the Celestial Empire*, Boston: James Munroe and Co, 1849, pp. 244–6.

11 The Spanish were excluded from Canton, but allowed to trade at Xiamen. They were based in Manila in the Philippines, which had been a Spanish colony since the sixteenth century.

12 *The Canton Register*, 1836.

13 W. C. Hunter, *The Fan Kwae at Canton before Treaty Days, 1825–44*, London: Kegan Paul, Trench & Co, 1882, reprint, Shanghai: The Oriental Affairs, 1938, p. 15.

14 From the Arabic word *sarraf*, meaning 'banker'. The term is still in use in Hong Kong to mean 'cashier'.

15 C. Toogood Downing, *The Fan-qui in China*, London: Henry Colburn, 1838, reprint, Shannon: Irish University Press, 1972, Vol. 1, p. 299.

16 Quoted in James Orange, *The Chater Collection: Pictures Relating to China, Hong Kong, Macao, 1655–1860*, London: Thornton Butterworth, Ltd, 1924, pp. 189–90.

17 Hunter, 1882, p. 27.

18 From the Portuguese word for 'purchaser' or 'purveyor'.

8

China Trade:
A Willow-Pattern Wonderland

It was the West's insatiable demand for tea that kept the traders busy in Canton since, at this time, tea could only be obtained from China. The first mention of its being drunk in England was in 1664, when directors of the English East India Company purchased a gift of tea, 2 lbs. 2 oz. (1 kilo), at a cost of £4 5s, to be presented to the King of England.[1] The fashion for drinking tea quickly spread from the court to the rest of society, and coffee-houses in the City of London became the most fashionable places in which to drink the brew. Tea was also purchased for home consumption, and its high cost meant that in most homes it was kept under lock and key. In the trading season of 1810 the East India Company exported from China twenty-seven million pounds of tea (Fig. 8.1), and by the middle of the century exports to Britain had grown to more than forty million pounds annually, well exceeding the twelve million pounds exported to America. To meet increasing consumption, in 1848 the directors of the East India Company engaged the experienced botanist Robert Fortune as botanical collector, to gather the finest varieties of tea in order to introduce Chinese tea into India. Fortune procured seeds and tea plants for government plantations established in the foothills of the Himalayas and almost 24,000 tea plants were successfully transplanted there.

Tea had been drunk in China since the fourth century AD, initially as a medicine, and then later for pleasure. The word 'tea' itself came from the

FIG. 8.1 A group of Chinese weighing tea chests while a European inspector keeps a tally; photograph by John Thomson, c.1873.

Xiamen dialect *te*, since Xiamen was the main port in Fujian through which black teas such as Bohea, Pekoe, and Souchong were first exported. Green teas, including Hyson, Twankay, and Gunpowder, were grown mostly in the central province of Zhejiang. When Xiamen was closed to trade, chop[2] boats brought the tea leaves slowly down the rivers and canals to Canton for sorting and packing; on the return trip, the boats carried cargoes of salt to the interior. Tea was called *cha* by the Cantonese, and this became the popular slang expression in Britain. Green tea was packed directly it was picked, but black tea was produced by placing the leaves in a brazier over a slow fire to brown them, the leaves being constantly turned by hand to prevent them from sticking together.

Scented teas were popular in England: flower petals from roses, jasmine, and especially orange flowers were added to the tea for a short while before packing, then removed by passing the tea through a sieve. Caper teas were another favourite, whereby the tea leaves were moistened with water, then stuffed into canvas bags and tightly closed. Resembling large footballs, the bags were placed on the floor and the workmen, each clinging firmly to a rope or a horizontal wooden pole, moved the bags to and fro with their feet (**Fig.** 8.2). By this method the tea leaves in each bag assumed the form of pellets, or capers.[3]

Inspectors employed by the East India Company examined the tea, and the prices were fixed by a consortium of the Select Committee representing the foreign traders together with the hong merchants. After tasting, the tea was carefully packed in lead-lined chests to keep it fresh, aromatic, and insect-free on the long sea journey to the West, where it was auctioned off at its destination. There was keen competition between nations and this led to the use of fast clipper ships, racing to land the first cargo of the season.

Tea yielded by far the best profit of all the exports out of Canton, and it quickly replaced silk as the main item traded. Silk, from gossamer-fine gauzes to stiff satins, had been the first commodity the traders exported to the West. In Europe, it was greatly esteemed for its high price and luxurious appearance, and was keenly desired by wealthy families for clothing and home furnishings, but it never reached the popularity that tea would achieve.

Since silk was in great demand by the Chinese themselves, on 17 August 1759 the Qianlong emperor announced a ban on its export. The English merchants petitioned and three years later raw silk was made available, although under ration, while silk piece goods were still prohibited, often having to be smuggled out at night under the protection of bribes paid to the Hoppo. When the ban on trade in silk was eventually relaxed and quotas raised, traders placed their orders for lengths of damask, satin, taffeta, and velvet as soon as they arrived in Canton, so the parcels would be ready in time for their departure.

Keeping silk dry on the journey to the West was a problem often solved by packing it between shipments of tea. The raw silk came from towns and the countryside to the south and west of Canton where, due to the rich alluvial soil from the Pearl River delta, silk worms produced seven harvests of silk each year between April and November. The raw silk was sent to the city, where it was woven into damasks and satins (Fig. 8.3), and by the early nineteenth century there were more than 17,000 men, women, and children engaged in its production in Canton alone.[4]

FIG. 8.2 Two men clinging to a pole while rolling scented caper and gunpowder teas encased in leather bags; photograph by John Thomson, c.1873.

FIG. 8.3 Women spinning silk thread; taken from an album of pith paintings showing silk cultivation, mid-nineteenth century.

Since a large quantity of silk was produced around the city, Canton became a major centre of embroidery. Nearly all the items of clothing, accessories, and household furnishings used in Chinese homes were decorated with it, and every girl and woman, and many men, were expected to know how to embroider. Books of woodblock-printed designs contained patterns to copy or to provide inspiration. By the middle of the nineteenth century, large shipments of silk shawls, embroidered in Canton's neighbouring villages, were exported to the United States and then re-exported to Mexico and South America. These so-called Canton shawls became highly desirable in Victorian England, as well. The distinctive silk crepe shawls with long fringes were woven at Sai Tsui, west of Shun Tak district, a few kilometres from the city. They were then brought to Canton, where artisans drew the designs of flowers and landscapes in Indian ink in each corner, before forwarding them to the embroiderers. The finished shawls were placed in cardboard boxes, delicately painted with Chinese scenes, then encased in lacquer boxes (Plate 17).

The other sizeable export through Canton was porcelain. Originally carried as ballast for the journey home, it soon became highly sought after, gaining the generic term, 'china'. It was shipped to the West from Canton on a large scale from about 1700 onwards. At first, traders bought Chinese-style artefacts, but soon Chinese potters began to copy Western wares. The traditional Chinese landscape of streams, bridges, and pavilions seen in the many gardens in Canton captured the imagination of Westerners and provided the inspiration for the well-known blue-and-white 'willow pattern' first created by the English potter Thomas Minton in 1789.

Plain porcelain was brought down by boat along the rivers from the kilns at Jingdezhen in Jiangxi province, and painted in studios in Canton according to purchasers' requests (Plate 18). Remarked Dr Downing: 'One of the most curious circumstances to be noticed in this part of the process is the number of artists employed in painting a single specimen. One man traces the outline of a flower, another of a pagoda, while a third is at work upon a river or a mountain; a fourth receives it to draw the circle round the edge, while a fifth puts on the pigments according to these marks. Each person has his own peculiar department beyond which he cannot proceed....'[5] Armorial porcelain was commissioned by noble or important families in the West, and bookplates showing the family crest or coats of arms were copied onto the porcelain. In the period from 1695 to 1820, some five thousand dinner and tea services were made with the coats of arms of British families.[6] The aristocracy in other European countries, such as Sweden, Portugal, and France, also commissioned armorial ware, but the numbers ordered per country were less than a tenth of the British demand.

Although these major commodities had to be purchased through the hong merchants, items for personal use could be obtained from the small

merchants or 'outside men' who set up shop around the factories. By 1822 the number of these small merchants was estimated to be as many as 5,000.[7] Craftsmen in Canton in the eighteenth century were renowned for their exquisite workmanship, and ornamental curios were often sent as tribute to the court in Beijing. In these works, artistic merit sometimes took second place, as the artisans 'showed off' their dexterity.

Much of the artisans' work was seen in the shops around the factories and in the homes of the hong merchants, so traders and ships' captains, especially from Britain and America, quickly seized the opportunity to pursue some private trade alongside official company business. Before they left home, they would take commissions from members of the aristocracy and country gentlemen, and while in Canton obtained further items, whichever caught the eye, to sell at a high profit upon their return. The East India Company required all private purchases made by their traders to be auctioned back in London at East India House, with the Company taking 15 per cent of the prices realized. Thus, private traders had to buy back their goods if they had prior orders for them. However, these 'China trade' goods of carved ivories, silverware, lacquered boxes, fans, embroidered shawls, and paintings found a ready market in the West. At a time when few people travelled more than 30 kilometres from their homes, the world was a strange and wondrous place and these curios, transported across oceans from the exotic East, had wide appeal.

Some men capitalized on the excitement in all things Chinese by displaying these works of art to the public. In 1838, Robert Burford, an artist specializing in panoramic paintings, exhibited his view of Canton and the surrounding countryside at his Panorama building, north of Leicester Square in London. The view was based on a painting by Canton artist Tunqua, complete with detailed descriptions of the sights, and was greatly enjoyed by the crowds who came to view it.[8] The Panorama building survives as a church although, sadly, the painting does not. Across the Atlantic, in the same year, American trader Nathan Dunn opened a Chinese museum in Philadelphia to showcase the huge collection he had acquired during a twelve-year residence in Canton. Large glass cases contained groups of life-size figures in Chinese dress, while other cases represented complete rooms furnished in the fashion of a wealthy Chinese mandarin. Dunn later moved the exhibits to a venue at Hyde Park Corner in London, where they remained for several years before being dispersed.[9]

Almost all the artisans engaged in trade in Canton belonged to one of the seventy-two guilds which covered all commercial activities (Fig. 8.4). The guilds, like trade-unions, controlled the number of people engaged in the craft, regulated the hours they worked, and maintained quality standards, wages, and prices. Ivory-carving, fan-making, jewellery production, painting on glass, and furniture-manufacturing, all were carried out in small shops

FIG. 8.4 Interior of the Chinese
Merchants Guild; *c*.1875.

around the factories. Normally each street was devoted to one particular
trade, but in Old China and New China streets, which ran between the fac-
tories (Plate 19), this division was not maintained: the shops there were
occupied by many trades for the foreigners' convenience.

Within the shop, shelves were stacked from floor to ceiling with goods
on offer. Salesmen sat quietly writing accounts while, at the back, the owner,
in a long gown of blue silk and a black skull-cap over his pigtail, kept a
watchful eye on the door for important customers. Browsers were given a
perfunctory greeting but, wrote Osmand Tiffany, Jr, if a visitor indicated the
possibility of making some purchases, 'the shopman darts like lightening out
of his hiding place, calls his assistant, tugs violently at the window cord to
show his goods to best advantage, bangs to the doors of his shop, and dives
down to the very darkest corners of his cases, and shows every thing with
the greatest good humor ten thousand times....

'On parting after a bargain,' Tiffany continues, 'the worthy dealer puts
on a long face and says, "I no hab catchee muchee ploffit dis time," though
the rascal knows he has. And finally, he bows and orders the cooley to
arrange the shop and pack the purchases. He reluctantly pulls open the doors
and then mounts behind the counter, where he sits chuckling at his success
until another barbarian enters.'[10]

Some of the most popular souvenirs of Canton were the pictorial
reminders of the traders' stay that were produced in many artists' studios.
Paintings in gouache depicted the processes involved in the production of
the three principal exports: tea, silk, and porcelain. Albums, containing from

four to fifty paintings, included standard views of Macau, Whampoa, and Canton, and later Shanghai, Xiamen, and Hong Kong when these ports were opened, as well as scenes from daily life, trades, crafts, furniture, flora, and fauna. Large paper panels painted with landscapes and exotic flora and fauna were shipped in sets to the West to decorate the walls of the country homes of the wealthy.

Several renowned painters of these China-trade works are keenly sought after today. Spoilum (active 1770–1805) and Youqua (active 1840–80s) had their studios in Old China Street, while Lamqua (active 1830–60) and his younger brother Tinqua (active 1840–70s), the best-known artist working in Canton in the mid-nineteenth century, had studios in New China Street (Plate 20). Finished paintings were for sale on the ground floor, while upstairs was the studio where the painters worked, seated at long benches, sleeves turned up and long queues wrapped around their heads out of the way. Large windows let in the light at each end of the room, and copies of European paintings or drawings of local scenes were displayed around the walls. There were reported to be over thirty artists' studios operating in Canton in 1835. Many followed the method of dividing up the work of a painting so that 'one artist makes trees all his life, another figures; this one draws feet and hands, that one houses. Thus each acquired in his line a certain perfection particularly in the finish of details, but none of them is capable of undertaking an entire painting.'[11]

The paintings were made on pith paper (or rice paper, as it is often wrongly called), the leaves of the plant brought from Yunnan, Fujian, or Taiwan. The paper was given several washes of a weak solution of alum: 'The next process is to trace the outline; and this is done quite mechanically. There appears to be a certain number of these outlines, which are printed off and sold for the use of the artists, as you see the same figures in the whole of the shops.... Whatever the subject may be, — whether a boat, a bird, or a mandarin, — it is laid upon the table, and the rice-paper is placed over it; and then, on account of the transparency of the latter, the figure is easily sketched upon it with black paint....

'Having prepared the colours, the artist proceeds to lay on that which we call the dead colouring. The general coat of the drapery, furniture, &c., is laid on the face of the paper; but where flesh is to be represented, the pigment is put on the reverse side of the picture, so as to produce that beautiful effect of transparency practised with such success by our miniature painters on ivory.'[12]

Western artists also made their way to Canton. Two of the earliest were Thomas Daniell and his nephew William, in Canton during 1785, whose work continues to be highly regarded. But the most famous painter on the South China coast in the first half of the nineteenth century was the Irish artist George Chinnery, who made several forays to Canton from his base in

Macau. His sketches of everyday scenes, and portraits in oil of sea captains, important merchants, and their families, give a vivid picture of life in the nineteenth century. Others in Canton at the time, some of whom met and worked alongside Chinnery, included Auguste Borget, the best-known French artist to visit China and Macau (between 1838 and his return to France in the 1840s), and William Prinsep, who had studied drawing under Chinnery in Calcutta. Some Chinese artists, such as Spoilum and Lamqua, who was a rival of Chinnery, also painted in the Western manner. Spoilum specialized in portraits in oil of merchants, both Western and Chinese, and sea captains, while the studios of Lamqua produced paintings of the hong merchants' gardens which the foreign traders could visit periodically.

Crateloads of fans were produced and shipped to Europe and America, where they were an important fashion accessory for ladies in the nineteenth century. The Chinese had carried fans for thousands of years, not just to cool the air, but also to gesticulate and give emphasis when speaking. Folding paper fans used by men were often inscribed with calligraphy and paintings as a means of artistic and scholarly expression. The ones made for export were much more elaborately decorated. 'Mandarin fans' were a favourite, so-called because they showed figures of mandarins and their consorts with tiny painted ivory faces and cut-and-pasted coloured silk robes. Another popular type was the brise fan, comprised of sticks only, carved and pierced, and made in many materials including ivory, bone, mother-of-pearl, enamelled silver or gold, tortoiseshell, and lacquer.

The maker's skill in carving was also applied to other works of art. There were several workshops in New China Street, including in the 1830s the studio of Chongshing at No. 5, and Luenchun's, 'Mother of pearl, Ivory and Tortoiseshell carver' at No. 6 (Plate 21). Mother-of-pearl and tortoiseshell showed off the skill of the carver to good advantage, while sandalwood was carved almost as delicately as was ivory. Fan and card cases made from it were popular for the fragrance they emitted. In 1834, three hundred tons of sandalwood were imported by the English and Americans into Canton, the best coming from Malabar, whose product was believed to contain more of the essential oil than did that from the Sandwich (Hawaii) and Fiji islands.

Ivory came from animal tusks, mainly elephant, and its colours ranged from white through to yellow and brown. It was a very versatile material, and could be stained, painted, used for inlay, or cut into strips for weaving into mats or baskets. Nothing was wasted and odd scraps were made into hair ornaments or else cut into tooth- or ear-picks. Among ivory products, the Chinese generally preferred mythological figurines from Chinese folklore, or finely carved brush pots, seals, snuff bottles, and chopsticks, whereas Westerners bought chess sets, fans, sewing-box fittings, and visiting-card cases. In the 1830s, Hangshing, at No. 1 New China Street, was known as an artisan who specialized in ivory carving, but Hoaching was 'the man... most

relied on by foreigners', for the 'splendid collection' he had on display: 'Some of the pagodas and baskets of ivory are made so thin and so delicately marked,' Dr Downing noted, 'that you are afraid to touch them lest they fall to pieces in your hand.'[13]

Although some carvers later brought their skills to Shanghai and Hong Kong, a curiosity particular to Canton was the ivory or sandalwood ball carved so that several smaller spheres were contained one inside the other, rotating freely. The American missionary Samuel Wells Williams, in Canton in the mid-nineteenth century, describes the process of making such objects, which mystified many: 'A piece of ivory or wood is first made perfectly globular, and then several conical holes are bored into it in such a manner that their apices all meet at the centre, which becomes hollow as the holes are bored into it. The sides of each having been marked with lines to indicate the number of globes to be cut out.... By successively cutting a little off the inside of each conical hole, the incisures meet, and a sphericle is at last detached, ...until the whole is completed, each being polished and carved before the next outer one is commenced. It takes three or four months to complete a ball with fifteen inner globes.'[14] A century later, it was possible to produce twenty-four concentric balls, and by 1975 carvers in workshops in Da Xin Road were seen producing ivory balls of as many as thirty-six layers (Fig. 8.5).

FIG. 8.5 Ivory carver in Canton, producing a concentric ball with 36 layers; late 1970s.

The workshops of the silversmiths were also situated around the factories. Cutshing had a studio at No. 8 New China Street and another in Old China Street, while Powing, Wongshing, Cumshing, Linchong, Sunshing, and Yatshing were all highly regarded, each signing their work with their own mark. Silver came from mines in the south-west province of Yunnan, as well as from bullion gained from trade with the West before opium was introduced. At first the silversmiths imitated existing European forms and motifs in embossed silver, such as tea and coffee pots, tea caddies, bowls, tureens, cutlery, condiment sets, trays, mugs, and card cases (Fig. 8.6). By the middle of the nineteenth century, however, Chinese symbolism was in vogue and covered most of the surface of the piece.

Canton also became a centre for export enamel. The Jesuits had introduced the technique of painting in enamels on metal to the palace workshops during the Kangxi emperor's reign. A bronze or copper body was first coated with a white enamel, then, after firing, the decoration was painted

FIG. 8.6 A pair of baluster-shaped vases made in silver by Powing for export; c.1800.

with coloured glazes, before being fired again. 'Canton' enamelware was characterized by vibrant colours and designs, with Westerners often pictured in a Chinese landscape, and was made in Western forms of tea pots, wine ewers, tea caddies, and bowls (Plate 22).

The back entrances of the factories opened onto Thirteen Hong Street, another busy street lined with local shops filled with strange and exotic goods. Nearby was Golden-Lily Street, where tiny shoes were made for ladies with bound feet, and Looking-glass Street, which had shops filled with mirrors painted with landscapes and flowers. The technique of 'back painting', in oils or colours mixed with gum, on the reverse of mirror glass began in the late eighteenth century, and may have been introduced into China by the Jesuits. At first, artists copied European prints of historical, religious, and mythological subjects, but later pictures of Chinese ladies and landscapes became popular with the Chinese as well.

Furniture and objets d'art of black lacquer, gilded or inlaid with mother-of-pearl, were popular in Chinese homes, and much was exported to the West in the eighteenth and nineteenth centuries. Although the production techniques were originally brought from Japan, hence the term 'japanning', the style of Chinese lacquerware was more highly decorated with figures and scenes in bas-relief than was its Japanese precursor. Black lacquer cabinets, fans, screens, tables (Plates 23 and 24) and tea caddies, dressing cases, sewing boxes, games boxes, card tables, and games boards, with designs of landscapes and figures picked out in gold leaf, were produced in large quantities. After the item was covered with lacquer, made from the sap of the Semac tree, the decorations were applied to it: 'The gilding is performed by another set of workmen in a large workshop. The figures of the design are drawn on thick paper, which is then pricked all over to allow the powdered chalk to fall on the table and form the outline. Another workman completes the picture by cutting the lines with a burin or needle, and filling them with vermilion mixed in lacquer, as thick as needed. This afterward is covered by means of a hair-pencil with gold in leaf, or in powder laid on with a dossil; the gold is often mixed with fine lampblack.'[15]

When the main business of tea- and porcelain-buying was concluded, the chests and trunks were packed with merchandise in Carpenter's Square

at the eastern end of Thirteen Hong Street, and the time came for the traders to leave Canton. The cargo of tea and porcelain was sent down river to Whampoa along with provisions needed for the journey. The authorities allowed a separate boat known as a chow-chow (miscellaneous) chop to take the various collections of goods bought for personal gain. Before the boat left, all chests, bales, boxes, and baskets were spread on the ground in front of the hong merchant's factory to the east of the creek. Mandarin boats and Hoppo boats were stationed outside the gate of the main landing-place to check on the baggage and purchases made by foreigners, to ensure duty was paid on every item, however small. These were examined at random in case any items deemed taxable were being smuggled out. Although these goods accounted for less than 10 per cent of the total trade, many men did so well that they were able to establish profitable businesses back home, or simply retire in comfort, after just a few voyages to Canton.

ENDNOTES

[1] H. B. Morse, *The Chronicles of the East India Company Trading to China, 1635–1834*, 5 vols., Oxford: Clarendon Press, 1926, reprint, Taipei: Ch'eng-wen Publishing Co, 1975, Vol. 1, p. 9.

[2] A chop was a measure of the quantity of goods of the same type, for example, a chop of tea, a chop of silk, and the like.

[3] The Venerable John Henry Gray, *Walks in the City of Canton*, Hong Kong: De Souza & Co, 1875, p. 92.

[4] Anders Ljungstedt, *An Historical Sketch of the Portuguese Settlements in China; and of the Roman Catholic Church and Mission in China & Description of the City of Canton*, Boston: James Munroe and Co, 1836, reprint, Viking Hong Kong Publications, 1992, p. 228.

[5] C. Toogood Downing, *The Fan-qui in China*, London: Henry Colburn, 1838, reprint, Shannon: Irish University Press, 1972, Vol. 2, pp. 83–4.

[6] David S. Howard, *A Tale of Three Cities: Canton, Shanghai & Hong Kong, Three Centuries of Sino-British Trade in the Decorative Arts*, London: Sotheby's, 1997, p. 94.

[7] H. A. Crosby Forbes, *Shopping in China: The Artisan Community at Canton 1825–1830*, Washington, D.C.: Museum of American China Trade/International Exhibitions Foundation, 1979, p. 2.

[8] *Description of a view of Canton, the River Tigress, and the Surrounding Country; Now Exhibiting at the Panorama, Leicester Square, Painted by the Proprietor, Robert Burford*, microform, London: Haymarket, T. Brettell, 1838, reprint, Zug: Inter Documentation Co, 1986.

[9] Jean Gordon Lee, *Philadelphians and the China Trade, 1784–1844*, Philadelphia: Philadelphia Museum of Art, 1984, pp. 11–18.

[10] Osmond Tiffany, Jr., *The Canton Chinese, or the American's Sojourn in the Celestial Empire*, Boston: James Munroe and Co, 1849, pp. 62–4.

[11] M. La Vollee, 'L'Artiste', *Revue de Paris* (1849), quoted in John Warner, *Tinqua*, Hong Kong: Urban Council, 1976, p. 5.

12 Downing, 1838, Vol. 2, pp. 96–9. Miniature portraits of loved ones were copied onto plates of ivory.

13 Downing, 1838, Vol. 2, p. 68.

14 S. Wells Williams, *The Middle Kingdom: A Survey of the Geography, Government, Education, Social Life, Arts, Religion etc. of the Chinese Empire and Its Inhabitants*, 2 vols., New York: Charles Scribner's Sons, 1895, reprint, New York: Paragon Book Reprint Corp., 1966, Vol. 2, pp. 59–60.

15 Williams, 1966, Vol. 2, p. 31.

9

Disobedience and Destruction:
The China Wars

To control their movements, the foreign traders and ships' officers were limited to the close vicinity of the factories, where they were confined for up to six months of the year. But instead of being cowed, the foreigners' isolation and boredom enforced a growing sense of complacency and superiority, as they became more and more indifferent to the threats from afar, and even to the mandarins close at hand. The five regulations issued in 1760, which governed many aspects of life for foreigners in Canton, were revised several times and extended (as in the eight regulations issued in June 1831 and reprinted in summary in the Addendum) in attempts to keep the barbarians in check. But there were many occasions when these were pushed to the limit, or even ignored, as in the length of their stay in Canton. Initially, this was restricted to the trading season of May to November, but increasingly they came and went as they pleased.

By 1831 the number of foreign traders resident in the factories stood at 145, of whom the great majority were British.[1] Unlike the cramped conditions of some of the other factories, the English quarters were most luxurious. William Hunter, the young American trader, was greatly impressed by 'the [English East India] "Factory" [who] entertained with unbounded hospitality and in a princely style': 'Their dining-room was of vast dimensions, opening upon the terrace overlooking the river. On the left was a library, amply stocked...; on the right a billiard-room. At one extremity of

the dining-room was a life-size portrait of George IV, in royal robes, with crown and sceptre....

'From the ceiling,' Hunter continues, was 'suspended a row of huge chandeliers, with wax lights; the table bore candelabra, reflecting a choice service amidst quantities of silver plate.'[2] Dinner, attended by stewards, consisted of two courses of meat and fish followed by an excellent dessert, with wines, claret, and Madeira. In the evening some men played cards or billiards, while others strolled on the terrace of the hong. Supper was announced at ten, after which they retired to rooms prepared with candles and slippers by their personal servants. Stifling summer nights, however, brought restless sleep plagued by prickly heat and mosquitoes, while cockroaches and rats were a constant discomfort.

At least the food was good, fresh, and plentiful. Familiar Western vegetables were on sale alongside oriental ones in the markets, while the wide variety of fruit grown nearby, like lychees, bananas, and oranges, was supplemented with grapes, pears, apples, and melons brought down river from the north. Rhubarb from Sichuan was used as a purgative and became an important export to the West from China. Fish and poultry were available all year round, and mutton, snipe, partridges, quail, and wildfowl could be had in the winter. Although originally forbidden, by this time servants were inexpensive and took care of all manner of household tasks, as constant familiarity with Europeans had taught them Western ways. When asked later how the traders passed their time, the artist George Chinnery sarcastically replied, 'They spent six months in Macao, having nothing to do, and the other six months in Canton, doing nothing.'[3]

Security was tight in the area around the factories. Old China Street and the other large thoroughfares had strong gates at the entrances, with small doors allowing one person through at a time. At night the gates were closed, as in the main city, and guarded by watchmen and soldiers. There were no street lamps and everyone, foreign residents included, had to carry a lantern with his name on it or risk a fine if he did not. Between Old China Street and Hog Lane an open space called Respondentia Walk ran down to the river.[4] This was a small area, about 50 metres square, laid out with flower-beds interspersed with gravel walks, fenced off with high railings, and out of bounds to the Chinese.

The gate at the right of the garden led to steps down to the river at the landing place, Jack Ass Point. Here traders and visitors alighted from boats that brought them from ships anchored at Whampoa, or crossed the river on the few days each month when foreigners were permitted to visit the pleasure gardens and the temple on the opposite bank. Hundreds of boat people, from their main anchorage at Shamien, clustered around, attracted by the business the factories brought them of transporting people and goods.

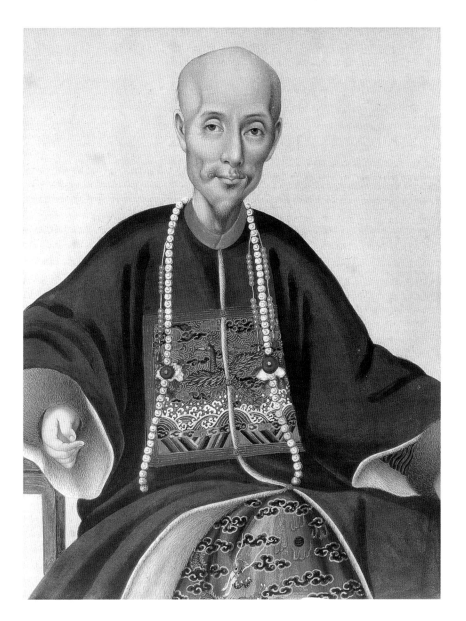

PLATE 12 A portrait of Howqua, the co-leader of the Hong merchants; painted by Tinqua's studio, c.1840–50.

PLATE 13 Portrait of a Western merchant wearing a silk embroidered waistcoat; reverse painting in gouache on mirror glass by Spoilum, late eighteenth century.

PLATE 14 The trial of pirates who attacked the crew of the French ship *Navigatre*, at Consoo House; painted by a follower of Spoilum in 1827.

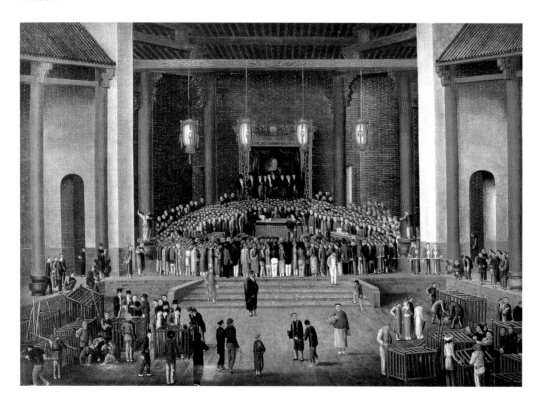

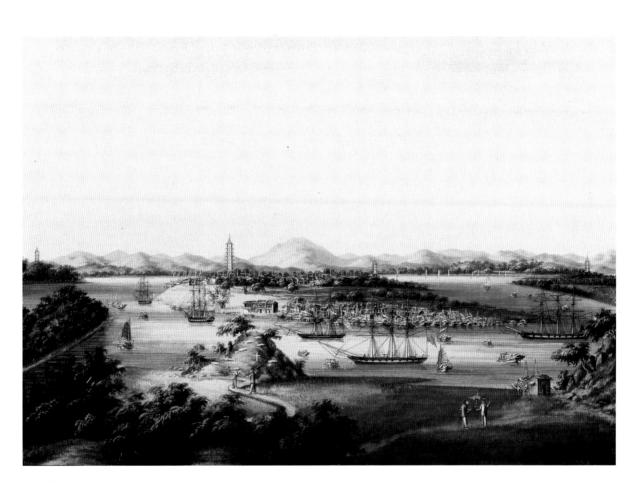

PLATE 15 A view of Whampoa with foreign ships lying at anchor; painted in the studio of Youqua, *c.*1850.

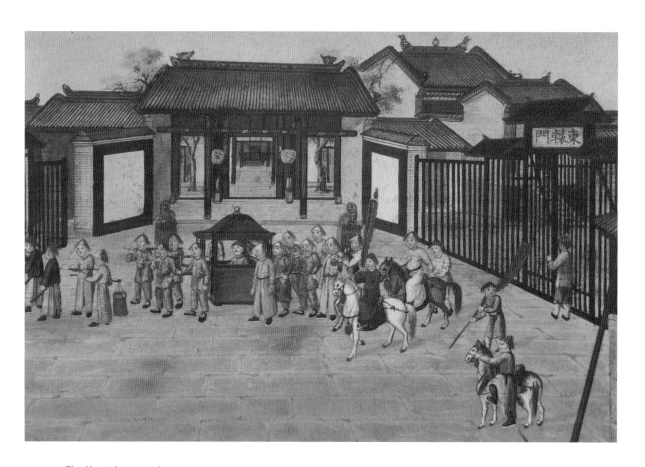

PLATE 16 The Hoppo's procession
leaving the Customs House;
painted by a Chinese artist,
c.1820.

PLATE 17 The painted cover of a box containing an embroidered Canton shawl, which would then be placed inside a lacquer box; mid-nineteenth century.

PLATE 18 One of a series of ten pith-paper paintings showing the production of ceramics; c.1790.

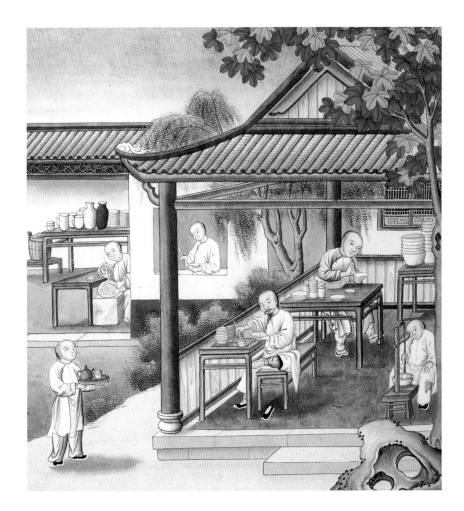

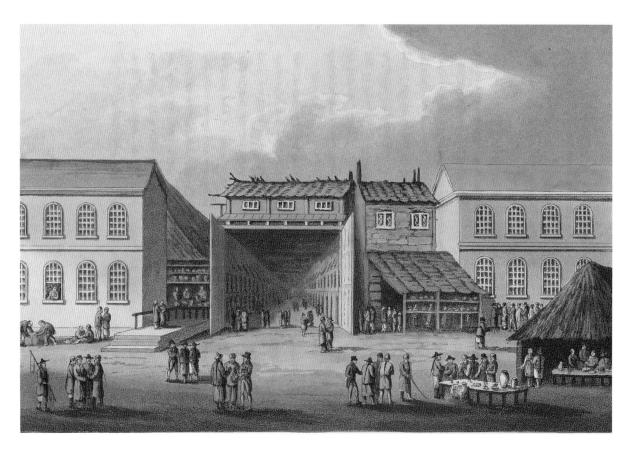

PLATE 19 The entrance to Old
China Street; coloured aquatint
by John Clark, from a drawing
by James Wathan, 1811.

PLATE 20 The interior of Tinqua's studio on the top floor of a building in New China Street; gouache, c.1855. Three painters work by the open windows while behind them, on the walls, can be seen paintings for sale.

PLATE 21 A Mandarin fan and carved ivory fan, both made in Luenchun's studio, No. 6 New China Street; mid-nineteenth century.

PLATE 22 A Canton enamel tea chest with twenty-one pewter tea canisters inside; made for the King of Sweden, c.1745.

PLATE 23 A Canton export lacquer bureau cabinet on a stand with pastoral scenes of figures in gardens; made in seven separate parts for ease of shipping, early nineteenth century.

PLATE 24 Interior of a cabinet-maker's shop, showing crafts-men making furniture in the Western style; *c.*1820.

PLATE 25 A view of the front of
the factories with the French
and American flags flying;
lithograph by Lauvergne,
*c.*1840.

PLATE 26 A regatta on the Pearl River, in front of the factories; painted in oils by Thomas Daniell, 1785.

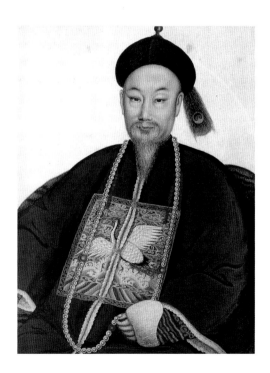

PLATE 27 Commissioner Lin Zexu; painted in the studio of Tinqua, c.1840.

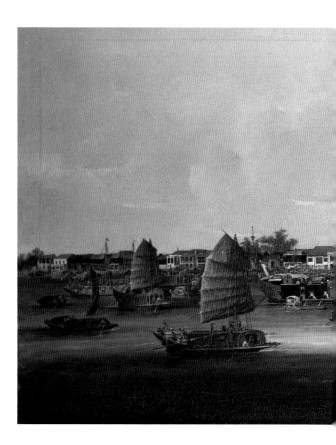

PLATE 28 Plan of attack for the 1858 bombardment of Canton, showing the Manchu quarter and the city gates; drawn by George Wingrove Cooke, the (London) *Times* special correspondent from 1858–60.

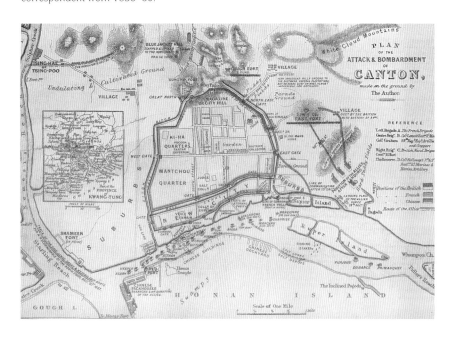

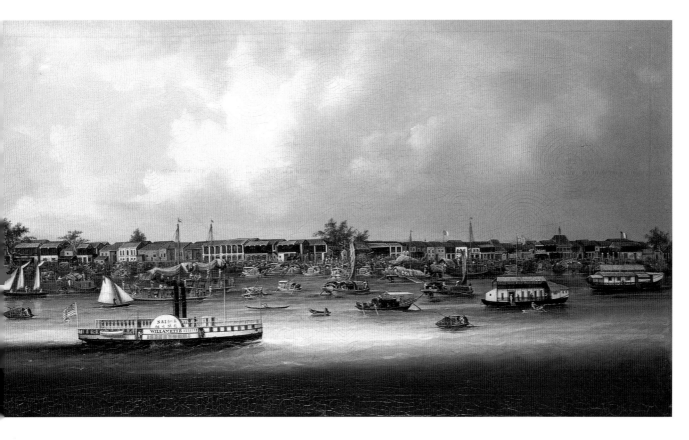

PLATE 29 A view of the factories on Honam; *c.*1860. Some traders, like the Americans and the Dutch, lived in covered 'chop boats', seen here flying their national flags.

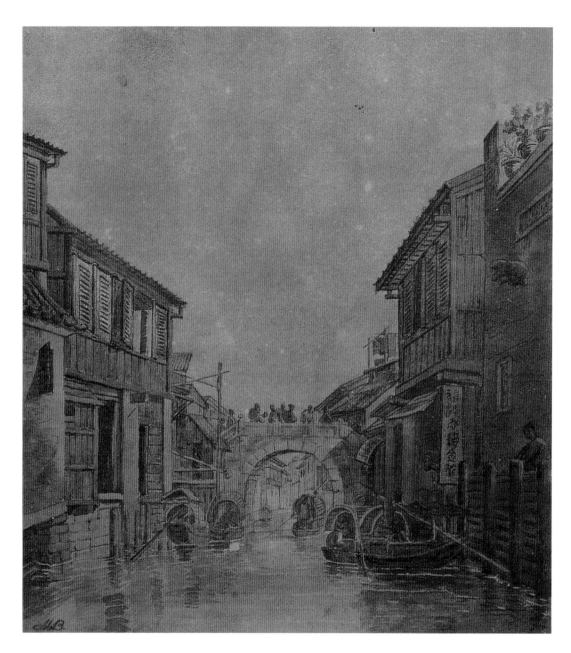

PLATE 30 Honam Bridge over
the Creek; watercolour
painted by Marciano Baptista,
dated 5 August 1863.

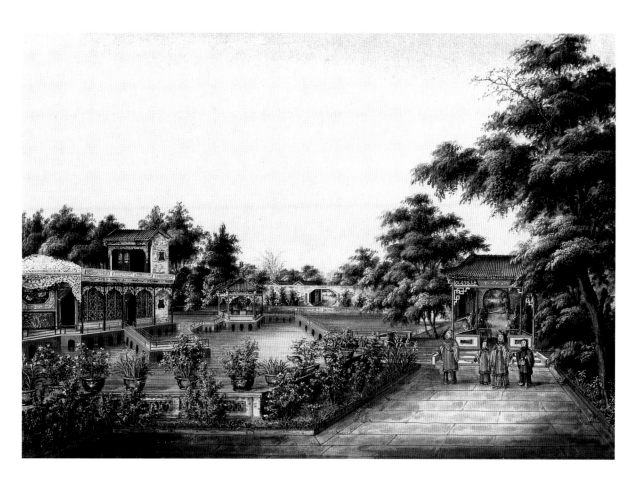

PLATE 31 An album painting on pith paper from the studio of Youqua, showing Howqua's garden on Fati with its summer houses, pavilions, and zigzag bridges; *c.*1850.

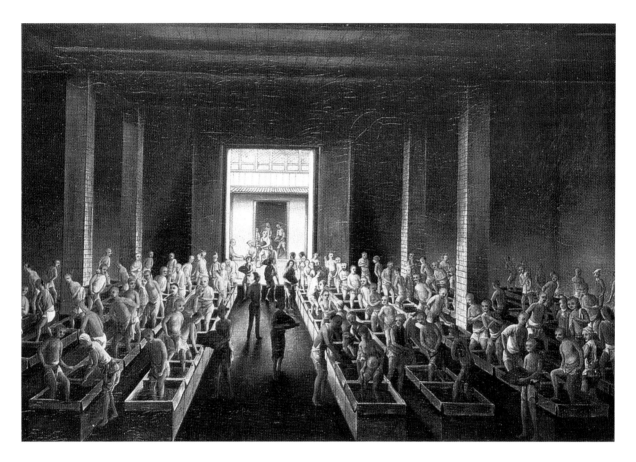

PLATE 32 A view of a tea warehouse, showing coolies treading tea into chests to pack tightly before shipping to the West; oil on canvas, mid-nineteenth century. The gloomy interior shows the reality of the working conditions, unlike the stylized paintings usually produced at the time to show silk, porcelain, and tea production.

The common landing-place used by Chinese natives and low-ranking sailors, opposite Hog Lane, was lined with small hovels where the lowliest and most profligate lived. Hog Lane was notorious for the spirit and grog shops that attracted the Western sailors, who were allowed only three days leave in Canton from their ships anchored at Whampoa. Arriving in parties of twenty to thirty, the sailors were quickly inebriated by *sam-shu*, a fermented rice wine, and they were frequently 'three sheets to the wind'. They became prey to crooks and vagabonds, and fights and disputes broke out, with the East India Company being called upon to intercede. 'Affairs of honour' between the traders were usually settled down river: to throw down the gauntlet it was only necessary to declare, 'Dane's Island, Sir!'

The making of the garden in front of the factories caused controversy, for the mandarins could not fathom why the foreigners wanted a pleasure garden when they came to Canton for the purpose of trading. At first the fences around the square were pulled down after the merchants left for Macau when the trading season ended. Missionary David Abeel, who passed through Canton in the early 1830s, noted: 'The open space before the factories is the rendezvous of multitudes of the natives, who assemble daily to transact business, gratify curiosity, or murder time. ...As the morning opens upon this scene, silence retires, and the ears of the stranger are assailed by a new and peculiar combination of sounds. Human voices of harsh, drawling tones, cries of confined dogs and cats, screams of roughly handled poultry, ...all unite in this inharmonious concert.

'The occupations of the tradesmen', Abeel continued, 'are varied. Meat, fish, vegetables, fruit, drugs, manufactures, every thing saleable is brought to this general market. A number convey their portable kitchens hither, and prepare such dishes, as suit the palates and purses of this promiscuous concourse. Others plant their barber's shop, or its necessary apparatus, in a convenient place, and spend their leisure hours in lolling about, and conversation. Those who frequent the place for trade, are probably less numerous than the groups of idlers, who pass their time in listening to stories, witnessing juggling tricks, attending the operations and lectures of empirics, gaping at objects of novelty, and too frequently endeavouring to obtain each other's money by gambling [Plate 25].

'When the crowd presses too closely upon any of these exhibitors, they have the most ludicrous and effectual mode of enlarging the circle. With imperturbable gravity, they draw from their pockets a cord, with a bullet attached to the end, and then closing their eyes, to exclude partiality, they whirl it around over their heads, gradually letting out the cord, and increasing the rapidity, until it comes whizzing before the faces of the intruders, and drives them back to the required distance.'[5]

As American trade increased and European trade diminished, the Americans took over the other factories in the centre row, Paoushun, Imperial,

Swedish, Old English, and Fungtai. At last, the mandarins allowed the traders to rebuild the fences, and in 1841 the ground in front of the American factory and the river was enclosed and became known as the American Garden. The area enclosed in front of the New English factory was laid out as a garden and called the Queen's Garden, after the reigning British monarch, and later the English Garden. Hog Lane, between the gardens, was acquired and the two gardens merged into one. The circumference of the two gardens was just a mile, and some, like interpreter Harry Parkes, rose at six and took exercise around it before breakfast. A tougher workout was achieved by rowing on the river. Young traders would race each evening after work, up and down the Macau Passage (Plate 26), their boats named after the different teas, 'Pekoe', 'Caper', and 'Gunpowder'. Races and regattas provided a welcome diversion, but for the most part it was a monotonous life, devoid of the companionship of women, lacking variety in conversation and entertainment. Most traders went to Canton with the sole intention of making money and retiring in comfort after just a few seasons.

With increasing nonchalance, the foreigners continued to disobey the regulations designed to limit their activities. For instance, it was clearly understood that Western women and children were forbidden by the Chinese authorities from residing in, or even entering, Canton, for fear that the traders might become permanent residents. Yet Mrs Baynes, wife of the president of the Select Committee of supercargoes no less, and her two companions proceeded to ignore the ruling. On 16 February 1830 the three ladies arrived at the English factory from Macau 'dressed in true London style', causing such interest that people took to the river outside the factory 'and paid three cash to see the Fanqui women'.

After a stay of about two months the ladies returned to Macau but, emboldened by their success, returned again in the autumn. That same November, twenty-one-year-old Harriet Low and her young aunt travelled up to Canton, concealed in cloaks and caps, disguised as boys. Harriet, a society beauty who had been painted by George Chinnery, had been living in Macau as companion to the wife of American trader William Low. Although the hong merchants had managed to turn a blind eye to the visit of the English East India Company ladies, the mandarins were apoplectic at the arrival of the Americans. With their usual insouciance, the Chinese authorities simply stopped foreign trade, withdrew servants, and cut off the supply of provisions. All the ladies retreated to Macau, Baynes lost his job, and no ladies attempted to enter Canton again until after the First China War of 1841–2.

The country traders, British trading under licence from the East India Company, had many grievances over the restrictions enforced by the Honourable Company. With the growing feeling that monopolies were becoming outdated, the East India Company's exclusive control finally came

to an end by an Act of Parliament enforced on 22 April 1834. The Company's splendid premises were rented out to individual merchants and part was used as a hotel. A superintendent of British trade was appointed to replace the president of the Select Committee, and Lord Napier, who had served with the British Navy at Trafalgar, was chosen. Unused to Chinese etiquette, he arrived in Canton without first obtaining permission from the mandarins and demanded to speak directly to the Viceroy without the intervention of the hong merchants. Naturally, this request was denied and he was ordered to leave for Macau. When he refused, again trade was stopped, servants were withdrawn, and the supply of provisions withheld. These moves in the end led to his ignominious departure for Macau where he died soon after, in October 1834. From this point forward, the superintendents of trade remained at Macau, and later Hong Kong, having little contact with the authorities in Canton.

Because the Chinese had no interest in any other Western import but the hard currency of silver, causing a 100 per cent imbalance of trade, the traders looked for another commodity easily available, but less costly, to balance the great demand for tea. Opium was the answer. Arab traders had introduced the drug, to be taken orally as a medicinal aid, into China during the Tang dynasty. Demand from those who had discovered the pleasures of smoking for its narcotic effects led the Chinese to import it from India. Opium was also grown in Yunnan province, but this was of a poorer quality, and more expensive, than that from India. In the eighteenth century, the Portuguese in Macau controlled most of the opium trade and by 1767 were importing over 1,000 chests per year from India, a small but valuable source of revenue.

Growing demand from 1773 attracted the interest of the English East India Company, who began to direct opium production and transport, mostly from Patna, Benares, and later Malwa. Seeing the profits involved, the Americans joined in, bringing the drug from Smyrna in Turkey. To process opium, the gum was collected from the seed pods of poppies, dried, shaped into balls weighing about four pounds, then wrapped in dried poppy leaves and sealed in mangowood chests, thirty to forty balls in each, before shipping.

The Chinese government had not restricted the importation of opium as a medicinal drug, but because of the growing fondness for smoking it and the indulgence's drastic physical effects, it was prohibited in 1796, but to no effect. At this point the East India Company ceased to carry the drug in its own ships. Instead, they circumvented the ruling by selling the opium at auction in Calcutta[6] to country merchants who then brought it to China. Foreign ships were not permitted to take opium to Whampoa, and it had to be offloaded below the Bogue, initially at Macau. Then, following objections by the Portuguese, from 1822 it was unloaded at the island of Lintin at the mouth of the Pearl River. Receiving ships held the opium while sales took

place at Canton, money was handed over, and written orders were sent down to Lintin. Chests of opium were delivered to smugglers, who distributed it from boats called 'fast crabs' along the coastal waterways of Guangdong province, and eventually up the coast.

Demand for the drug grew rapidly: from the mandarins down to the poorest coolie, opium was indispensable. In 1816–17, 3,210 chests were imported, increasing to 34,000 chests twenty years later.[7] In 1836 alone the extract suitable for smoking supplied about twelve and half million smokers (Fig. 9.1). Six to twelve pipes were smoked at a time and heavy users would smoke over a hundred pipes a day. The wealthy could afford fresh extract each time, but poorer addicts had to make do with ash mixed with scrapings of the pipe added to tobacco or tea.

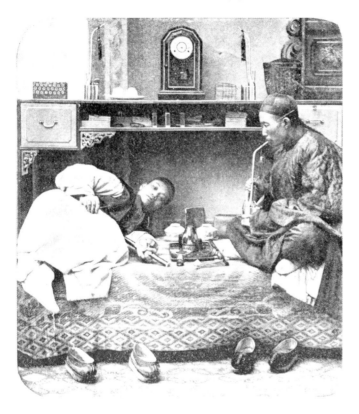

FIG. 9.1 Two men reclining on a couch smoking, the one on the left holding an opium pipe. The tray between them holds the apparatus needed to fill the opium pipe; c. 1890.

Pressure was growing on the Emperor to suppress the import of opium, even though many officials were users themselves. On 10 March 1839, Commissioner Lin Zexu (Plate 27) arrived in Canton on orders from the Emperor to resolve the opium problem. To an observer, Lin 'had a dignified air, rather a harsh or firm expression, was a large, corpulent man, with heavy black moustache and long beard, and appeared to be about sixty years of age. His own boat was followed by a great many others, on the sides of which, on a black ground, were painted in gold letters the rank of the principal occupants, while flags of various colours were displayed abaft. The crews were neatly dressed in new uniforms of red trimmed with white, and conical rattan hats of the same colours. These boats contained the principal officers of the city, civil and military, from the Viceroy to the Superintendent of the Salt Department. The walls of the "Red Fort", nearly opposite the Factories on the Honam shore, were lined with soldiers, as were those of the "Dutch Folly", …arrayed in bright, new uniforms. Both shores of the river, every door and window, and every spot of standing ground, were thick with people.'[8]

Lin's instructions were to stop the opium imports, while at the same time allowing the rest of foreign trade to continue under the old conditions. He ordered the surrender of all the 20,283 chests of opium from the Canton Custom's House, on which duty, albeit illegal, had already been paid.

An offer of 1,037 chests was rejected, so he promptly ordered the blockade of the factories by land and sea, effectively making the foreign merchants prisoners. Chinese servants were told to leave, supplies of fresh water and provisions were cut off, and the hong merchants were stripped of their official rank, with the two chief hong merchants at the time, Howqua and Mowqua, being placed in chains. Captain Charles Elliot, who had been appointed chief superintendent of British trade at Canton in 1836, arrived from Macau. Taking matters into his own hands, he ordered the full number of chests delivered up to Lin at Humen at the Bogue. There the opium was mixed with lime and soaked with water to render it useless.

Outraged by China's presumptuousness, Britain decided that the only fitting response was war. The capture of the Bogue forts in January 1841 led to the Chuenpi Convention, agreed to by Elliot and the Chinese authorities. The latter were ordered to pay $6 million within seven days to the British government and to those traders who suffered from the losses, to reopen Canton to trade, and to give the island of Hong Kong, which had been select-ed by Elliot as an alternative to Macau, to the British crown. (In fact, the subsequent shortage of opium resulted in prices on future shipments rising ten-fold.[9]) Four million dollars were paid out of the treasury and the rest by the hong merchants — Howqua himself paying $820,000. Elliot's actions met with disapproval from the British government: he was withdrawn and banished to become consul-general to the Republic of Texas. Four months later, hostilities broke out again when the British and Dutch factories were plundered by Chinese troops and partly pulled down. Ironically, fire junks sent against British ships drifted the wrong way and set fire to some of Howqua's own warehouses.

The Treaty of Nanjing, which brought an end to the war and ceded Hong Kong in perpetuity to Britain, was signed on 29 August 1842 aboard the British flagship HMS *Cornwallis*, anchored in the Yangzi River near the city of Nanjing. The signatories were Sir Henry Pottinger, Elliot's successor, on behalf of England, and the two high commissioners, Keying and Ilipu, on behalf of China, together with the Viceroy of Nanjing. In the treaty the co-hong monopoly was to be abolished and free trade inaugurated.[10] Nevertheless, the mandarins in Canton ordered new fortifications to be built along the Pearl River, despite the treaty forbidding this, so Sir Henry demanded other ports, besides Canton, be opened for British trade. Shanghai, Ningbo, Xiamen, and Fuzhou became 'treaty ports', places where foreigners were governed by their own laws, controlled the tariffs on all international trade, and where wives and children could live permanently, a system known as extraterritoriality. This removed, at one step, Canton's unique monopoly of the China trade.

Once the Treaty of Nanjing was signed, Canton was supposed to be open to all, as was the case in other treaty ports. The walled city was always

a matter of much curiosity to the foreign population, although few had ever attempted to enter it. In the late eighteenth century, William Hickey, an East India Company cadet, together with three companions, were determined to see inside the walls. They pushed their way past the soldiers on guard at the gates, and went on through to the suburbs on the other side, returning and 'encountering the same pelting and insults we had before, and in an increased degree, dirt and filth of every kind being cast at us. Let no stranger, therefore, ever think of forcing his way into Canton in the expectation of his curiosity being gratified by handsome buildings, or in any respect whatever, for like us he will meet with nothing but insult and disappointment.'[11]

Lord Macartney also entered in early January 1794 from the Water Gate in the New City and crossed from one end of the city to the other, but most traders and visitors made do with the view of the interior of the city as seen from the roofs of the factories. The signing of the treaty made no difference, however, to the ease of entry. The mandarins agreed that in theory the foreigners could enter, but, unfortunately, in practice they could not guarantee their safety. Consequently, although many wished to, very few actually dared to venture through the gates. Intrepid Ida Pfeiffer, a German widow who visited Canton in the early 1850s, was the first European woman to ride through the streets around the walls of Canton, although disguised as a man. Her companion was Herr Richard von Carlowitz, who had founded the first German firm in Canton, Carlowitz & Company, in 1844.

On 8 October 1856, the lorcha *Arrow*, a vessel with a Western hull and a Chinese rig, flying the British flag, was boarded by Chinese, who pulled down the flag and imprisoned the twelve men on board. The Viceroy at the time, Yeh Mingchen, contended that among the men was a pirate. Unknown to Yeh was the expiration of the British registration of the boat eleven days earlier, but Harry Parkes, who by this time had risen to become the Acting British consul, nevertheless construed the Chinese actions as an infringement of British sovereignty and demanded the return of the ship's crew. Yeh would not apologize and so, fearful that the treaty system would break down if not reaffirmed and extended, John Bowring, Chief Superintendent of Trade, and Parkes used the incident as an excuse for another period of hostilities: the Second China War.[12]

The bombardment of Canton by Admiral Sir Michael Seymour and his troops in December 1856 led to all the factories being destroyed by fire in retaliation by the Chinese. Soon after, a French missionary, suspected by the Chinese of being a foreign subversive, was executed in Guangxi, and the French joined forces with the British. The start of hostilities was delayed as the British had their hands full with the Indian Mutiny, and it was not until the end of 1857 that the Western allies felt strong enough to attack.

During the hostilities, it was suggested to a commander of one of Britain's ships that a shot be fired at the large bell hung in the bell tower, first

built in 1378 (Fig. 9.2), immediately behind the Temple of the Five Genii. The huge bell, weighing over 5,000 kilos, lacked a clapper, so any sound from it was thought to foretell calamity to the city. A cannon ball did strike the bell, removing a piece of the lower rim and making it ring out, signalling the fall of Canton. Sir Charles van Straubenzee attacked the city and it was taken on 29 December 1857.

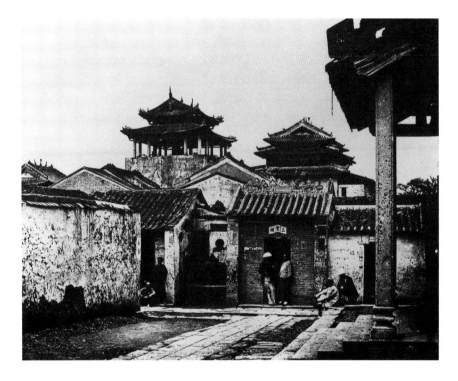

FIG. 9.2 The Bell Tower appearing above and behind the Five Genii Temple. The cast iron bell remains today, though it has been re-hung with the missing piece now at the other side; photograph by Felice Beato, 1860. Collection of Jane and Michael G. Wilson, Courtesy of Santa Barbara Museum of Art.

The yamen of Viceroy Yeh was destroyed during the offensive. Yeh, born in Hubei province in 1807, was a clever man, who had passed the imperial examinations to the *jinshi* level and became a member of the prestigious Hanlin Academy in Beijing (Fig. 9.3). A steady rise in government positions led to his being appointed acting viceroy of Guangdong and Guanxi provinces in 1852, becoming concurrently Imperial commissioner in charge of foreign affairs in 1853. On 5 January 1858 the Viceroy was captured while trying to escape over the wall of the yamen of a lower-ranking mandarin on Great Market Street (now Huifu West Road) near the Temple of the Five Genii and brought to British headquarters. He was interrogated, then put aboard the HMS *Inflexible* and shipped off to Calcutta. There he remained until his death the following year, when his body was brought back to China and buried at his birthplace of Hanyang in Hubei province.

Maligned by many Western observers, and reviled by some who scarcely knew him, Yeh received a fairer consideration by Consular Chaplain Reverend

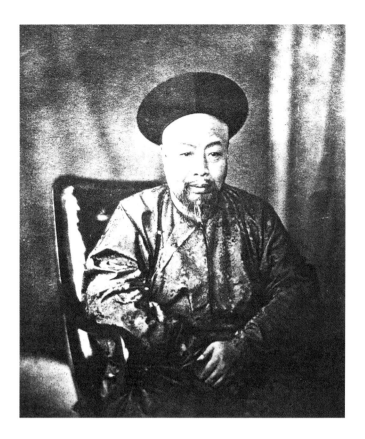

John Gray: 'His private life was distinguished by purity and simplicity, and by an eminent degree of that filial piety, which ranks highest among the virtues of Chinese morality. Habitually, he used neither wine nor opium. And though without male offspring, he had only two wives. He had but one child, a daughter.'[13]

The Treaty of Tianjin, signed in 1858, allowed for eight more treaty ports to open. When the Chinese government refused to ratify the treaty, however, hostilities resumed (Plate 28), and Canton was held by British and French troops until October 1861. The Five-Storey Pagoda became officers' quarters and barracks, the first and second floors used by the French and the third to fifth floors by the British. To keep the troops amused during the occupation of the city, cricket was played on the Tartar parade ground below, sometimes against visitors from the new British colony of Hong Kong. Theatrical performances were put on, with men taking the women's parts, and race meetings using little ponies were held in January each year on a makeshift course beyond the wall to the north, after the rice was harvested. Outside the North-East Gate was a British military cemetery, where two-hundred officers and soldiers were buried, casualties of the hostilities of the 1850s and of diseases incurred during the occupation of the city.

Shells directed at the Great South Gate, and at triumphal arches built to commemorate the exclusion of the British from Canton in 1848, had set fire to the building containing the clepsydra water clock. The copper jars were destroyed, but new ones were cast as copies of the old in 1860, paid for by the Viceroy Lao Ts'ung-kwang, and replaced when the building was restored a few years later. By this time pocket watches had become available and the water clock was less relied upon. The street where the clepsydra stood, Sheung Mun Tai, known for its numerous bookshops, was also burned during the bombardment. Splendid editions of the Chinese classics and woodblocks of principal works of great value were destroyed. Many traders and missionaries, who had also taken up residence in the factories, lost out in the battle, and claimed for property destroyed in the fires, the traders for their costly furniture, the missionaries for their printing presses used to print Christian tracts and bibles.

French troops, who were less disciplined than their British counterparts, ran riot in the city. They looted P'an Shih-ch'eng's garden and summer houses, breaking the carved wooden screens, bending enamel jars, and destroying the pictures, as they did on a much greater scale at Yuanming-yuan, the old summer palace near Beijing in 1860. They also turned their aggression on the Hai Chuang Temple on Honam, wrecking that too. Part of the Confucian temple of the Nan-hai district was damaged during the bombardment, and soon after, a building in the rear of the complex was converted into a residence for Her Britannic Majesty's consular students to study Chinese before being sent to the growing number of treaty ports throughout China.

The Tartar General's yamen was in a poor state when it was captured by Allied troops. They found rotting empty halls with thousands of bats hanging from the ceilings and a wilderness outside; only two rooms appeared to have been used by the mandarin. After cleaning out the yamen, papering the walls, and clearing away the jungle, the soldiers turned it into a barracks, and then a hospital for the British troops, before it was accidentally destroyed by fire in 1859. The rear half to the north of the yamen, an area of about 7 hectares, was walled off in 1861 and became the residence of the British consul, Sir Daniel Brooke Robertson. High walls surrounded the park, over-grown with dense thickets of undergrowth, with some ancient banyan trees rising high above (Fig. 9.4). A herd of deer roamed the grounds; these

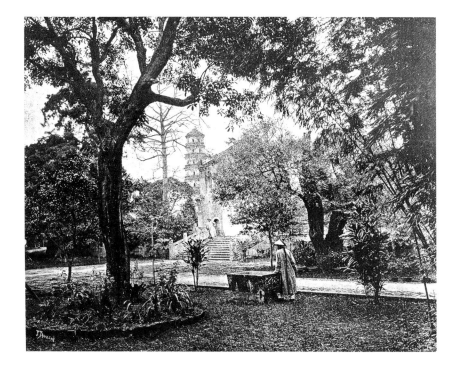

FIG. 9.4 Garden of old Tartar General's yamen, occupied at the time by the British Consul. In the background is the Flowery Pagoda which British soldiers had scaled in 1859. Photograph by John Thomson, 1873.

were kept by many wealthy officials for their auspicious connotations. With only the sound of birdsong, it was a cool and shady retreat in the middle of the city.

On the orders of Jui-lin, the Tartar General, who was an enlightened and cultivated man with an easy rapport with Westerners, part of the grounds of the yamen was used by British officers to instruct the Tartar and Chinese artillery in European drill and in the use of foreign arms. With the British occupying the hallowed halls of the Tartar General's yamen, and the French resident in the Treasurer's yamen, the tide had turned. For the next eighty years the fankwaes would gradually encroach on Chinese territory. The Celestials were powerless to object.

ENDNOTES

[1] H. B. Morse, *The Chronicles of the East India Company Trading to China, 1635–1834*, 5 vols., Oxford: Clarendon Press, 1926, reprint, Taipei: Ch'eng-wen Publishing Co, 1975, Vol. 4, p. 346. The list went as follows: 66 English, 52 Parsees (who were counted as British), total 118; 15 Americans, 3 Dutch, 3 Swedish, 1 French, 1 Swiss, and 4 Spanish.

[2] W. C. Hunter, *The Fan Kwae at Canton before Treaty Days, 1825–44*, London: Kegan Paul, Trench & Co, 1882, reprint, Shanghai: The Oriental Affairs, 1938, pp. 18–19.

[3] Sir Arthur A. T. Cunynghame, *An Aide-de-camp's Recollections of Service in China*, London: Saunders-Otely, 1844, Vol. 2, p. 99.

[4] 'Respondentia was a loan on the security of a ship's lading, repayment being conditional on the safe arrival of the cargo at port of destination.' Morse, 1926, Vol. 1, p. 286.

[5] David Abeel, *Journal of a Residence in China, and the Neighbouring Countries from 1830–1833*, New York: J. Abeel Williamson, 1836, pp. 88–90.

[6] Calcutta had been founded by the English East India Company in the late 1600s and was the capital of British India from 1773 to 1911.

[7] C. Toogood Downing, *The Fan-qui in China*, London: Henry Colburn, 1838, reprint, Shannon: Irish University Press, 1972, Vol. 3, p. 168.

[8] Quoted in James Orange, *The Chater Collection: Pictures Relating to China, Hong Kong, Macao, 1655–1860*, London: Thornton Butterworth, Ltd, 1924, p. 202.

[9] Hunter, 1882, p. 48.

[10] The American traders, realizing the advantage the British would have in China, arranged the signing of the Treaty of Mong-ha (Wanghia) to gain the right to trade at the same treaty ports. This document was signed by Caleb Cushing, Commissioner and Plenipotentiary of the United States of America to China, and Keying, the Chinese High Commissioner, in the Kwun Yam temple outside the city walls of Macau on 3 July 1844. Keying was later recalled to Beijing, after having incurred the displeasure of the court, and sent the silken cord. This was an indication that he should end his life by strangulation. As an Imperial clansman he was allowed this privilege in favour of decapitation, a worse fate, as the

Chinese believe the body must arrive complete in the next world. He then committed suicide, aged 72.

[11] William B. Hickey, *Memoirs of William Hickey*, ed. Alfred Spenser, 3d edition, London: Hurst & Blackett, 1919–25, p. 225.

[12] The Second China War resulted in the importation of opium being legalized and taxed. Chinese domestic production also grew in response to increasing demand. However, vigorous reforms by the Qing government and the British parliament finally forbade its shipment to China in 1911, the year the Manchu government fell.

[13] The Venerable John Henry Gray, *Walks in the City of Canton*, Hong Kong: De Souza & Co, 1075, p. 412.

10
Across the River:
Honam and Fati

As the demand for tea continued to grow and more warehouses were needed for packing this and other merchandise prior to export, in 1847 the British merchants had leased the north-western corner of the island of Honam, on the opposite shore of the Pearl River facing the factories. During the bombardment of Canton, British troops were quartered in the warehouses and it was to these buildings that the foreign merchants returned after the fighting at the end of 1857. With the promise of an open city, no one wished to return to the restrictions of the previous years, so the factories were not rebuilt. Soon native Chinese buildings were altered to provide comfortable temporary accommodation pending the selection of a permanent foreign enclave.

Trading in tea and silk, several Parsee merchants and Western traders from companies such as Jardine's, Russell's, Dent's, and Deacon & Company[1] settled on Honam, and a small suburb known as Honam Point developed, with a few streets separating the river from the villages and rice fields behind it (Plate 29). Although many traders eventually moved across to a newly formed island of Shamien in the 1860s, close to where the factories had stood, there was still a sizeable number of Western and Parsee merchants on Honam some twenty-five years later. For a while the suburb gained an importance not enjoyed before or since.

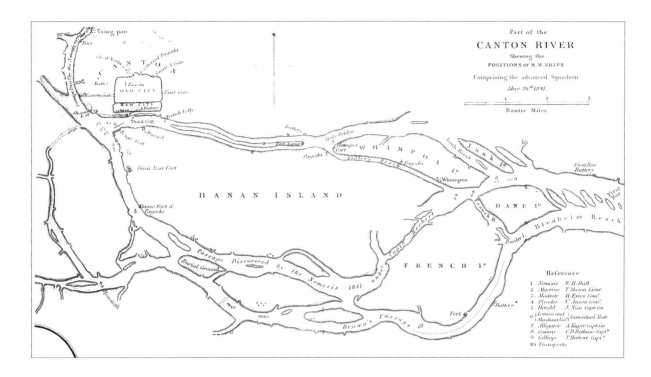

FIG. 10.1 Map showing Honam (Hanan) Island and the approaches from Macau up the Pearl River and the inner passage; published by Henry Colburn in 1845.

The shoreline of Honam stretched for about three kilometres facing the city of Canton, although the island itself was about 16 kilometres long and 5.5 kilometres at its widest point **(Fig. 10.1)**. At this period in history, from the middle of the nineteenth century and for the next 100 years, it was called *Honam*, meaning 'south bank' in Cantonese. In earlier times and again today, it was called Honan (Henan) after the province in central China. The name dates back to the Han dynasty, so a Chinese legend goes, when an official brought several pine trees from Henan province and planted them on the island. The following winter was very cold, and, unusually for sub-tropical Canton, snow fell on the trees. The snow was so strange that no one knew what to call it, but from then on the island was named after the province where the trees had originated.[2]

Members of two British embassies to Beijing had been housed on Honam during their short stop-overs in Canton. In the first, the embassy led by Lord Macartney from 1792 to 1794 had tried, and failed, to persuade the Qianlong emperor to open other ports in China to trade with Great Britain. The embassy was housed, on their arrival on 19 December 1793, in several spacious buildings within the garden of the Hong merchant Howqua's country villa, next to a Buddhist temple. These buildings were temporary structures, matsheds, made with a framework of bamboo covered with straw matting provided by the merchants of the English factory, and fitted out with glass windows and fireplaces, as the embassy arrived in the winter.

The second embassy, led by Lord Amherst, actually took up residence in the Hai-chuang (Ocean Banner) Temple, on their return overland from Beijing from the beginning of January 1817 until they left for Macau and England three weeks later. The Hai-chuang Temple, which faced the factories, was the best-known temple on Honam, and one of the biggest in Canton (Fig. 10.2). According to the regulations issued in 1831, this was one of the few places the foreign traders were allowed to visit, and only on the eighth, eighteenth, and twenty-eighth days of the moon.

FIG. 10.2 A building at the Hai-chuang Temple; painted by Auguste Borget, *c*.1839.

A Buddhist temple called the Qian Chu, the 'Temple of a Thousand Autumns', was first established on the site over one thousand years ago. The present Hai-chuang Temple was founded around 1600 and enlarged one hundred years later. According to legend, in the latter half of the seventeenth century a son-in-law of the Kangxi emperor was sent south from Beijing to bring the rebellious province under the control of the ruling Manchus. His orders were to exterminate the thirteen villages on Honam Island as punishment for their opposition to the imperial forces. Divine intervention, in the form of a dream, prevented the Prince from carrying out the execution of the abbot of the Ocean Banner Monastery, a very devout man. The Abbot then dissuaded the Prince from slaying the villagers. In gratitude, donations of money and land poured in, making it, for a time, the largest Buddhist monastery in Canton.

The monks were always very hospitable to foreign visitors. Henry Ellis, who accompanied Lord Amherst's embassy in 1817, recorded: 'The building was sufficiently spacious, and by the exertions of the gentlemen of the

Factory, had been rendered capable of accommodating the whole party with considerable comfort.'[3] The effect of the party's presence at the Ocean Banner monastery was not negligible. Ellis also records: 'To provide for our accommodation it has been necessary to displace the colossal representations of Fo [the main Buddhas] from the principal hall, and to send them, as we are told, on a visit to their kindred upon the opposite bank',[4] while the priests continued their worship in a nearby hall.

American missionary S. Wells Williams, who visited the monastery in the middle of the nineteenth century, elaborated: 'Its grounds cover about seven acres, surrounded by a wall.… The [brick] buildings consist mostly of cloisters or apartments surrounding a court, within which is a temple, a pavilion, or a hall; these courts are overshadowed by bastard-banian trees, the resort of thousands of birds. The outer gateway leads up a gravelled walk to a high portico guarded by two huge demonic figures.… [T]he main temple, a low building one hundred feet square, and surrounded by pillars… contains three wooden gilded images, in a sitting posture, called *San Pao Fuh*, or the Past, Present and Future Buddha, each of them about twenty-five feet high, and surrounded by numerous altars and attendant images.'[5]

Ranged on both sides of the temple's main hall were images of the Eighteen Lohan, apostles of Buddha. In another large hall behind the first was an image of Kwun Yam and a white marble pagoda containing a relic of Buddha. Behind the temple were accommodation for two hundred priests, a printing office and library, and a crematorium and mausoleum for departed priests. To the right of the temple were pigsties, where a herd of swine was fed by worshippers, fulfilling Buddha's command that every man should prevent the destruction of a single living creature. Up to sixty priests performed ceremonies of worship in the early morning and late afternoon, some dressed in robes of saffron yellow, others in grey, while the abbot wore a purple robe purposely patched to suggest the vow of poverty.

The recently renovated Haizhuang Temple is now listed as one of four famous temples of Guangdong province. Reached by the Renmin Bridge near Shamien, the main entrance on Nanhua Middle Road leads to the temple, through spacious grounds and courtyards with large incense burners and a seven-storey iron pagoda. The three imposing halls were restored some years ago, the centre one containing the three huge fibreglass representations of Buddha and a large cast-iron bell dated to the year 2537 of the Buddhist calendar, corresponding to 1993, the year of the restoration. It is a popular place of worship, with resident monks and stalls selling incense sticks, religious souvenirs, and items used for veneration. Several huge banyan trees bear notices announcing that they are over 400 years old, and the spacious flower garden, where flowers, fruit, and vegetables were once cultivated for sale, is now a pleasure garden called Haizhuang Park, opened to visitors in 1929. The pigsties, fortunately, are gone.

Close by the Ocean Banner Monastery were the country mansions belonging to two wealthy merchants, Punqua and Howqua. Wrote Henry Ellis: 'On the 12th [of January 1817] we visited the villas of Puan-ke-qua and How-qua, the two chief Hong merchants, both situated near the temple in which we are quartered; the former, to which we first went, was interesting as a specimen of Chinese taste in laying out grounds; the great object is to produce as much variety within a small compass as possible, and to furnish pretexts for excursions or entertainment. Puan-ke-qua was surrounded by his children and grandchildren, the latter in such complete full dress of Mandarins that they could with difficulty waddle under the weight of clothes

'How-qua's house, though not yet finished, was on a scale of magnificence worthy of his fortune, estimated at two millions. This villa, or rather palace, is divided into suites of apartments, highly and tastefully decorated with gilding and carved work, and placed in situations adapted to the different seasons of the year. ...How-qua and his brother, a Mandarin holding some office, waited upon us themselves. A nephew of How-qua had lately distinguished himself at the examination for civil honours, and placards (like those of office used by the Mandarins) announcing his success in the legal forms, were placed round the outer court: two bands attended to salute the Embassador on his entrance and departure. Within the inclosure of the garden stand the ruins of the house occupied by Lord Macartney, separated only by a wall from our present residence....

'How-qua's person and looks bespoke that his great wealth had not been accumulated without proportionate anxiety. He is generally supposed parsimonious, but neither his house nor its furniture agreed with the imputation; his domestic establishment, we were informed, consisted of between two and three hundred persons daily feeding at his expense.'[6]

The hong merchants were equally generous to the foreigners, and entertained them on a grand scale, with banquets of up to thirty courses, spread over two days. Dinner was served in both the English and Chinese manner, interspersed with musical or theatrical performances and fireworks. Likewise, the décor was equally international, as missionary Howard Malcom discovered when he visited Howqua's home in 1840: 'Besides gorgeous Chinese lanterns, hung Dutch, English, and Chinese chandeliers, of every size and pattern. Italian oil-paintings, Chinese hangings, French clocks, Geneva boxes, British plate, &c, &c, adorned the same rooms, strewed with natural curiosities, wax fruits, models, and costly trifles, from every part of the world.'[7] Just as chinoiserie style had evolved in the West, so wealthy Chinese in the nineteenth century acquired a taste for Western-style furniture, art, and ornaments. Much of this furniture was later copied, not always successfully, from drawings taken from the *Illustrated London News*, which many educated Chinese were keen to see as soon as the paper arrived in Canton.

A guest of Punqua in 1860 was equally impressed: 'The apartments are vast, the floors being in marble; they are ornamented with columns of the same material and of sandalwood encrusted with mother-o'-pearl, *gold, silver, and precious stones.* Splendid looking-glasses of a prodigious height, furniture in precious wood covered with Japan lacquer, and magnificent *carpets of velvet and silk*, decorate the rooms. The apartments are separated from each other by movable partitions of cypress and sandalwood, which are ornamented with charming designs cut right through the wood, so as to permit one room to be seen from the other. From the ceilings are suspended chandeliers ornamented with *precious stones*.'[8]

Although the mansions are long gone, the area in which they were situated, now a maze of narrow granite-paved streets, has a feel of nineteenth-century Canton, with ancient banyan trees surviving in what was once Howqua's garden. Honam Canal (**Plate 30**) led in from the river at this point, but a small bridge is all that remains, plus a small flight of steps from the main road, Nanhua West Road, to a lower level, inaccessible to vehicles.

Howqua maintained another garden, just for pleasure, across the branch of the Pearl River known as the Macau or Inner Passage, at Fati, a long, straggling village on the shore opposite to the city. Beyond the village were rice fields and a tea plantation for domestic consumption. But Fati means 'flower ground' and it was best known for the numbers of gardens neatly arranged on the banks of the river. On set days each month the foreign traders could visit Howqua's garden, with its large lotus pond, rockery, summer houses, zig-zag wooden bridges, and meandering paths among flowers and dwarfed fruit trees (**Plate 31**). An excursion to Fati was a welcome respite from the confines of the factories, especially at the Lunar New Year holiday, when between thirty and forty younger members of the trading houses, together with servants and cooks, would cross the Pearl River. William Hunter remembers: 'We made the most of these outings, amused ourselves in walking about the Gardens and firing off no end of crackers, or smoking and joking until summoned to dinner, tiffin having been discussed on the way. We would find the table prepared in a room of the flower-seller Aching, and spread precisely as if in the Factory, nothing being forgotten down to finger bowls, and everyone's servant, with some house coolies, in waiting.'[9]

The Lunar New Year holiday in January or February also drew crowds of wealthy Chinese families clad in colourful finery, who would walk around the grounds or rest in small pavilions. Doctor Downing recalled that 'originally intended for the visits of the Chinese gentry, [the gardens] are now considerably modified in accordance with European taste, to suit the wishes of the foreigners. Every enclosure, to which any person may have access by the payment of a trifling sum of money, is arranged somewhat in the style of the tea-gardens in England. The accommodations are in every respect

convenient and the ornaments highly picturesque and delightful. The pro-
prietor of each little plot of ground dwells in a small building facing the river,
and when a party of gentlemen arrives, they are ushered into one of the
rooms which extend in ranges on each side of the gardens. ...In these cool
retreats, the host prepares refreshments in a superior style, and tea and
coffee usually finish the repast.

'The garden-beds', Dr Downing continued, 'are filled with plants, laid
out in rows, or placed in elegant pots, ready for transportation. Many of
them display flowers of the most brilliant colours, or fill the air around
with grateful odours. ...Beyond, at the further end of the garden, groves of
fruit trees and flowering shrubs are separated from each other by gravel
walks, having seats and arbours at regular intervals, so as to form pleasantly-
shaded promenades.'[10]

Ornamental evergreen shrubs cut in
the shape of dragons and lions, men and
women, with artificial hands and feet
cunningly attached, never ceased to amaze
the foreign visitors. Potted plants had their
branches trained to form the Chinese
characters for happiness and long life, and
bamboo was bent to writhe in serpentine
curves (Fig. 10.3). Nurseries were full of
exotic blooms, bonsai, and bushes of camel-
lias, azaleas, and hibiscus, surrounded by
orchards of oranges, pomegranates, pome-
los, and carambola. Many kinds of seeds
and young plants were carefully carried
back to the West, where the new species
were introduced to great acclaim.

On a much larger commercial scale
were the nurseries for the culture of jasmine.
Jasminum grandiflorum had been introduced
from India, and by the late eighteenth cen-
tury fragrant jasmine gardens extended
many miles along the Pearl River. Flower
buds due to open that day were gathered
before dawn and covered with damp cloths.
Flower sellers from across the river bought

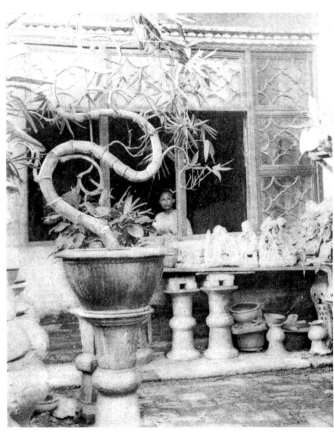

the buds and took them back to the city, where hundreds of workers strung
the jasmine into head-dresses and lampshades, the human warmth or heat
from the lamp causing the perfume to unfold. The flowers were also used in
the making of perfume and cosmetics, and to scent food, wine, and other
drinks, particularly tea leaves.

FIG. 10.3 A pot of bamboo in a
nursery on Fati, trained into a
serpentine form; 1900.

Despite these pleasant diversions on Fati, there was much work to be done back on Honam. Along Chau Tau Street, which runs south and parallel with the western shoreline of the Macau Passage, there were several factories where tea was prepared for export. These were large lofty buildings of one floor divided into several rooms, some for firing or sorting tea, and others for weighing and packing. Women and girls sat with circular rattan trays on their laps, picking over harvested tea and removing stems (Fig. 10.4), before the leaves were winnowed and baked over a charcoal fire. After the tea was weighed, coolies trod it into lead-lined chests, each containing twenty pounds (about 9 kilos) (Plate 32). The chests were then soldered to make them airtight and the necessary identification and description was pasted on before inspection and shipment.

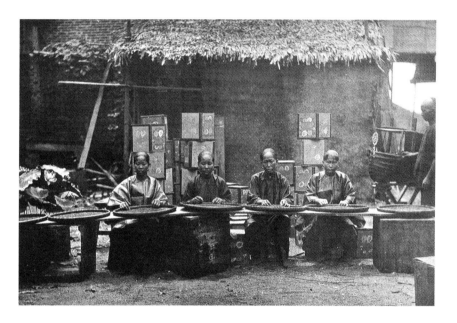

FIG. 10.4 Women sorting tea leaves in circular rattan trays; photograph by John Thomson, c.1873.

At the southern end of Chau Tau Street was the Cheung Loong Company, which manufactured matting from reeds grown in the countryside around Canton. The matting was wrapped around the tea chests and protected the tea on the long sea journey by absorbing the moisture, keeping the tea fresh. It was also produced in many designs and colours for use as flooring, and more than 100,000 rolls, each measuring 36.5 metres, were exported each year to the United States (Fig. 10.5).

Two of the warehouses have survived and stand at the corner of Tongfu West Road and Zhoutou Road. Built of brick but painted white, both have towering columns reaching up to a terracotta tiled roof, supported by a network of pine beams. Square windows around the walls, and small circular windows high up at each end, let in a little light. The bigger of the two, a huge

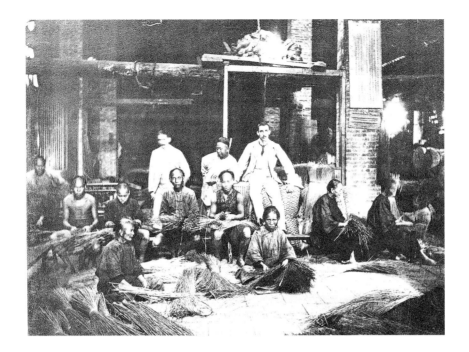

FIG. 10.5 A Western businessman seated on a bale of woven matting, surrounded by Chinese workers; photograph by John Thomson, c.1873.

FIG. 10.6 An advertisement for the Chyloong ginger factory on Honam; 1904.

cavernous building, surely once the Choy Sang tea hong, the largest tea hong in Canton, is now a car repair centre; the other is used as a godown. Further down the river more old warehouses front both sides of the Macau Passage.

Another important export beginning in the middle of the nineteenth century was preserved ginger, much of it produced by the Chyloong ginger factory in Outer Ngo Chau Street (Fig. 10.6). At the time, the street fronted onto the Pearl River, but with recent reclamation it is one of a myriad of small streets inland from Binjiang West Road, now a six-lane thoroughfare. Shoots or stems of ginger were steeped in vats of water for four days, the water being changed once during that time. They were then removed from the vats and spread on wooden tables, where workers pierced the shoots in several places with sharp bodkins. After being boiled in a copper caldron, the shoots were placed in a vat of water and rice flour for two days, then for a short time in a trough filled with water and lime obtained from cockle shells (Fig. 10.7). Finally, they were reboiled in a mixture made from a picul of ginger to a picul of sugar that had been purified by passing it through the whites of eggs. When cold, the stems of ginger were packed in porcelain jars painted with blue and white designs of plum

CHYLOONG,

DEALER IN SWEETMEATS, SOY

AND

ALL KINDS OF CANTON PRESERVES.

Outer Ngo Chau Street.

HONAM, CANTON,

NOTICE.

An attempt has been made by a person in *Hongkong* to palm off upon persons purchasing sweetmeats for Export an inferior article upon which he places my name, in order to deceive those who may purchase: thereby injuring my former reputation. This is to inform my old customers that there has been no change made in my manufactures and that my sweetmeats can be obtained at no other place than where it has been made for the past 100 years, at above address. Persons residing abroad should be particular when giving orders, to purchase no others which bear my name, as they are of inferior quality.

(*Signed*) **CHYLOONG.**

Canton, 20th April, 1904.

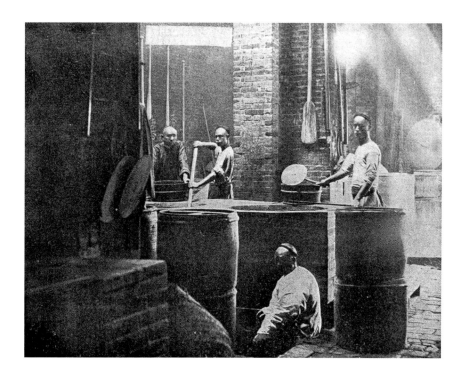

blossom. The ginger factory, which occupied the same premises for over a hundred years, has long gone but the jars themselves became treasured ornaments once the contents had been eaten, and preserved ginger is still a delicacy exported from China today.

Workshops, which had previously operated in the streets around the factories, followed the foreigners to Honam, and a street parallel with the river and running south of a small canal was lined with shops selling the kind of curios previously found in Old China and New China streets. Hoaching, 'whose ivory-carvings are superior to everything that has been attempted in this branch of art',[11] had a shop here run by his two sons. Other favourites were Khe-cheong the silversmith, and Hipqua's lacquerware shop, whose stock included tables, tea-poys, desks, work-boxes, and cigar boxes. Hung-cheung and Lee-ching were both renowned for their exquisite jewellery, the latter having several other shops in Canton. The painter Lamqua had a studio on Honam, and beautiful silk gauzes and damasks could be purchased from Yancheong.

The street later developed into Nanhua West Road, where many three-storey *qilou* (overhead structures) were built with pavement-wide first-floor canopies in a continuous corridor to protect pedestrians from the sun and rain. More shops on what is now Hongde Road, running south from the Red Fort, sold inexpensive crockery and glass especially made for the Western market. Off at the eastern side was the lane the foreigners called Furniture

Street, where several cabinetmakers made European styles in mahogany and rosewood. Pockets of old Canton still survive between here and Tongfu West Road, with narrow granite-paved streets, many of whose houses still have sliding wooden bars across the doorways to allow fresh air to enter and to keep undesirables out.

The Chinese population on Honam continued to grow and by the end of the century it had reached about two hundred thousand inhabitants. As well as the Hai-chuang Temple, worshippers had been drawn to the temple dedicated to the goddess of mothers and children, Kam Fa, since the Ming dynasty, especially on the dcity's birthday, the seventeenth day of the fourth month of the lunar calendar. The temple, near the Red Fort and opposite the factories, was rebuilt in the early years of the Qing dynasty and restored several times in the nineteenth century. Within the temple were gilded images of Kam Fa and her twenty attendants, each the guardian of a different stage of childhood. Around the ridge beams of the green tiled roof were countless small ceramic figures portraying scenes from folklore.

For local entertainment a Chinese theatre was erected in 1890, with seating for 1,500 people. Performances of Cantonese opera, also called Yue opera, after the formal name of the province, lasted from 11 a.m. to 6 p.m., and then began again at 8 p.m., continuing through the night. A full company of 150 players was engaged; as no women were allowed on the stage, young men played the female parts (Fig. 10.8). Street theatricals also took place throughout Canton at festival times, paid for by public subscription. Matsheds were erected where the performances took place, as they are in

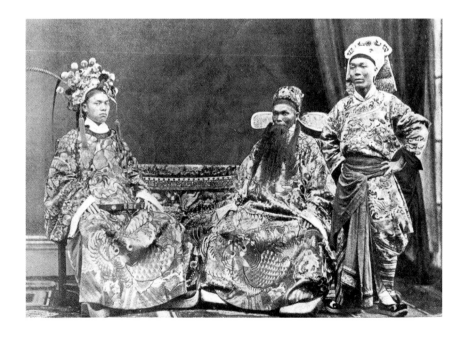

FIG. 10.8 Actors dressed for a performance of Cantonese opera; photograph taken in a studio thought to be that of William Floyd, c.1870.

Chinese communities today. Troops of actors, attired in sumptuous gowns representing those of earlier dynasties, were hired to perform scenes from court life and battles between Celestials and Barbarians, accompanied by drums, gongs, and the shrill falsetto of the principal actors speaking the Nanjing, or old court, dialect of the Ming dynasty.

The abolition of Canton's monopoly in foreign trade had led to the development of a maritime customs regime administered under an inspector general. In 1859 the Imperial Maritime Customs was established at Honam; its deputy commissioner was the young Robert Hart, later to become Sir Robert Hart, the Inspector General of the Chinese Imperial Customs in Beijing. Under Hart's tenure, the maritime customs, and its system of exact report of revenue from foreign shipping, became the one dependable and substantial source of revenue for the Manchu government. Native Chinese customs stations came under the control of the Imperial Maritime Customs in 1901. In 1904 there was a customs bureau opium gowdown on Chau Tau Street, where duty-paid opium was stored for re-export or transit into the interior.

The Customs Club had been operating on Honam since the 1860s, providing accommodation and entertainment for the lower ranks of officials in foreign trade, such as tide-waiters, the customs officers who boarded the ships on arrival, and consular constables. By 1918 the club had relocated to the new customs building at the tip of Honam Point, facing the river near where ferry boats leave today for other parts of the province. Now inland and hidden from view along an alleyway off Tongfu West Road, the majestic three-storey yellow and brown painted building with its arched windows and columns is decorated with white stucco work and shields. Behind, on Signal Hill, a flag was raised to salute incoming ships; today a television mast and transmitter stand in its place (Fig. 10.9).

The only accommodation for visitors on Honam in the 1870s was the Canton Hotel, near Outer Ngo Chau Street and the Kam Fa temple, run by a Portuguese named A. F. do Rozario, who spoke little English and held a monopoly not to the advantage of travellers. Although said not to suit 'fastidious folk', the hotel was conveniently placed on the water's edge, so guests could disembark from a sampan onto steps which led directly into the hotel. In that same period, a racecourse provided entertainment for the lower ranks of officials. Paddy fields near the Baiyun Mountains had been the venue of the first pony races started while the city was under Anglo-French military rule in the late 1850s, and they continued there after the resumption of Chinese civil government. An ugly incident occurred in 1870, however, when an attempt to combine a race meeting with a boat excursion led to the foreigners being stoned by hostile natives. As a result, the races were relocated to Honam, considered safer than the previous site, and the first recorded meeting was in December 1874, again on cleared rice fields.

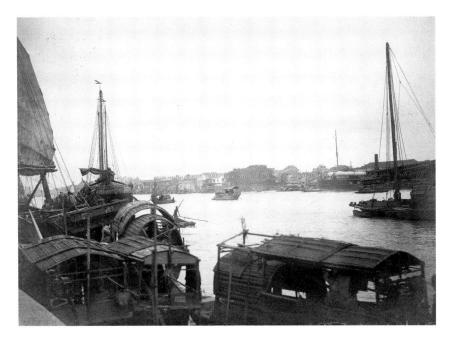

FIG. 10.9 Looking across to the shoreline of Honam with the Customs House and Signal Hill; photograph by Afong Lai, c.1880.

A small hill in the centre of the 900-metre race track hid the ponies and riders from view midway through the race, which added greatly to the excitement. The races were an annual event on the island and many owners brought their jockeys and ponies up from Hong Kong for the race meeting.

When the artificial island of Shamien was established after 1862, many traders gradually moved across the river to it. Once access to the walled city was possible and movement no longer confined to a small area, visits to Honam and Fati became less desirable. Guide books published in the 1870s still devoted much space to the Ocean Banner monastery and the Fati flower gardens, but by the end of the nineteenth century the mentions were reduced to a handful of pages at the back of the book. Today a few nurseries survive on Fati, but modern residential blocks rise over Fong Tsuen district to house the ever-increasing population. The heyday of Honam and Fati is over.

ENDNOTES

¹ Albert Deacon had arrived in Canton in 1852 to join Augustine Heard, William Low's one-time partner at Russell & Company, who had set up an independent office. Six years later Albert resigned to start his own business, trading in tea with his elder brother James. Albert and Kate Deacon's daughter was born on Honam in 1859, one of the few British children to be born there. Their infant son Fredric had died the previous October and is buried in the New Protestant Cemetery in Macau.

2 *Lingnan Science Journal* Vol. 10 (August 1931): p. 154.

3 Henry Ellis, *Journal of the Proceedings of the Late Embassy to China*, London: John Murray, 1817, p. 407.

4 Ellis, 1817, p. 420.

5 S. Wells Williams, *The Middle Kingdom: A Survey of the Geography, Government, Education, Social Life, Arts, Religion etc. of the Chinese Empire and Its Inhabitants*, 2 vols., New York: Charles Scribner's Sons, 1895, reprint, New York: Paragon Book Reprint Corp., 1966, Vol. 1, pp. 164–5.

6 Ellis, 1817, pp. 416–18.

7 Howard Malcom, *Travels in Hindustan and China*, Edinburgh: Chambers, 1840, p. 48.

8 W. C. Hunter, *Bits of Old China*, London: Kegan Paul, Trench & Co, 1885, p. 81. Quote drawn from a letter dated 11 April 1860.

9 Hunter, 1885, p. 8.

10 C. Toogood Downing, *The Fan-qui in China*, London: Henry Colburn, 1838, reprint, Shannon: Irish University Press, 1972, Vol. 3, pp. 204–6.

11 Wm. Fred. Mayers, Dennys, N. B., & King, C., *The Treaty Ports of China and Japan: A Complete Guide to the Open Ports of those Countries, together with Peking, Yedo, Hongkong and Macao. Forming a Guide Book & Vade Mecum for Travellers, Merchants, and Residents in General with 29 Maps and Plans*, London: Trubner and Co, and Hong Kong: A. Shortrede & Co, 1867, p. 182.

11

A European Refuge:
The Island of Shamien

The accommodation on Honam was only ever viewed as temporary by the British, and there was much pressure on Sir Harry Parkes, Acting British Consul in Canton, after the disruptions of the late 1850s, to find a permanent place for them to settle. Somewhere more in keeping with their increased power and status was needed, this time well away from the Chinese hoi-polloi but with plentiful servants and all the comforts of home. Finally in 1859 a sandbar, to the west of where the factories had stood, was selected by Sir Harry and leased from the Chinese government to become the artificial island of Shamien. Surrounded by water, and with gates on the bridges to keep the Chinese out, the presence of the settlement was in retaliation for all those years of being excluded from Canton's walled city, yet at the same time was itself as restricting as the earlier arrangements had been.

The sandbar seemed a wise choice, for it lay close to the Western Suburbs, where the Chinese merchants lived and whose business with the foreigners was long established. There was a safe anchorage for steamers, and it benefitted from the cooling winds drifting up the Macau Passage. The remains of two old forts, various rickety boats, and shanty houses were removed, and the inhabitants evicted. Obliged by treaty to offer a substitute for the factories, the Chinese government assisted in the formation of the site. Between 1859 and 1862 the mud flats were filled in and a granite wall

erected to form an island, taking the shape of a half an egg. The cost of building was variously estimated to be between $280,000 and $325,000 (approximately £70,000 to £81,250), of which four-fifths was borne by the British government out of the indemnity negotiated from the Chinese. The British allowed their allies, the French, to have the remaining fifth as reward for their assistance in the recent hostilities, but the amount of French trade in Canton was quite small and their representatives did not join the British on Shamien until much later.

Other nations were not included at first, and so the Americans decided to rebuild on the old factory site, which had become the haunt of quack doctors, gamblers, and other ne'er-do-wells. By the early 1870s two American trading firms, Russell & Company and Smith, Archer & Company, occupied an elegant two-storey building set in spacious grounds enclosed by a high wall, and this became the American concession ground. Smith, Archer soon folded, and Russell's later went through hard times, having suffered losses in the American Civil War, and their business in Canton came to an end in 1891.[1] Today, pleasure grounds known as the Wenhua Cultural Park cover the site, providing entertainment for young and old.

The island of Shamien measured 2,850 feet (almost 900 metres) long, about two and a half times the length of the old factories site, by 950 feet (300 metres) wide, and was separated from the Western Suburbs to the north by a narrow canal. Two bridges linked the island to the mainland, the English Bridge in the centre of the island, and the French Bridge to the east. A path ran along the shoreline: on the northern side it was known as Canal Street (now Shamian North Street), and on the southern side, by the river, as the Bund or Esplanade. Parallel to Canal Street, in the centre of the island, was the wide Central Avenue (Shamian Main Street), and south of that was Front Avenue, at one time called Garden Road (Shamian South Street). Five short roads crossed the avenues at right angles, the fifth, on the eastern end, delineating the boundary of the English concession from that of the French.

The site was divided into six blocks on the north shoreline, and five in the central part (Fig. 11.1), the total being sub-divided into eighty-two lots. Six lots, comprising one block in the middle of the central portion, were reserved for the British consulate. At the west end of the central part a small triangular single lot was set aside for an Anglican church. The remaining seventy-five lots were put up for sale at a public auction on 4 September 1861. Parkes, in a letter to his wife some days later, wrote that he was greatly relieved for, despite some opposition from the merchants, 'the first day's sale showed a very good result. The Parsees bid right royally against our first-class merchants for front lots.' Fifty-five lots were sold by the second day, and so, Parkes concluded, 'Shamien may now be considered a complete success.'[2]

Initial development of the island was slow, however, as not all merchants wished to move across from Honam. At first only the church and

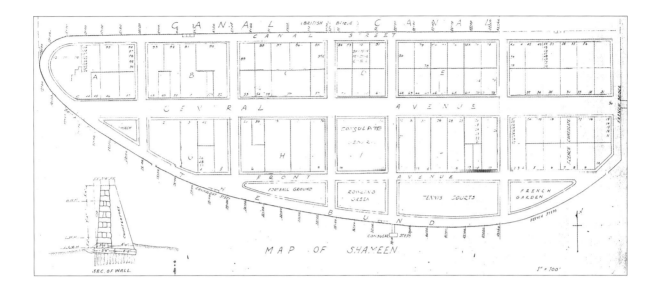

parsonage, plus residences for three private companies, were built. The Anglicans' Christ Church was erected on Front Avenue between 1864 and 1865 (Fig. 11.2), paid for by the proceeds of an indemnity fund compensating for the loss of a church on the factory site. Sunk into the turf of the southern boundary wall was a granite tablet, now no longer there, retrieved after the factories were destroyed and giving the exact geographical position of the factory site as fixed by HMS *Rapid* in 1853. There was a resident chaplain at the parsonage and the church could hold some 120 worshippers, although the total number of foreigners, not including women and children, was half of that, down from over 300 in 1856. With its plain whitewashed interior, the church draws a full congregation today for the Sunday morning services conducted both in Cantonese and English.

The reduction in numbers in the 1860s was due to a lessening of Canton's importance as a trading post. This was brought about, in part, by the opening of more treaty ports in China: by 1870 there were fifteen and six years later, a further five. Three of the original ones, Ningbo, Fuzhou, and Xiamen, grew slowly, but the fourth, Shanghai, quickly succeeded, as it was close to the heartland of tea and porcelain production and the steadily developing silk manufacturing industry.

The buildings for the British consulate were erected on Shamien in 1865 and occupied by the junior members and

FIG. 11.1 Plan of Shamien island showing the division of lots in the two concessions, *c*.1920s.

FIG. 11.2 The Anglican church on Shamien; photographed *c*.1907.

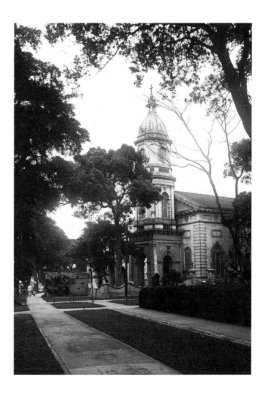

staff, who moved over from Honam. The British consul, Sir Daniel Brooke Robertson, continued to live in the rear half of the Tartar General's yamen to maintain a political presence in the Old City. The French consul likewise took up residence in the Treasurer's yamen. Those who needed to see either consul in person travelled by sedan chair through the walled city, an hour's ride from Shamien. Both consuls and their families were isolated from the European community, living within an often hostile Chinese community, although Sir Brooke claimed he enjoyed the distance from his countrymen for the quiet reading and contemplation it afforded him.

A group of residents in the English section formed the Canton Garden Fund in 1864 and organized the planting of several hundred trees, including many varieties of fruit trees. These were full of singing birds: wild pigeons, doves, thrushes, and blackbirds. Broad walks were shaded by banyans, while handsome brick houses and a bicycle track gave the appearance of an English suburb (Fig. 11.3). The tranquillity of the island and the convenience of its location drew more businesses away from Honam, although they continued to use the warehouses there for weighing and packing their teas. A municipal council was founded in 1871 to manage the affairs of Shamien; its duties included the collection of rates and taxes, and the preservation of law and order. A police superintendent was appointed and the following year a fire engine purchased. Improvements to living conditions continued when gas lighting arrived in 1887 and electricity was introduced in April 1892.

The French section remained unoccupied for nearly thirty years until 1889, when a number of lots were sold and built on, including the construction

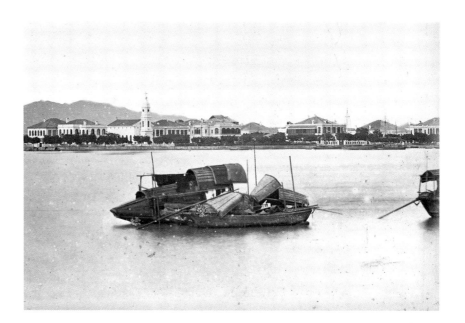

FIG. 11.3 A view of Shamien showing the Anglican church and European-style mansions along the Bund; photographed by Afong Lai, *c.*1880.

of a pretty little Roman Catholic church still in use today (Plate 33). There was an imposing French post office (Plate 34), the French bank, Banque de l'Indochine, and a French consulate erected in 1890. A public garden was laid out, complete with a bandstand. The French formed their own municipal council, with its own bylaws and police force, and unlike the prosaic street names of the British concession, 'the names of the streets, such as the *Rue de la Fusée*, the *Rue de la Dordogne*, and the *Rue de la Charente*, recall the vessels once manned by the brave sailors who had for a brief time sojourned in this remote Chinese town'[5] Visitors stayed at the Hôtel de la Paix, which took over business from the Hôtel des Colonies, under Portuguese management. The resident French population in the French concession was always very small, however, even though at least one trading company, Vaucher Frères, moved across from Honam, while maintaining a branch in Hong Kong from 1855 to 1890.

Coastal steamers brought visitors and businessmen from Hong Kong and elsewhere, anchoring alongside the island in the English section. There were several sets of steps for embarking and disembarking that faced the mainland, remains of which are still there, leading into the now stagnant water of the canal. Another set of landing steps on the Bund, for larger vessels, were known as Deacon's Steps, as the offices and godown of the trading firm Deacon & Company were immediately behind them. After residing on Honam, Deacon's moved across to Shamien, where it first occupied imposing premises on Front Avenue, near to the Anglican church, later operating from Central Avenue (Fig. 11.4). The company eventually diversified from tea and established import–export business in many major cities in Asia including Hong Kong, where it continues to prosper. Both of their original office buildings still stand on Shamien, but a five-star hotel, the White Swan, was built on reclaimed land where the landing steps once stood.

All across Shamien, large two-storied houses in the classical Italianate style were built with deep verandas, each with its own garden. As with the factories, these combined office and warehouse on the ground floor with residential accommodation for senior personnel above. Furnished in the English style, the houses were spacious and cool in the summer, but they could be chilly in the winter. The head office of Jardine, Matheson had moved to Hong Kong in 1841, but the company retained a 'beautiful house' on Front Avenue. The traveller and writer Isabella Bird stayed there in 1879, noting that 'all the business connected with tea, silk, and other productions, which is carried on by such renowned firms as Jardine, Matheson, and Co., the Dents, the Deacons, and others, is transacted in these handsome dwellings of stone or brick, each standing in its tropical garden, with a wall or ornamental railing or bamboo hedge surrounding it, but without any outward sign of commerce at all. The settlement, insular and exclusive, hears little and knows less of the

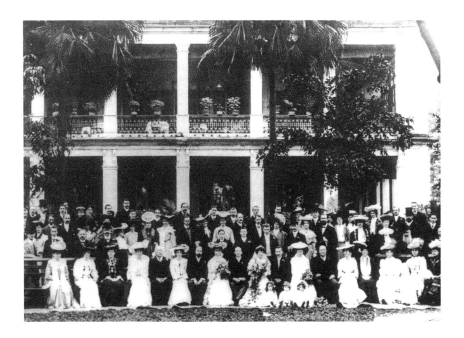

FIG. 11.4 The wedding party of Harold Staples Smith outside the offices of Deacon & Company on Shamien in April 1906.

crowded Chinese city at its gates. It reproduces English life as far as possible, and adds a boundless hospitality of its own, receiving all strangers who are in any way accredited, and many who are not.'[4]

The Parsee merchants who had bid so keenly for the front lots were well established on the island. Beginning in 1794, Cowasjee Pallonjee & Company had a branch in the Canton factories that dealt in opium, spices, and silk. Their three-storey headquarters on Shamien occupied the first lot in the French concession facing the river. The business had failed by the early 1920s, although the building remains. D. Sassoon Sons & Company occupied a large property on Front Avenue. The firm's founder, David Sassoon, was born in Baghdad in 1792 and was the first Jewish trader to settle in the factories in the 1840s. From the opium trade, the firm gradually diversified into shipping, banking, and real estate.

Representatives of other nations were eventually admitted onto Shamien. By 1873 there were ten consulates, including that of the United States, as well as the Portuguese and Dutch, although the Danish consul continued to use the services provided by Jardine's. Major banks gradually opened in imposing classical-style buildings on Central Avenue, such as the Chartered Bank of India, Australia and China, the Bank of Taiwan, and the National City Bank of New York. The Hongkong and Shanghai Banking Corporation (HSBC), today a major institution world-wide, first set up a sub-branch in Canton in 1880, then handsome premises were opened on Central Avenue, across from the Chartered Bank, on 29 October 1921 (Fig. 11.5).

By the early years of the twentieth century, alongside the big companies were numerous small businesses, many of them run by Parsees or Indians. Pohoomull Brothers (India), in the French concession, was typical of these, for they were, as their advertisements announced, 'Exporters of shawls, jade, curios, silk piece goods and drapers.' Most of these companies dealt in raw silk or silk products, since much of the tea trade had by this time moved elsewhere. Many others were commission or shipping agents handling such exports. They operated from smaller premises tucked away in terraces off the side streets, or in Kussra Terrace off Canal Street in the French concession, which is still there today.

To serve the needs of the inhabitants of Shamien, a number of businesses opened dealing in daily necessities. Milk was provided by a dairy farm established in 1893 in the British section, but in 1909, after several cows died of 'cattle plague', the farm moved across to Pak Hok Tung (White Crane's Nest) on Fati. The farm relocated again after the same misfortune occurred, but with the establishment of the Dairy Farm Company in Hong Kong there was less demand. The Canton Dispensary operated in Canal Street next to the English Bridge, where a pharmacy still operates in the same building. The dispensary was taken over by Alexander Skirving Watson, whose uncle had been the noted physician, Dr Thomas Boswall Watson of Macau, Chinnery's doctor and himself a painter of some repute. In 1902, A. S. Watson and Company opened a condensing and aerated water plant on Shamien. Today, the company is part of the Hutchison Whampoa Group in Hong Kong. Their shops, a mixture of dispensary and small supermarket, are in many large cities in China and South-East Asia.

Recreation for businessmen and their families, who could now join them, was much improved after the poor facilities of the factory days. The Canton Club opened in premises in Central Avenue in 1868, supported by subscriptions and the interest from an indemnity fund. It had a library, reading rooms, and a billiard room, and meetings were held there to decide matters affecting the upkeep of the island. Unlike the Customs Club on

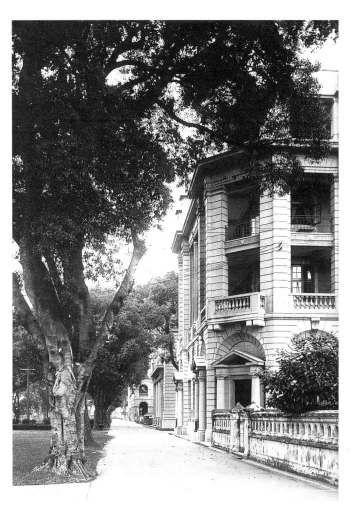

FIG. 11.5 The Hongkong and Shanghai bank building; photographed c.1921.

Honam, the Canton Club was for the élite of the foreigners' society, the consular officials and leading traders on the island. Consular Chaplain, the Reverend John Gray, was its Honorary Librarian, and Theo Sampson, head of the Chinese government school, as well as being the government's emigration agent, was the Honorary Secretary and Treasurer.

Guest speakers entertained the residents at social evenings held at the Canton Club, such as one that took place on 31 January 1873, when the American tea trader Gideon Nye told of life in the factories, forty years before, in a the first of a series of lectures nicely titled 'The Morning of My Life in China'. The club's beautiful stained-glass windows still survive intact today. There was also a Masonic hall, and amateur dramatics took place at the Concordia Hall, the theatre for Shamien, built with funds from the compensation for Queen's Garden when it was destroyed along with the factories. The acting, however, is said to have been often rather poor, and the theatre could be very cold and draughty. An indoor swimming pool opened on Canal Street in 1887 and remains in use today.

Between Front Avenue and the Bund was a public garden, shaded by leafy banyans, and a football pitch (**Figs. 11.6 and 11.7**). At the east end of the public garden was the Shamien Lawn Tennis Club and Croquet Lawn, which opened in August 1877. The tennis club was the pride of the British concession, producing many champions in the Far East, and the envy of foreign residents throughout South China. A number of stables were built for the horses raced on Honam, the last being erected on Shamien in August 1890, after which the meetings transferred to Hong Kong, where racing had become well established.

Families went pony riding in the evenings and took picnics in boats up little creeks off the Pearl River. The Canton Regatta Club had been estab-

FIG. 11.6 The Bund on Shamien, alongside the Pearl River; photographed *c*.1920.

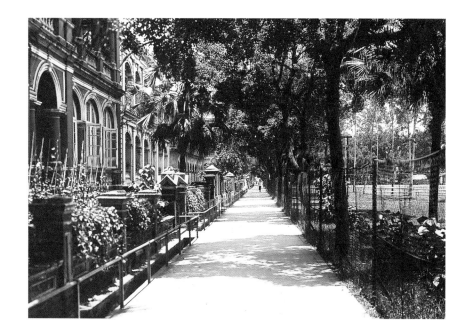

lished back in 1837 by residents of the factories, but the outbreak of war forced it to relocate to Hong Kong soon after. Revived again when the hostilities ended, the annual regatta became a high point on the social and sporting calendar of Shamien. There was keen competition between the hongs on the island and various rowing clubs from Hong Kong. The Regatta Club's centenary was celebrated on Shamien in 1937.

Security was tight around the island. Chinese gunboats of the Imperial Maritime Customs, under foreign commanders, were stationed around the island to protect the residents. Guards stood at the two bridges, preventing Chinese from crossing unless they had a pass. No Chinese were allowed to own property on Shamien nor even to sleep there as guests. They were only allowed to reside on the island as servants, with a ratio of about three servants to every one foreigner.[5] At 9 p.m. the gates to the two bridges were locked (Figs. 11.8 and 11.9) and the curfew announced by the sound from a very long horn. Wesleyan missionary John Turner, who spent five years in and around the city from 1886, described the process: 'This [horn] the watchman raises up and down as he blows, thus giving a very weird crescendo and diminuendo effect to its deep sounding note. It is blown for several minutes in this way, together with the measured beating of a leather drum, graduated from very slow to very fast, and so back again by degrees to very slow. When the horn reaches its softest vanishing tone, and the drum its lowest dying rap, a cannon startles all the air with its loud report. This curious process is repeated three times.'[6]

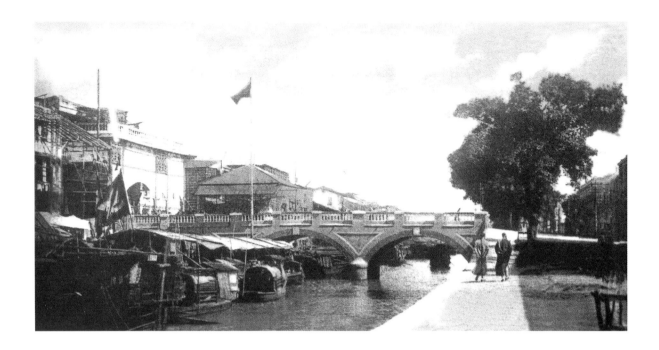

FIG. 11.8 The English, otherwise known as West, Bridge, leading to the Western Suburbs; photographed c.1890.

In spite of security precautions, problems did occur. In 1883, strong anti-foreign feeling arose in Canton after an incident at one of the steamboat wharves when a Chinese man was shot in a drunken brawl, and another died falling from the British paddle-steamer *Hankow* between Hong Kong and Canton after being kicked by a Portuguese ticket collector. This incident resulted in a serious riot on Shamien on 12 September. The Western population abandoned the island on two large river steamers, leaving the incensed mob to loot and burn fourteen large houses, including Concordia Hall.

Peace returned, however, and with its familiar and comfortable European flavour, Shamien attracted travellers from all points of the globe. Visitors arrived daily by boat, a trip of about seven hours from Hong Kong and a little less from Macau. The Shamien Hotel opened in May 1888 to accommodate them, built on the site previously occupied by Concordia Hall and conveniently situated in the centre of the island close to the English Bridge. It was renamed the Victoria Hotel in November 1895 in honour of the reigning British monarch, the only British-owned hotel in Canton and notorious for its dismal food (Fig. 11.10). The proprietor, one William Farmer, later bid, and lost out, on renting the Boa Vista Hotel in Macau (later called the Bela Vista Hotel) in 1903.[7] An ambitious man, Farmer was also, by the 1920s, the owner of a merchant's and shipping agency based on Shamien.

The Victoria Hotel provided guests eager to go sight-seeing with sedan chairs and guides. The chairs, one for the traveller, one for the guide, were carried on the shoulders of the bearers, in front and behind, who moved at

a loping half-trot, the skin on their necks hardened and calloused by the countless loads they had carried. The supporting poles were attached to the chair nearly two-thirds from the top so the passenger sat up high, behind the closed door, stifled by the heat, and peering out through small curtained windows. Guests were carried across the small canal bridges and through the crowded, noisy, narrow streets of the suburbs and the city. Foreigners had been forbidden to travel in sedan chairs, or on horseback, until the middle of the nine-teenth century, so a ride around the path on top of the city walls became a popular three-hour excursion.

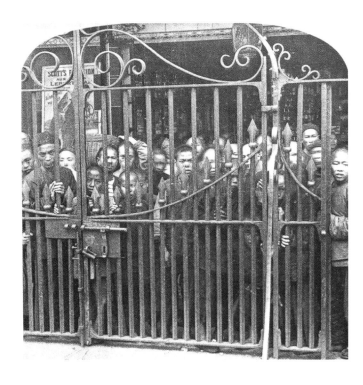

The general public travelled in sedan chairs made of bamboo and covered with dusty black oil-cloth carried by two or three groaning bearers (Fig. 11.11). Wealthy mer-chants and lower-ranking mandarins sat in smart four-bearer chairs covered with blue cloth and decorated with braid and tassels, while high officials had eight bearers. Some private companies had liveried bearers, the number increasing with status, and ten per chair was not uncommon. Rickshaws were introduced into Canton in the late nineteenth

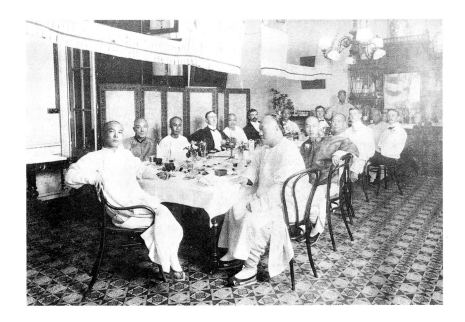

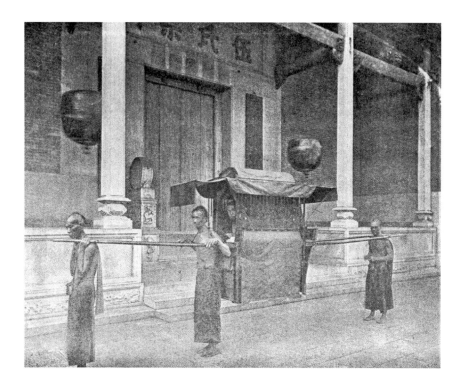

FIG. 11.11 A public sedan chair carried by three bearers; *c*.1900.

century for public use on flat ground, although there was little space for them in the crowded streets of the walled city, and sedan chairs continued to be the conveyance of choice.

Local guides were essential for apprehensive new arrivals. One, whose name became a byword in Canton, was Ah Kum, who had been a servant of Reverend Gray for many years and whose English was considered good. The Reverend was a great authority on all matters of local interest, especially Chinese rites and customs, and had passed his knowledge on to Ah Kum, and his successive generations. Francis and Harriet Clark were glad of Ah Kum's assistance on their visit in the 1890s: 'He not only knew everything in Canton, but could speak intelligent English to explain to us what we saw. He knew how to keep the land sharks who snap at every innocent traveller away from us, and though he doubtless piloted us to stores which paid him a good commission, he would not let us pay more than twice what a thing was worth, even to his friends.'[8]

A particular advantage of a guide meant safety from the jeering crowds, who would hurl both insults and worse at foreign tourists. The walled city, when at last opened to foreigners, was a big draw, and guides were essential for visitors fearful of getting lost and never finding their way out. Said Rounsevelle Wildman, the United States consul-general from Hong Kong, on a visit in 1900: 'There is no such thing as a straight line, or a chance to take

your bearing from the sun. It is a bedlam, a babel, a chaos, a lunatic asylum, in one, and yet everyone is going sedately about on his own business. The first day I said I could wander forever through these wonderful thorough-fares; the second day my ears ached, and my brain was dizzy. I was glad to return to the European city of refuge, Shameen.'[9]

ENDNOTES

[1] A clerk in Russell's, Englishman Robert Shewan, took over, and in 1895 Charles Tomes was admitted as partner, the company being renamed Shewan, Tomes & Company. The business of the new firm included shipping, insurance, import–export, and serving as manufacturing agents. It was acquired by the Hong Kong company Wheelock Marden in 1951 and in the 1980s absorbed by the Hong Kong group Hutchison Whampoa.

[2] Stanley Lane-Poole, *Sir Harry Parkes in China*, London: Methuen & Co, 1901, reprint, Taipei: Ch'eng-wen Publishing Co, 1968, pp. 279–80.

[3] Edmund Plauchut, *China and the Chinese*, trans. Mrs Arthur Bell, London: Hurst and Blackett, 1899, p. 51.

[4] Isabella L. Bird, *The Golden Cheronsee and the Way Thither*, London: John Murray, 1883, pp. 44–5.

[5] According to a census taken in 1911 there were 323 foreigners, including 165 British, and 1,078 Chinese staff living on the island. Carl Smith Index file, Public Records Office, Hong Kong.

[6] J. A. Turner, *Kwang Tung or Five Years in South China*, London: S. W. Partridge & Co, 1894, p. 24.

[7] Farmer went on to buy a hotel on a corner of the Praia Grande in Macau and named it the Macao Hotel. The Bela Vista Hotel, overlooking the Praia Grande, became the home of the Portuguese consul after Macau was returned to China in December 1999.

[8] Rev. Francis E. Clark & Mrs Harriet E. Clark, *Our Journey Around the World, an Illustrated Record of a Year's Travel*, Hartford, Conn.: A. D. Worthington, 1895, pp. 164–65.

[9] Rounsevelle Wildman, *China's Open Door: A Sketch of Chinese Life and History*, Boston: Lothrop Publishing Co, 1900, p. 237.

God and Mammon

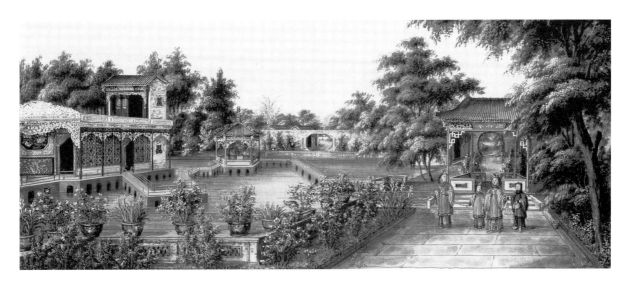

12

Made in China:
Shopping in the Suburbs

The growth of a wealthy population on Shamien, together with the number of foreign visitors who arrived in Canton in the late nineteenth century, caused the Chinese businesses in the Western Suburbs to flourish. There was much across the English Bridge to amaze and tempt the wide-eyed visitor, just as the infamous Qing Ping market does today, with its stalls selling tobacco, Chinese herbs, dried mushrooms, and fish, and the busy covered wet market with many exotic and endangered species on sale.

The curios so beloved of the early traders continued to be produced in the streets around where the factories had been, although several craftsmen, especially silversmiths, had relocated to Shanghai and Hong Kong. With the advent of the camera, there was less demand for the rice-paper paintings of the factory days, and photographers' studios opened in their place. Afong Lai, one of the best known of the Canton photographers, and his descendants, operated studios from the 1850s to 1941, with branches also in Hong Kong and Shanghai. In 1932 their Canton studio was at 224 Shakee Ma Loo (Canal Road), conveniently opposite Shamien.

To assist visitors in finding their way around the city and suburbs, *The Canton Directory*, written by American missionary doctor John Glasgow Kerr, was indispensable. First published in 1873, and revised several times with slightly different titles, Kerr's guide was based partly on Reverend Gray's

141

The following is a *list of objects of more or less interest to Strangers —*

INDUSTRIES. —

Silk Weaving.	Gold Beating.
Silk Embroidery.	Tobacco Cutting.
Ivory & Sandalwood Carving.	Idol Factory.
Block Cutting & Printing.	Flour Mill.
Painting Lacquer Ware.	Preparing Salted Ducks' Eggs.
Painting Porcelain.	Hatching Ducks by Heat.
Mending Porcelain.	Weaving Matting.
Rice-Paper Paintings.	Distillery.
Jade Stone Jewelry.	Pawn Shops.
Cutting & Polishing Jade Stone.	Rice Cleaning.
Tea Sorting & Firing.	Glass Blowing.
Brass & Bronze Casting.	Silver & Gold Workers.

— FOOD. —

Bird's Nest Gelatin.	Soy.
Salted Ducks' Eggs.	Sweet-Meats.
Salted & Dried Meats.	Bamboo Roots.
Sharks' Fins.	Pickles.
Vermicelli.	Bêche de Mer.
Bean Curd.	Blood.
Dog's & Rat's Meat.	Sprouted Beans.

— MEDICINES. —

Wax Pills	Tigers' Bones.
Deers' Horns.	Stalactites.
Petrified Bones	Sea Horse.
Petrified Crabs	Pearls.
Snakes.	Ginseng.
Scales of Armadillo.	Tendons of Deer & other Animals.

— IDOLATRY & IMMORAL PRACTICES. —

Mass in Buddhist Temples.	Ancestral Tablets.
Worship in Shops & Temple of Horrors.	Worship of Ancestors.
	Worship of Tombs.
Buddhist Priests & Nuns.	Paper Money, Clothing, &c., for the Dead.
Taoist Priests	
Idol Processions.	Ta-tsiu or Street Worship.
Gambling.	Festivals.
Cricket Fighting.	Theatricals.
Fortune Telling.	Opium Dens.

— SUNDRY CURIOS. —

Gong.	Vegetable Wax.
Razor.	Coffins.
Wedding Sedan.	Fire Works.
Wedding Head Dress.	Gold Fish.
Betel Nut.	Trial by Torture.
Ladies Small Feet.	Street Gates.
Ladies Boots.	City Wall & Gates.
Ladies Shoes.	Pillows.
Models of Small Feet.	Shoes.
Gum for Ladies Hair.	Musical Instruments.
Old Cash.	Pipes (Opium & Tobacco).
Locks.	Military Weapons.
Official Dress.	Cage for Transport of Prisoners.
Antique Curios.	Instruments of Torture.
Rain Coat	

FIG. 12.1 A list of things to see and do, from the 1889 edition of *The Canton Guide* by Dr J. G. Kerr.

book, *Walks in the City of Canton*,[1] and remains a fascinating memoir more than a century later. Two day-long itineraries were suggested for visitors staying on Shamien, which included a heady mixture of shops, pagodas, and temples, with a trip to the execution ground thrown in for good measure. Kerr also included a list of things to see and do, from 'cricket fighting' to 'instruments of torture' (**Fig. 12.1**). After Kerr's death in 1901, the directory was rewritten and brought up to date three years later (and again in 1918) to include sightseeing trips to the surrounding countryside. Re-titled *A Guide to the City and Suburbs of Canton*, it increased in size to almost a hundred pages from the original sixteen.

No Western maps of the walled city existed until the middle of the nineteenth century, since the city was off-limits to foreigners. Those who ventured in relied instead on a native hand-drawn map with the Chinese characters replaced by Roman letters. A few Western maps were made, based on sightings taken from vantage points on nearby hills. Kerr used one of these in his guide: 'A very good map of the enceinte [was] made by an American missionary, Daniel Vrooman, by taking the angles of all the conspicuous buildings therein, with the highest points in the suburbs; he then taught a native to pace the streets between them, compass in hand (noting courses and distances, which he fixed by the principal gates), until a complete plan was filled out. When the city was opened four years afterwards this map was found to need no important corrections.'[2]

Across the English Bridge and running parallel with the shore of Shamien was Canal Road, a street with many small shop-houses and brothels. Hundreds of sampans tied up alongside this road, since they were

forbidden to tie up on the Shamien side (Fig. 12.2). Behind and parallel to Canal Road was Sai Hing Street. There at Number 1 was Wang Hing, a famous silversmith, whose business of engraving and jade-carving was founded in the mid-nineteenth century; the company later opened a branch in Hong Kong. Along the street Wassiamull Assomull, an Indian merchant who established his business in 1864, was a dealer in silk embroideries, Canton shawls, ramie, all types of silk weaves, ivory, and sandalwood, as well as gold and silver ornaments. Assomull had another branch in Hong Kong, where some of his descendants still live today. Other shops in the street stocked lacquerware, silk goods, embroidery, silver, and ivory carvings in great variety.

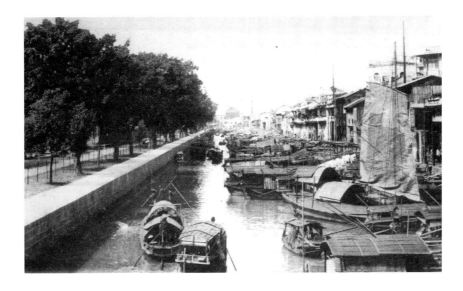

FIG. 12.2 The canal between Shamien Island and Canal Road in the Western Suburbs, with sampans tied up alongside; early twentieth century.

Nearby, in White Rice Street, was Pohing, the renowned and long-established store selling chinaware for the European market (Fig. 12.3). Numerous patterns were available here on shelves packed from floor to ceiling, from glazed pottery garden stools to willow-pattern and armorial dinner services. Carved furniture inset with marble panels could be found on Sai Lai Cho Ti, near the Wah Lam Temple, while the Ng Sheong furniture company in New Bean Street sold blackwood furniture. Popular with Europeans then, but seen as monstrously ornate now, the huge Victorian whatnots, dressing tables, and throne-like chairs, elaborately carved with bamboo, dragons, and other auspicious Chinese motifs, make a marriage of the most awkward kind.

The main streets in the Western Suburbs were named 'wards', each separated from the others by fire-proof walls, and at short intervals were marked by watchtowers used as fire lookouts. The wards numbered eighteen and were named in numerical order, called 'pu' preceded by the number, a

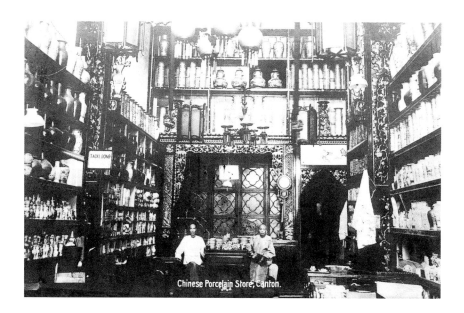

FIG. 12.3 A Chinese store, the shelves stacked floor to ceiling with porcelain; *c*.1900.

Chinese Porcelain Store, Canton.

pu being a distance of ten *li* (5.3 kilometres). According to a Chinese legend, when the Manchus attacked Canton, the commander of the army was so enraged at local resistance that he ordered the massacre of all inhabitants within 18 *pu*, that is, 95 kilometres from the West Gate. Word of this got out, and as the Manchus did not know the true extent of the distance, the area was quickly renamed by placing signs at intervals to represent a *pu*. The massacre ended at the eighteenth sign, and the street names have retained this appendage ever since.[3]

Shap Pat Pu, or Eighteenth Ward, was one of the finest and most fashionable thoroughfares in Canton (Fig. 12.4). Shops here specialized in furniture and small articles, like trays and dressing cases, of blackwood inlaid with mother-of-pearl (Plate 35). The street was best known, however, for the many millionaires who had their town residences here, including Howqua, the richest of them all. Reverend John Gray, Consular Chaplain for the British Protestant community on Shamien until he left for Hong Kong in 1878, and his wife were frequent visitors to Howqua's home in Shap Pat Pu: 'This mansion consists, in short, of three or four houses, and in the rear of each of which, are neat gardens containing not only plants and flowers of various kinds, but also lofty trees, which, with their wide spreading branches, afford an agreeable shade from the fierce rays of a tropical sun. There are, also, boudoirs and bowers in which, during the hot months of summer, the members of the family spend much of their time. In this large family residence, not less than five hundred souls reside.'[4]

The Grays were also invited to dine with Howqua and his family at their country mansion on Honam. The meals served included some Western food

served with wine and champagne, but, although each race was curious about the other's customs, neither ate the other's dishes with much relish. Delicacies of stewed black cat, dogs, rats, shark's fin, and sea slug were an acquired taste few Westerners sought to satisfy. John Stoddard relates, tongue in cheek, of meeting a Chinese youth who, after eating for the first time a European dinner, wrote of his experience: 'Dishes of half-raw meat were served, from which pieces were cut with sword-like instruments and placed before the guests. Finally came a green and white substance, the smell of which was overpowering. This, I was informed, was a compound of sour milk, baked in the sun, under whose influence it remains until it becomes filled with insects; yet the greener and livelier it is, the greater relish with which it is eaten! This is called *Che-sze*.'[5]

The eastern end of Shap Pat Pu became the Seventeenth Ward, and was also called Tseung Lan Kai or Physic Street, for the many large medicine shops located there. One could buy 'a box of grasshoppers, [which] …when ground into a powder, make a popular remedy for some ailments. …A favorite cure for fever, for example, is a soup of scorpions. Dysentery is treated by running a needle through the tongue. The flesh of rats is supposed to make the hair grow. Dried lizards are recommended as a tonic for "that tired feeling", and iron filings are said to be a good astringent.'[6] Long, brilliantly coloured sign boards proclaimed the wares on offer, showing the shopkeepers' preference for high-flown classical phrases used for common, and often unrelated, items. Yung Ki (Sign of the Eternal) sold swallows' nests and bird's nest gelatine imported from Borneo, Indonesia, and Sumatra, while Tien Yih Shen (Celestial Advantage combined with Attention) advertised a shop selling cushions and rattan mats.

The other name for Physic Street, however, was Curio Street, and it attracted large crowds, especially at a fair held every Lunar New Year's Eve. Many of the shops were like museums, filled with carved blackwood furniture, antique porcelains, and ancient bronzes. Hoaching, the great ivory carver, had a shop here, but many pieces had to be ordered, some taking

FIG. 12.4 Shap Pat Pu, the Eighteenth Ward; 1909. This photograph was taken from one of the night-watch bridges which stretched from roof to roof across the street.

three or four years before they were ready. The high blank walls of the mansions behind were lined on each side of the street with tables where itinerant traders gathered. Everything was on offer, from antiques, bronzes, and coins, to imported crockery, glass ornaments, books, and prints. Many of the items, particularly furs and embroidered robes, were unredeemed pledges from pawnshops. Dogs, cats, and monkeys destined for the pot were on sale: 'Black cats... cost more in China than cats of any other color', wrote John Stoddard, in Canton in 1890, 'for the Chinese believe that the flesh of dark-coated felines makes good blood. To some Chinamen, dogs fried in oil are also irresistible.... Moreover, hundreds of rats, dried and hung up by the tails, are exposed for sale in Canton streets, and shark's fins, antique duck eggs, and sea slugs are considered delicacies.'[7]

Amongst all this, itinerant barbers would set up their stalls in the street, wherever they could find customers. Apart from plaiting a man's queue, the long pigtail imposed on the Chinese by the ruling Manchus, the barber would 'also shave the eyebrows, clean the ears, pull teeth, and massage', as well as scraping the inside of the sufferer's eyelids (**Fig. 12.5**). After these tonsorial treatments, passers-by could pit their wits with the players of chess or cards, munching on pickles or dumplings at the same time.

Seventeenth Ward ended at the street made up of Ninth, Eighth, and Seventh wards, which ran alongside the western wall of the city, called High Street by the foreigners. Thirteen Hong Street, and Tai Ping (Great Peace) Street nearby, were both known for their many banks and money-exchange

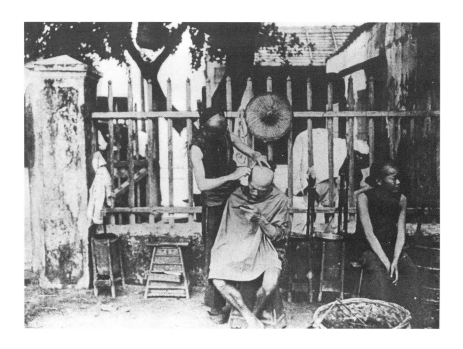

FIG. 12.5 An itinerant barber at work; c.1913.

PLATE 33 A recent photograph of the Roman Catholic church in the former French concession on Shamien.

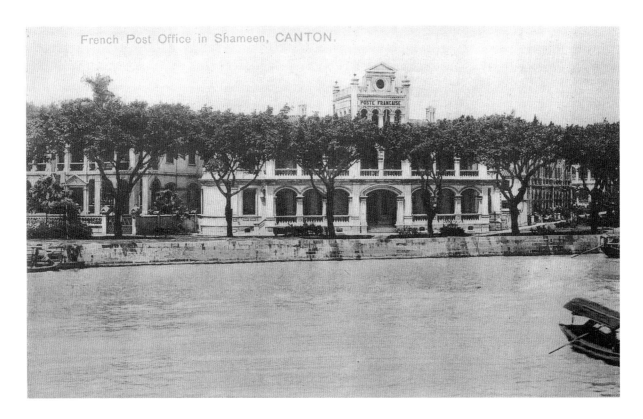

French Post Office in Shameen, CANTON.

POSTE FRANÇAISE

PLATE 34 The French Post Office
on Shamien; photographed in
the early twentieth century.

PLATE 35 A lady's dressing case made of lacquered wood inlaid with mother-of-pearl; characters reveal that it was made in Shap Pat Pu, *c.*1910. Also a man's sandalwood and feather fan, made by 'CHEONG KEE SANG, DEALER IN Folding fans of Sandal Wood Ivory Bone Lacquered Gilt Embroidered Painted with Pictures... Tai Sin Road [Da Xin Road]'; *c.*1900s.

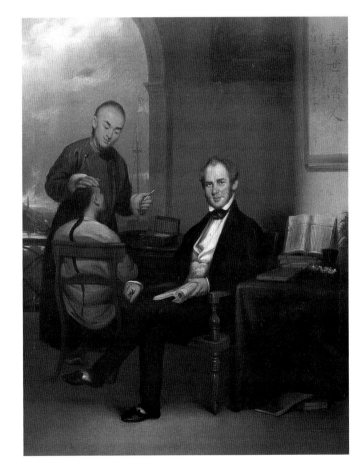

PLATE 36 Dr Peter Parker and his student Kwan A-to, nephew of the painter Lamqua, examining a patient; oil painting by Lamqua, *c.*1840.

PLATE 37 The view from Honam towards the factories showing the Protestant Church, while on the Honam side of the Pearl River, coolies load chests of tea into a waiting sampan; painting from the school of Tinqua, 1855.

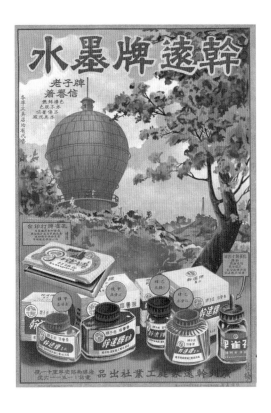

PLATE 38 An advertisement for ink, showing the water tower on Yu Hill built in 1932 and, in the distance, the monument to Sun Yatsen and the Five-Storey Pagoda, symbols of new and old Canton; 1940s.

PLATE 39 The obelisk in Yuexiu Park erected to honour Dr Sun Yatsen, with the Sun Yatsen Memorial Hall in the centre and the Five-Storey Pagoda to the right; c.1970.

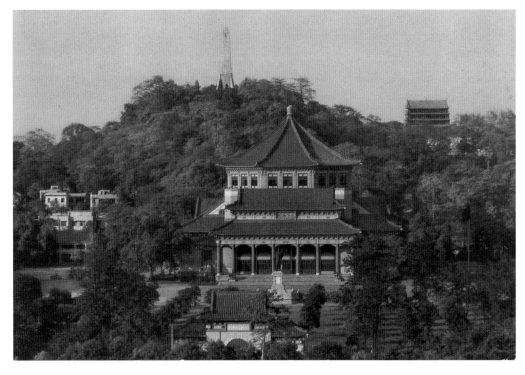

PLATE 40 Poster of a view from Honam of the Bund, showing the Customs House and the Sun Company department store with the Hotel Asia on the roof; 1940s.

PLATE 41 Woodblock print of the main gate of the Sixth Peasant Movement Institute on Zhongshan 4 Road, once the Confucian Panyu Academy; c.1965.

PLATE 42 A propaganda poster printed for the Guangdong Mail and Telegraphic Service Co announcing that the company serves the people; printed by New China Offset, Canton, January 1953. Links with other Communist countries are shown, with the seated lady reading a letter from North Korea, the man holding an overseas remittance, the woman handing a mail order to the postman, and the seated young man reading the local daily paper, while the postman brings news from further afield in China, *The People's Daily*, from Beijing.

PLATE 43 A view of the hall of the
Chinese Export Commodities
Fair; *c.*1975.

brokers. From these, a short street led to a bridge over the moat to Great Peace Gate. This was one of the principal gates leading to the New City, where the shops catered mostly to the domestic market. Here the streets were narrow and winding, with ample opportunity for the newcomer to get lost.

From Great Peace Gate, Chong Un Street led into the city and was lined with shops some of whose attached workrooms produced embroidered silk robes for officials, while others worked on opera costumes or banners for ancestral halls. Little Market Street had shops selling feather fans, gold and silver jewellery, and all manner of military equipment, from saddles to suits of armour. Shops in Heavenly Peace Street (Fig. 12.6) sold bronze vessels, marble ornaments, and palm-leaf fans. Moat Street, now Dade Lu, ran along the outside of the south wall of the Old City and had shops selling furs, paintings, carpets, and costly hardwood furniture inlaid with mother-of-pearl.

Parallel to Moat Street was Great New Street, Tai Sun Kai, better known then as Jade Stone Street, with shops selling jade, ivory carvings, silverware, Canton enamel, silver and copper jewellery inlaid with kingfisher feathers, fans, bronzes, and lacquerware. For centuries this was the most famous street for ivory carving, where carvers worked patiently on spherical globes with as many as thirty-six layers achieved by 1975. Today in Da Xin Road, just one street-side display case of ivory carvings remains.

Wrote a bemused visitor in a letter in the 1880s: 'This vast City is one labyrinth of lanes bordered by houses and shops running in every direction, and any new-comer, alone, would soon lose his way here. So narrow are the thoroughfares that one seems to be passing for hours through the interior of some mammoth establishment, where, in endless succession, wares of all varieties are exposed for sale, and where manufacturers and producers of the same may be seen at their work. Many of the streets form long arcades, covered, and but dimly lighted. The tempered and mellow light, the brilliant gilt and vermilion signs, with their quaint Chinese lettering, the color and variety of goods offered for sale, and the odd faces and costumes of buyers and sellers, all combine to form a picture at once strange and pleasing....

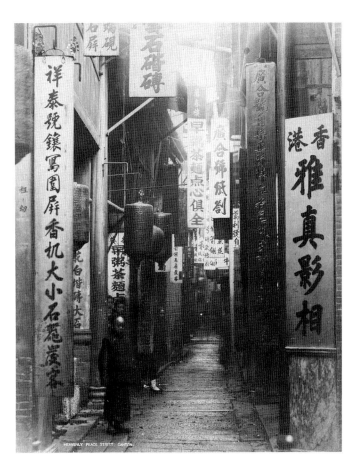

FIG. 12.6 Heavenly Peace Street in the New City; c.1890.

Here were shops where the most beautiful silks and crapes and embroidered goods, vases, countless articles bearing the quaint finish of Chinese art, fans, carved boxes, artificial flowers, &c, &c, were offered for sale. ...A thousand little incidents of interior life were disclosed, for everything seemed open to the eye of the passer by. There were shouting and calling! Laughing and scolding! What a singular Chinese Babel!'[8]

ENDNOTES

Dr Kerr's guide also contained some information from Wm. Fred. Mayers, N. B. Dennys, & C. King, *The Treaty Ports of China and Japan: A Complete Guide to the Open Ports of those Countries, together with Peking, Yedo, Hongkong and Macao. Forming a Guide Book & Vade Mecum for Travellers, Merchants, and Residents in General with 29 Maps and Plans*, London: Trubner and Co, and Hong Kong: A. Shortrede & Co, 1867.

[2] S. Wells Williams, *The Middle Kingdom: A Survey of the Geography, Government, Education, Social Life, Arts, Religion etc. of the Chinese Empire and Its Inhabitants*, New York: Charles Scribner's Sons, 1895, reprint, New York: Paragon Book Reprint Corp., 1966, p. 169. Rev. Vrooman first arrived in Canton in 1852, sent by the American Board of Commissioners for Foreign Missions. His 'Map of the City and Entire Suburbs of Canton' was published in Canton in 1860.

[3] Ng Yong Sang, *Canton, City of the Rams*, Canton: M. S. Cheung, 1936, pp, 85–6.

[4] The Venerable John Henry Gray, *Walks in the City of Canton*, Hong Kong: De Souza & Co, 1875, p. 168.

[5] John L. Stoddard, *John L. Stoddard's Lectures*, Boston: Balch Brothers Co., 1890, Vol. 3, p. 321.

[6] Stoddard, 1890, Vol. 3, pp. 301–2.

[7] Stoddard, 1890, Vol. 3, p. 291.

[8] Dr J. G. Kerr, *The Canton Guide*, 4th edition, Hong Kong: Kelly & Walsh, Ltd, and Canton: A. S. Watson & Co Ltd, 1889, pp. 2–3.

13
Spreading the Word:
Christianity Comes to China

Most foreign merchants came to Canton simply to make money, maintaining friendly but distant relations with the Chinese and returning home with a superficial view of the country and its people. But another group of Westerners arrived with far higher ideals. Not for them the safe confines of a European enclave: the missionaries came to live alongside the native population and learn the language in order to spread the Gospel, as well as bringing tangible benefits from Western civilization to the closed world of Chinese culture. By the late nineteenth century a growing number of missionaries of several denominations were settled in the 'labyrinth of lanes' of the 'Chinese Babel', so feared by the faint-hearted.

For centuries, the West had viewed China as ripe for Christian conversion. Through great missionary effort Nestorian communities were established in China between the seventh and fourteenth centuries, but these were later absorbed by Islam. The first Protestant missionaries had accompanied the Dutch to Formosa (Taiwan) in 1627, but in 1662 five were beheaded and the rest expelled. After the Manchu government in the eighteenth century had prohibited the preaching of Christianity, Canton was the only foothold that Western missionaries held in China in the days before the establishment of the treaty ports.

Dr Robert Morrison, the first Protestant missionary in China of the modern movement, was sent out in 1807 by the London Missionary Society at

the age of twenty-five. Denied passage on an English East India Company ship, he arrived in Canton after a journey, via America, of 222 days at sea. Unable to reside in the Company's factory, Morrison took a room in No. 4 American (the fourth building or rental area in the American hong) with the traders Olyphant & Company of New York. Over the next twenty years, twelve more missionaries of other nationalities arrived. Since they were unable to live and hold services anywhere but in the factories, their often narrow, intolerant outlook made for an uneasy relationship with the traders interested only in commerce.

Morrison had learned the language from a Cantonese in London, as foreigners in China were forbidden to learn Chinese or buy Chinese books and any Chinese person caught assisting them could be executed. Despite the East India Company's initial disapproval, two years after his arrival Morrison's knowledge of Chinese was proving so valuable that they were glad to engage him as their Chinese translator, a position he held until his death. At the same time he dispensed medicine to the Chinese, reasoning it was better to treat their bodies first, until their souls could be reached. His motive for learning the language went far deeper than just being useful to the Company. On his way to Canton he was asked if he really expected to make an impression on the idolatry of the Chinese. 'No, Sir', he answered, 'I expect God will.'[1]

FIG. 13.1 Dr Robert Morrison and his Chinese assistants; an engraving after a painting by George Chinnery, c.1830.

In 1813, Dr William Milne arrived to join Morrison in Canton. They worked together for a few months, but the printing of Christian literature aroused the wrath of the mandarins. The ensuing harassment led to Milne moving to Malacca to found the Anglo-Chinese College, where he set up a printing press to produce the tracts and Bibles needed for the mission in China. By 1818 the two men had translated the Bible into Chinese; at the same time, with the encouragement and help of some members of the East India Company, Morrison compiled the first Chinese/English dictionary, the whole six-volume work of 4,595 pages being published by 1823, at a cost of twelve thousand pounds (Fig. 13.1). He continued his work with Dr Livingstone, an English

East India Company physician and part-time librarian of the Company's well stocked library, who founded a dispensary for the Chinese in 1820. Morrison died at his lodgings at No. 6 Danish Hong in Canton on 1 August 1834 and lies buried in the Protestant cemetery in Macau.

Reverend Karl Friedrich Gutzlaff, of the Netherlands Missionary Society, succeeded to Morrison's position as interpreter with the East India Company. A young Pomeranian from Germany, Gutzlaff arrived on the China coast in 1831. As missionaries were not allowed to travel outside Canton, he took the opportunity as an interpreter to travel, first on the Company's ship, the *Lord Amherst*, in 1832, and later on Jardine, Matheson's opium-carrying ships, which sailed along the coast and up the rivers of the interior, so that he could distribute his Christian tracts more widely. Gutzlaff saw no conflict between his work as a missionary and the effects opium had on his potential converts. By 1840 he had taken ten voyages along the coast and, by his own estimation, distributed tracts to 30,000,000 people (**Fig. 13.2**).[2] Unfortunately, the tracts and Bibles were not received in the spirit in which they were intended, and were subsequently sold for the paper value alone, much of the material being used by the Chinese for making the soles of boots and shoes.

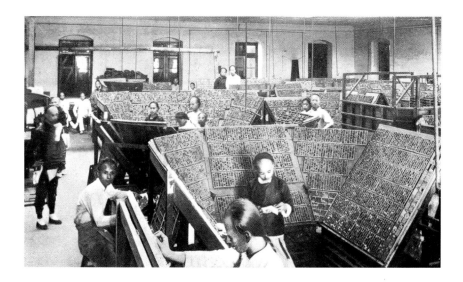

FIG. 13.2 Chinese assistants setting type in a Mission printing office; *c.*1900.

The first American missionaries in China, Reverend Elijah Coleman Bridgman, of the American Board of Commissioners for Foreign Missions, and Reverend David Abeel, of the American Dutch Reformed Church, arrived in Canton in February 1830. Abeel soon left for Java to explore missionary possibilities in South-East Asia, but Bridgman stayed and founded *The Chinese Repository* in May 1832. A monthly collection of news, reviews, and excerpts of previous writings about China, it continued to be published through to December 1851. Produced from his rooms at No. 2 American, it

was intended to give foreigners in Canton greater insight into the country and its people.

Another American missionary, Samuel Wells Williams, arrived in Canton in 1833, aged 21, like Bridgman also sent from the mission of the American Board. As well as editing and publishing *The Chinese Repository*, and producing dictionaries of the Chinese language, Williams wrote the definitive two-volume work, *The Middle Kingdom, A Survey of the Geography, Government, Literature, Social Life, Arts, and History of the Chinese Empire and Its Inhabitants*, first published in New York in 1848. With the number of missionaries resident in the rooms of the American factory, due to the piety of its occupants it soon became known as Zion's Corner. Its cramped conditions were a far cry from the splendour of the accommodations provided at the English East India Company's factory.

Dr Peter Parker, the first bona fide medical missionary to China, was officially appointed by the mission of the American Board and arrived in Canton in 1834, aged 30. Missionary doctors concentrated first on diseases of the eyes, a field in which doctor–patient contact was less personal and where Western medicine was strong and Chinese medicine weak. Parker opened an ophthalmic hospital in November 1835 at Factory No. 3, Fungtai hong. This location opened directly onto Hog Lane, a busy street of shops catering to the Chinese, and meant that visiting Chinese patients were less conspicuous. The British doctor C. Toogood Downing paid a call: 'On the first floor is the receiving room, which is tolerably large and well furnished. Around the walls are arranged portraits in oil and water colours of some of the most remarkable patients who have been here treated, with their different appearance before and after the operation.... Above, on the third floor, is the room where operations are performed, and two or three others containing beds for the in-door patients.'[5]

As medical knowledge increased and missionary doctors became accepted by Chinese patients, the Westerners eventually expanded into other fields of medicine. On one occasion Dr Jardine, himself a former surgeon, assisted Dr Parker with an amputation of a broken arm. The sufferer, imagining the foreigners saw financial gain from the painful operation, was given $50 for the privilege by Dr Jardine, who was known to be a benevolent man. Native Chinese were trained to assist in medical procedures, becoming medical students and eventually doctors in their own right. Among the first native doctors were Liang A-fa, the first Chinese converted to Christianity by Morrison, and Parker's chief assistant Kwan A-to, nephew of the famous painters Lamqua and Tingqua (Plate 36). In fact, Kwan A-to ran the hospital for six months in 1844. In-patients provided their own bedding, food, and nursing care, but treatment was free and Parker's hospital was supported financially by the Western traders. Howqua, the chief hong merchant, provided the building first at a nominal sum of $500 per year and later rent-free.

From the beginning, the hospital was a great success. Less than a month after opening, Dr Parker was reporting, 'My patients are from all classes, men, women (with feet and without), and children. Nearly as many from within the city as without.'[4] One patient was Commissioner Lin Zexu, who was troubled by a hernia. 'Declining to submit personally to an examination by the foreign physician', he sent his brother, said to be the same build, 'to be fitted with the recommended truss.' His brother took away 'the last six trusses in stock, none of which were ever returned.'[5]

Parker left Canton in June 1840, during the First China War, but returned in October 1842. He was followed a month later by his wife, who became the first Western woman to take up regular residence in Canton. A part-time appointment as Chinese Secretary to the American Legation eventually led to his dismissal by the American Board in 1847, but he continued to work at the hospital, distributing tracts in the waiting room where religious services were also held. In 1855 he was joined by thirty-one year old Dr John Glasgow Kerr, representative of the American Presbyterian Board and eventual author of *The Canton Directory*.

When, at the end of 1857, the initial hostilities of the Second China War had passed and it was safe to return to Canton, the missionaries did not join the traders across the river on Honam, but instead moved to the suburbs to be closer to the native population. The hospital in the factories had been destroyed, so Dr Kerr and his wife rented a building in the Southern Suburbs and renamed it Po Chi, 'Diffusive Benevolence'. Then in 1866 a plot of land was purchased on the old factory site, and three years later the first phase of the Medical Missionary Society's hospital officially opened. Otherwise known as the Canton Hospital, it was supported by contributions from both foreigners and local people. Over time, the hospital expanded to include a chapel, operating theatres, dispensing room, private wards for paying patients as well as public wards, and an out-patient department. Eventually, in 1931, the Chinese board of directors of Lingnan University took control of the institution, ending 96 years of foreign management. After 1949 the Canton Hospital joined with the Sun Yatsen Hospital (Second Zhongshan Medical School) on Renqi Road.

Western ways of healing continued to compete with traditional Chinese medicine, which was dispensed in a very different manner. Chinese doctors made house calls and followed a long-established method of diagnosis, which involved looking closely at the patient's face, listening intently to his voice, asking questions about his diet, and taking his pulse. A female patient would sit behind a bamboo screen, her wrist resting on a small padded pillow. The results of the examination, based on the ancient principles of *yin* and *yang*, decided which medicine was to be prescribed. This would be purchased from an herbalist's shop, such as the Chenliji Medicine Company, which had been founded in 1599, making it the earliest medicine shop in

China. These small quantities of herbs were then boiled in chicken stock and the extract drunk. Traditional Chinese medicine continues to have countless faithful followers today.

Although the Western medicine promoted by the medical missionaries was more and more becoming accepted, Christian beliefs were not embraced as readily. Parents encouraged their children to taunt the missionaries as they passed through the streets in the suburbs and out to the villages around. Insults like 'story-telling devils' and 'red-bristled barbarians' were hurled at them along with more substantial missiles. As W. H. Medhurst of the London Missionary Society found, after his arrival in Canton in 1835, to avoid detection en route to the interior, it was necessary not only to adopt Chinese dress, including the long queue, and the language, but dark glasses and the mannerisms as well. Well inland, missionaries lived incognito and in seclusion, deprived of society as they attempted to gain converts.

Catholicism had arrived in China in August 1552 when the Italian Jesuit Francis Xavier landed at the small island of St John's, about 80 kilometres west of Macau. After failing in his attempts to reach the mainland, he died there four months later. But the next to try were more successful. In 1581, Father Michel Ruggiero reached Macau, where he learned Chinese before travelling on to Zhaoqing, the vice-regal city on the West River where he was allowed to stay and preach. Two years later Father Matteo Ricci, aged 31, took the same route before in 1601 finally reaching Beijing, where he preached and translated Christian works into Chinese until his death nine years later. Ricci's skills in mathematics and astronomy gained him favour at the imperial court and paved the way for other Jesuits to follow, forming a centre for scientific learning and experimentation. Ricci's teachings had great influence on Chinese intellectuals in the seventeenth century. Christian converts were made, but growing strife between other Catholic missions in the early eighteenth century led to the expulsion of all those not needed for scientific purposes, and official toleration for Christianity ended.

In 1844 a representative of the French government, Monsieur de Lagrené, asked that these orders be rescinded, and a memorial from Keying, the Imperial Commissioner, petitioned the Emperor for complete tolerance of Catholic converts. This was granted and confiscated churches were returned. When other branches of the Christian faith were brought to Keying's notice, he announced that all Western religions were to be on the same footing. Protestant missionaries then intended to move out of the factories into houses which they had rented in the suburbs to use as both residence and chapel. At these sites they planned to hold religious meetings using native preachers and to distribute tracts. The Chinese authorities employed their usual delaying tactics, however, and one year later the missionaries were still not allowed to preach anywhere but in the factories.

Finally, in May 1847 land was purchased at the site of the British and Dutch factories, which had been partly destroyed in 1841, and a Protestant church erected at a cost of $13,783.34 (Plate 37). Half of the money to pay for the construction was raised from a subscription from British residents in Canton and the rest from the British government. Reverend John Gray was consular chaplain in Canton from 1851 until 1878, when he became archdeacon of Hong Kong. The church was destroyed in the devastating fires of December 1856, which razed the factories to the ground and wrecked the printing presses the missionaries had used to produce Bibles and tracts. The only surviving relic from the church was a white marble tablet commemorating six Englishmen murdered in an incident in December 1847 at Hwang Chu Kee, a small village some 6 kilometres from the city. This plaque was recovered from the ruins and later placed in Christ Church on Shamien.

Roman Catholicism also established itself in the city. In 1860 the French authorities, suffused with power after the taking of Canton, claimed the site of Viceroy Yeh's yamen in the New City as indemnity for other pieces of land where they had built small chapels. The yamen had lain empty since it was bombarded and occupied by the Allies during the Second China War. The French Mission Cathedral, also known as the Sacred Heart Basilica, was built on the site between 1860 and 1863 (Fig. 13.3). An imposing Perpendicular Gothic structure, it was said at the time to be the largest church in China.

The cathedral, reached today off Yide Road, was built of solid granite brought up by river to Canton from the quarries at Ngau Tau Kok in Kowloon, Hong Kong, giving it its present name of Stone House, *Shishi*. The spires, nearly 60 metres high, dominated the skyline of the city, although they were not completed until 1880, due to the great expense required for their construction. The two pointed spires worried the Chinese, who believed they would cast unfavourable influences, but the French mollified them by saying that they were like the horns of the ram, symbol of the city of Canton. Behind the

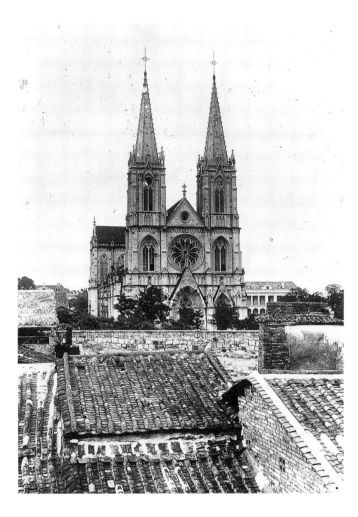

FIG. 13.3 The Roman Catholic cathedral; photographed February 1933.

cathedral, the French authorities established a school for about 100 boys in 1862, and next to it an orphanage where the children were cared for by Chinese nurses. The French government ran another school in a park on the east side of the Treasurer's yamen in the Old City, after French troops occupied the site during the Second China War. The school, École Pichon, was under the secular order of the Marist Brothers of the Missions Étrangères de Paris, who taught the Chinese boys in French.

By 1866 twelve missionaries of different denominations, including the London Missionary Society, the American Board of Commissioners for Foreign Missions, the Wesleyan Methodist Missionary Society, and the American Presbyterian Board, were resident in the suburbs of Canton. The group was joined that year by American Presbyterian minister Reverend Henry Varnum Noyes and his wife, from Cleveland, Ohio. Two of Henry's sisters followed, Harriet, and Martha who was to become the third wife of Dr Kerr in 1886. Reverend Daniel Vrooman, who had made such a reliable map of Canton when the city was still closed to foreigners, had come out with the mission of the American Board, but by 1872 he had left to become a self-sustaining missionary and, at the same time, manager of the Canton Cotton Yarn Mill.

FIG. 13.4 Miss Harriet Noyes, headmistress of the True Light Seminary for Girls; early twentieth century.

The close-knit community encouraged intermarriage, for although choice may have been limited, the missionaries shared similar ideals and background. A wife, assisting as teacher or nurse, was essential for her work with the local women and children. Many male missionaries married two or three times, for some wives died in childbirth, while others with a delicate constitution could not tolerate the difficult climate combined with restricting Western dress. All too often, they succumbed to an early death.

Harriet Noyes (Fig. 13.4) arrived in Canton on 14 January 1868 aged 24 and set about learning the Cantonese dialect. Seeing that Chinese women had low social status and little chance for education, two year later she obtained funds and annual support from the Philadelphia Women's Board of Foreign Missions to erect a building, furnish classrooms and dormitories, and open a small chapel. The Female Seminary and Training School, run by Miss Noyes and her colleague Miss Lillie Happer, opened on 16 June 1872 on Yan Tsai Street in the Southern Suburbs, adjoining the Canton Hospital. It had accommodation for thirty girls, who were to be given an education so they could join in religious services and raise their children in the Christian manner. The curriculum included history, mathematics, science, Bible study, and English, with some of the pupils even learning Latin and Greek before going on to become teachers or social workers.

At first the recruitment of students was slow, as Chinese parents did not trust the foreign women, and when the school opened there were only six enrolled. But numbers picked up and soon the school was full. One Sunday in January 1875, while the staff and pupils were at church, tragedy struck when the school was burnt down by a group of Chinese, envious of its success. Although the Treaty of Tianjin had sanctioned the activities of the Christian missionaries in China, and both Chinese and foreigners were granted the freedom to practice their faith, in practice bigotry, ignorance, and fear were the causes of many such outrages against missionaries.

Undeterred, the organizers rebuilt the school in 1878, this time with space for eighty pupils. The following year Harriet's brother, Reverend Noyes, founded the Pui Ying School for Boys at Pak Hok Tung on Fati. Reached by sampan from Shamien and surrounded by palm, guava, and pomelo trees and groves of bamboo, the mission compound was separated from the village by high walls on three sides and a canal on the fourth. Severance Hall, a large four-storey building, served as the assembly hall and gymnasium on the ground floor, with classrooms on the second, and students' and teachers' living quarters on the top two floors. The hall was named after a well-known industrialist and philanthropist, Mr Louis H. Severance, a Presbyterian from Cleveland, Ohio, whose donation funded the building as well as several other Protestant schools and colleges in China.

In 1917, Miss Noyes moved her school, now named the True Light Seminary for Girls, across the river to Pak Hok Tung, next to her brother's school. A primary-school branch opened in Hong Kong in 1935, with students going back to Canton for secondary education. After 1949, as the Westerners left China, all missionary-run schools closed, were moved to Hong Kong, or were taken over, to be renamed and run by the Chinese government. The True Light Seminary in Canton became the Twenty-second Middle School, later reverting to its original name in Chinese, Tsang Kwong Girls Middle School.

During the Japanese occupation of 1941–5, Pui Ying School for Boys, along with other missionary-run schools, moved to north-west Guangdong province, returning afterwards to Canton to become the Eighth Middle School. In the Cultural Revolution, the school buildings were used as a marine parts factory. Severance Hall was still standing in the heart of Fati in 1975, but the compound walls and other buildings had been torn down. The main building on the large campus was built in 1979 and in 1984 the institution was re-named Pui Ying Middle School, becoming co-educational. A picture of its founder, Reverend Henry Noyes, still has pride of place in a trophy room near the entrance.

Reverend Dr Andrew P. Happer, of the American Presbyterian Board, was another missionary whose small-school beginnings would lead to far greater glory. After graduating from the University of Pennsylvania as a

medical doctor in 1844, Happer arrived in Macau the following year and opened a mission school. In 1847 he moved to Canton, where he lived in the Danish Hong, and in the same year he married Elizabeth, daughter of Reverend James Dyer Ball. Their second daughter, Lillie, born in 1853, would become the assistant of Harriet Noyes. After Elizabeth died, he remarried and, with his new wife, opened a school for boys on Fati. Classes began on 28 March 1888, then in 1893 the school joined forces with Pui Ying School.

Reverend Happer died the following year in Ohio, but the school carried on, run by a faculty of six: two Americans — Reverend Henry Noyes and Reverend J. J. Boggs, and four Chinese teachers.[6] After several changes of location, by the spring of 1904 thirteen hectares of land on Honam were purchased for a permanent site. With the school's move to the new site, the English name changed to the Canton Christian College, with the Chinese name Ling Nam Hok Tong (Lingnan school)(Figs. 13.5 and 13.6), and girls were admitted for the first time. It became Lingnan University in 1927, two years later affiliating with the Union Theological College at Fong Tsuen, although each remained on its own campus.

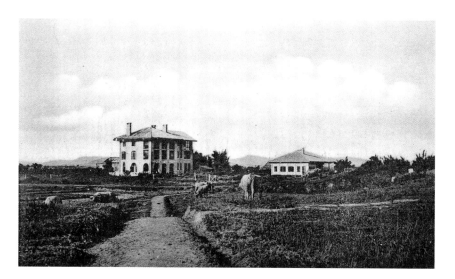

FIG. 13.5 The Canton Christian College in 1900.

In addition to treating the sick and educating the young, the missionaries also tried to bring comfort to the outcasts of society. When Dr Kerr saw how the mentally ill were neglected, being made the butts of village humour or kept in chains if seriously afflicted, he used his own funds to buy a plot of land in 1892 at Fong Tsuen to establish a mental asylum. With further help from an anonymous donor, the home finally opened on 20 February 1898, the first of its kind in China. The following year Kerr resigned from the Canton Hospital, after forty-four years of service, and moved across to Fati, taking thirty male medical students with him.

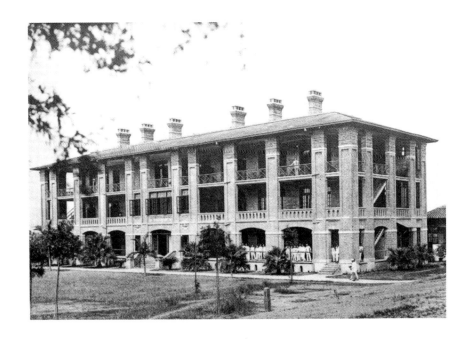

FIG. 13.6 Martin Hall at Lingnan University, completed in 1907 and named after Henry Martin of Cincinnati, a generous early donor.

Kerr's Refuge for the Insane was a brick two-storey building whose two sections were connected at the upper storey by a wooden bridge. The compound was surrounded by 'a brick wall complete with pieces of jagged glass on top, within which the patients exercised. On summer evenings when the windows were open to show the restraining bars, strange shouts and cries would float across... and sometimes, when the moon was bright, a small figure wearing the long gown of the intellectual would stand on the bridge and recite reams of the Chinese classics, an eerie proceeding which made [the young Jean McNeur] shiver with fright.'[7] John Glasgow Kerr died on 10 August 1901, aged 77, and records show that this indefatigable doctor had treated 750,000 patients, trained 150 Chinese as doctors, and translated countless medical books and papers. His asylum continued to expand under the direction of his assistant, Dr Charles Selden, and was eventually taken over by the Canton city government in 1927.

Dr Kerr was buried in a cemetery for foreigners formed in 1865 at Pak Hok Tung, opposite the forts in the Macau passage; prior to this time, foreigners had been buried on Dane's Island. There was also a cemetery for Protestant missionaries in the Eastern Suburbs, close to the leper asylum, where the American Presbyterian Board physician, Reverend Dr Dyer Ball, father of the author of the famous reference work *Things Chinese*, was buried in the spring of 1866. The senior Ball's eldest daughter Elizabeth, the first wife of Andrew Happer, had been buried there only three months before.

It was in Canton that the first Western female physician in China set up in practice. Dr Mary Niles, from Wisconsin, was the daughter of a

Presbyterian minister and in 1883, aged 29 years, joined Dr Kerr at the Canton Hospital. In 1889, while Dr Niles was working at the hospital, 'a little waif of three years was picked up from an ash heap and brought to the hospital for healing.'[8] On hearing that the child was blind, the rescuer was all for taking her back to the heap when Dr Niles intervened. By 1896 she had founded at Fong Tsuen, near the site chosen for Kerr's Refuge for the Insane, the Ming Sam (Clear Heart) School for Blind Girls (Fig. 13.7), which was housed in its own building with accommodation for thirty pupils.

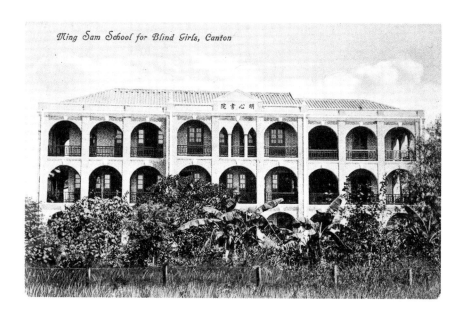

FIG. 13.7 The Ming Sam (Clear Heart) School for Blind Girls; photographed c.1900.

Some of the blind girls rescued were taken from the flower boats, where they had been sold by their families into prostitution. The men who owned them often tried to steal them back, so Dr Niles and her assistant Miss Durham kept a fierce white chow dog, which snarled when strangers approached. A new building erected in 1922 was funded by a Parsee philanthropist, Mr M. J. Patell, owner of a general merchant's and commissions agency in Canton and Hong Kong.

A teaching hospital for women was founded in 1901 by Dr Mary Fulton of the American Presbyterian Board and the Canton Hospital. A former student in Ohio of Miss Martha Noyes, Dr Fulton was the second woman physician to be assigned to the Canton mission, arriving in 1884. The hospital's facilities in To Po Street in the Western Suburbs could hold about 100 patients, and eventually became the Hackett Medical College, named after one of its greatest supporters, Mr E. A. Hackett of Indiana. The nine students lodged in an old dye house, and classes and a dispensary were housed in a church. By the 1930s, it was one of China's outstanding

women's medical schools, with a staff of 34 and 187 graduates. It later became the Rouji Women's Hospital.

Increasingly impressed by the benefits of Western medicine, in the second half of the nineteenth century several wealthy Cantonese businessmen founded hospitals in which it could be practised. A dispensary, run on Western lines but with a completely Chinese staff, was established in 1871 in the old Consoo House. Two years later, the once-splendid residence of the mandarin P'an Shih-ch'eng, which had been confiscated by the government, was purchased at a cost of $60,000 and the dispensary and headquarters of the dispensary's managing committee transferred there.[9] Wealthy Chinese also founded teaching hospitals, such as the Nam Wah Medical School, the first Western medical school in China, which opened in 1879. The Kwong Wah Medical College was founded by Western-trained Chinese physicians and opened in November 1909, and others soon followed.

In the 1880s, the Chinese authorities in Canton began to see the advantages of a broader, Western-style education, and a government school for teaching English was set up in 1889 under the patronage of the Tartar General, with Mr Theo Sampson as its headmaster. Sampson, a long-time resident of Canton, had previously been an agent for the British West Indian Emigration Agency, sending Chinese males to Demerara in British Guyana to work on the sugar plantations. The school was at the western end of the Street of Benevolence and Love, not far from the British consulate. It consisted of a few private dwellings knocked together into a series of connecting rooms, with its own kitchen and little garden. The size of the class fluctuated from zero to over a dozen, attendance and punctuality not being the students' greatest strengths.

A radical announcement reverberated through the country on 3 September 1905, when an imperial edict was issued, abolishing the traditional literary examinations that had been in force for over a thousand years. The American missionary Arthur Smith, a long-time observer of China, declared that this innovation might 'justly be reckoned among the most remarkable and decisive intellectual revolutions in the history of mankind.'[10] Schools were ordered to offer Western learning, and as a result Chinese youth looked to foreign schools for education. Many went to study in the British colony of Hong Kong, others to Japan, a popular choice for practical reasons since it was not far away and the written language was similar to Chinese, or to Britain or America. One student who took advantage of the opportunity to study overseas was Sun Yatsen, the future leader of modern China. Sun was born in 1866 at Cuiheng, a village in Zhongshan county, about 80 kilometres from Canton. He studied first in an Anglican school in Hawaii, then returned to Hong Kong, where he attended Queen's College. His medical training began at the Canton Hospital, followed by medical school in Hong Kong, at the forerunner of the University of Hong Kong.

With the imperial examinations abolished, the Canton examination hall was demolished and the National University of Guangdong founded on the site in 1924, the authorities preserving a few remaining cubicles to remind current students of the trials of the past. Classrooms were arranged round two quadrangles either side of a hall and clock tower. The institution was renamed the Sun Yatsen University two years later and became a centre of Western education for Guangdong province. Soon after, it moved 8 kilometres east of the city to extensive premises, with more than forty faculties and dormitories for male and female undergraduates. (The buildings on the old examination site continued as a middle school for the university.) The grounds covered an area of 800 hectares, making it one of the largest universities in China.

The name later changed to Zhongshan University, in honour of Sun's birthplace, the new university moving to Honam where it took over Lingnan University and converted it into a college of arts. The university ceased operations in 1952, after the Communist takeover, but in 1967 Lingnan College opened in Hong Kong, and in recent years has been accorded full university status in the Territory. A group of Hong Kong Lingnan alumni re-established their connections with Zhongshan University in 1986, and a faculty opened up soon after within the campus on Honam. Today Zhongshan University is a high-tech campus and, with over 14,000 students, one of China's major universities.

More missionary societies arrived in Canton in the early years of the twentieth century (Fig. 13.8). The Young Men's Christian Association (YMCA)

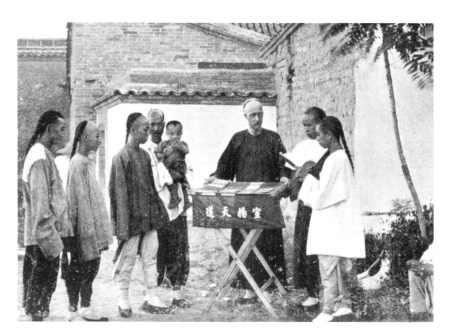

FIG. 13.8 A missionary with his stack of bibles, hoping to attract customers; 1909.

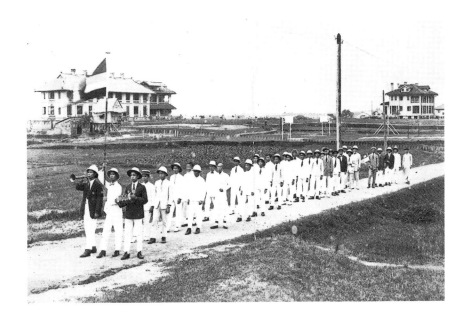

established offices near the Gate of the Five Genii on the new Bund in the Southern Suburbs in 1909, on land previously occupied by the Baptist mission. Nearby in Tsang-sha Street was the Wesleyan chapel and school for boys and girls, founded in 1904. Several Protestant churches were built in the Western Suburbs, and more missionaries moved to Fati to form a growing community there, near where the Noyes family had settled. The Church Missionary Society was at Pak Hok Tung, while the Berlin Missionary Society and George McNeur, of the Presbyterian Church of New Zealand, and his wife Margaret were nearby at Fong Tsuen (Figs. 13.9 and 13.10).

Despite all the efforts and dedication of the missionaries, often in the face of real danger, converts were few. The tangible, long-term advantage that the missionaries brought was the introduction of a more liberal and modern Western outlook to the static and traditional culture of China. Western science, mathematics, geography, and history were learnt by students who hitherto had studied only the Confucian classics. The missionaries taught their pupils to analyze and not just to learn by rote, and prompted them to question the sagacity of the Chinese government. Many students later took part in the liberal movement which supported Dr Sun Yatsen in the revolution of 1911 in his attempt

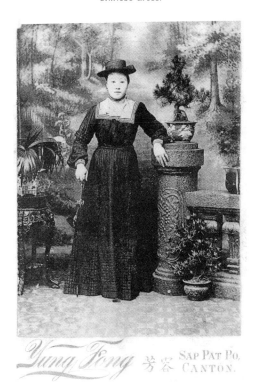

to overthrow the decadent Manchu rule. Ironic, then, in the end, that the mid-twentieth century conflicts that brought about the Communist creed where all classes are considered equal resulted in the expulsion of the missionaries. The saviours would become the outcasts.

ENDNOTES

[1] Peter Ward Fay, *The Opium War, 1840–1842*, Chapel Hill: University of North Carolina Press, 1997, p. 87.

[2] Howard Malcom, *Travels in Hindustan and China*, Edinburgh: Chambers, 1840, p. 51.

[3] C. T. Downing, *The Fan-qui in China*, London: Henry Colburn, 1838, reprint, Shannon: Irish University Press, 1972, pp. 180–3.

[4] 1836 report by Dr P. Parker, quoted in Sara Tucker, *The Canton Hospital and Medicine in Nineteenth Century China, 1835–1900*, Ph.D. dissertation, Indiana University, Bloomington, 1982, p. 26.

[5] Tucker, 1982, pp. 45–6.

[6] C. H. Corbett, *Lingnan University*, New York: Trustees of Lingnan University, 1963, pp. 24–5.

[7] Jean McNeur was a daughter of missionary parents, George and Margaret McNeur of the New Zealand Presbyterian church, and later married Samuel Moore. Jean Moore, *Daughter of China, An Autobiography: Jean Moore (1907–1992)*, ed. Margaret Moore, privately published, 1992, p. 6.

[8] Tucker, 1982, p. 264.

[9] J. G. Kerr, 'Benevolent Institutions of Canton', *The China Review* 3(1874): 112–13.

[10] Corbett, 1963, pp. 41–2.

14

Revolution and Change:
The Twentieth Century

Although the foreign missionaries in China did not deliberately set out to engender unrest, their teachings often provoked and aroused those with whom they came into contact, at times with far-reaching consequences. Canton was the scene of many important events that triggered momentous nationwide changes over the next half-century. It was in Canton in the 1830s that religious tracts handed to a peasant, already disillusioned at failing the imperial examinations, moved his disturbed and fevered imagination and led to the Taiping Rebellion more than a decade later. It was in Canton that Sun Yatsen first mounted his revolutionary attacks on the Qing government that culminated in its downfall in 1911. And it was from Canton that Mao Zedong would promote his view of Communism that would change the way of life in China forever.

Hong Xiuquan was born in 1814 into a Hakka peasant family living some 50 kilometres north of Canton. He tried to improve his lot by studying to become an official, and at eighteen became a village schoolteacher, a rural intellectual who sympathized with the poor conditions endured by his fellow men. While in Canton in 1836 to sit the examinations, Hong saw missionaries preaching and distributing religious books and tracts in the street. He was handed some, one a compilation of extracts and tales from the Bible put together by Liang A-fa, who had been assistant pastor to Dr Robert Morrison, then set them aside. Hong failed the examinations twice. Furious and upset,

he fell ill and suffered hallucinations, believing himself to be a nineteenth-century version of Jesus Christ, whose calling was to liberate China from the rule of the Manchus. He made a further attempt to pass in 1843 and failed again, an event which coincided with the defeat the year before of the Qing government in the First China War. Inspired by the Christian teachings he had been given years before, Hong organized a group called the Society for the Worship of God (Pai Shang Ti Hui). Gradually the influence of the group spread into the neighbouring provinces.

Armed resistance began in 1850 and the following year Hong proclaimed the coming of the 'Heavenly Kingdom of Great Peace', the Taiping Tien Kuo. The rebels took Nanjing in 1853, making it the capital of the Taiping Kingdom. Almost the whole of Guangdong province was occupied by the rebels and Canton was besieged. In retaliation, imperial troops slaughtered thousands of rebels in the north of the city: 'So many [were] executed,' one Western observer reported, 'that the baskets sent for the heads were not sufficient to carry the whole, so that the mandarins determined on sending to the Governor-General boxes containing only the right ears!'[1]

A combination of poor organization and lack of military discipline meant the Taiping rebels failed to crush the tottering Manchu regime. In 1864, with help from Western volunteers of the 'Ever Victorious Army', a foreign-led and armed auxiliary force, the Chinese army recaptured Nanjing to find Hong had already committed suicide. Nevertheless, wrote Peter Laurie, a young employee of Jardine's, already dismayed by the sights of Canton, 'it is a peculiar trait in Chinese justice that when any offender escapes, his mother, his wife, and all members of his family are immediately seized in his place. In the Nam-hoi prison we saw the mother and many of the female relatives of the great Tae-ping-wong — the illustrious rebel chief.... The mother of this great man was a miserable, withered, leprous hag. The family were allowed their liberty with the rest of the inmates during the day, but at six o'clock every evening they were locked and barred in a small suffocating den scarcely large enough to hold them.'[2]

The Taipings' extended revolt, which cost the lives of almost 20 million people, seriously weakened the Manchu dynasty and contributed to its eventual downfall. The end finally came in 1911, triggered by a rebellion led by Dr Sun Yatsen and supporters of his Revolutionary Alliance, a secret organization. Sun had staged his first, unsuccessful, coup to overthrow the Manchu government in 1895 in Canton. Further attempts were made, then in April 1911 the Tartar General was shot, and later that year the new Tartar General was assassinated by a bomb as he arrived in Canton.

The rebellion of 27 April 1911 spurred on the offensive. The yamen of Viceroy Zhang Mingqi was attacked, resulting in the loss of more than a hundred lives. The rebels were killed or captured by defending bannermen as they lost their way in the maze of passageways in the yamen. Those

captured were later beheaded. The remains of seventy-two martyrs were collected and a monument to the heroes erected (Fig. 14.1). Set amid lovely gardens and woodlands to the north-east of East Gate, in the area now known as Huanghuagang (Yellow Flower Hill), the mausoleum was completed in 1918, built in a mixture of Western and Chinese styles. With bronze urns and Chinese lions, a stone replica of the Liberty Bell, an Egyptian obelisk, and a little building at the back of the pavilion in the style of the Trianon at Versailles, it symbolized China's new desire to learn from great periods of Western history.

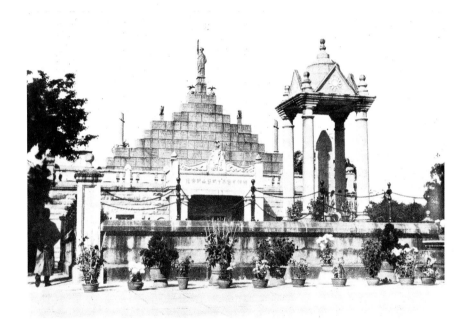

FIG. 14.1 The Tomb of the Seventy-Two Martyrs on Yellow Flower Hill; photographed in 1930.

When the revolution broke out on a grand scale in October 1911, the Viceroy recognized the futility of resistance and readily agreed to the transfer of government to the revolutionary leaders on 10 October. The new Republic of China, founded the following year, brought sweeping changes to the constitution. Dr Sun Yatsen, as first provisional president of the Republic, established the Guomindang (Nationalist party) which became the leading party in the new government. The restrictions against the boat people, barbers, actors, and yamen runners were removed; they were to be given full civic rights and could take an active part in the new elections.

With emancipation for women increasing, footbinding was at last generally seen as outmoded and out of place. One man, renowned reform leader K'ang Yu-wei, from Nan-hai district, had attempted to abolish it as early as 1882, but the time was not right. In 1894, Kang started the

Unbound Foot Association in Canton, later moving it to Shanghai. Then, in 1898, he submitted a memorial to the Emperor describing the practice as outmoded and regressive. Another anti-footbinding organization, the Natural Foot Society, was headed by Mrs Alicia Little, the wife of a British Yangzi River merchant. Mrs Little preached in Canton on her anti-footbinding tour in the late 1890s, assisted by Dr John Kerr and Dr Mary Fulton. All of these activities helped to hasten the practice's demise. The ban by the new Republic in 1912 sounded the death knell, although resistance to having natural feet lingered on in parts of the country for some decades after.

A clean-up campaign in the city had begun in 1908, when sixty-three flower boats were ordered to vacate their anchorage at Tai Sha Tau, an island on the Pearl River now linked to the mainland. If they did not comply, the order stated, the boats would be set on fire, since it was planned to have pleasure boats anchored there and restaurants built along the shoreline. The following year, a serious typhoon greatly reduced the number of flower boats on the Pearl River, and the Viceroy seized the opportunity to end the immoral trade by imposing severe restrictions on the prostitutes.

At about the same time, a mass of tumbledown wharves and shanty huts along the foreshore were replaced by an embankment known as the Bund, which was built along the river with up to four-storey high Western-style buildings. A power station in the middle provided electric lighting and the Bund became the fashionable part of the city. One of the new buildings was the Customs House, a red brick building in the European style adorned with a clock tower. A fire in 1912 destroyed 400 houses including the Customs House, the main post office, the Canton and Hong Kong steamer wharf, and two hotels. The General Post Office and the Customs House were rebuilt four years later, and steamers tied up in front of the Customs House where berthing numbers, cut at intervals on the paving stones in front, remained until the end of the twentieth century.

Under the Republic's system of government, mayors and municipal councils replaced the old system of administration run by the mandarins. Dr Sun Ke, the only son of Dr Sun Yatsen and a graduate of Columbia University, became the first mayor of Canton in February 1921. Canton's Municipal Council, formed that same year, carried out dramatic changes. Six municipal bureaux were formed: Finance, Police, Public Works, Public Utilities, Health, and Education. Two more, Land Administration and Social Welfare, were added in 1924. The Canton Municipal Council also set up several kindergartens, middle schools, a technical institute, an academy of art, and medical colleges in the 1920s and 1930s.

The ancient city walls were demolished in 1920 and 1921 (Fig. 14.2) and the creek to the right of where the factories had stood was filled in and called Taiping Maloo, now Renmin South Road. Tree-lined thoroughfares, 30 metres wide, were laid so that motor buses, taxis, and trams could travel

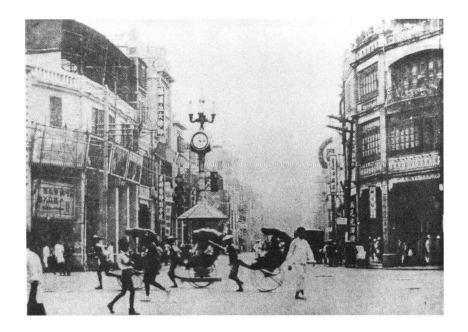

FIG. 14.2 Rickshaws in Canton at the junction of Wing Hon, once called Sheung Mun Tai and now Beijing Road, and Wai Oi Road, previously Street of Benevolence and Love and now Zhongshan Road; *c.*1936.

alongside rickshaws and sedan chairs. Buses were introduced in 1921 by a group of Chinese, returned from Canada, who named their firm The Canadian Company, and two hundred buses ran along fifteen different routes. Although the firm soon went out of business, its equipment taken over by the Municipal Council, the buses continued to be called 'Canadians' by the Cantonese for many years after.

Communications improved substantially when the Kowloon Canton Railway (KCR) opened in 1911 (**Fig. 14.3**). Linking Kowloon in Hong Kong with Canton, the railway had its terminus on the waterfront at Tai Sha Tau. Another line ran from Wong Sha, a short distance upriver from Shamien, to Hankow, a treaty port on the Yangzi River, now a part of Wuhan. Railways supplemented the river steamers, carrying goods produced by the many newly opened mills and factories (**Plate 38**). Imports included cotton yarn, rice, coal, and salted fish. Most of the exports from Canton, such as silk, tea, ginger, earthenware, matting, firecrackers, furniture, ivory, and embroidered household goods, went to Hong Kong to be reshipped to the rest of the world.

The old yamens were demolished and the land around them turned into parks. The Governor's yamen, in the heart of the city, became First Park in 1920. Later renamed Central Park, with a pavilion for concerts, a tennis court, and flower shows held there regularly, it is now the Renmin, or People's, Park. The Treasurer's yamen, where the French consulate had been, was converted into Wing Hon Park in 1929. It then became a zoological garden, housing the clepsydra water clock removed from the building in

Sheung Mun Tai. Since 1958 it has been a children's park, with dodgem cars, swings, and roundabouts providing endless amusement. The site of the Tartar General's yamen was turned into Tsing Wai Park in 1932, while the old British consulate building in the same grounds became the headquarters of the municipal department of education. Sir Brooke Robertson's successor as consul in 1877, A. R. Hewlett, had also resided in the yamen before moving to Shamien, and junior officials and cadets continued to be housed there until the yamen was handed over in 1928.

Yuexiu Park was formed in 1927 by enclosing Yu Hill and Kwun Yam Hill, and the Five-Storey Pagoda became the Canton Municipal Museum two years later. After the museum's opening, it was fashionable to take tiffin, a light lunch, on the top floor, and it remains a pleasant place to sit with a cool drink, looking south towards the Pearl River. The clepsydra is housed there now and recent renovation has made the museum a real treasure-trove of old Canton. Next to it is the Zhongyuan Library, now the Guangzhou Art Museum, founded in memory of Deng Zhongyuan, a general of the Guomindang who was assassinated in 1925.

Two monuments dedicated to Sun Yatsen stand close by the museum. One, a tall tapering granite obelisk, was built in 1929 on the site of the Kwun Yam temple, which was pulled down to make way for its construction. The other, the imposing memorial hall dedicated to Dr Sun, is south of Yuexiu Park, on the eastern side of Jiefang Road, built on land formerly used by the Manchu bannermen as their parade ground. Designed by Lu Yanzhi, who also designed the obelisk, the hall and museum cover an area of 60,000 square metres, and opened in November 1931. The roof is covered with blue glazed tiles made in the ancient pottery kilns at Shek Wan, near Foshan,

west of Canton. The hall seats more than 5,000 people and is used for rallies and cultural events (Plate 39).

In the early decades of the twentieth century, a number of modern department stores opened in Canton. One was a branch of the Sincere Company (Xianshi), established by Chinese-Australian merchant Ma Yingbiao, which opened in 1914 in Changdi, along the Bund near the Canton Hospital. It had several novel features to attract customers, including a lift, which was such an attraction the company had to charge 5c per ride to deter the crowds. Later the store itself was so crowded it was necessary to charge admission. The building of the Sun Company's department store followed it in 1918, also on the Bund. That business had been started six years earlier by several Chinese-Australian merchants and, at its peak, employed almost 900 people.

The company had a second five-storey department store on the Street of Benevolence and Love, by that time called Wai Oi Road, at the corner with Sheung Mun Tai, that featured a restaurant, cinema, and roof garden. Today the store, now called Xin Da Xin and still a style-setter, towers over the same junction, renamed Zhongshan 5 Road and Beijing Road. The store on the Bund had every modern appointment, such as electric lifts, a Chinese restaurant, theatre, and cinema (Plate 40), and with twelve storeys was the tallest building in Canton at the time. The department store, no longer dim and dismal as it was in 1975, has been totally refurbished in recent years, a monument to conspicuous consumption of the Western kind, and has its own website.

Above the department store, and also under Sun Company management, was the Hotel Asia, built in the foreign style, with a cupola on the roof, and much patronized by the Chinese. The 'Leading Hotel in South China', it boasted 'First Class Accommodation, Electric Lights, Fans and Elevators, Roof Garden, Hairdressing Saloon', and offered 'Splendid Views of City and Pearl River, Excellent Cuisine [all at] Moderate Rates'. The other leading hotel was the Oi Kwan (now Aiqun Hotel — Love the Masses Hotel), another modern marvel. Located nearby, on reclaimed land at the corner of the Bund and Changdi Damalu, it was founded by Hong Kong businessmen in 1937, and with fifteen storeys, was the tallest hotel in Canton for many years.

In 1930 graves were removed from a cemetery in Tung Shan district, a burgeoning residential area in the Eastern Suburbs, prior to forming a race-course. The following year a Chinese syndicate put up $210,000 to promote the Kwangtung Race Club and hold regular meetings on the Shek Pau race-course. Not far away, the old east parade ground for the Chinese troops became Tung Kwan Second Park. Further down the Bund, beyond Tai Sha Tau, land was reclaimed and a scheme was planned for a Chinese Shamien, a housing development for Chinese built in the Western style. A few palatial homes like those of the wealthy Straits Chinese were erected, but fear of future rebellions prevented many of the rich from investing in the property.

After being given full civic rights, the Tanka people could now live and work ashore, and by 1921 the floating population had decreased to about 30,000. The Bund was straightened, and in 1931 the island on which the Dutch Folly Fort stood was reclaimed and merged with the north shore of Changdi to form Haichu Park. The three-span iron Haichu Bridge opened two years later, built by a Tianjin-based firm of engineers, McDonnel & Gorman. This was the first bridge to span the Pearl River and linked Honam to the city of Canton.[3] Previously it had been thought that large numbers of boat people would pull any bridge down, for it would have deprived them of that part of their livelihood earned from transporting people across the river. By this time the population on Honam had grown to about 300,000, with brokerage shops, warehouses, shipyards, two Japanese-run hotels, and the tea, ginger, and matting industries as before.

In spite of the greater freedom gained with the new Republic, and Sun Yatsen's personal popularity, political instability racked the country as warlords battled for control. Nowhere was this felt more than in Canton. After stepping aside in 1916 to let Yuan Shikai become president, Sun's authority was virtually confined to Canton, where he was supported by his army, the students, the workers, and the poor. The Kwangtung Cement Works on Honam became the headquarters from which he ran his Southern Republic. In order to pay the mercenaries, mainly from Yunnan and Guangxi, who helped him to hold his territory against rival warlords, 'the Cantonese during the last years of Sun Yat-sen were almost the most heavily taxed people on earth', said an American, Harry Franck, resident in the winter of 1923.[4] All temples and monasteries were declared to belong to the government and many were torn down to make way for new roads, or, like the famous Chan clan's temple, used as soldiers' barracks.

Gambling increased again, opium-smoking and prostitution, once almost stamped out, were back, and Canton was seen as a dangerous place. Life became exceedingly difficult for many people, and those who could afford to left. Foreign tourists lodged in the safety of the Victoria Hotel on Shamien eyed the Chinese city over the English Bridge nervously but seldom dared to venture across. Harry Franck writes of a party of tourists under such tight protection from the guide that one complained, 'he was dying to cross [the] creek and get some pictures. A woman resident of Shamien happening to pass at that moment spoke up in the friendly way of exiles in the East and told him nothing would be easier; if he would just cross that bridge and keep swinging around to his right he could return by the other and find himself back on the island again. For an instant it looked as if he would actually do this brave thing.' But a friend in the party refused to join him, and his wife implored him not to go. Striding up and down on the embankment, 'half striking his fist at the native city across the way, through which [Franck's] wife and mother, American teachers and school-girls, walked or

were chaired by half-naked coolies daily, not infrequently late at night and alone, he cried: "By G-g-u-um, if I didn't have a wife, and four children at home I'd go across that creek all by myself!"[5]

The May Fourth Movement in 1919[6] had inspired a new feeling of nationalism in a whole generation of Chinese youth, and led to the formation of the Chinese Communist Party (CCP). Lu Xun, a leader of the movement, was also a writer and intellectual whose works exerted a profound impact on modern Chinese literature and society. In 1927 he was living and teaching at the Sun Yatsen University. The quadrangles of the old university have now gone, one to make way for the Guangdong Provincial Museum reached off Wenming Road. The centre building and clock tower is now a museum dedicated to Lu, with possessions and photographs of revolutionary members of the Communist Party in the 1920s and 1930s. To Mao Zedong, the ultimate leader of the CCP, and his followers, Lu Xun was a pioneer of Communist thought.

Mao was born in 1893 in Hunan province to a well-to-do peasant family. After a basic education, at 25 he found a job in the library of Beijing University. His political thinking developed quickly, and he was one of the delegates at a meeting of the newly formed Chinese Communist Party in Shanghai in 1921. By 1924 he was in Canton teaching young peasants, seen as the backbone of the revolution, to be Communists. The following year the Confucian temple of Pan-yu, in what had been the Old City, was converted to house the Canton Peasant Movement Institute. Mao was made its director in 1926, with Zhou Enlai, First Premier of the People's Republic of China until his death in 1976, a member of its faculty.

The Institute enrolled 327 peasants from twenty provinces who, after training, were sent to the countryside 'to guide the peasant movement under the leadership of the Party and start armed struggle against imperialism and feudalism'. Today the buildings at 42 Zhongshan 4 Road are preserved as a museum. Within the walled compound a path leads over a bridge to the main gateway. Side halls on the left of the temple were turned into reading rooms and dormitories. The original changing rooms for the scholars became the library for the cadets, while Chongsheng Hall, the main hall in the back building, became the refectory. On the right were lecture halls, now featuring Mao's office and bedroom preserved with its simple rattan furniture (Plate 41).

In May 1924, the French governor-general of Indo-China and his entourage, on their way back to Hanoi, stopped at the Victoria Hotel for dinner with the French community of Shamien. A bomb, thrown through the window in an attempt to assassinate the governor-general, missed him but killed or injured several of the French residents. In fact, the bomb had been thrown by an Annamite revolutionary, who had followed the governor-general up from Indo-China and whose body was found in the river near

the Dutch Folly Fort some days later. But in retribution all rules and curfews for the Chinese on the island were strictly reinforced, and no longer could they gather to sit and gossip on the Shamien Bund in the evening. In defiance, all Chinese on the island went on strike, led by the compradore of the Canton branch of an American firm. Merchants would not sell food, all transport was withdrawn, and the dispute dragged on for seven weeks.

The following year saw even worse upheavals. Incited in May by disturbances in Shanghai against foreign imperialism, and emboldened by the example of a seamen's strike in Hong Kong, a general strike of all native labour in Canton was called on 20 June 1925. This was followed three days later by an attack on Shamien. On this day, a parade of Chinese military cadets and Lingnan students marched along the waterfront facing Shamien on Canal Road, then called Shakee Road. Lined up on the island opposite were British and French marines. Each side later claiming that the other had acted first, shots were fired, killing a large number of the Chinese demonstrators and leaving many more injured, including foreigners. All concourse with the foreign residents, who at this time numbered about 700,[7] was boycotted and their servants left, and Shamien was besieged for about 16 months. Three hundred British troops from Hong Kong were quartered on the island. With barbed wire, sandbags, fortifications, and big guns, Shamien had all the appearance of being under siege (Fig. 14.4). When it was over, Shakee Road was renamed Liuersan, literally '6/23' Road, to commemorate the massacre of 23 June, whose name it still retains.

The Communists had established the United Front in 1924 by joining forces with Sun Yatsen's Guomindang. After Sun's death from cancer in

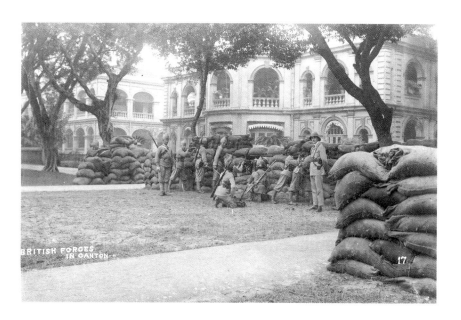

FIG. 14.4 British forces on Shamien, sandbags at the ready; 1925.

Beijing in 1925, tension began to develop between the Guomindang and the CCP. In the years that followed, the commander-in-chief of the Guomindang army, Chiang Kai-shek, expelled Communists from positions of high leadership, ended the Guomindang's alliance with the Communists, and eventually ordered their liquidation. In December 1927 some 5,000 people perished in the suppression of the Canton Commune by Chiang's forces. A museum and memorial garden were eventually established in 1957 on the site of one of the execution grounds at Honghuagang (Red Flower) Hill, off Zhongshan 3 Road. From 1928 to 1937, Canton was officially under the control of the Nationalist government.[8]

The spasmodic fighting, constant movement of troops, and rivalries of the warlords in the south seriously affected trade, and as a result many foreigners left Canton in this period. The city's importance had already begun to decline once restrictions on using cities other than Canton as bases for trade were removed, for it made economic sense to ship tea, porcelain, and silk from Shanghai and ports in Fuzhou, with their greater proximity to the production areas. Colonial Hong Kong, featuring a deep harbour and safe British banking system, also attracted investors to its conservative and stable lifestyle. By the 1930s, Canton had been eclipsed by Shanghai and Beijing as a tourist destination as well, and was reduced to a few slim chapters in general guidebooks to China.

When war broke out against Japan in 1937, Canton became a target of Japanese air raids. The Japanese had occupied northern China since the Sino-Japanese War (1894–5), when they gained control of the Liaodong peninsula. Many Japanese lived on Shamien island in the 1920s and 1930s, and there was a Japanese consulate, hospital, primary school, and several Japanese companies located there. In October 1938 the Japanese occupied Canton, although Shamien was left undisturbed. On 8 December 1941, however, in the wake of the Japanese attack on Pearl Harbour and the day of the capture of Hong Kong, they occupied the island. Japanese Christians continued to use the Anglican church throughout the occupation and it remained unharmed.

After the Japanese surrendered in 1945, Shamien reverted to Chinese rule, coming under the Canton government's jurisdiction in October the following year. By this time all the British had left, although many Portuguese, Swiss, and Germans remained. In early 1949 the Nationalist forces collapsed, the Communists rapidly won control of the entire country, and Chiang was forced to flee to Taiwan, where he established a Nationalist government-in-exile. Canton was taken by the Communists on 14 October 1949, and from then on, along with the rest of China, was effectively closed to the Western world.

For the next four decades, China was in turmoil. Traditional ways were cast aside as the Communists planned to transform China into a socialist society. Propaganda posters and pictures of Chairman Mao Zedong replaced

traditional artwork in every home (Plate 42). As the state took over their companies, foreign businessmen left Canton, as well as other cities, many moving to Hong Kong. Fear of Western imperialism meant religion was strictly controlled, and missionaries also were forced to leave as restrictions were tightened on freedom of expression and thought.

Mao's differences with other CCP leaders, such as Deng Xiaoping, who advocated more moderate policies, drove him to launch the Great Proletarian Cultural Revolution in 1966, to purge his opponents, and to try to restore his ideal of a Chinese revolution. Students around the country formed bands of Red Guards to 'Smash the Four Olds': old ideas, old culture, old customs, and old habits. The Red Guards persecuted artists, writers, intellectuals, and those with foreign connections.

Valuable books and collections of antiques were destroyed, but everyone owned a copy of the 'little red book' containing quotations of the Chairman. Chaos reigned as temples, artwork, books, and anything associated with traditional or foreign cultures was desecrated. The Roman Catholic cathedral was used as a warehouse and most of the stained glass windows smashed, although fortunately the rose-window survived. Many streets in Canton were renamed to reflect the new order. The main north-south thoroughfare of Sze Pai Lau is now Jiefang (Liberation) Road, the Street of Benevolence and Love is Zhongshan Road (sections 4, 5, 6), named for Sun Yatsen's birthplace, and Sheung Mun Tai is Beijing Road.

The emphasis of the People's Republic on self-reliance above all else, as well as its fear of foreigners and foreign ways, caused economic isolation and stagnation. One of the few opportunities for Westerners to visit China in this period was to attend the twice yearly Canton Trade Fair, first held in 1920 and revived in 1957 (Plate 43). Textiles, to tractors, to traditional handicrafts were on display in 1975 in the vast halls of the trade fair buildings. But the ivory carvings echoed the style of the proletarian posters, and the Shek Wan pottery kilns, which had made the finest Ming porcelain, now produced clumsy statues of Mao and figures from revolutionary operas.

Mao's death in September 1976 brought an end to the Cultural Revolution. Under Deng's government, in 1984, as part of a new policy inviting foreign investment, Canton was designated one of China's 'open' cities. Money began to flow in from the many Hong Kong people originally from the city and surrounding Pearl River delta, who formed joint ventures with mainland firms. New housing, stylish shops, and modern government buildings were constructed, and Canton is now served by three railways, as well as having one of China's most extensive highway networks. Its Baiyun Airport, named after the hills surrounding the city, is the largest on the South China mainland. The Export Commodities Fair continues to attract merchants twice a year, eager for the chance to buy from the long-established market, or to sell to those 1.2 billion customers in China.

Trade, however, is not the only reason to visit Canton. Like nineteenth-century travellers, present-day visitors are discovering a city with a wealth of history, one that is now easier to get around and is home to a friendly, garrulous, and industrious people. Although new roads now cut a swathe through the city, where only the ringing of bicycle bells disturbed the peace in 1975 (Fig. 14.5), the Old City still retains a flavour of the past. Shops open onto tree-lined streets, hawkers sell longnans and oranges, and people wander down side alleyways to their homes. Grand old banyan trees spread their branches, bringing welcome shade in the humid heat. Where the West

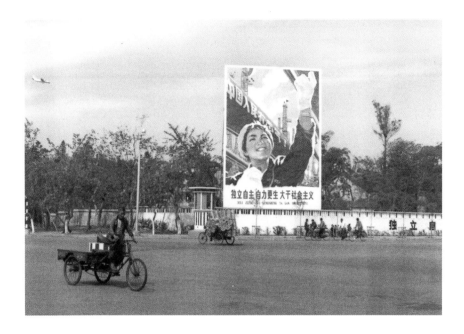

FIG. 14.5 A revolutionary poster at the intersection of Renmin North Road, opposite the hall of the Chinese Export Commodities Fair and the Dongfang Hotel; photographed by the author, October 1975.

Gate once stood, a new metro station retains the old name, Ximen Kou. Across Renmin Road, into the one-time Western Suburbs, there is a different feel, as the streets pulsate to the sound of Canto-pop and Mandarin love songs. Youths with dyed hair dress in the latest styles and enjoy Five Rams ice cream. Across on Shamien, the presence of the White Swan Hotel, which opened in 1982, has meant that limited motor transport is admitted to the island, via a new access road. Development is restricted, however, as since 1996 the island has become a historical and cultural site under national protection.

Today the city covers 1,500 square kilometres, with a population of 3.62 million, while greater Canton, an area of 7,500 square kilometres, has a population of nearly double that. Sleek and cheerful yellow subway trains run under the city, and traffic speeds along six-lane multiple flyovers around the periphery. In this independent and strong-willed city Cantonese is spoken

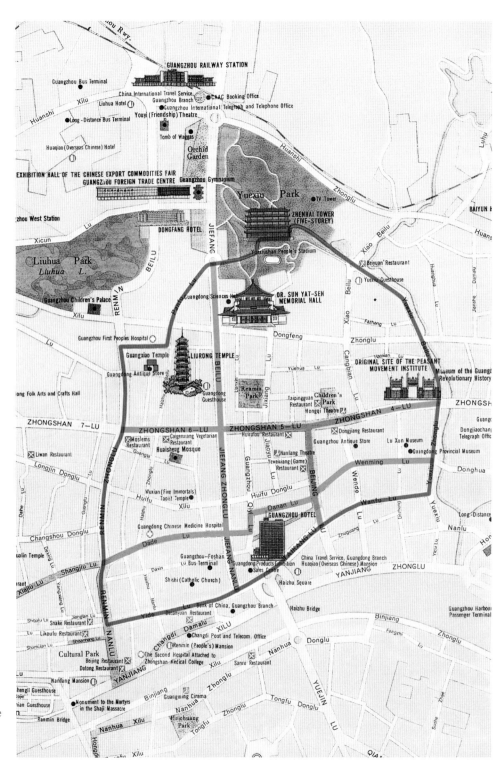

FIG. 14.6 Recent map of Canton showing the route of the city walls with the three main streets marked.

widely, despite the official requirement throughout China to speak the national language, Mandarin (Putonghua). Radio and television stations broadcast in Cantonese, and Hong Kong channels are the most popular. Western religious observance is making a comeback, and many churches have been restored and used for worship, although all now belong to the same officially recognized denomination. First viewed as a novelty, churches are filled on Sundays and at religious festivals with past and present converts.

At the start of another century, old Canton lives on, but the pragmatic Cantonese prefer to look ahead and welcome further modernization and other new developments **(Fig. 14.6)**. They are proud of their fast-growing and modern city with its long history. Canton's traditional role as a gateway for both trade and tourism keeps it in touch, as it always has, with the world outside China's borders, and so it will remain, well into the third millennium.

ENDNOTES

[1] J. Scarth, *Twelve Years in China, The People, the Rebels and the Mandarins, by a British Resident*, Edinburgh: Thomas Constable, 1860, reprint, Wilmington, Del.: Scholarly Resources, Inc, 1972, p. 220.

[2] Peter George Laurie, *A Reminiscence of Canton*, London: Harrison & Sons, 1866, p. 54.

[3] The bridge was bombed by the Japanese in the late 1930s but later rebuilt.

[4] Harry A. Franck, *Roving Through Southern China*, London: T. Fisher Unwin, Ltd, 1926, p. 266.

[5] Franck, 1926, pp. 248–49.

[6] The Treaty of Versailles transferred Germany's rights in China's Shandong province to Japan, instead of restoring them to China. This action resulted in merchant boycotts and workers' strikes, and led to the May Fourth Movement, which sought to modernize Chinese social and intellectual life while advocating Chinese independence, politically and economically, from the West.

[7] In 1926 there were about 40 foreigners and 200 Chinese in the French concession; in the British concession were 679 foreigners and 1,619 Chinese.

[8] After Chiang had unified China under his own leadership, he launched a new series of campaigns in the early and mid-1930s against the Communists led by Mao Zedong and Zhou Enlai. These assaults drove the Communists to their Long March, a historic 9,600-kilometre journey from Jiangxi province in south-eastern China to northern Shaanxi province in 1934 and 1935. The Long March marked the emergence of Mao Zedong as the dominant leader of the party.

Addendum

A translation of the eight regulations to define the activities of foreigners in Canton, issued in *The Canton Register* of Monday, 6 June 1831, as summarized by William Hunter[1]:

REGULATION 1 All vessels of war are prohibited from entering the Bogue. Vessels of war acting as convoy to merchantmen must anchor outside at Sea till their merchantships are ready to depart, and then sail away with them.

REGULATION 2 Neither women, guns, spears, nor arms of any kind can be brought to the Factories.

REGULATION 3 All river pilots and ships' Compradores must be registered at the office of the 'Tung-Che' [assistant magistrate] at Macao. That officer will also furnish each one of them with a license, or badge, which must be worn around the waist. He must produce it whenever called for. All other boatmen and people must not have communication with foreigners, unless under the immediate control of the ships' Compradores; and should smuggling take place the Compradore of the ship engaged in it will be punished.

REGULATION 4 Each Factory is restricted for its service to 8 Chinese (irrespective of the number of occupants), say 2 porters, 4 water-carriers, 1 person to take care of goods ('godown coolie'), and one ma-chen (intended for the foreign word 'merchant'), who originally performed all the duties of the 'House Compradore,' as he is styled to-day.

REGULATION 5 prohibits foreigners from rowing about the river in their own boats for 'pleasure'. On the 8th, 18th and 28th days of the moon 'they may take the air,' as fixed by the Government in the 21st year of Kea-King [Jiaqing] (1819). All ships' boats passing the Custom-houses on the river must be detained and examined, to guard against guns, swords, or firearms being furtively carried in them. On 8th, 18th and 28th days of the moon these foreign barbarians may visit the Flower Gardens

and the Honam Joss-House, but not in droves of over ten at one time. When they have 'refreshed' they must return to the Factories, not be allowed to pass the night 'out', or collect together to carouse. Should they do so, then, when the next 'holiday' comes, they shall not be permitted to go. If the ten should presume to enter villages, public places, or bazaars, punishment will be inflicted upon the Linguist who accompanies them.

REGULATION 6 Foreigners are not allowed to present petitions. If they have anything to represent, it must be done through the hong merchants.

REGULATION 7 Hong merchants are not to owe debts to foreigners. Smuggling goods to and from the city is prohibited.

REGULATION 8 Foreign ships arriving with merchandise must not loiter about outside the river; they must come direct to Whampoa. They must not rove about the bays at pleasure and sell to rascally natives goods subject to duty, that these may smuggle them, and thereby defraud his Celestial Majesty's revenue.

ENDNOTES

1 William C. Hunter, *The Fan Kwae at Canton before Treaty Days, 1825–44*, Kegan Paul, Trench & Co, London, 1882, reprint the Oriental Affairs, Shanghai, 1938, pp. 17–18.

Table of Chinese Dynasties and Periods Referred to in the Text

Western Zhou dynasty	1100–771 BC
Qin dynasty	221–206 BC
Han dynasty	206 BC–AD 220
Western Han period	206 BC–AD 9
Three Kingdoms period	AD 220–265
Western Jin period	265–317
Eastern Jin period	317–420
Sui dynasty	581–618
Tang dynasty	618–906
Northern Song	960–1127
Southern Song	1128–1279
Yuan dynasty	1279–1368
Ming dynasty	1368–1644
Qing dynasty	1644–1911
Republic	1912–1949

English/Pinyin and Cantonese/Pinyin Glossary

Chan	Chen
Ch'eng-huang	Chengwang
Chan family temple	Chen family temple
Chau Tau	Zhoutou
Chiang Kai-shek	Jiang Jieshi
Fa Tap	Huata
Fati	Huadi
Fong Tsuen	Fangcun
Hai Chu	Haizhu
Haichu	Haizhu
Hai-chuang	Haizhuang
Hoi-pu	Yuehaiguanpu
Huang Ch'ao	Huangchao
Hung mo kwai	Hung mao gui
Jui-lin	Ruilin
Kam Fa	Jinhua
Kung so	Gongsuo
Kwan Ti	Guangdi
Kwang Tap	Guanta
Kwangtung	Guangdong
Kwong Hau	Guangxiao
Kwong Nga	Guangya
Kwong Wah	Guanghua
Kwun Yam	Guanyin
Lai Heung Yuen	Lixiang Yuan
Lao Ts'ung-kwang	Lao Chongguang
Lotus mountain	Lianhua
Lu Ying	Luying
Luk Yung	Liurong
Man Cheung	Wenchang
Mean people, chien-min	Jianmin
Mong–ha	Wanghia

Nam Wah	Nanhua
Nan Yue kingdom	Southern Yue kingdom
Ng Kwok-ying	Wu Guoying
Ng Ping-chuen	Wu Binjian
Ng Sing Kwun	Wu Xian Guan
P'an Chen-ch'eng	Pan Zhencheng
P'an Shih-ch'eng	Pan Shichen
Pai Lau	Pailou
Pai Shang Ti Hui	Baishangdihui
Pak Hok Tung	Baihedong
Pak Tai	Beidai
Pearl River	Zhujiang
Po Chi	Boji
Pu	Fu
Sai Lai Cho Ti	Xilai Chodi
Sam Tuen Kung	San Yun Tong
Sea Calming Tower	Zhenhai Lou
Sea of Learning Hall	Xuehaitang Academy
Shamien	Shamian
Shang-ti	Shangdi
Shap Pat Pu	Shibafu
Shek Wan	Shiwan
Shishi	Shengxin
Shun Tak	Shunde
Sincere Company	Xianshi
Siu-tsai	Xiucai
St John's Island	Sancian dao
Sun Company	Daxin
Swatow	Shantou
Tai Sha Tau	Dashatou
Taiping Tien Kuo	Taipingtianguo
Tanka	Danjia
Tin Hau	Tianhou
Tomb of Abu Wangus	Qingzhen Xianxian Gumu
Tsang Kwong	Zhenguang
Tsing Wai	Jinghui
Tung Kwan	Dongguan

Tung Shan	Dongshan
Wah Lam	Hualin
Lu Wai Lung	Lu Huineng
Wai Shing Chi	Huaisheng Mosque
Wing Hon	Yonghan
Yan Oi	Renai

Sources for Illustrations

Photographs were provided by, or reproduced with the kind permission of, the following individuals and organizations. Care has been taken to trace and acknowledge the sources of all illustrations included, but in some instances this has not been possible. Where omissions have occurred, the Publishers will be pleased to correct them in future editions, provided they receive due notice.

T. Allom, *China, In a Series of Views…*, Fisher, London, 1843: Plate 12, Figs. 4.2, 4.4, and 5.7.

G. W. Browne and N. H. Dole, eds., *The New America & The Far East: China*, vol. 5, Marshall Jones Co, Boston, 1910: Figs. 6.3, 10.7, and 11.11.

———, *China Travel: Guangzhou and Foshan*, China International Travel Service, Guangzhou Branch, and [the] Editorial Department of the Guangdong People's Publishing House, Guangzhou, 1977: Plate 43.

———, *China's Best Arts & Crafts, Guangdong Province Special* (vol. 1, No. 1), China's Best Publishing Inc., Guangzhou, 1980: Fig. 8.5.

J. R. Chitty, *Things Seen in China*, Seeley & Co, Ltd, London, 1909: Figs. 6.9 and 12.4.

Christie, Manson & Woods, Ltd, London: Plates 14, 20, and 26.

Patrick Connor: Fig. 13.1.

G. W. Cooke, *China: Being 'The Times' Special Correspondence from China in the Years 1857–58*, G. Routledge & Co, London, 1858: Plate 28.

C. H. Corbett, *Lingnan University*, Trustees of Lingnan University, New York, 1963: Figs. 5.2 and 13.6.

Dorys Annette Cree: Plate 2.

C. Crossman, *The Decorative Arts of the China Trade*, Antique Collector's Club, Suffolk, 1991: Plates 24 and 36.

Dennis George Crow: Figs. 5.4, 5.5, and 6.4.

Daniel Wolf Collection, New York City: Fig. 10.5.

Deacon & Co, Ltd, Hong Kong: Fig. 11.4.

Valery Garrett: End covers; Plates 1, 3, 4, 5, 6, 7, 8, 9, 10, 11, 15, 17, 19, 21, 23, 25, 31, 33, 35, 38, 39, 40, 41, and 42; Figs. 1.4, 2.1, 2.2, 2.3, 2.5, 3.3, 3.5, 3.7, 3.11, 4.5, 4.7, 5.1, 5.3, 6.5, 6.6, 7.1, 8.3, 10.9, 11.2, 11.3, 11.5, 11.6, 11.7, 11.8, 12.2, 12.6, 13.3, 13.10, 14.4, and 14.5.

Guangzhou Museum: Figs. 1.1, 1.2, 4.7, and 11.1.

Rev. E. J. Hardy, *John Chinaman at Home*, T. Fisher Unwin, London, 1912: Figs. 3.1 and 10.8.

Sue Hess: Figs. 6.2 and 11.9.

Hong Kong Museum of Art Collection, Hong Kong: Plates 16 and 37.

Horstmann & Godfrey, Ltd, Hong Kong: Plate 27; Figs. 3.10, 8.4, and 14.3.

International Museum of Photography at George Eastman House, Rochester, N.Y.: Fig. 11.10.

Rev. J. G. Kerr, *The Canton Guide*, 4th edition, Kelly & Walsh, Ltd, Hong Kong, A. S. Watson & Co, Ltd, Canton, 1889: Figs. 3.2 and 12.1.

Rev. J. G. Kerr, *A Guide to the City and Suburbs of Canton*, Kelly & Walsh, Ltd, Hong Kong, 1904: Fig. 10.6.

E. B.-S. Lee, *Modern Canton*, The Mercury Press, Shanghai, 1936: Fig. 14.2.

————, *The Living China, A Pictorial Record 1930*, Wu Luen Tak, et al., eds., The Liang You Printing & Publishing Co, Ltd, Shanghai, 1930: Fig. 14.1.

Rev. J. Macgowan, *Pictures of Southern China*, The Religious Tract Society, London, 1897: Figs. 4.3, 4.6, and 12.5.

————, *Marciano Baptista and His Art*, Leal Senado Art Galleries, Macau, 1990: Plate 30.

A. J. Marlowe, *Chinese Export Silver,* John Sparks, Ltd, London, 1990: Fig. 8.6.

Martin Gregory Gallery, London: Plates 13, 18, and 29.

T. T. Meadows, *Desultory Notes on the Government and People of China*, W. Allen & Co, London, 1847: Fig. 3.8.

Margaret Moore: Figs. 13.7 and 13.9.

H. B. Morse, *The International Relations of the Chinese Empire*, vols. 1–3, Kelly & Walsh, Ltd, Shanghai, 1910–18: Fig. 7.2.

————, *Nagel's Encyclopaedia—Guide, China*, Nagel Publishers, Geneva, 1978: Fig. 1.3.

Robert Nield: Fig. 10.1.

Royal Asiatic Society, London: Figs. 7.3 and 9.3.

Santa Barbara Museum of Art, Santa Barbara, Collection of Jane and Michael G. Wilson: Figs. 2.4, 3.6, 6.1, 6.8, and 9.2.

E. R. Scidmore, *China, The Long-Lived Empire*, The Century Co, New York, 1900: Fig. 10.3.

Anne Selby: Plate 34; Figs. 12.3 and 13.5.

Rev. A. H. Smith, *Village Life in China,* Fleming H. Revell Co, New York, 1899: Fig. 3.9.

Rev. A. H. Smith, *The Uplift of China*, Church Missionary Society, London, 1907: Figs. 13.2 and 13.8.

Sotheby's, London: Plates 22 and 32.

J. L. Stoddard, *John L. Stoddard's Lectures*, vol. 3, Balch Brothers Co., Boston, 1897: Figs. 3.7, 5.6, 9.1, and 9.4.

J. Thomson, *China and Its People in Early Photographs*, Sampson Low, Marston Low, and Searle, London, 1873, reprint Dover Publications, Inc, New York, 1982: Figs. 2.6, 4.1, 6.7, 8.1, 8.2, 10.4, and 10.5.

True Light Seminary: Fig. 13.4.

Victoria & Albert Museum (V&A Picture Library), London: Plate 12 and back cover.

Wattis Fine Art, Hong Kong: Fig. 10.2.

Selected Bibliography

Abeel, David, *Journal of a Residence in China, and the Neighbouring Countries from 1830–1833*, New York: J. Abeel Williamson, 1836.

Abel, Clarke, *Narrative of a Journey in the Interior of China, …1816–17*, London: Orme & Brown, 1818, London: Longman, 1819.

Albert Victor, Prince, and Prince George of Wales, *The Cruise of Her Majesty's Ship 'Bacchante', 1879–1882*, London: Macmillan & Co., 1886.

Almack, William, *A Journey to China from London in a Sailing Vessel in 1837*, manuscript, 1837.

Astley, Thomas, *Collection of Voyages and Travel, 1745–1747, A New General Collection of Voyages and Travels: Consisting of the Esteemed Relations, Which Have Been Hitherto Published in Any Language, Comprehending Every Thing Remarkable in Its Kind, In Europe, Asia, Africa, and America*, vols. 1–4, London: T. Astley, 1745–7.

Ball, J. Dyer, *Things Chinese*, Hong Kong: Oxford University Press, 1982, reprint of 5th edition, Shanghai: Kelly & Walsh, 1925.

Bard, Solomon, *Traders of Hong Kong: Some Foreign Merchant Houses, 1841–1899*, Hong Kong: Urban Council, 1993.

Barrow, John, *Travels in China from Pekin to Canton*, London: Cadwell & W. Davies, 1806.

Bird, Isabella L., *The Golden Cheronsee and the Way Thither*, London: John Murray, 1883.

Bonner-Smith, D., & Lumby, E., *The Second China War, 1856–1860*, London: Navy Records Society, vol. XCV, 1954.

Bowra, E. C., *A History of the Kwang-tung Province of the Chinese Empire*, Hong Kong: De Souza & Co, 1872.

Boxer, C. R., *South China in the Sixteenth Century: Being the Narratives of Geleote Pereira, Fr. Gaspar da Cruz, O.P., [and] Fr. Martin de Rada, O.E.S.A., (1550–1575)*, ed. C. R. Boxer, London: The Hakluyt Society, 1953.

Braga, J. M., 'A Seller of "Sing-Songs"', *Journal of Oriental Studies* 6, University of Hong Kong, Hong Kong, (1961–4):61–108.

Brassey, Mrs, *Around the World: A Voyage in the Sunbeam, Our Home on the Ocean for Eleven Months*, London: Longmans, 1879.

Bridgman, Elijah C., *Description of the City of Canton*, Canton, 1834, reprint, Cambridge: Chadwyck-Healey Ltd, 1996.

Browne, G. Waldo, & Dole, N. H., eds., *The New America & The Far East: China*, Boston: Marshall Jones Co, 1910.

The Canton Incident of June 23rd: The Truth, pamphlet, 1925.

The Canton Miscellany, vols. 1–5, Canton, 1831.

The Canton Register, 1828–1843, microform, Chicago: Dept. of Photoduplication, University of Chicago Library.

Canton, Its Port, Industries and Trade, Canton: The Canton Advertising Commission Agency, 1932.

Chang Hsin-Pao, *Commissioner Lin and the Opium War*, Cambridge: Harvard University Press, 1964.

Chau Ju-Kua, His Work on the Chinese and Arab Trade in the 12th and 13th centuries, entitled Chu-fai-chi, Trans. from Chinese by F. Hirth & W. W. Rockhill, St. Petersburg: Imperial Academy of Sciences, 1911.

Cheong Weng Eang, *The Hong Merchants of Canton*, Surrey: Curzon Press, 1997.

China Trade, Paintings and Objects: A Catalogue, Salem, Mass.: Peabody Museum, 1970.

The Chinese Repository (Hong Kong), 1832–51.

Claims against China, Washington, D.C.: Government Printing Office, 1869.

Clark, Rev. Francis E. & Mrs Harriet E. Clark, *Our Journey Around the World, an Illustrated Record of a Year's Travel*, Hartford, Conn.: A. D. Worthington, 1895.

Clunas, Craig, *Chinese Export Watercolours*, London: Victoria & Albert Museum, Far Eastern Series, 1984.

Clunas, Craig, ed. *Chinese Export Art and Design*, London: Victoria & Albert Museum, 1987.

Collis, Maurice, *Foreign Mud: The Opium Imbroglio at Canton in the 1830s and the Anglo Chinese War*, London: Faber, 1946.

Connor, Patrick, *George Chinnery, 1774–1852: Artist of the China Coast*, Suffolk: Antique Collector's Club, 1993.

Connor, Patrick, *The China Trade, 1600–1860*, Brighton: The Royal Pavilion, Art Gallery & Museums, 1986.

Cooke, George Wingrove, *China: Being 'The Times' Special Correspondence from China in the Years 1857–58*, London: G. Routledge & Co, 1858.

Corbett, C.H., *Lingnan University*, New York: Trustees of Lingnan University, 1963.

Cranmer-Byng, J. L., ed., *An Embassy to China: Being the Journal Kept by Lord Macartney During His Embassy to the Emperor Chien-lung, 1793–1794*, London: Longmans, 1962.

Croft, Michael, *Red Carpet to China*, London: Longman's Green, 1958.

Crossman, Carl, *A Catalog of China Trade Paintings and Objects*, Salem, Mass.: Peabody Museum, 1970.

Crossman, Carl, *The China Trade, Export Paintings, Furniture, Silver and Other Objects*, Princeton: The Pyne Press, 1972.

Crossman, Carl, *The Decorative Arts of the China Trade*, Suffolk: Antique Collector's Club, 1991.

Cumming, Constance Gordon, *Wandering in China*, London: Wm. Blackwood & Sons, 1888.

Cummins, J. S., *A Question of Rites: Friar Domingo Navarette and the Jesuits in China*, Aldershott: Scolar Press, 1993.

Cunynghame, Sir Arthur A. T., *An Aide-de-camp's Recollections of Service in China*, 2 vols., London: Saunders-Otely, 1844.

Davis, Sir John F., *Sketches of China, Partly During an Inland Journey of Four Months, Between Peking, Nanking, and Canton, with Notices and Observations Relative to the Present*, London: Charles Knight, 1841.

Davis, Sir John F., *The Chinese: A General Description of China and Its Inhabitants*, 2 vols., London: Charles Knight, 1836.

Denker, E. P., *After the Chinese Taste, China's Influence in America, 1730–1930*, Salem, Mass.: Peabody Museum, 1985.

Description of a View of Canton, the River Tigress, and the Surrounding Country; Now Exhibiting at the Panorama, Leicester Square, Painted by the Proprietor, Robert Burford, microform, London: Haymarket, T. Brettell, 1838, reprint, Zug: Inter Documentation Co, 1986.

Directory and Chronicles of China, Japan, Straits Settlements, Indo-China, Philippines, etc, Hong Kong: Hong Kong Daily Press, 1923.

Downing, C. Toogood, *The Fan-qui in China*, London: Henry Colburn, 1838, reprint, Shannon: Irish University Press, 1972.

Downs, Jacques M., *The Golden Ghetto: The American Commercial Community at Canton and the Shaping of American Foreign Policy, 1784–1844*, Bethlehem, Penn.: Lehigh University Press, 1997.

Du Halde, Jean-Baptiste, *The Description of the Empire of China*, London: T. Gardner, 1738–41.

Dulles, Foster Rhea, *The Old China Trade*, Boston: Houghton Mifflin Co., 1930.

Eames, J. B., *The English in China: Being an Account of the Intercourse and Relations between England and China from the Year 1600 to the Year 1843 and a Summary of Later Developments*, reprint, London: Curzon Press, 1974.

Ellis, Henry, *Journal of the Proceedings of the Late Embassy to China*, London: John Murray, 1817.

Feller, Dr J. Q., *The Canton Famille Rose Porcelains*, Salem, Mass.: Peabody Museum, 1982.

Field, Henry, *From Egypt to Japan*, New York: Scribner, Armstrong & Co, 1877.

Fisher, Lt Colonel, *A Personal Narrative on Three Years Service in China*, London: Richard Bentley, 1863.

Forbes, H. A. Crosby, Kernan, John Devereux, and Wilkins, Ruth S., *Chinese Export Silver 1785 to 1885*, Milton: Museum of the China Trade, 1975.

Forbes, H. A. Crosby, *Shopping in China: The Artisan Community at Canton 1825–1830*, Washington, D.C.: Museum of American China Trade/International Exhibitions Foundation, 1979.

Forbes, R B., *Remarks on China and the China Trade*, Boston: Samuel Dickinson, 1844.

Forbes, R B., *Personal Reminiscences*, Boston: Little, Brown & Co, 1882.

Franck, Harry A., *Roving Through Southern China*, London: T. Fisher Unwin, Ltd, 1926.

Fu Lo-Shu, *A Documentary Chronicle of Sino-Western Relations (1644–1820)*, Tucson: University of Arizona Press, 1966.

Geil, William, *Eighteen Capitals of China*, London: Constable, 1911.

Goodrich, L. Carrington, *A Short History of the Chinese People*, New York: Harper & Row, 1959.

Gordon, Elinor, *Collecting Chinese Export Porcelain*, London: John Murray, 1978.

Graves, Rev. R. H., *Forty Years in China, or China in Transition*, Baltimore: R. H. Woodward, 1895, reprint, Wilmington, Del.: Scholarly Resources Inc., 1972, p. 28.

Gray, the Venerable John Henry, *Walks in the City of Canton*, Hong Kong: De Souza & Co, 1875.

Gray, J. H., *China, A History of the Laws, Manners and Customs of the People*, 2 vols., ed. W. Gow, London: Macmillan & Co, 1878.

Gray, Mrs, *Fourteen Months in Canton*, London: Macmillan and Co, 1880.

Greenberg, M., *British Trade and the Opening of China, 1800–1842*, Cambridge: Cambridge University Press, 1951.

Guangzhou Museum, ed., *Historical and Cultural Pictorial of Guangzhou*, Hong Kong: Guangdong People's Publishing House, 1996.

Guide to China, Official Services, Vol. D, Tokyo: Japanese Government Railways, 1923.

Gulik, Edward V., *Peter Parker and the Opening of China*, Cambridge: Harvard Studies in American–East Asian History, 1973.

Hao Yen-Ping, *The Comprador in Nineteenth Century China: Bridge Between East and West*, Cambridge: Harvard University Press, 1970.

Hardy, E. J., *John Chinaman at Home*, London: T. Fisher Unwin, 1912.

Harrison, B., *Waiting for China*, Hong Kong: Hong Kong University Press, 1979.

Hawes, D. S., *To the Farthest Gulf: The Story of the American China Trade*, Ipswich, Mass.: The Ipswich Press, 1990.

Hickey, William B., *Memoirs of William Hickey*, ed. Alfred Spenser, 3d edition, 4 vols., London: Hurst & Blackett, 1919–25.

Hirth, F., 'The Geographical Distribution of Commercial Products in Kwang-tung', *The China Review* 2(1872).

Hirth, F., 'The Manufacture of Canton Matting', *The China Review* 1(1872).

Hosie, Alexander, *Manchuria, Its People, Resources and Recent History*, London: Methuen & Co, 1904, p. 157.

Howard, David S., *A Tale of Three Cities: Canton, Shanghai & Hong Kong, Three Centuries of Sino-British Trade in the Decorative Arts*, London: Sotheby's, 1997.

Howard, David S., *New York and the China Trade*, New York: The New York Historical Society, 1984.

Hunter, W. C., *Bits of Old China*, London: Kegan Paul, Trench & Co, 1885.

Hunter, W. C., *The Fan Kwae at Canton before Treaty Days, 1825–44*, London: Kegan Paul, Trench & Co, 1882, reprint, Shanghai: The Oriental Affairs, 1938.

Hurley, R. C., *The Tourist's Guide to Canton, the West River and Macao*, Hong Kong: R. C. Hurley, 1898.

Hutcheon, Robin, *Souvenirs of Auguste Borget*, Hong Kong: South China Morning Post, 1979.

Hutcheon, Robin, *The Merchants of Shameen, The Story of Deacon & Co.*, Hong Kong: Deacon & Co Ltd, 1990.

Irons, Neville J., *Carving of the Old China Trade, Silver of the Old China Trade*, London: The House of Fans, Hong Kong: Kaiserreich Kunst, 1983.

Jades from the Tomb of the King of Nanyue, Guangzhou: The Museum of the Western Han Tomb of the Nanyue King, 1991.

Jehle, M. A., *From Brant Point to the Bocca Tigris: Nantucket and the China Trade*, Nantucket, Mass.: Nantucket Historical Association, 1994.

Johansson, B., ed., *The Golden Age of China Trade*, Hong Kong: Viking Press, 1992.

Jourdain, Margaret, & Jenyns, R. Soame, *Chinese Export Art in the Eighteenth Century*, London: Country Life Ltd, 1950.

Kerr, J. G., *The Canton Directory*, Canton: Canton Printing Press, 1873.

Kerr, J. G., 'The Native Benevolent Institutions of Canton', *The China Review* 2 (1873).

Kerr, Rev. J. G., 'Benevolent Institutions of Canton', *The China Review* 3(1874): 108–14.

Kerr, J. G., 'The Prisons of Canton', *The China Review* 4(1875–6): 115–22.

Kerr, Dr J. G., *The Canton Guide*, 4th edition, Hong Kong: Kelly & Walsh, Ltd, and Canton: A. S. Watson & Co Ltd, 1889.

Kerr, Dr J. G., *A Guide to the City and Suburbs of Canton*, Hong Kong: Kelly & Walsh, Ltd, 1904.

Kerr, Dr J. G., *A Guide to the City and Suburbs of Canton*, Hong Kong: Kelly & Walsh, Ltd, 1918.

Langdon, William B., *Ten Thousand Things Relating to China and the Chinese*, London: Vizetelly Brothers and Co., 1843.

Laurie, Peter George, *A Reminiscence of Canton*, London: Harrison & Sons, 1866.

Lee, Edward Bing-Shuey, *Modern Canton*, Shanghai: The Mercury Press, 1936.

Lee, Jean Gordon, *Philadelphians and the China Trade, 1784–1844*, Philadelphia: Philadelphia Museum of Art, 1984.

Lingnan Science Journal, The Canton Hospital, vol. 9 (1930): 331–8; Honam Island, vol. 10 (1931): 153–87.

Ljungstedt, Anders, *An Historical Sketch of the Portuguese Settlements in China; and of the Roman Catholic Church and Mission in China & Description of the City of Canton*, Boston: James Munroe and Co, 1836, reprint, Viking Hong Kong Publications, 1992.

Loch, Capt Granville G., *The Closing Events of the Campaign in China: The Operations in the Yang-tze-kiang; and the Treaty of Nanking*, London: John Murray, 1843.

Loercher, Jacob G., *Map of the Province of Canton: According to the Map of the Kwong-Tung T'u Shot, with Coastline Taken from Navy Charts and Details Supplied by Several Protestant Missionaries*, Hong Kong: Basel Mission, 1879.

Loercher, Jacob G., *Register of Names: A Companion to the Map of the Provinces of Canton as Published by the Basel Mission Society*, Hong Kong: Basel Mission, 1880.

Loines, Elma, *The China Trade Post-Bag: The Seth Low Family of Salem and New York, 1829–1873*, Falmouth Me.: Falmouth Publishing House, 1953.

Low, William Henry, *The Canton Letters, 1839–1841, of William Henry Low*, intro. by Jane Duncan Phillips, Salem, Mass.: Essex Institute, 1948.

Mackenzie, K. S., *Narrative of the Second Campaign in China*, London: Richard Bentley, 1842.

Macgowan, Rev. J., *Pictures of Southern China*, London: The Religious Tract Society, 1897.

Malcom, Howard, *Travels in Hindustan and China*, Edinburgh: Chambers, 1840.

Marlowe, Alan J., *Chinese Export Silver*, London: John Sparks Ltd, 1990.

Martin, W.A.P., *The Awakening of China*, London: Hodder & Stoughton, 1907.

Mayers, Wm. Fred., *The Chinese Government*, 3rd edition, Hong Kong: Kelly & Walsh Ltd, London: Kegan Paul, Trench, Trubner & Co, Ltd, 1897.

Mayers, Wm. Fred., Dennys, N. B., & King, C., *The Treaty Ports of China and Japan: A Complete Guide to the Open Ports of those Countries, together with Peking, Yedo, Honghong and Macao. Forming a Guide Book & Vade Mecum for Travellers, Merchants, and Residents in General with 29 Maps and Plans*, London: Trubner and Co, and Hong Kong: A. Shortrede & Co, 1867.

Meadows, T. T., *Desultory Notes on the Government and People of China*, London: W. Allen & Co, 1847.

Medhurst, W. H., *China: Its State and Prospects*, London: John Snow, 1838.

Medhurst, W. H., *The Foreigner in Far Cathay*, London: Edward Stanford, 1872.

Moore, Jean, *Daughter of China, An Autobiography: Jean Moore (1907–1992)*, ed. Margaret Moore, privately published, 1992.

Morrison, John R., *A Chinese Commercial Guide*, 3rd edition, Canton: The Chinese Repository, 1848.

Morse, Edward, *Glimpses of China and Chinese Homes*, Boston: Little, Brown, 1902.

Morse, H. B., *The Chronicles of the East India Company Trading to China, 1635–1834*, 5 vols., Oxford: Clarendon Press, 1926, reprint, Taipei: Ch'eng-wen Publishing Co, 1975.

Morse, H. B., *The Gilds of China*, London: Longmans Green, 1909.

Morse, H. B., *The International Relations of the Chinese Empire*, Shanghai: Kelly & Walsh, 1910–18.

Mudge, Jean M., *Chinese Export Porcelain for the American Trade, 1785–1835*, London and Toronto: Associated University Presses, 1981.

Mui H.-C., ed., *William Melrose in China, 1845–1855: The Letters of a Scottish Tea Merchant*, Edinburgh: Scottish History Society/T. A. Constable Ltd, 1973.

Mundy, W. W., *Canton and the Bogue*, London: Samuel Tinsley, 1875.

Nelson, C. H, *Directly from China: Export Goods for the American Market, 1784–1930*, Salem, Mass.: Peabody Museum, 1985.

Ng Yong Sang, *Canton, City of the Rams*, Canton: M. S. Cheung, 1936.

Nieuhof, Jan, *An Embassy from the East India Company of the United Provinces to the Grand Tartar Cham Emperour of China*, trans. John Ogilby, London: John Macock, 1669.

Noyes, Henry, *China Born*, London: Peter Owen, 1989.

Nye, Gideon, *The Morning of My Life in China: Lectures Delivered to the Canton Community between 1873 and 1874*, Canton, 1874–5.

Old Fashions of Guangzhou, Guangzhou: People's Fine Arts Publishing House, 1996.

Oliphant, L., *Lord Elgin's Mission to China and Japan*, Edinburgh & London: Wm. Blackwood & Sons, 1859.

Orange, James, *The Chater Collection: Pictures Relating to China, Hong Kong, Macao, 1655–1860*, London: Thornton Butterworth, Ltd, 1924.

Osbeck, Per, *A Voyage to China and the East Indies*, n.p., 1771.

Papers relating to the Proceedings of Her Majesty's Naval Forces at Canton, London: Blue Book, 1857.

Parmentier, Jan, *Tea Time in Flanders, the Maritime Trade between the Southern Netherlands and China in the 18th Century*, Hong Kong: Ludion Press, 1996.

Pfeiffer, Ida, *A Woman's Journey Round the World*, London: Ward & Lock, 1856.

Phillips, Richard, *An Account of a Voyage to India, China etc in His Majesty's Ship Caroline*, London, 1806.

Plauchut, Edmund, *China and the Chinese*, trans. Mrs Arthur Bell, London: Hurst and Blackett, 1899.

Precious Cargo: Objects of the China Trade, New York: The Chinese Porcelain Co., 1985.

Quincy, Joseph, ed., *The Journal of Major Samuel Shaw, the First American Consul at Canton, with a Life of the Author*, Boston, 1847, reprint, Taipei: Cheng-wen, 1968.

Ready, Oliver, *Life and Sport in China*, London: Chapman & Hall, 1903.

Scarth, J., *Twelve Years in China, The People, the Rebels and the Mandarins, by a British Resident*, Edinburgh: Thomas Constable, 1860, reprint, Wilmington, Del.: Scholarly Resources, Inc, 1972.

Schafer, Edward H., *The Golden Peaches of Samarkand*, Berkeley: University of California Press, 1963.

Seton, Grace Thompson, *Chinese Lanterns*, New York: Dodd, Mead & Co, 1924.

Sirr, H. C., *China and the Chinese*, 2 vols., 1849, reprint, San Francisco: Chinese Materials Center, Inc, 1978.

Smith, Albert, *To China and Back, Being a Diary Kept Out and Home*, 1859, reprint, Hong Kong: Hong Kong University Press, 1974.

Smith, Rev. George, *A Narrative of an Exploratory Visit to Each of the Consular Cities of China, and to the Islands of Hong Kong and Chusan, on Behalf of the Church Missionary Society, in the Years 1844, 1845, 1846*, London: Seeley, Burnside & Seeley, 1847, reprint, Taipei: Ch'eng Wen Publishing Co, 1972.

Smith, H. Staples, *Diary of Events and the Progress on Shameen 1859–1938*, comp. H. S. Smith, 1938.

Spense, Jonathan, *God's Chinese Son*, New York: W. W. Norton & Co, 1996.

Staunton, Sir George, *An Authentic Account of an Embassy from the King of Great Britain to the Emperor of China*, 2 vols., London: G. Nicol, 1797.

Staunton, Sir George Thomas, *Miscellaneous Notices Relating to China, and Our Commercial Intercourses with that Country, including a Few Translations from the Chinese Language*, London: John Murray, 1822–50.

Stevens, George B., *The Life, Letters and Journal of the Rev. & Hon. Peter Parker (1804–1888)*, Boston and Chicago, 1896.

Stoddard, John L., *John L. Stoddard's Lectures*, Boston: Balch Brothers Co., 1890.

Tamarin A., & Glubok, S., *Voyaging to Cathay: Americans in the China Trade*, New York: Viking Press, 1976.

Thomson, John, *China and Its People in Early Photographs*, London: Sampson Low, Marston Low, and Searle, 1873, reprint, New York: Dover Publications, Inc, 1982.

Thomson, John, *Thomson's China: Travel and Adventures of a Nineteenth-century Photographer*, Hong Kong: Oxford University Press, 1993.

Thomson, John, *Through China with a Camera*, London & New York: Harper & Bros., 1899.

Tiffany, Osmond Jr, *The Canton Chinese, or the American's Sojourn in the Celestial Empire*, Boston: James Munroe and Co, 1849.

Tillotson, G.H.R., *Fan Kwae Pictures: The Hongkong Bank Art Collection*, London: Spink & Son, 1987.

Trade Winds: The Lure of the China Trade, 16th-19th Centuries, New York: The Katonah Gallery, 1985.

Travels of Peter Mundy III, Cambridge: Hakluyt Society, 1907–36.

Treves, Sir Frederick, *The Other Side of the Lantern*, London: Cassel & Company Ltd, 1905.

Tucker, Sara, *The Canton Hospital and Medicine in Nineteenth Century China, 1835–1900*, Ph.D. dissertation, Indiana University, Bloomington, 1982.

Turner, J. A., *Kwang Tung or Five Years in South China*, London: S. W. Partridge & Co, 1894.

Urban Council, *Gateways to China*, Hong Kong: Hong Kong Museum of Art, 1987.

Vogel, Ezra F., *Canton under Communism: Programs and Politics in a Provincial Capital, 1949–1968*, Cambridge: Harvard University Press, 1969.

Vogel, Ezra F., *One Step Ahead in China: Guangdong under Reform*, Cambridge: Harvard University Press, 1989.

Wade, Thomas, *The Army of the Chinese Empire*, Canton: The Chinese Repository, 1851, vol. 20, reprint, Tokyo: Maruzen Co, Ltd.

Wakefield, C. C., *Future Trade in the Far East*, London and New York: Whittaker & Co, 1896.

Wakeman, Frederic E., Jr, *Strangers at the Gate: Social Disorder in South China (1839–1861)*, Berkeley: University of California Press, 1966.

Waln, Nora, *The House of Exile*, London: Penguin, 1938, reprint, London: Penguin, 1986.

Ward, Barbara, 'The Red Boats of the Canton Delta', Proceedings of the International Conference on Sinology, Taipei, *Academica Sinica* 6 (1981): 233–59.

Wathen, James, *Journal of a Voyage in 1811 & 1812 to Madras and China*, London: J. Nichols, Son, and Bentley, 1814.

Werner, E.T.C., *China of the Chinese*, London: Pitman, 1919.

White, Stephen, *John Thomson: A Window to the Orient*, New York: Thames & Hudson, 1986.

Wildman, Rounsevelle, *China's Open Door: A Sketch of Chinese Life and History*, Boston: Lothrop Publishing Co, 1900.

Wiley, Rev. I. W., *China and Japan: A Record of Observations Made during a Residence of Several Years in China, and a Tour of Official Visitation to the Missions of Both Countries in 1877–78*, Cincinnati: Hitchcock and Walden, New York: Phillips and Hunt, 1879.

Williams, Mrs H. Dwight (Martha Noyes), *A Year in China*, New York: Hurd & Houghton, 1864.

Williams, S. Wells, *The Chinese Commercial Guide*, 5th edition, Hong Kong: A. Shortrede & Co, 1863.

Williams, S. Wells, *The Middle Kingdom: A Survey of the Geography, Government, Education, Social Life, Arts, Religion etc. of the Chinese Empire and Its Inhabitants*, 2 vols., New York: Charles Scribner's Sons, 1895, reprint, New York: Paragon Book Reprint Corp., 1966.

Williamson, Rev. G. R., *Memoirs of Rev. David Abeel, Late Missionary to China*, New York: Robert Carter, 1848, reprint, Wilmington, Del.: Scholarly Resources Inc, 1972.

Wise, Michael, *Travellers Tales of the South China Coast, Hong Kong, Macau, Canton*, Singapore: Times Books International, 1986.

Wood, William M., *Fankwei, or The San Jacinto in the Seas of India, China, and Japan*, New York: Harper Bros., 1859.

Wood, W. W., *Sketches of China: With Illustrations*, Philadelphia: Carey & Lea, 1830.

Yule, H., *Cathay and the Way Thither*, vol. 4, series 2, Taipei: Cheng-wen, 1967.

Yvan, Dr Melchior, *Inside Canton*, London: Henry Vizetelly, 1858.

Index

A

A. S. Watson & Company, 131
Abahai, 11
Abeel, Reverend David, 99, 151
Abu Wangus, 7, 8,
 tomb of (Qingzhen Xianxian
 Gumu), *plate 2*
Abu Zayd, 8
Afong Lai, xi, *123, 128,* 141
Africa, 6
Agate Lane (Manaoxiang), 8
Ah Kum, 136
Alexander, William, *41, 54*
Allom, Thomas, *39, 41, 57*
America, 80, 85, 88, 89, 118, 150,
 161
American Board of Commissioners for
 Foreign Missions, 151, 152, 153,
 156
American Civil War, 126
American Concession Ground, 126
American Dutch Reformed Church, 151
American Garden, 100
American Legation, 153
American Presbyterian Board, 153,
 156, 157, 159, 160
Amherst, Lord, 113
Ammidon, Philip, 80
ancestor worship, 68, 69
Anglican Church (Christ Church),
 Shamien, 126, *127, 128,* 129,
 155, 175
Anglo-Chinese College, Malacca, 80,
 150
Arab quarter *(fanfang)*, xii, 6, 8
Arabia, 8
Arrow, lorcha, 104
artisans, 38, 89-95

Assomull, Wassiamull, 143
Astor, John Jacob, 75
Austria, 80

B

Baghdad, 130
Baiyun Airport, 6, 176
Baiyun Mountains, 6, 44, 65, *plate 7*
Ball, James Dyer (author of *Things
 Chinese*), 27
Ball, Reverend James Dyer, 158, 159
Bamboo Gate, 15
Bank of Taiwan, 130
bannermen, 16–17, 18, *19,* 166
Banque de l'Indochine, 129
Baptist mission, 163
Baptista, Marciano, *plate 30*
Baqi Yi Ma Road (Eight-banner two-
 horse Road), 20
Batavia, 74
Bate, Commander W. Thornton, *79*
Baynes, Mr, President of the Select
 Company, 100
Baynes, Mrs, 100
Beato, Felice, *17, 29, 60, 69, 105, 106*
Beijing, ix, xiii, 4, 11, 13, 14, 15, 16,
 25, 26, 29, 30, 74, 75, 89, 107,
 108, 112, 113, 122, 154, 175
Beijing Road (Sheung Mun Ti), 20,
 171, 176
Beijing University, 173
Bell Tower, 105, *105*
Benares, 101
Berlin Missionary Society, 163
Binjiang West Road, 119
Bird Cage Fort, 53
Bird, Isabella, 129
Birmingham, 45

boat people, 37, 98, 167, 172
 see also Tanka fisherfolk
Bocca Tigris, see Bogue forts
Bodhidharma, 67
Boggs, Reverend J.J., 158
Bogue forts, 74, 82, 101, 103
Bombay, 79
Borget, Auguste, 52, 92, *113*
Boston, 75, 80
Bowra, E.C., 58
Bowring, Sir John, 67, 104
Bridgman, Reverend Elijah Coleman,
 151, 152
Brighton, Royal Pavilion at, ix
Britain, x, 77, 85, 86, 89, 103, 112,
 113, 161
British troops, 104, 106, 107, 111
British West Indian Emigration Agency,
 161
Buddhism, 6, 59, 60, 67
Bund, the Canton, 163, 168, 171, 172,
 plate 40
 on Shamien, 126, *128,* 129, *132,*
 132, 174
Burford, Robert, 89

C

Calcutta, 92, 101, 105
Canada, 75, 169
Canadian Company, The, 169
Canal Road (Shakee Road), 141, 142,
 143, 174
Canal Street (Shamian North Street),
 126, 132
Canton Buddhist Association, 66
Canton Christian College, 158, *158*
Canton Club, 131
Canton Cotton Yarn Mill, 156

Canton Directory, The, xi, 141, 153
Canton Dispensary, 131
Canton Guide, The, 22, *24,* 63, *142*
Canton Hospital, 152–153, 160, 161
Canton Hotel, 122
Canton Municipal Council, 168
Canton Municipal Museum
 (Guangzhou Museum of History),
 9, 170
Canton Railway Station, *170*
Canton Regatta Club, 132–133
Canton Register, The, 78, 81
Canton system, 76
Canton Trade Fair,
 see Chinese Export Commodities
 Fair
Cantonese (Yue) opera, 121–122, *121*
Cape of Good Hope, 75
Carlowitz & Company, 104
Carlowitz, Herr Richard von, 104
Carpenter's Square, 94
Cemeteries,
 British Military, 106
 at Dane's Island, 82, 159
 at Eastern Suburbs, 159
 at Fati, 159
 at French Island, 82
Central Avenue (Shamian Main Street),
 126, 129, 130, 131
Chan Family Temple, 69–70, *70,* 172,
 plate 11
Changdi, 171, 172
Changdi Damalu, 171
Charles I, King, 74
Charles Magniac & Company, 78
Chartered Bank of India, Australia and
 China, 130
Chau Tau Street, 118, 122
Chenliji Medicine Company, 153
Cheung Loong Matting Company, 118
Chi-chin-qua, 77
Chiang Kai-shek, 175, 179
Chihli province,
 see Hebei

China Hotel, 3
China trade wares, ix, 89–95, *93,*
 141–144, *144, plate 17, plate 21,*
 plate 22, plate 23, plate 35
Chinese: A General Description of China
 and Its Inhabitants, The, x
Chinese Communist Party, 69, 173, 175
Chinese Export Commodities Fair, xi,
 10, 176, *plate 43*
Chinese Repository, The, 151, 152
Chinese troops, 16, 45, 103, 108
Chinese women, 42–43, *43*
Chinnery, George, 91–92, 98, 100,
 131, *150*
chinoiserie, ix, *115,* 143
Chong Un Street, 147
Chongshing (artisan), 92
Choy Sang tea hong, 119
Chuenpi Convention, 103
Church Missionary Society, 41, 163
Chyloong ginger factory, 119, *119*
city gates, 15, *15,* 29
City of Rams, 61
City of the Dead, 44, *44*
city temple (Temple of Horrors) xiii,
 62–63
city walls, 9, *10,* 14–15, *15,* 104, 168
Clark, Francis and Harriet, 62, 136
clepsydra, 29–30, *30,* 106, 169, 170
Cleveland, Ohio, 156, 157
Cochin Chinese, 9
Co-hong, 40, 75, 76, 103
Colburn, Henry, *112*
Columbia University, 168
Communists, 165, 173, 174, 179
 takeover by, xi, 162
compradors, 81, 83, 174
Concordia Hall, 132, 134
Confucian temple of Canton depart-
 ment, 68
Confucian temple of Nan-hai district,
 68, *69,* 107
Confucian temple of Pan-yu district,
 68, 173

Confucianism, 68
Confucius, 68
Consoo House, 81, 82, 161, *plate 14*
consular officials, xi, 128
 see also consuls
consulates,
 British, 126, 128
 Danish, 130
 Dutch, 130
 French, 128, 129
 Japanese, 175
 Portuguese, 130, *133*
 United States, 130
consuls,
 British, 18, *19,* 128
 Danish, 80, 130
 French, 80, 128
 United States, 32, 75, 80, 136
Cooke, George Wingrove, *plate 28*
Courteen Association, 74
Cowasjee Pallonjee & Company, 130
Cree, Dr Edward, *plate 2*
Cultural Revolution, xi, xii, 8, 66, 68,
 157, 176
Cumming, Constance Gordon, 44
Cumshing (artisan), 93
Cushing, Caleb, 108
Customs Club, 122, 131–132
Customs House, 28, 102, 168, *plate 5,*
 plate 16, plate 40
 on Honam, 122, *123*
Cutshing (artisan), 93

D

D. Sassoon Sons & Company, 130
Da Xin Road, 93
Dairy Farm Company, 131
Dane's Island, 82, 99
Daniell, Thomas, 91, *plate 10, plate 26*
Daniell, William, 91
Daoguang emperor, 40
Daoism, 59, 60
Davis, John Francis, x
de Andrade, Fernao Peres, 73

de Andrade, Simon, 73
Deacon, Albert, 123
 children of, 123
Deacon & Company, 111, 129, *130*
Deacon, James (brother of Albert), 123
Deacon, Kate (wife of Albert), 123
Deacon's Steps, 129
Demerara (British Guyana), 161
Deng Xiaoping, 176
Deng Zhongyuan, 170
Denmark, 80
Dent & Company, 78–79, 111, 129
Dent, John, 79
Dent, Lancelot, 79
Dent, Wilkinson, 79
Dent, William, 78, 79
Devils' Talk, 83
Dharmayasa, 65
Dodwell & Company, xi
Dongfang Hotel, xi, 66
Downing, Dr C. Toogood, 82, 88, 93,
 116–117, 152
dragon boat festival, 56–57
dragon boats, 56, *57*
Du Halde, Jean-Baptiste, 57
duck boats, 53, *plate 10*
Dunn, Nathan, 89
Durham, Miss, 160
Dutch East India Company, x, 74
Dutch Folly Fort, 52, *52,* 54, 102, 172,
 174
 see also Hai Chu, Pearl Island

E
earth god, 62,
East Gate, 13, 15, 45, 47, 50, 167,
 plate 3
East India Company, 74, 76, 77, 78,
 79, 81, 83, 86, 89, 99, 151
 see also English East India
 Company
Eastern Jin period, 64
Eastern Suburbs, xiii, 15, 37, 44, 171,
 plate 8

Eastern Wu state, 11
École Pichon, 156
Eight Banner system, 16
Elliot, Captain Charles, 103
Ellis, Henry, 113–114, 115
emperor's merchant, 75
emperor's temple (Palace of Ten
 Thousand Ages), 33–34, *34*
Empress of China, the, 75
English Bridge (to Shamien), 126, 131,
 133, *134,* 134, *135,* 141, 142, 172
English East India Company (the
 Company, the Honourable
 Company, the John Company, the
 East India Company), 11, 74, 85,
 100, 101, 150
English Garden, 100
Europe, 11
Ever Victorious Army, 166
examinations, 21, 23, 25
 abolished, 21, 161
 civil, 23
 halls, 23–24, *23, 24,* 65, 162
 military, 25, 45, *plate 4*
execution ground, 15, 49, *50*
executions, 50

F
Fa Tap (Flowery Pagoda), xi, *17, 19, 66,*
 66, *107*
factories (hongs), ix, 11, 31, 76, 77, *78,*
 79, 81, 97–199, 104, 111, *plate 25,*
 plate 26, plate 37
 American, *78,* 80, 81, 100, 150,
 152
 Chowchow, 80
 Chunqua's, 80
 church at, 155, *plate 37*
 Creek, 81
 Danish, 80, 151, 158
 Dutch, 81, 103, 155
 French, *78,* 80,
 Fungtai, 80, 100, 152
 Howqua's, 81, 103

 Imperial, 80, 81, 99
 Kinqua's, 81
 Mowqua's, 81
 New English, *78, 80,* 81, 97, 100,
 103, 152, 155
 Old English, 80, 100
 Paoushun, 80, 99
 Samqua's, 81
 Spanish, 80
 Swedish, 80, 81, 100
Farmer, William, 134, 137
Fati, xiii, 53, 116–118, *117,* 123, 131,
 157, 158, *163,* 163
Fiji islands, 92
First China War, x, 100, 103, 153, 166
First Park (Renmin Park), 169
Five Genii, 4, 61
Five Rams Muslim restaurant, 8
Five Rams statue, *plate 1*
Five-Storey Pagoda (Zhenhai Lou), 9,
 10, 22, 23, 64, 65, 66, 106, 170,
 plate 38, plate 39
flower boats, *54, 55,* 55, *56,* 168
Floyd, William, *19, 121*
Fong Tsuen district, 123, 158, 160,
 163
Forbes, Paul S., 80
Forbes, Robert Bennett, 80
Forbidden City, 11, 34, 75
foreign merchants, ix, 10, 40, 111,
 plate 13
 American, 75, 80, 101
 Arab, ix, 6, 7, 8, 9, 51, 73, 101
 Armenian, 8, 79
 country traders, 77, 80, 100
 Danish, 75
 Dutch, 11, 52, 73, 74, 75, 82
 English, 11, 75, 82, 97, 112
 French, 75, 82,
 Indian, 79, 131
 Japanese, 10, 11
 Jewish, 8, 130,
 Parsee, 8, 79, 111, 126, 130, 131
 Persian, 8, 9

Portuguese, x, 10, 11, 73, 74, 82, 101
Swedish, 75, 82
Fortune, Robert, 85
forts, on the river, 51, 103, 159
on Shamien, 55, 125
Foshan, 170
Foundling Asylum, 45, *46*, 47
France, 88, 92
Franck, Harry, 172
French Bridge (to Shamian), 126, 133
French Concession on Shamien, 126, 128, 131
French East India Company, 74
French Folly Fort, 52
French Island, 82
French Post Office, 129, *plate 34*
French Revolution, 74
French troops, 41, 104, 106, 107, 156
Front Avenue (Shamian South Street, Garden Road), 126, 127, 129, 132, *133*
Fujian province, 9, 54, 61, 74, 86, 91
Fulton, Dr Mary, 160, 168
Furniture Street, 120
Fuzhou, 9, 103, 127, 175

G
Gaozu, Han emperor, 5
Gate of Eternal Joy, 15
Gate of Eternal Purity, 15
Gate of Literature, 15, 33
Gate of the Five Genii, 15, 28, 163
Gate of Virtue (Sze Pai Lau, South Gate), 13, 15, 28, 30
General Post Office, 168
George III, King, x
George IV, King, 98
as Prince Regent, ix
Germany, 151
ginger manufacturing, 119–120, *120*
Goa, 73
Golden-Lily Street, 94

Governor, 28–29
yamen of, 28, 31, 169
Governor-General of Guangdong and Guangxi, 26
yamen of, 26, 27
see also Viceroy
Governor-General of Indo-China, 173
Grain Commissioner, 31
yamen of, 31
Grand Turk, the, 75
Gray, Reverend John, xi, 68, 105–106, 132, 136, 141, 144, 155
Great Market Street (Huifu West Road), 61, 105
Great New Street (Tai Sun Kai,), 93, 147
see also Da Xin Road
Great North Gate, 13, 15
Great Peace Gate, 15, 147
Great South Gate, 15, 16, 29, 106
Green Standard Army, 16
Guangdong province, ix, 11, 21, 26, 27, 61, 65, 69, 70, 114, 157, 166
Guangdong Provincial Museum, 23, 173
Guangta Road, 7, 8
Guangxi province, 26, 27, 104, 172
Guangxiao Road, 65
Guangya Middle School for Boys, 23
Guangzhou Qiyi Road, 30
Guangzhou Art Museum, 170
guildhalls, 51, *90,*
Swatow guildhall 51, 61
Guomindang (Nationalist party), 167, 170, 174, 175
Gutzlaff, Reverend Karl Friedrich, 151

H
Hackett Medical College, 160–161
Hackett, Mr E. A., 160
Hai Chu (Pearl Island), 51
Hai-chuang temple, 107, 113, *113,* 114, 121, 123
Haichu Bridge, 172

Haichu Park, 172
Hainan island, 31
Haizhuang Park, 114
Hakka women, 43
Han dynasty, 5, 31, 112
Hangshing (artisan), 92
Hangzhou, 13
Hankow, 169
Hankow, the, 134
Hanlin Academy, Beijing, 105
Hanoi, 173
Hanyang, Hubei province, 105
Happer, Elizabeth, 158, 159
Happer, Miss Lillie, 156, 158
Happer, Reverend Dr Andrew P., 157–158, 159
Hart, Sir Robert, 122
Hawaii, 161
Heard, Augustine, 123
Heavenly Peace Street, 147, *147*
Hebei province, 40, 45
Henan (Honan) province, 112
Hewlett, A. R., 170
Hickey, William, 104
High Street (Tsang-sha Street), 146, 163
Hipqua (artisan), 120
HMS *Cornwallis,* 103
HMS *Inflexible,* 105
HMS *Rapid,* 127
Hoaching (artisan), 92, 120, 145
Hog Lane, 80, 98, 99, 100, 152
Home for Aged Females, 46
Home for Aged Men, 47
Home for Lepers, 47
Home for the Blind, 47
Honam, xiii, 51, 53, 102, 107, 111–116, *112,* 118–123, *123,* 128, 129, 153, 158, 162, 172, *plate 29*
Honam Bridge, *plate 30*
Honam Canal, 116, 120
Honam Point, 111, 122
hong merchants, 37, 40, 76, 77, 86, see also factories belonging to,

Hong Kong, x, xi, xii, 54, 63, 67, 78, 91, 93, 101, 103, 106, 123, 129, 131, 132, 133, 134, 136, 137, 141, 143, 144, 155, 157, 161, 169, 174, 175, 176, 179

Hong Kong Chinese, ix

Hong Xiuquan, 165–166

Hongde Road, 120

Honghuagang (Red Flower Hill), 175

Hongkong and Shanghai Banking Corporation, 130, *131*

Hoppo (Hoi-Kwan, Imperial Commissioner of the Guangdong Customs,), 28, 29, 61, 76, 82, 83, 87 yamen of, 28, *plate 5, plate 16*

Hotel Aiqun, 171

Hotel Asia, 171, *plate 40*

Hotel de la Paix, 129

Hotel des Colonies, 129

Howqua (Wu Guo-ying/Ng Kwok-ying), 76

Howqua II (Wu Binjian/Ng Ping-chuen), 76, 77, 103, 152, *plate 12 and back cover* pleasure garden on Fati, 116, *plate 31* residences, 112, 115, 116, 144 see also factories

Huang Ch'ao, 8

Huang Ting-piao, 58

Huanghuagang (Yellow Flower Hill, Tomb of the Seventy-Two Martyrs), 167, *167*

Hubei province, 105

Huifu East Road, 22, 30

Humen, 103

Hunan province, 57, 173

Hung-cheung (artisan), 120

Hunter, William, x, 80, 81, 97, 116

Hutchison Whampoa Group, 131, 137

Hwang Chu Kee incident, 155

I

Ilipu, High Commissioner, 103

Illustrated London News, 115

Imperial Maritime Customs, 122, 133

incense market, 6

India, 11, 60, 64, 65, 68, 77, 79, 85, 101

Indian Mutiny, 104

Indian Ocean, 6

Indonesia, 11, 74

Islam, 7, 149

J

Jack Ass Point, 98

Jakarta, 74

Japan, 10, 11, 73, 94, 161

Japanese trade, 10

Japanese war, 58, 157, 175

Jardine, Dr William, 78, 152

Jardine, Matheson & Company, 78, 79, 80, 81, 111, 129, 130, 151, 166

Java, 74, 151

Jeejeeboy, Sir Jamsetjee, 79

Jesuits, 93, 94, 154

Jiajing emperor, 10, 56

Jiang Qing, xi

Jiangxi province, 88, 179

Jiaoyu Road, 22

Jiaozhou prefecture, 11

Jiefang North Road, 4, 8

Jiefang Road, 13, 170, 176

Jin dynasty, 5

Jingdezhen, 88

Jui-Lin, Tartar General, 18, 108

June 23rd incident, 174, *174*

K

K'ang Yu-wei, 167–168

Kam Fa Temple, 121, 122

Kangxi emperor, 7, 17, 74, 93, 113

Kashmir, 65

Kerr, Dr John Glasgow, xi, 22, 47, 63, 141, 142, 153, 156, 158, 159, 160, 168

Keying, the Imperial Commissioner for Foreign Affairs, 61, 103, 108, 154

Khe-cheong (artisan), 120

Kowloon Canton Railway, 169

Kowloon, Hong Kong, 155, 169

Kussra Terrace, 131

Kwan A-to, 152, *plate 36*

Kwan Ti, god of martial arts, 63, *63*

Kwang Tap (Smooth Pagoda), 6–7, *7,* 51, 66, 68

Kwangtung Cement Works, 172

Kwangtung Race Club, 171

Kwong Hau Buddhist temple, 64, *64,* 65

Kwong Nga Academy of Learning, 23, 45

Kwong Wah Medical College, 161

Kwun Yam, Goddess of Mercy, 63–64, 66, 114 temple of, 64

L

Lagrene, M. de, 154

Lai Heung Yuen, 40, *41,* 41

Lamqua, 91, 92, 120, 152, *plate 36*

Lao Ts'ung-kwang, Viceroy, 106

Laurie, Peter, 166

Lauvergne, M., *plate 25*

Lee-ching (artisan), 120

Li Maoying, 51

Liang A-fa, 152, 165

Liaodong peninsula, 175

Lin Zexu, Commissioner, 102, 103, 153, *plate 27*

Linchong (artisan), 93

Lingnan region, 5, 6

Lingnan University, 153, 158, *159,* 162

linguists, 83, *83*

Lintin Island, 82, 101, *102*

Literary Chancellor, 22 yamen of, 22, 30

Little East Gate, 15, 45

Little Market Street, 147

Little, Mrs Alicia, 168

Little North Gate, 15

Little South Gate, 15

Liu Ch'ang-yu, Viceroy, *26, 33*

Liuersan ('6/23 Road'), 174
Liurong Road, 65
Livingstone, Dr, 150–151
Liwanhu Park, 41
Ljungstedt, Anders, 53
London, 85, 89
London Missionary Society, 149, 154, 156
Long March, 179
Looking-glass Street, 94
Lord Amherst, the, 151
Lotus Mountain, 3
Low, Harriet, 100
Low, William, 80, 100
Lu Wai Lung, Sixth Patriarch, 65, 66
Lu Xun, 173
Lu Yanzhi, 170
Luenchun (artisan), 92, *plate 21*

M
Ma Yingbiao, 171
Macartney, Lord, x, 104, 112
Macau, x, 10, 51, 54, 58, 73, 82, 91, 92, 98, 99, 101, 103, 108, 113, 123, 131, 134, 137, 151, 154, 158
 Macau, or Inner, Passage, 53, 100, 112, 116, 118, 119, 125
 Taipa, 74
Magistrates, 31, 32, *32*
 Nan-hai, 31, 45
 yamen of, 31, 32, 68
 Pan-yu, 12, 31, 45
 yamen of, 31, 32
Malabar, 92
Malacca, 11, 150
Malaysia, 8
Malcom, Howard, 115
Malwa, 101
Man Cheung, god of literature, 51, 59, 63, *63*
 temple of, 68
Manchu army, 11, *14*, 16, 18
Manchu women, 18
Manchuria, 11

Mandarins, 21–35, *31*, 37, 40, 50, 51, 54, *54*, 75, 77, 83, 97, 99, 100, 102, 103, 104, 135, 166
 civil ranks, 21, 26
 dress of, 26, 34
 military ranks, 21, 26
Mao Zedong, Chairman, xi, xii, 165, 173, 175, 176, 179
Marist Brothers, 156
maritime silk route, 6
Martin Hall (Lingnan University), *159*
Martin, Henry, 159
Masonic Hall, 132
Matheson, James, 78, 80
matting manufacturing, 118, *119*
May Fourth Movement, 173, 179
Mayers, William, 17, 18, 50
McDonnel & Gorman, 172
McNeur, George and Margaret, 163, 164
McNeur, Jean, 159, 164
Medhurst, W. H., 154
Medina, 7
Mexico, 88
Middle East, ix, 6, 11
Middle Kingdom: A Survey of the Geography, Government, Literature, Social Life, Arts, and History of The Chinese Empire and Its Inhabitants, The, 152
Miller, M., *26, 83*
Milne, Dr William, 150
Ming city, 5, 9, *9*
Ming dynasty, 9, 11, 21, 27, 29, 56, 73, 121, 122
Ming Sam (Clear Heart) School for Blind Girls, 160, *160*
mint, 45
Minton, Thomas, 88
Mishi Road, 68
missionaries, x, 27, 104, 106, 133, 149–164, 165, 176
Missions Etrangeres de Paris, 156
Moat Street (Dade Lu), 147

Mohammed, the Prophet, 7
Mongolian Tartars, 16
Mongols, 9
Moore, Samuel, 164
Morrison, Dr Robert, 149–151, *150, 152,* 165
Morse, Edward, 29, 38
Mowqua, 103
 see also factories
Mundy, Peter, x, 74
Muslims, 8

N
Nagasaki, 11
Nam Wah Medical School, 161
Nan Yue Kingdom, 3, 4
Nan Yue kings' palace, 4–5, 17, 64
 tomb of (Nanyuewang), 3, *4,* 4
Nan-hai district, 65, 68, 167
Nanhua Middle Road, 114
Nanhua West Road, 116, 120
Nanjing, 103, 122, 166
Napier, Lord, 101
Napoleonic wars, 77
National City Bank of New York, 130
National University of Guangdong, 162
 see also Sun Yatsen University
Natural Foot Society, 168
Navigatre, the, 82
Nestorians, 149
Netherlands Missionary Society, 151
New Bean Street, 143
New China Street, 80, 90, 91, 92, 93, 120
New City, 10, 13, 14, 15, 21, 27, 28, 29, 33, 37, 49, 61, 104, 147, 155
New York, 75
Ng Sheong furniture company, 143
Ngau Tau Kok, Kowloon, Hong Kong, 155
Nieuhof, Jan, x, *14, 15,*74
Niles, Dr Mary, 159–160
Ningbo, 103, 127
North-East Gate, 45, 106

Northern Song dynasty, 9, 65, 66
Northern Suburbs, 44, *plate 7*
Noyes, Harriet, 156–158
Noyes, Martha, 156, 160
Noyes, Reverend Henry Varnum, 156, 157, 158
Nyc, Gideon, 152

O
Ocean Banner monastery,
 see Hai-chuang temple
Oil Gate, 15, 27
Old China Street, 80, 81, 90, 91, 93, 98, 120, *plate 19*
Old City, 10, 13, 15, 21, 23, 28, 29, 31, 61, 62, 63, 64, 65, 68, 128, 147, 156, 173, 177
Olyphant & Company, 150
opium, ix, x, 11, 42, 101–103, *102*, 109, 151
Osbeck, Per, 75, 77
Outer Ngo Chau Street, 119, 122
Overseas Chinese, 10

P
P'an Chen-ch'eng, 40, 76,
 see also Punqua I
P'an Shih-ch'eng, 40, 41, 43, 55, 76, 161
 garden (Lai Heung Yuen), 40, *41*, 107,
Pak Hok Tung, 131, 157, 159, 163
Pak Tai, god of the north, 51, 63
 temple of, 63
Pakistan, 8
Pan Hill, 4
Pan Yu, 4, 5, 11
Pan-yu district, 62, 68
Pang Chi Fu, 45
Panorama building, Leicester Square, 89
Panxi restaurant, xii, 41
parade grounds
 for Chinese troops, 45, 171
 for Manchu bannermen, 44, 170
Parker, Dr Peter, 152–153, *plate 36*
 wife of, 153

Parkes, Sir Harry, 100, 104, 125, 126
Patell, Mr M.J., 160
Patna, 101
pawn warehouses, 39, *40*
Pearl River, ix, x, xi, xii, xiii, 5, 10, 11, 20, 37, 40, 49, 50, 52, *54*, 66, 74, 82, 101, 116, 117, 119, 132, 168, 172, *plate 9*
Pearl River delta, 55, 87, 176
People's Republic of China, 176
Pfeiffer, Ida, 104
Philadelphia, 89
Philadelphia Women's Board of
 Foreign Missions, 156
Philippine Company of Manila, 80
Physic Street (Tseung Lan Kai,
 Seventeenth Ward), *38* 145
Pires, Tomes, 73
Pohing, 143
Pohoomull Brothers, 131
porcelain, ix, 11, 88, 143, *144*, 145, *plate 18*
Portugal, 88
Pottinger, Sir Henry, 103
Powing (artisan), 93, *94*
Prefect, 31, 45, 62, 68
 yamen of, 31
Presbyterian Church of New Zealand, 163
Prince Charles, the, 75
Prinsep, William, 92
prisons, 32, 166
provincial capital, Canton as, 9, 22
Provincial Judge, 30
 yamen of, 30
Pui Ying School for Boys, 157, 158
Punqua I (P'an Chen-ch'eng), 76
Punqua II, 76, 115
Punqua III, 76, 77, 116

Q
Qian Chu ('temple of a thousand
 autumns'), 113
Qianlong emperor, ix, x, 67, 68, 76, 87, 112

Qin city, *9*
Qin dynasty, 5, 75
Qin Shihuangdi, 5, 45
Qing dynasty, ix, xiii, 11, 14, 16, 20, 23, 25, 27, 37, 45, 53, 56, 121
Qing Ping market, 141
Quangzhou, 7, 10
Queen's College, Hong Kong, 161
Queen's Garden, 100, 132

R
racecourses
 at Shek Pau, 171
 in north of city, 106, 122
 on Honam, 122, 132
Red Boats, 55–56, 58
Red Fort, 102, 120, 121
Red Guards, xi, 68, 176
Refuge for the Insane, 158–159, 160
Regulations governing foreign trade, 97
 five regulations (1760), 76, 97
 eight regulations (1831), 97, 113, 181
Renmin Bridge, 114
Renmin Middle Road, 8
Renmin North Road, *177*
Renmin South Road (Taiping Maloo), 168
Republic of China, 12, 167
Respondentia Walk, 98
Ricci, Father Matteo, 154
rickshaws, 135, 169, *169*
Robertson, Sir Daniel Brooke, 107, 128, 170
Roman Catholic cathedral (French
 Mission Cathedral, Sacred Heart
 Basilica), xi, 155, *155*, 176
Roman Catholic church on Shamien,
 129, *plate 33*
Rouji Women's Hospital (Hackett
 Medical College), 161
Rozario, A. F. do, 122
Ruan Yuan, Viceroy, 22
Ruggieri, Father Michele, 154

Russell & Company, 80, 111, 126, 137
Russell, Samuel, 80

S
Sai Hing Street, 143
Sai Lai Cho Ti, 143
Sai Tsui, 88
Salem, 75
Salt Commissioner, 30, 41, 47, 102
 yamen of, 30
salt trade, 30, 41, 47
Sam Yuen Kung (Daoist monastery),
 64
Sampson, Theodore, 132, 161
Sandwich islands, 92
Sassoon, David, 130
Sea of Learning Hall (Xuehaitang
 Academy), 22
Second China War, 41, 51, 61, 104–107,
 109, 153, 155, 156, *plate 28*
sedan chairs, 18, 33, *33*, 37, 38, 128,
 135, *136*, 136, 169
Selden, Dr Charles, 159
Severance Hall, 157
Severance, Mr Louis, 157
Seymour, Admiral Sir Michael, 104
Shaanxi province, 179
Shamian Main Street (Central Avenue),
 126
Shamian North Street (Canal Street),
 126
Shamian South Street (Front Avenue,
 Garden Road), 126
Shamien, xii, xiii, 51, 98, 111, 114, 123,
 125–137, *127, 128*, 141, 142, 144,
 157, 169, 170, 172, 173, 175, 177
Shamien Hotel, 134
Shandong province, 179
Shang-ti, god of war, 61
Shanghai, xiii, 91, 93, 103, 127, 141,
 168, 173, 174, 175
Shangjiu Road, 67
Shap Pat Pu, (Eighteenth Ward,
 Shibafu Road), 144, 145, *145, 163*

Shaw, Samuel, 75
Shek Wan pottery, 69, 170, 176
Shenzhen River, xi
Sheung Mun Tai 29, *30,* 106, *169,* 170,
 171, 176
 see also Beijing Road
Shewan, Robert, 137
Shewan, Tomes & Company, 137
Shing Wong (Ch'eng-huang, city god),
 62
Shun Tak district, 88
Shunzhi emperor, 11, 28
Siamese, 10
Signal Hill, 122, *123*
silk, ix, x, 6, 11, 86–88, *87,* 111
Silk Road, 6, 60
Sincere Company, 171
Singapore, 54
Sino-Japanese War, 175
Sixth Peasant Movement Institute,
 173, *plate 41*
Smith, Archer & Company, 126
Smith, Arthur, 161
Smith, Harold Staples, *130*
Smith, Reverend George, 41
Smyrna, 101
Society for the Worship of God (*Pai
 Shang Ti Hui*), 166
Song city, *9*
Song dynasty, 5, 8–9, 23, 51, 61,
South America, 88
Southern Sect of Zen (Ch'an)
 Buddhism, 65, 67
Southern Song dynasty, 5, 22
Southern Suburbs, 49, 51, 153, 156,
 163, *plate 9*
Spoilum, 91, 92, *plate 13*
St John's Island (Sancian dao), 154
Stoddard, John, 145, 146
Straubenzee, Sir Charles van, 105
Street of Benevolence and Love (Yan
 Oi, Wai Oi), xiii, 4, 13, 17, 22, 28,
 29, 62, 64, 68, 161, *169,* 171, 176
 see also Zhongshan Road 4, 5, 6

Su Dongpo, 65
Sui city, *9*
Sui dynasty, 6, 29
Sun Company department store
 (Nanfang), xii, 171, *plate 40*
Sun Ke, Dr, 168
Sun Quan, emperor, 11
Sun Yatsen, 161, 163, 165, 166, 167,
 168, 170, 172, 174
Sun Yatsen Hospital (Second
 Zhongshan Medical School), 153
Sun Yatsen Memorial Hall, 170,
 plate 39
Sun Yatsen Obelisk, 170, *plate 38,*
 plate 39
Sun Yatsen University, 162, 173
Sunshing (artisan), 93
Swatow region, 51
Sweden, 75, 88
Swedish East India Company, 75
Sweet Water Lane (Tianshuixiang), 8
Sze Pai Lau Street, 13, 17, 21, 28, 29,
 31, 176
 see also Jiefang Road

T
Tachai, xii
Taching, xii
Tai Ping (Great Peace) Street, 146,
 168
Tai Sha Tau, 168, 169, 171
Taiping Rebellion, 165–166
Taiwan, 91, 149, 175
Tang city, 5, 6, 8, *9*
Tang dynasty, ix, 9, 21, 29, 51, 73, 101
Tang Yu, 65
Tanka fisherfolk, 53, 56, 58, 172
Tartar General, 17, 18, 29, 161, 166
 yamen of, 17, 18, *19,* 28, 107, *107,*
 108, 128, 170
Tartar Quarter, 13, *17,* 17, 18, 26, 65,
 plate 28
Tartar soldiers, 11, 13, 17, 44
 see also bannermen

tea, ix, x, 11, 85–86, *86, 87,* 111, 116, 118, *118,* 128, *plate 32*
Temple of Kwan Ti, 63
Temple of the Five Genii, 15, 60, *60, 105, 105*
Temple of the Five Hundred Genii, 66–68, *67, 68,* 143
Temple of Six Banyans, 65–66
Things Chinese, 159
Thirteen Hong Street (Shisanhang Road), 81, 94, 95, 146
Thomson, John, xi, *19, 23, 23, 38, 68, 86, 87, 107, 118, 119*
Thousand Character Classic, The, 23
Three Character Classic, The, 21
Three Kingdoms period, 11
Tiffany, Oswald, x, 79, 90
Tin Hau, Queen of Heaven, 51, 61
Tinqua, 91, 152, *plate 12, plate 20, plate 27, plate 37*
Tomes, Charles, 137
Tong Pau Fort, 52
Tongfu West Road, 118, 121, 122
Trafalgar, Battle of, 101
Tranquil River Gate (Water Gate), 15, 104
Treasurer, 29
 yamen of, 29, *29,* 108, 128, 156, 169
Treaty of Mong-ha, 108
Treaty of Nanjing, 103
Treaty of Tianjin, 106, 157
Treaty of Versailles, 179
True Light Seminary for Girls, 156–157
Tsing Wai Park, 170
Tung Kwan Second Park, 171
Tung Shan district, 171
Tunqua, 89
Turkey, 101
Turner, John, 133

U

Unbound Foot Association, 168
Union Theological College, 158

United Front, 174
United States,
 see America
University of Hong Kong, 161
University of Pennsylvania, 157
Uygurs, 8

V

Vaucher Frères, 129
Viceroy, 26, 27, 29, 68, 76, 101, 102, 168
 yamen of, 27, *27,* 61
 see also Governor-General
Viceroy of Guangdong and Guangxi, *26,* 105
Viceroy of Nanjing, 103
Victoria Hotel, 134, *135,* 172, 173
Vietnam, 5, 82,
Vrooman, Reverend Daniel, *28,* 142, 156

W

Wai Shing Chi (Huaisheng Mosque), 7, *7,*
Walks in the City of Canton, xi, 142
Wang Hing, 143
Wat Yuen, 57
Wathan, James, *plate 19*
Watson, Alexander Skirving, 131
Watson, Dr Thomas Boswall, 131
Weddell, Captain John, 74
Wende Road, 5
Wenhua Cultural Park, 126
Wenming Road, 23, 63, 173
Wesleyan chapel and school, 163
West Gate, 8, 13, 15, 69, 144, 177
West River, 26, 27, 154
Western Han period, 5
Western Suburbs, xiii, 15, 37, *38,* 40, 42, 47, 63, 66, 69, 125, 126, 143, 160, 163, 177
Western Zhou dynasty, 4
Whampoa, 31, 75, 81, 82, 83, 91, 98, 99, 101, *plate 15*

Wheelock Marden, 137
White Rice Street, 143
White Swan hotel, 129, 177
Wildman, Rounsevelle, 32, 136
Williams, Samuel Wells, 93, 114, 152
Wing Hon (Yonghan) Park, 169
Wirgman, Charles, *plate 3*
Wisconsin, 159
Wong Sha, 169
Wongshing (artisan), 93
Wood, William M., 38
Wuhan, 169
Wuzhou, 26, 27

X

Xavier, Father Francis, 154
Xi'an, 4
Xiajiu Road, 67
Xiamen, 74, 76, 86, 91, 103, 127
Xian Yunxing, 29
Xianwang, Zhou king, 4
Ximen Kou (West Gate), 177
Xinjiang, 8
Xinxing county, Guangdong province, 65
Xizong emperor, 8
Xuande emperor, 10, 73

Y

yamens, 14, 21, *28,* 33
Yan Tsai Street, 156
Yancheong (artisan), 120
Yangcheng, 'City of Rams', 4
Yangzi River, 103, 169
Yatshing (artisan), 93
Yeh Mingchen, Viceroy, 104, 105, *106*
 yamen of, 105, 155
Yide Road, 155
Yingyuan Road, 64
Young Men's Christian Association (YMCA), 162
Youqua, 91, *plate 15, plate 31 and front cover*

Yu Fan, 64
Yu Hill, 4, 9, 22, 65, 170, *plate 38*
Yuan dynasty, 9
Yuan Shikai, 172
Yuanmingyuan, 107
Yue people, 4, 11
Yuexiu Middle Road, 23
Yuexiu Park, 4, 9, 170, *plate 39*
Yunnan province, 91, 93, 101, 172
Yuqi Street, 67
Yushan College, 5
Yuyuan Academy, 22
Yvan, Dr, 55

Z
Zhang Mingqi, Viceroy,
 yamen of, 166
Zhang Zhidong, Viceroy 22, 45,
Zhao Jiande, King, 5, 64
Zhao Mei, King, 3, 4, 5
Zhao Tuo, General, 5
Zhaoqing, 27, 154
Zhejiang province, 86
Zhenhai Lou ('Sea-calming' tower),
 9
 see also Five-Storey Pagoda)
Zhong Qichun, 22

Zhongshan county, 161
Zhongshan Road, 13, 176
Zhongshan 3 Road, 175
Zhongshan 4 Road, 5, 62, 173
Zhongshan 5 Road, 62, 171
Zhongshan 6 Road, 8, 65
Zhongshan 7 Road, 69
Zhongshan University, 162
Zhongyuan Library, 170
Zhou Enlai, 173, 179
Zhoutou Road, 118
Zhu Liangzu, General, 9
Zion's corner, 152

Book Design by **Lea & Ink Design**